THE COMPLETE IDIOT'S GUIDE® TO

Creating a Graphic Novel

Second Edition

THE
COMPLETE
IDIOT'S
GUIDE® TO

Creating a Graphic
Novel

Second Edition

by Nat Gertler and Steve Lieber

ALPHA

A member of Penguin Group (USA) Inc.

To Lara, who put up with me.—Nat
To Sara, who put up with me.—Steve

ALPHA BOOKS

Published by the Penguin Group

Penguin Group (USA) Inc., 375 Hudson Street, New York, New York 10014, USA

Penguin Group (Canada), 90 Eglinton Avenue East, Suite 700, Toronto, Ontario M4P 2Y3, Canada (a division of Pearson Penguin Canada Inc.)

Penguin Books Ltd., 80 Strand, London WC2R 0RL, England

Penguin Ireland, 25 St. Stephen's Green, Dublin 2, Ireland (a division of Penguin Books Ltd.)

Penguin Group (Australia), 250 Camberwell Road, Camberwell, Victoria 3124, Australia (a division of Pearson Australia Group Pty. Ltd.)

Penguin Books India Pvt. Ltd., 11 Community Centre, Panchsheel Park, New Delhi—110 017, India

Penguin Group (NZ), 67 Apollo Drive, Rosedale, North Shore, Auckland 1311, New Zealand (a division of Pearson New Zealand Ltd.)

Penguin Books (South Africa) (Pty.) Ltd., 24 Sturdee Avenue, Rosebank, Johannesburg 2196, South Africa

Penguin Books Ltd., Registered Offices: 80 Strand, London WC2R 0RL, England

Copyright © 2009 by Nat Gertler and Steve Lieber

International Standard Book Number: 978-1-59257-942-6
Library of Congress Catalog Card Number: 2009926594

11 10 09 8 7 6 5 4 3 2 1

Interpretation of the printing code: The rightmost number of the first series of numbers is the year of the book's printing; the rightmost number of the second series of numbers is the number of the book's printing. For example, a printing code of 09-1 shows that the first printing occurred in 2009.

Printed in the United States of America

Note: This publication contains the opinions and ideas of its authors. It is intended to provide helpful and informative material on the subject matter covered. It is sold with the understanding that the authors and publisher are not engaged in rendering professional services in the book. If the reader requires personal assistance or advice, a competent professional should be consulted.

The authors and publisher specifically disclaim any responsibility for any liability, loss, or risk, personal or otherwise, which is incurred as a consequence, directly or indirectly, of the use and application of any of the contents of this book.

Most Alpha books are available at special quantity discounts for bulk purchases for sales promotions, premiums, fund-raising, or educational use. Special books, or book excerpts, can also be created to fit specific needs.

For details, write: Special Markets, Alpha Books, 375 Hudson Street, New York, NY 10014.

Publisher: *Marie Butler-Knight*
Editorial Director: *Mike Sanders*
Senior Managing Editor: *Billy Fields*
Acquisitions Editor: *Tom Stevens*
Senior Development Editor: *Phil Kitchel*
Production Editor: *Kayla Dugger*

Cover Designer: *Bill Thomas*
Book Designer: *Trina Wurst*
Indexer: *Heather McNeill*
Layout: *Ayanna Lacey*
Proofreader: *Laura Caddell*

Contents at a Glance

Part 1: **Planning Your Novel** 1

 1 The Novel World of Graphic Novels 3
What is a graphic novel? Why make a graphic novel? Where did all the pizza go? Two of those three questions are answered here.

 2 What's Your Goal? 9
This chapter helps you figure out why you want to make a graphic novel, the first step toward getting it going.

 3 Creating a Creative Team Creatively 17
If you don't want to be a one-man graphic novel, here's a guide to finding your graphic novel drummer or lead guitar.

 4 What's It All About? 29
The theme of this chapter is picking your graphic novel's theme. This chapter's genre is "how-to guide."

Part 2: **The Writer's Art** 37

 5 Who, Why, and Huh?: Interesting People and Events 39
Here's how to make fascinating people and events if you want an interesting graphic novel. Otherwise, skip it!

 6 What, Where, When, and Watchamacallit? 47
Interesting people and events would seem odd in an empty void. Here's how to match them with interesting settings.

 7 Planning the Panels 55
Now that you have your story concept, it's time to break it down into the many individual rectangles that make up a graphic novel.

 8 Delicious Dialogue 67
Here's some tips on putting words into people's mouths.

 9 A Bit of *The Big Con*: Script 77
This chapter is an actual script for a full chapter of the graphic novel The Big Con. *You can compare it to the drawn version of the story in Chapters 18 and 21.*

Part 3: **Putting It in Pencil** 87

 10 Designing Your Characters 89
Most artists only draw each person once. The graphic novelist has to draw the same folks again and again. Here's how to design characters that can be drawn repeatedly and expressively.

 11 Places, Things, and Other Dead Nouns 99
Here are tips on designing everything but the kitchen sink. In fact, you can even use these tips to design a kitchen sink.

12 Decrypt the Script 107
The artist has to act as interpreter, turning a writer's script into a vision of images. This chapter covers turning a writer's direction into readable comics.

13 Lovely Layouts 117
A layout is a rough drawing of the graphic novel page. Read this to learn how to design pages that work.

14 Getting Ready to Render 127
Here are the tools and rules for drawing the page, putting it down on paper.

15 Digital Tools 139
You can get hardware, software, perhaps even underware to help with your graphic novel art.

16 Drawing for Graphic Novels 147
Here's how to place characters, create perspective, and pull off all the other tricks to make your artwork work.

17 Stylize Yourself—Finding Your Voice 159
You can bring work to life by doing something beyond generic drawing. Here's how to find your style and build some flair.

18 A Bit of *The Big Con*: Pencils 167
This is the pencil-drawn version of the script in Chapter 9, so you can see how one artist interpreted and rendered that script.

Part 4: Polishing the Pages 177

19 Inking the Art 179
Pencil art is a thing of beauty. However, graphic novels are actually drawn with a printing press, and to prepare for that, you darken your drawings with ink, as seen here.

20 Varsity Letterin' 191
This chapter teaches you to use your computer to add dialogue, captions, and sound effects quickly and correctly.

21 A Bit of *The Big Con*: The Finished Pages 203
In Chapter 9 you saw the script; in Chapter 18 you saw the pencil art. Now here is the chapter in its final form, completely lettered and inked.

22 Colors Besides Black and White 213
If you want to publish a color graphic novel, here's how to treat your story as a coloring book and your computer as a great big box of crayons.

Part 5: Bring Out Your Book 223

23 Pretty Please Publish Me! 225
Finding a publisher willing to put out your graphic novel is often the hardest part. This chapter has tips to make it as easy as possible.

24 Releasing on the Cheap 235
If getting your graphic novel read is more important than making money off of it, here are a number of ways to put it out without losing much.

25 Put It Out Yourself: Printing 247
If you want your graphic novel to be a real book and can't or don't want to find a publisher, here's how to find a printer and help them turn it into a big pile of books.

26 Put It Out Yourself: Print On Demand 257
If you want your graphic novel to be a real book but won't sell a big pile, here's how to affordably print a small pile.

27 Put It Out Yourself: Distribution 265
Here's how to get that book into the comics shops and bookstores.

28 Promoting and Publicizing 277
Getting your books into stores doesn't do much good if customers don't want them. You can spread the word and build demands with the tips in this chapter.

29 And Then …: The Graphic Novel Career Paths 287
As this chapter shows, you can make graphic novels just one step on your creative road.

Appendixes

A Graphic Novel Publishers 293

B Comic Book Conventions 297

C Other Resources for Graphic Novelists 299

Index 301

Contents

Part 1: Planning Your Novel 1

1 The Novel World of Graphic Novels 3

What's a Graphic Novel? (The Short Answer)............................3
Why a Graphic Novel ..4
 Speaking for Yourself ..*4*
 Speaking to Everyone ...*4*
 Speaking to Just One Person ...*4*
 As Aggressive As You Want ..*6*
 As Long As You Want ...*6*
How Big Is Big? ...7
 Graphic Novels Today: The Current Market*7*
 Graphic Novels Next Tuesday: The Future Market*7*
What's a Graphic Novel? (The Long Answer).........................7
 Not So Novel After All ...*8*
 If Not, Then What? ..*8*

2 What's Your Goal? 9

For Money or for the Monet ...9
 Money Is Far from Certain ...*10*
 Art Is a Sure Bet ..*10*
 Counterfeiter's Truth: Money Can Be Art*11*
For Yourself or an Audience? ..12
Lone Hero or Superteam? ...13
 Knowing Thyself ..*13*
 Weaknesses? Moi? ..*14*
 Time Constraints ..*14*
 Your Desires ...*15*
One Big Book or a Plethora of Pamphlets?...........................15
Don't Be a Goalie..16

3 Creating a Creative Team Creatively 17

Typical Titanic Team Members ...17
 Writer...*18*
 Penciler ..*18*
 Inker ..*18*
 Letterer ...*19*
 Colorist ...*19*
 Cover Artist ..*20*
 Designer..*20*
 Editor/Proofreader/Sounding Board................................*20*
Collaborate Uniquely, Like Others21

Rating Goodness? Gracious! .. 21
Good Writing .. 21
Good Penciling .. 22
Good Inking .. 23
Good Lettering .. 24
Good Coloring .. 24
Working Well Together .. 24
Creative Crew, Where Are You? 25
The Benefits of Paying People 26
Doing Right with Rights .. 26
Doling Out Dollars .. 27

4 What's It All About? 29

Genres Are Generally Germaine 29
The Thousand-Pound Superhero Gorilla 29
A Big Creamy Slice O' Life 30
Auto-By-You .. 30
Burglars, Killers, and Other Fine Folk 31
Graphic History .. 31
Future Robots of America .. 31
Lovey-Dovey Love .. 32
Eek! Horror! .. 32
And All the Rest .. 32
Make a Theme-Filled Cupcake 34
Emotional Exploration .. 34
Existential Exposition .. 34
Action, Action, Action .. 35
Hilarity Ensues .. 35
The Concept of Concept .. 35

Part 2: The Writer's Art 37

5 Who, Why, and Huh?: Interesting People and Events 39

Who Are These Characters? 39
Awesome and Average Abilities 40
Attitude? No Problem! .. 40
Have Strength in Weaknesses 41
Putting the Stories in Histories 42
Revealing Characters You Never Vealed 42
You Look Like Yourself .. 42
"He Chose What?!?" .. 43
Why Should Anyone Care? .. 44
Conflict: Picking a Fight .. 44
Change Isn't Just Nickels and Dimes 44
A Perfect Effect Has No Defect 45
Example Characters: *The Big Con* 45

6 What, Where, When, and Watchamacallit? **47**

You're Nowhere Without a Place ... 47
 Real Places Are Where It's Really At.................................. 47
 Made-Up Places: Fake Estate.. 48
 Really Fictional Places .. 48
Time for Time .. 49
Paperize It .. 51
Plot-Checkin' Fricassee .. 52
Pile on the Problems ... 52
Combinations and Permutations 53
Take Out the Garbage! .. 54

7 Planning the Panels **55**

Pacing to the Pages .. 55
Script Style: Every Which Way but Wrong 56
 Full-of-Possibilities Script ... 56
 Laying Out the Information .. 57
 Plots to Make You Plotz .. 58
Breaking the Page Window Is a Pane 58
 Use the Rhythm Method .. 59
 Panel Planning ... 60
Set Your Scene .. 61
 What's Going On? ... 61
 Who's Going On? .. 61
 Where's Going On? .. 62
 What Impact? .. 62
 Reading Replete with Research 63
Be a Remote Control Cameraman 63
Angles That Work Angelically .. 64
How Loose Is Too Loose, Lautrec? 65

8 Delicious Dialogue **67**

Dallying with Dialogue .. 67
 "Sounds Like Someone!" .. 68
 Brevity: The Soul of Fit ... 68
 Balloon Physics... 69
 Interesting Interchanges ... 69
 Here's a Thought .. 71
Captions Courageous .. 71
Sounds Effective.. 72
Mark Your Words... 73
 Typing Type Types and Blatant Balloons............................ 73
 That Dashed Double Dash 74

9 A Bit of *The Big Con:* Script **77**

Part 3: Putting It in Pencil 87

10 Designing Your Characters 89

Reading Is Fundamental .. 89
Start at the Head .. 90
 The Basics of Basic Shapes ... 90
 Finding the Right Features .. 91
Body Building ... 92
Dressing for Success ... 93
Your Work, It's Fantastic! ... 95
Put It All Together .. 96

11 Places, Things, and Other Dead Nouns 99

Read That Script Again ... 99
 How Important? .. 100
If You're Sticking Around .. 100
 What Needs to Happen Here? 101
 How Big? ... 101
 What's the Feel? ... 101
 Believable or Correct? .. 101
 Is This Going to Ruin My Life? 102
Getting Real .. 102
Making Stuff Up .. 103
 Make It Clear .. 103
 Make It Consistent ... 103
 Make It Familiar ... 103
Getting Your Props .. 104
No Sheet, Sherlock .. 105

12 Decrypt the Script 107

Different Sorts of Scripts ... 107
Read Like a Writer .. 107
Pick a Theme ... 109
Using the Theme ... 109
 You Can't Always Get What You Want 111
 A Digression About Original Art Size 111
 The Strength to Resist Your Strengths 112
Motifs .. 113
 Repeated Shots and Imagery 114
Harm Reduction .. 115
 Is It Just a Misunderstanding? 115
 Work It Out ... 115
 Surrender, but Subvert .. 115
 Cut Your Losses .. 116

13 Lovely Layouts 117

Thumbs Up .. 117
Left to Right, Top to Bottom.................................... 119
Calling the Shots ... 121
The Shape of Things to Come.................................. 121
Timing .. 123
Composition .. 124
What If They Don't Fit Together? 124
The Little Version of *The Big Con* 125

14 Getting Ready to Render 127

Some Art Supplies You Need 127
 Paper.. *128*
 Pencils.. *128*
 Erasers.. *129*
 Rulers... *130*
 T-Square... *131*
 Tables.. *131*
 Light Box ... *132*
Assembling Reference ... 132
 Get It Right.. *132*
 Using Models.. *132*
 Reference from the Web *134*
Blowing Up Your Thumbs.. 134
 Have Your Digital Slaves Do It *134*
 The Low-Budget Way... *135*
Letting Your Live Art Bleed.................................... 136

15 Digital Tools 139

Image Editors: Photoshop and More 139
 Photoshop.. *140*
 The GIMP... *140*
 Manga Studio .. *141*
Post-Paper Possibilities .. 142
 Graphic Tablets.. *142*
 Draw on the Screen ... *143*
 Take Two Tablets and Call Me in a Couple of Years *145*
3-D Models... 145
 Poser's Possibilities... *145*

16 Drawing for Graphic Novels 147

What the Job Requires ... 147
How to Learn to Draw ... 148
 Some Good Books... *148*
 Simple Forms ... *149*
Depth .. 151

Acting Out: Finding the Right Gesture 153
Lay Down the Action Line .. 154
Exaggerate .. 154
Silhouettes with Negative Space .. 155
Bodies Should Bend and Twist ... 155
Is It Interactive? .. 156
Let There Be Light .. 156
Handing Off the Pencilled Pages ... 157

17 Stylize Yourself—Finding Your Voice 159

Factors That Influence Style .. 159
Taking Control of the Process ... 161
Expanding Your Range of Influences ... 161
Too Many Options .. 161
Experiments Are Free .. 163
Experiments in Drawing Technique ... 163
Experiments with Subject Matter .. 164
Formal Experiments ... 165

18 A Bit of *The Big Con:* Pencils 167

Part 4: Polishing the Pages 177

19 Inking the Art 179

Which Way to Work? ... 179
Your Job, Should You Choose to Accept It 180
Ways to Get Better .. 181
Tool Time .. 181
Your Brush with Destiny ... 181
Dip Pens .. 182
Fountain Pens and Technical Pens ... 183
Markers ... 184
What Brand of Ink? .. 184
Changing the Pencils ... 185
Tangencies ... 185
Incomplete Pencils ... 185
Ways to Ink ... 186
Transitions and Textures .. 188
Inking for Color or Black and White 188
Books on Drawing with Ink ... 189

20 Varsity Letterin' 191

Hand Lettering? Is That Like ASL? 191
Down with the Hand, Up with the Digits 192
Letterer Requirements .. 193
Founts of Fonts ... 193
Pushing the Page In .. 194

Putting the Text in Context 195
 A Few Words on Little Letters............................... 195
 Capital Ideas.. 196
Blowing Up Balloons .. 196
 Wagging the Tail.. 198
 Stroking All Around... 199
 Flattening a Balloon .. 199
 Bursting Out and Other Tricks............................... 199
 A Sound Philosophy .. 200

21 A Bit of *The Big Con:* The Finished Pages 203

22 Colors Besides Black and White 213
Four Colors? Not Millions?.. 213
Don't Paint Yourself into a Corner 214
 Causing Contrast.. 214
 Blocking Out Without Blacking Out 215
 Going Loco with Local Color 215
Showing Light and Shade .. 216
Pick Your Crayons Carefully 217
Colorful Computer ... 217
Putting the Page in Place.. 218
Flatting: Bad for Tires, Good for Colors 219
Surrendering to Rendering ... 220
 Getting Cute with Cuts 220
 Attempt Advanced Tricks Carefully......................... 221

Part 5: Bring Out Your Book 223

23 Pretty Please Publish Me! 225
Pitching in the Strike Zone.. 225
Maybe They Want Colorful Envelopes 227
 What They Do Want... 227
 What They Shun .. 228
Picking Publishers to Pitch.. 228
Convention Contention .. 230
Honor an Offer?... 230
 Page Rate Can Pay Great 230
 Royalties Can Be Royally Wonderful 231
 Profit? What Profit? .. 232
Right and Wrong Rights Deals 233

24 Releasing on the Cheap 235
Limiting Losses Rather Than Gathering Gains.................... 235
Photocopicomics... 236
Print-on-Polite-Request.. 237

Online Outlets...238
 Where in the Web's Wideness Do You Fit?....................239
 Millions in Viewers, Pennies in the Bank....................240
 Spread the Word..243
 Things for Your Flash Memories................................243
Putting the "Sell" in Cell Phone....................................244

25 Put It Out Yourself: Printing **247**
A Single Spurt or Slowly Serialized?.............................247
Pick a Perfect Printer..248
 "I Quote, Therefore I Am".......................................249
 Pricing the Price...250
Prepress with Success...251
 Each Page Is a Picture, Pretty or Not.........................252
 Cutting and Bleeding...252
 Avoid Gutter Talk..253
 Please Your Printer Properly.....................................253
 Complete Idiot's Guide to Dummies............................253
The Proof Is in the Proof...254

26 Put It Out Yourself: Print On Demand **257**
When to Demand Print On Demand...............................257
 For Show Art, Not Show Business...............................258
 For Show Business, Not Comics Business......................258
 For Show Then Business...258
 For Already-Shown Business.......................................259
Setting You Up with Set-Up...260
Where to Demand Your Printing....................................260
 Ka-Blam..261
 ComiXpress...261
 Lulu..262
 Café Press...262
 CreateSpace...263

27 Put It Out Yourself: Distribution **265**
Diamond: A Gem of an Operation..................................265
 Pitching on the Diamond...266
 Running Diamond's Bases..267
Direct Distributors on Parade.......................................268
 Haven: A Bit of Heaven?..268
 Last Gasp: A Breath of Fresh Air..............................269
 Slaves Laboring for the Big Kahuna............................269
 Distribute On Demand..270
Dealing with Dealers...270

Your Barcode: Always Tip the Bartender, Never Eat
 the Peanuts ... 271
 UPC: It's a Piece of Cupcake 271
 ISBN: It's Something Bookstores Need........................ 273
 Code Diseases.. 273
Get Yourshelf in Bookstores.. 274
 Look, a Nook for Your Book ... 274
 Hardcovers, Softcovers, and Hard Realities 275

28 Promoting and Publicizing **277**
Press. Release. Repeat. .. 277
 What to Say... 278
 Who to Tell ... 280
 When to Release .. 281
Get Your Book Viewed and Re-Viewed.................................. 281
Adding Ads ... 282
The Conventions of Conventions ... 283
Autographing Like a Superstar.. 284

29 And Then ...: The Graphic Novel Career Paths **287**
Do More Graphic Novels .. 287
 ... But Not Your Graphic Novels 288
 The Dark Winter of the Graphic Novelist.................... 288
Moving Beyond Comics.. 289
 Everyone Kneads a Gud Editter 290
 Even Those Who Can Do, Teach................................... 290
 The Screen Is One Big Panel.. 291
 Boarding Stories .. 291
 Games Are Work... 291
 And Everything Else.. 292

Appendixes

A Graphic Novel Publishers **293**

B Comic Book Conventions **297**

C Other Resources for Graphic Novelists **299**

Index **301**

Foreword

When I was a young idiot and learning my craft, there was no such thing as a guide to creating a graphic novel.

In fact, in those days, there was no such thing as a graphic novel. All we had were comic books, plain and simple. Crudely printed and garish, reviled by parents and teachers, they were widely perceived as being produced by and for idiots. Despite these drawbacks—or perhaps because of them—the fans knew that these objects were more than mass-produced disposable fodder for the hard of thinking.

We who loved the medium could distinguish between artists and writers and even letterers back in those days, when no one was given or, conceivably, asked for any credit for their work. We could follow convoluted continuities, appreciate resonances in words and pictures, follow the evolution of creators and characters, and assiduously preserve and collect the issues we loved.

A few of us fans even aspired to work in the medium ourselves, despite the unlikelihood of that ever becoming a reality—not least because there was no clear point of entry, let alone any course of study or training which might give us the skills required to emulate our idols. For most aspirants, blatant copying was the most obvious route to take. In my case, I would imitate entire stories, line for line, only changing details of the protagonists' costumes and facial features in a futile attempt to disguise my plagiarism.

Back then, even the most rudimentary aspects of production were unknown to the hopeful artist. For instance, I drew most of my attempts at the size of a printed comic book, not discovering until years later that real comic artwork was drawn at a size far larger. Still, if my eyesight suffered, my hand control probably benefited.

Like my peers, I would devour books on figure drawing, perspective, and composition. The local art store carried a few Walter T. Foster books on cartooning, which gave frustratingly meager information about tools and techniques, and once in a while an actual comic book would show an artist at work or have a page of "How I Draw" instruction.

Slowly, though, through trial and error, we learnt. And some of us, with a generous helping of luck, finally broke into the business; befriended other tyros and seasoned pros; and shared knowledge, tips, and techniques. Eventually, too, comics themselves grew up and mutated into graphic novels, finally finding shelf space in real bookstores and being discussed as literature and art by mainstream critics.

Anybody wanting to break into the field now is doubly blessed; not only are there graphic novels of every shade and genre—from the traditional adventure staples to intense autobiographical memoirs—to inspire, but there are also a raft of instructional books that leave no pen nib or pixel unturned in their mission to educate the would-be graphic novelist.

I can't break my lifetime's self-educating habit of reading every one of those books that I can find, and I'm here to tell you that none is as comprehensive or as focused as the volume you're holding in your hands now. I can't imagine a better grounding in the skills and secrets of the field than this guide.

I might not be a complete idiot now, but even after more than 30 years of experience, I've learnt plenty from it. There's no question that you will, too.

—Dave Gibbons, co-creator, *Watchmen*

May 2009

Introduction

You're not an idiot. You're just someone who wants to know more than you do about creating graphic novels. You probably have some ideas about creating graphic novels yourself, and want to know how to go about it. I understand. I've been there myself.

To give you a full picture of the creation process, this book has two main authors. I'm Nat Gertler, and I'll tell you about writing and producing graphic novels, because that's what I do. I've written comic books and graphic novels for literally dozens of publishers. I'm also the one-man company known as About Comics, producer and publisher of graphic novels.

Doing a mighty job showing you the all-important art portion of graphic novels is apple-fritter-eatin' Steve Lieber. Steve is a veteran graphic storyteller, having drawn tales about everyone from the Batman to the inventors of the atom bomb. Between the two of us, we've done just about everything there is to do in comics, and where there's something we haven't done, we've called in an expert friend to tell you about it.

> **Sidebars**
>
> WHA...? A **sidebar** is a separate bit of text presented alongside the main text. In this book, we use several different types of sidebars. For example, in Wha ...? sidebars like this one, we're putting definitions of special terms and graphic novel lingo.

> **Steve Sez: Sez Who?**
>
> I'm Steve. If you see a little sidebar like this one, that's me interjecting an artist's point of view into a chapter written by Nat. I might use it to suggest a way of writing that makes things easier for an artist, for example, or I can point out that I don't actually eat apple fritters. Meanwhile, Nat has his own Nat Sez sidebars for pudding-lovin' writer/publisher insight in the chapters that I write.

What the Book Does

This book shows you how graphic novels get made, from the very beginning of the concept to the end result that you can hold in your hands. In **Part 1, "Planning Your Novel,"** we tell you about planning your graphic novel, including how to work out your story concept and how to find collaborators if you need them.

I show you how to write graphic novels in **Part 2, "The Writer's Art."** Here, you learn to plan the details of the plot, work out the dialogue, and put things in a script form.

In **Part 3, "Putting It in Pencil,"** Steve shows you the first stage of the traditional drawing process. You'll see how to lay out the page by figuring out where the panels go and composing the content of each panel. You'll learn about drawing comics with a pencil, where you can make plenty of mistakes without causing a real problem (unless there's a worldwide eraser shortage). This part has plenty of tricks you can use and traps to avoid in crafting and telling your story.

> **Tip-Top Tip**
>
> Check out these sidebars to see tips and tricks to help you work better, faster, and smarter.

In **Part 4, "Polishing the Pages,"** you learn about finishing the art. You learn not only how to ink your pencil drawings to sharpen them and make them reproducible, but also how to add text and colors.

Part 5, "Bring Out Your Book," is all about getting your graphic novel to the readers. You can find a publisher for your graphic novel; you can publish it yourself; you can even use the Internet to bring it to people. If you just want to stick your graphic novel in a drawer and not let anyone see it, this part won't be any good to you.

Throughout the book you can see, step by step, the creation of a portion of a graphic novel. Steve and I are collaborating on an eight-page section of the new graphic novel *The Big Con*, and you'll get to see those eight pages in each stage as the tale evolves from being a mere concept into being a script, to pencil drawings, and finally to inked and lettered drawings. By the time you're done with this book, you'll know that chapter inside and out.

And the book doesn't end when the drawing is done. You'll also learn how to find a publisher for your graphic novel, or even how to publish it yourself and get it into the hands of readers. (Getting the readers to actually open the book and read it once it's in their hands is up to you, although if there's enough demand we'll be glad to write *The Complete Idiot's Guide to Getting People to Open Your Graphic Novel and Start Reading It.*)

> **A Novel Example**
>
> We use these sidebars to recommend graphic novels that show good examples of what we're talking about in the text. For instance, if we were discussing the concept of "Steve-y goodness", I might suggest you go to the store and ask for a copy of the Antarctic crime thriller graphic novel *Whiteout*, which is full of Steve-y goodness.

What the Book Will Not Do

There are plenty of things that this book will not and cannot do. The biggest thing is that this book cannot be a general how-to-draw book. Drawing is a huge topic, and there are far too many different aspects to it to cover here. There are plenty of classes and books out there to teach you drawing, and Steve'll even clue you in on some of his favorite books. Instead, the drawing parts of this book will teach you the special aspects of drawing that are unique to comics. You won't see stuff here on how to draw the human hand, but you will see things on how to make sure your characters are consistent from panel to panel (always with the same number of hands!) and how to tell the story through your drawings.

Similarly, when it comes to doing electronic production of comics, we'll be suggesting some programs, but there's no way we can teach you all about those programs. If you look around the bookstore or library, you'll see books on each of these computer programs, many of them as thick as a phone book (and some no more exciting—but some are *Complete Idiot's Guides*, full of wisdom and knowledge and cartoons).

Tools, Not Rules

We'll show you ways to create graphic novels. That doesn't mean that we'll be showing you the right way. Of course I don't mean we'll show you the wrong way, either. Creating graphic novels is a creative experience, which means that

there isn't just one right way to do anything. We'll show you ways that work, usually the most common ways, and some interesting things we've tried. Don't let that limit you! Most people draw their graphic novels with pencils then go over it with pen and ink, but if you want to try doing one in crayon, go for it!

Think of this book as a toolbox. Each suggestion we make is a tool you can use if you want, but no one way is right for every creator and every project. Some suggestions will be flathead screwdrivers, good for almost every project, while others are size 15 Torx drivers, which you may never use (but which are still good to have around).

People who tell you there is only one right way of doing things should be ignored, unless they're paying for the work. If they're paying you, you should listen carefully to what they say, smiling and nodding all the time. Then, when they're not looking, do it your own way, and draw pictures of them with funny hair in your graphic novel.

Acknowledgments

The authors would like to show our appreciation to colorist extraordinaire Tom Luth for sharing his expertise on coloring. We'd also like to thank the mighty Harris Miller for handling the business end of the book, and the many fine folks at Alpha—Tom Stevens, Phil Kitchel, Kayla Dugger, and all the various other magical penguins in the great mystical Penguin Group—for their hard work in putting this book together and the patience they showed in dealing with our struggles to make this the finest book possible. Finally, we'd like to invent a delicious cruelty-free, chemical-free, calorie-free cheeseburger and live in luxury off of the patent rights. We really would.

Trademarks

Part 1

Planning Your Novel

Graphic novels don't happen by accident. Oh, every once in a while you'll be carrying a bucket of ink, accidentally trip over a ream of paper left lying about, and find yourself facing an 112-page, coming-of-age tale about a young armadillo learning to fight zombies. But you can't count on that.

In this part of the book, you'll read about the current state of graphic novels, what you can do with them, and why you would want to make one. After considering your goals, you get suggestions on figuring out what parts of the work you want to do and finding out how to locate and identify collaborators for the bits you don't want to do. And then there's the big question: What kind of graphic novel do you want to do? And what color will the zombies be?

The Novel World of Graphic Novels

In This Chapter

- ◆ What is all this graphic novel nonsense anyway?
- ◆ Where did graphic novels come from?
- ◆ Where are graphic novels going?

The concept of *graphic novels* has taken the world by storm. Suddenly, if you read the hipster magazines, they're all talking about graphic novels. If you listen to public radio, they're interviewing the creators of graphic novels. And if you watch *Friends*, they're talking about Ross getting rid of his pet monkey, which proves it's a rerun because if it were a new show, he'd be getting rid of his pet graphic novel!

In fact, the graphic novel is now treated as something so special, so magical, and so wonderful that you'd think there must be some sort of special magic pixies who create them. That's not true. I'm Nat, I'm a graphic novel writer, and I'm here to tell you that graphic novels can be created by ordinary pixies just like you and me. This book is here to show you how.

What's a Graphic Novel? (The Short Answer)

A *graphic novel* is a comics project of substantial length that is designed to be understood as a single work.

That may sound like a simple explanation. After I tell you a bit about why people do graphic novels and where they come from, you'll see that there are actually a few twists in that explanation, so I'll answer the question "What is a graphic novel?" again toward the end of the chapter.

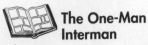

The One-Man Interman

For an example of what one person can do, check out *The Interman*, a full-color action spy graphic novel, totally created and published by one person, Jeff Parker. If this tale ever gets turned into a movie, they'll need more than one person just to dice the tomatoes for the crew's salad.

Why a Graphic Novel

If you've got a story to tell, you can tell it in plenty of ways. You can write a novel, make a movie, spin the story in a song, stage a play, make a TV show, or even dance it as a New Age cutting-edge hula. Why choose the graphic novel form?

Speaking for Yourself

A graphic novel lets you put forth a very personal vision. Many graphic novels are the work of a single person, and even those that are created by collaboration usually involve a small, tight team of people, generally no more than are in a good rock band.

If you want to tell a story visually, that's about as tight a team as you can get. In contrast, putting on a play takes about as many people as a big band. Making a TV show takes about as many people as a marching band. To make a major motion picture, you can expect to involve as many people in a band of thousands (woodwinds included). And the more people who become involved, the less likely the work will reflect anyone's personal vision, much less yours.

Speaking to Everyone

One of the great things about the graphic novel form is that it's very immediate. You could write a prose novel and spend paragraph after paragraph describing exactly what a certain item looks like, and still not be sure that the reader is envisioning the same thing you are. With a graphic novel, you convey that image instantly. A clear drawing ensures that you and the reader are both seeing the same thing.

In fact, most graphic novels communicate so much by image that you can follow much of what's going on even when it's written in a foreign language. You may not understand what everyone's saying to each other, but the places, actions, and facial expressions will tell most of the tale.

Going, Going, Gon

Try any volume of the *Gon* series to see visual storytelling at its purest. These tales of a small dinosaur holding his own in the fierce animal kingdom may not be realistic, but they do follow reality in one way: animals don't talk. There is no dialog and no sound effects within the stories, so you can read the original Japanese printings as easily as the English-language editions.

Speaking to Just One Person

Graphic novels let you bare your soul in ways that can be tough in other visual forms. Plays and movies are watched by theaters filled with people, and TV shows are watched by families together, so any emotions you choose to convey and any emotions that you bring out in your audience have to be ones that

can be shared with the group. In some ways, this can limit the exploration of uncomfortable topics. If you make a movie entitled *My Cruel High School Days*, the guy watching a movie with his date will be concerned not only about how he feels about the story, but how his date might react to the emotion he's showing. If he laughs at the hero's suffering, he's afraid he'll be seen as cruel; if he cries, he's afraid he'll be seen as a wuss. The only emotions he allows himself to experience are the emotions his date shares—the emotions that everyone in the theater shares.

Awkward But with Great Potential

Ariel Schrag created an impressive series of expressive, emotional autobiographical graphic novels about her high school years. The amazing thing is that she started creating them while she was still in high school, so the work is fresh, honest, and not tinged by the extremes of nostalgia. The first book, *Awkward,* has fairly crude storytelling. The second, *Definition,* has a deceptively crude surface style that richly conveys emotions, a style that carries into *Potential* and beyond, as you can see in this example from her fourth graphic novel *Likewise.* Warning: the frank visual depiction of teenage sexuality in these books may make some folks uncomfortable.

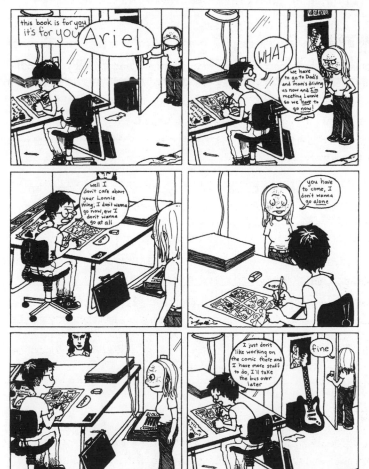

The graphic novelist at work, from Likewise.

(©2003 Ariel Schrag)

Ah, but make *My Cruel High School Days* a graphic novel and it will have no such public audience. It may be read by hundreds of thousands of people, but they're each reading it one at a time. Now the guy can laugh or cry however he sees fit, because he's not sharing the experience. It's an intimate sharing between the creator and the reader. Just don't let his date find out about that intimacy!

As Aggressive As You Want

A graphic novel need not be quiet and intimate. It can be huge. It can be explosive and dynamic. It can burst out in ways that other things don't dare to.

These days, filmmakers can do just about anything. If they need to show a bunny rabbit transforming into a Sherman tank, they can. However, that shot will eat up a half million dollars of the budget. As such, the fancy things are limited, or set aside for movies that are about little more than special effects.

Ah, but for the graphic novelist, turning a rabbit into a tank is not only possible, but it takes roughly the same amount of effort as showing someone drinking coffee. You may be limited by your imagination, or limited by your drawing skills, but you aren't limited in terms of how many sets you can use or how many special effects you have.

The only greater freedom is being a graphic novel writer working in collaboration with an artist. Then you can write that, in one panel, 50 rabbits turn into 50 different tanks. It takes you only 10 seconds to put that in your script, but the artist might spend hours creating the image, while constantly thanking you in terms that would make a sailor blush.

As Long As You Want

The graphic novel grew out of the comic book, which grew out of the comic strip, but the graphic novel is far more free-form. You don't have to tell gags four panels at a time, or get a story wrapped up in the 22 pages of a typical comic book. In recent years comic books have tended to tell longer stories (really, serializing a graphic novel over several issues), but even so the tales have to be broken up into 22-page chapters. Trying to tell a long story with those limitations can be like trying to rewrite *Moby Dick* as a series of limericks.

> Call me, let's say, Ishmael
> My job is hunting the whale
> To capture his skull
> And his body in full ...
> But I'm getting ahead on this tale.

Sure, its fun to try, but it's imposing an unneeded and often damaging rhythm on the work.

A graphic novel can be 48 little pages or 480 oversized pages—whatever you need to tell the tale you want and tell it well. That can change not only what

story you tell but also how you tell it. You can rush through unimportant scenes, such as where the hero eats salad. You can linger slowly on scenes that you think are vital ... say, the ones in which the hero eats ice cream.

How Big Is Big?

The graphic novel business is like the Hulk, seeming nerdish and unimportant most of the time, and then suddenly getting fiercely large and impressive. The only difference is that the Hulk gets large when you make him angry, and the graphic novel business gets big when you make it money. Oh, and the graphic novel business doesn't wear purple pants.

Graphic Novels Today: The Current Market

When we wrote the first edition of this book, the newest number we had was that in 2002, American consumers (that's business talk for "human beings") had spent an estimated $100 million on original graphic novels and bound collections of comic books. We thought that was huge. Now we have the 2007 number: $375 million (according to industry website ICv2.com). That's just one small part of the bigger graphic novel picture, because graphic novels are shipped around the world, translated into other languages, and often generate additional money from being licensed to Hollywood. It also doesn't include the money spent on individual issues that are later collected in book form, which in many cases adds up to more money than is spent on the collections.

Shopping for a Shop

To find a comic shop near you that might carry the graphic novels discussed here, use ComicShopLocator.com or call 1-888-COMIC-BOOK. That actually reaches the same information as 1-888-BOOGA-BOOGA.

Graphic Novels Next Tuesday: The Future Market

The future of the graphic novel market looks quite sunny. Graphic novels have become more popular even as sales of most books have shrunk. Bookstores, eager to latch onto anything that can sell, are devoting ever more space to graphic novels. Mainstream publishers also want to give the graphic novel business a try. When they do, they will come equipped with business resources and mainstream selling acumen that traditional comics publishers often lack.

As graphic novels become a standard part of pop culture, they're popping up in new and varied venues. If you haven't seen graphic novels in your local video store yet, you soon will. Then you'll start noticing them at the CD shop. Next thing you know, they'll be skulking behind the bushes, waiting to jump out at you, and there will be *no way to escape* ...

What's a Graphic Novel? (The Long Answer)

It's all well and good to say that graphic novels are becoming popular, but what is a graphic novel? With a name like "graphic novel," you can be pretty sure that it isn't a liverwurst-filled donut, but you might also be pretty sure that it isn't something it actually is.

Not So Novel After All

The immediate assumption is that a graphic novel is a graphic form of a novel, but that's too limiting. Just as a comic book doesn't have to be a book, a graphic novel doesn't have to be a novel. A prose version of *A Contract with God and Other Tenement Stories*, the book that popularized the term "graphic novel," wouldn't count as a novel. It would be a book of related short stories.

The Pulitzer Prize-winning *Maus*, on the other hand, is a single long work, but it wouldn't count as a novel, either. Despite the fact that the characters are drawn as mice, cats, and other animals, the story is a true tale of the author's father during the Holocaust and his later relationship with his son, while novels are fiction.

And still, there's more to a graphic novel than being a bunch of comics in a single book. A graphic novel is still a graphic novel when it's in serial form.

If Not, Then What?

A graphic novel is a comics project of substantial length that is designed to be understood as a single work. Fiction, nonfiction—even a comics format cookbook—would count as a graphic novel.

That doesn't mean that every book of comics counts as a graphic novel. For example, *It's A Dog's Life, Snoopy*, a collection of a year's worth of the Peanuts comic strip, is not a graphic novel, because those strips weren't meant to be a single work. Nor is *The Greatest Batman Stories Ever Told*, although bookstores won't hesitate to put it in the graphic novel section.

So all questions are answered, right? Sure, if no troublemaker pops up and asks "what counts as comics?" Do you need to have traditional word balloons for speech? Does it count as comics if there's only one panel per page? What about if you use photographs rather than drawing?

That's a whole 'nother can of worms, and the answer is: It doesn't matter. If there's something you want to create, do it! Let someone else worry about whether to call it a "graphic novel" or a "chocolate orangutan" or anything else!

The Least You Need to Know

- A graphic novel is a long comics work intended to be seen as a single unit.

- The graphic novel concept is flexible enough to include fiction and non-fiction, serialized work and original books, and a broad range of genres and styles.

- Graphic novels are an integral part of pop culture, and the future for them looks bright.

What's Your Goal?

In This Chapter

◆ Why are you doing a graphic novel?

◆ How much of it should you do yourself?

◆ Should you make one big graphic novel or a bunch of comic books?

You want to make a graphic novel. You know that, I (Nat, the graphic novel–writing, pudding-lovin' cowriter of this book) know that. Otherwise, you wouldn't have bought this book at the store, or borrowed it from the library, or stolen it from that guy on the bus. But understanding *why* you want to make a graphic novel and *what aspect* of creating a graphic novel interests you can be key in reaching your goals. You can't start to reach your goals until you know what those goals are.

In this chapter, I show you a number of things to think about in shaping your goals. Many of these things may seem glaringly obvious. Obvious things are usually the most important.

For Money or for the Monet

The key question in setting your goals is to figure out whether your main goal is to make a living (maybe even make a killing) or make art. Ideally, almost everyone wants both. They want to spend their days chronicling the dark pain they feel within, then spend their nights driving Ferraris and licking caviar off the ripped abs of a hot model of their preferred gender. We'd all like to have everything, but this is a good time to separate things you'd merely *like* to have from those things you really want.

Money Is Far from Certain

There are huge successes in any popular art form. In acting, for example, you can talk about Tom Cruise, Jim Carrey, Angelina Jolie, and other folks who make millions per movie and can pick and choose their films. Past that, you can see thousands of people who aren't superstars but who make a living from acting—the sort of people you see playing waiters who serve Tom Cruise and Angelina Jolie. Such folks aren't stars, but they *are* working actors, and they may be making an okay living or just squeaking by.

But what you don't see is that for every working actor there are plenty of would-be working actors who really are waiters. Most of the people who set out to be actors never really make a living at it.

The same thing is true of graphic novelists and the comics arts in general. There are some people who make millions doing such work (although even the top ones don't make anywhere near what superstar actors make). Then there is a larger base of people who make an income, and may make a living, but don't make a killing. Beyond that is a very large group that wants to be making an income but isn't. This includes not only the would-be graphic novelists, but also the used-to-be's, folks whose style or efforts fell out of fashion for some reason.

And the sad truth is that the difference between the financially successful and the unsuccessful creators can't simply be chalked up to talent or quality of ideas. While being a talented creator and having good ideas will obviously help you succeed, and being able to promote yourself and your work will help immensely, luck also plays heavily into the results.

A large portion of even the folks working in the graphic novel field cannot count on it for their primary source of income. When you see Jane Graphic-novelist signing autographs at a comics convention, it's easy to assume she is well-known to the world at large and generally successful. You don't see what Jane is doing the next day: signing a credit card slip for a quart of milk because she's out of cash.

Art Is a Sure Bet

If your goal is to express yourself, to get your ideas out, and to exercise your creative soul, you're almost certain to reach your goal. If your dream is to get it down on paper, then the only thing that can stop you is the fiendish paper-swiping aliens from Omicron-7.

That's the good news. The bad news is that even striving to be an artist can be a struggle. If you're not making money doing comics, you're likely to spend a lot of your time and energy making money from something else. Time becomes scarce. When you can only catch a few hours here and a few hours there to work on your graphic novel, you lose momentum.

Helping Our History

A little karma can go a long way. If you want to help creators from the past who have fallen on hard times, surf over to www.heroinitiative.org for a charity that helps such creators.

A Comic a Day

See the value of creative momentum by looking at some 24-hour comics—24-page stories completely written and drawn in 24 consecutive hours. It's crazy, but it works. Search the web for "24 hour comics," or get the book *24 Hour Comics* for examples, then consider taking part in the annual 24 Hour Comics Day to make your own.

But don't let that worry you too much. Many creators, particularly younger ones, manage to do amazing work in their spare hours. It becomes a bit harder as you get older, particularly as you build a family. But hey, the kids have bedtimes, and you don't!

Even so, working toward artistic greatness is often frustrating. Your work won't be perfect. I don't mean that it won't be perfect at first, I mean that it will *never* be perfect. Think of the best graphic novel you've ever read. I guarantee that not only isn't it perfect, but that the creator knew that it wasn't perfect, and could list a dozen things that were wrong with it quicker than you could name the handsomest five of the Seven Dwarfs.

In fact, it's worse than that. The moment you've completed the graphic novel, you won't be able to see the hundred good things you achieved from your list of 103 Good Things I Want in This Graphic Novel. Anyone who reads it will be able to see the 100 Good Things, but all you'll see are your 3 Failures.

Dealing with the Difference

Years later, you'll be able to see all the good things you achieved in your graphic novel rather than all the things you failed to do. Until then, focus on the value of learning. Seeing your mistakes and weaknesses gives you the chance to improve. On your next graphic novel, you won't make the same mistakes. You'll find a whole different set of mistakes to make!

So if you strive for art, you will achieve art. You just may not always be happy about it.

Counterfeiter's Truth: Money Can Be Art

There are ways to make graphic novels that are more oriented to creating art, and ways that work better for earning money, but money and art are not opposites. It's easy to look at someone's little autobiographical comic and say "that's art," then look at *Superhero/Supervillain Punch-Out Volume 2* and say "that's done for money," but those two things aren't as distinct as it might at first appear.

Superhero Superart

Want a clear example that superheroes and art are not mutually exclusive? Try *Marvels* by Kurt Busiek and Alex Ross. This book is firmly grounded in the Marvel superhero universe, embracing all sorts of details about the history of Spider-Man, the Fantastic Four, and the rest. Yet within that, writer Busiek spins a tale about how average people get carried along through changing times and forces beyond their control. Artist Ross's hyperrealism humanizes the superhero to a remarkable degree. You'll never wonder again whether superhero outfits ever wrinkle.

Superhero works may be commercially popular, but even when they're put out by the most disinterested hack (and few are these days; there are too many interested folks competing for the gigs), they can't help but express something. In the hands of someone who loves superheroes or is truly inspired by the genre, superheroes can be exciting, creative, personal—even high art. But if you want to do superheroes, you already know that.

Perhaps the more surprising news is that doing comics that are primarily intended to be art can actually be quite profitable. Far too many folks spend their days trying to do work they believe is the source of the big money, turning out pale variations of existing successful work. Such works often fail to get published, much less get popular. Meanwhile, *Strangers in Paradise*, an original romantic dramedy, became a surprise success, and *Fun Home*, Alison Bechdel's dark autobiography, was a critical and commercial hit.

Hero-Less Hollywood Hopes

Much of the biggest money in the graphic novel business comes from licensing the story for a movie. Cut a movie deal and you get bucks from the movie company plus bucks from increased sales of your book. It's easy to look at the movies and assume that the real Hollywood money comes from making the next generic superhero. Look closer and you'll notice that few of the major superhero movies are based on *new* superheroes. *The Dark Knight, Iron Man, Watchmen, Hulk, X-Men Origins: Wolverine* … they all feature decades-old characters. It's too late to invent an old hero, unless you also invent a time machine.

The newer creations Hollywood snaps up are far more eclectic in nature. *Ghost World* was a slice-of-life comic, *300* an historical action epic, and *30 Days of Night* a fierce piece of horror.

For Yourself or an Audience?

If you're doing a graphic novel primarily for the money, attracting a big audience is inherently part of your goal. That's one question you don't have to worry about. Go get a sugary snack and come back in time for the next part of this chapter.

Art

Art is anything you create with the intention of creating art.

If your goal is *artistic*, then the question becomes more difficult. Is your goal to tell the story? Or is it to have the story be read by someone else? Those may sound like the same thing, but they're very different. Emily Dickinson needed to write her poems, but when they were finished she'd satisfied her artistic itch and then just stuck them in a drawer. The poems were art whether anyone saw them or not. On the other hand, stand-up comedians need audiences. The art of true stand-up comedy relies not on deciding what bugs you about shoelaces, but from the effect that declaring it has on an audience.

So if you do your graphic novel in a forest, and there's no one around to see it, is it art? That's your choice.

It's an important choice to make, because other decisions will be based on it. For example, let's say you're good at writing and creating concepts, but a poor illustrator. If your goal is expressing yourself, then you'll still want to illustrate your own work. On the other hand, having a good illustrator not only draws more readers to your work, it helps them understand the work. It does you no good to create a love scene if the readers squint at it and ask "Why is that fuzzy lump proclaiming love to that strange-looking tree?"

Lone Hero or Superteam?

The question of whether to go it alone or to work with others is a tricky one. The common practice of publishing a new issue in a comic book series every month has really encouraged people to work collaboratively. It's hard for one person to write and do all the artwork on more than 20 pages month in and month out. By having several people working on a different part of the same story, the deadline is easier to achieve. Besides, if Joe Pencilguy had to skip drawing an issue of *The Amazing Adjective*, Chris Newcomer could be brought in without the next issue seeming radically different.

> ### Sinister Synergies
>
> Like-minded collaborators can create synergies, but pairings of people who work differently sometimes create quite well-rounded work. *The Fantastic Four*, *The Incredible Hulk*, and *The X-Men* were all created by the same main team. Jack Kirby is known for his broad and kinetic action pieces, while Stan Lee is known for his very human character dialogue. Together, they created works that were broad, kinetic, *and* human all at once.

Graphic novels don't have that same monthly deadline problem. This makes it far more possible for one person to do all the work. But just because it's possible doesn't mean that you have to work that way.

Working solo means that you get a pure vision on the page. This can be a wonderful thing. On the other hand, working in collaboration means that everyone can do what they're best at and avoid what they're bad at. A collaborative work can have a synergy, creating a work that is stronger than the individual contributions.

Knowing Thyself

Are you a collaborator? Do you play well with others, or do you need to be the boss in any situation? Worse yet, do you deal with conflict simply by shutting down your own concerns and giving in to others, allowing your resentment to silently build until you snap and suddenly discover that you're running naked through the streets, throwing marshmallows at police cars?

> ### Steve Sez: Be Up Front
>
> Type-A control freaks and passive-aggressive people can still engage in productive collaboration if they know themselves well enough to tell their collaborator about their tendencies up front. Working with an editor as intermediary and referee can help, too.

Collaborating isn't for everyone. If you're apt to drive yourself up the wall or drive your collaborators through the wall, then you probably shouldn't be driving at all. That doesn't mean that you can't get help with individual aspects of the work, but you should probably handle most of the major aspects of writing and drawing yourself. This will save your sanity and keep you from wasting perfectly good marshmallows.

Weaknesses? Moi?

When I was a kid, I just knew I could do *anything*. Riding a bike simply involved moving your legs real fast. Shooting baskets meant thrusting the ball in the right direction. Playing the piano was nothing more than pushing down on the keys. Who couldn't do these things?

Many skinned knees, missed baskets, and songs that sounded like a cat got on the keyboard taught me that things were harder than they looked. Doing graphic novels is a lot like that. While most people don't just assume they can draw, a lot assume they can write good stories, or do readable lettering, or handle other aspects of graphic novel creation that they've never tried.

Don't assume that. Certainly, before you start doing a long work, try doing a very short one—a story a few pages long—and start discovering where your strengths and weaknesses lie.

 Little No-No in Blunderland

> The clearest example of a work that is impaired by someone not recognizing his weakness is an old newspaper comic strip by Winsor McCay. Look at any of the available collections of his *Little Nemo in Slumberland*, a classic dream series. You'll see a work that is reasonably written, amazingly drawn, gorgeously colored—and looks like it was lettered by an inept six-year-old. The randomly shaped word balloons with twisted, tilted writing doesn't ruin the work, but it does detract from the reading experience.

The bad news is that you will have weaknesses. The good news is that you can conquer them, at least to some degree, or just get around them. I've learned to ride a bike, and if you want to spend the time, you can improve on almost any of your weaknesses if it's important enough to you.

But you don't have to. If I spent years, I could possibly learn to draw well enough to craft a readable comic, but I'd rather spend my time writing and working with artists who are more talented than I could ever be.

Time Constraints

The more work you do yourself, the longer it takes. If you're *serializing* your graphic novel, then you'll have deadlines to meet along the way. Even if you're not serializing and don't have any deadlines, you do want to get the book done eventually, particularly if you're not getting paid until the work is complete.

WHA...? **Serializing**

Serializing means releasing your story in sections. Many graphic novels are serialized in individual comics before being collected into a single volume.

By collaborating, you're doing a smaller portion of the work, and the graphic novel gets completed more quickly. Even if you're not as satisfied working with others, you will get that very real satisfaction that comes from having a work completed and released.

Collaborating doesn't always speed things up as much as you'd like. You'll always lose a bit of time finding collaborators and communicating back and forth with them, but sometimes collaboration can be incredibly efficient. If you're apt to spend more time figuring out what to draw than actually drawing it, hooking up with a fast writer can turn you into one speedy artist.

Your Desires

What do you *want* to do? If you want to create a work that's all yours, then by all means do so. If you have broad ideas about what the story should be but don't want to get caught up in the details, find a writer who wants to share your vision and stick that person with the writing chores. And if you're bad at anatomy but love doing all the line work and cross-hatching, then you are an inker at heart and you should be proud of that.

This isn't to say that you will always get to do what you want, particularly if you want to make money. But look at it this way: the things you like are most likely the things you'll be good at, and the things you're good at are what you're most likely to make money from.

One Big Book or a Plethora of Pamphlets?

For some people, format is a big deal. Some dream of having a big, thick, real book. There's something about having a book on the shelf with your name on the spine that makes you feel like a legit author.

Other people grew up on comic book *pamphlets* and have a real love for the form. Sure, they'll be happy when a longer, serialized story is collected into a book, but that's just something that comes afterward, a bonus on the tail end of the "real thing."

Going straight for the book format means a lot fewer compromises in the content, since you don't have to break it down into issue-length chapters. But if you're a procrastinator by nature, putting out a series of issues gives you deadlines that force you to get the work done. Deadlines help us get things done. Want proof? You wouldn't be holding this book in your hand right now if my editor hadn't imposed a deadline for it. (A cruel and unusual one, I might add.)

Issuing pamphlets has other advantages. People read the work and give you feedback, some of which will be annoying and pointless, but some will be useful. There are often business advantages as well, but I'll talk about those in the more business-oriented portions of this book, all the way up in Part 5.

 Personal Splendor

Collaborative works can still be quite personal. Consider Harvey Pekar, famed for his comics autobiography. Various artists have brought Harvey's scripts to life, ranging from the *American Splendor* short stories drawn by underground master Robert Crumb to the stand-alone graphic novel *The Quitter*, drawn by Dean Haspiel.

 Pamphlet

Some comics fans use the term **pamphlet** to refer to the traditional staple-bound comic book, generally 24 to 48 pages long. Others feel the term denigrates the traditional comics printing format.

If you're working with a publisher, that publisher is apt to have views about what format is right. You may have to compromise your goals, but you'll never reach them unless you have them in mind.

Don't Be a Goalie

Goals are guidelines. They can give your efforts direction and something to work toward. But goals aren't really what it's all about. Don't be so focused on your goals that you miss opportunities along the way. On your trek to California (your goal), you can't just drive by Abe's Alligator Petting Farm when you see the exit coming up. You might find that Abe's is really where you want to be! Even if you decide to keep going to California, at least you'll have learned things about petting alligators.

Steve Sez: A Philosophical Difference

The question of straying from one's goals is an area where the experiences of some writers and illustrators differ. Many artists (including me) have found that in the early days of one's career, tunnel vision is an extremely valuable trait. Writers can multitask much more effectively than artists can. Drawing comics means spending long hours at the board. For artists who work in a labor-intensive manner, even small distractions from a goal can mean big delays in ever achieving it.

The Least You Need to Know

◆ Thinking about your goals is the first step in working toward them.

◆ You can create graphic novels for commercial reasons or for artistic reasons—or, if you're lucky, both.

◆ Creating a graphic novel for the sake of creating it is different from creating a graphic novel to have people read it, but both are viable goals.

◆ Collaborating has its pros and its cons. Whether you should collaborate depends on your attitude, personality, strengths, and desires.

◆ Creating a graphic novel for initial release in book form can minimize creative compromise; on the other hand, issuing the graphic novel as a series of comic book chapters can keep you motivated and build your audience.

◆ Aim for your goals, but don't overlook opportunities that arise along the way.

Creating a Creative Team Creatively

In This Chapter

◆ Who makes up the creative team?

◆ How do you find creative teammates?

◆ How do you split the work and rewards?

If you want to create your graphic novel all by yourself, you may want to skip this chapter about lining up other people to work with. *Don't.* I'm not saying this simply because I, Nat the writer guy, slaved over a hot laptop for hours to craft it and fill it with insight, pouring my creative soul into it.

No, this chapter might actually be useful. As you see all the little jobs that creating a graphic novel can involve, you might find that you'd rather leave some of the small things to someone else.

Typical Titanic Team Members

You can split up the work on a graphic novel in many different ways. The comics field has been around long enough that certain standard categories have emerged. Even if you don't break the work up in traditional ways, knowing the names for the standard jobs can help you communicate with collaborators just what you're looking for.

Writer

When you tell people that you write comics or graphic novels, about half of them will say, "Oh, you put the words in the balloons?" When you tell them that, actually, putting the words in the balloons is the job of the *letterer*, be prepared for a look of disinterest. In that person's eyes, you've gone from being someone who puts the words in balloons to someone who *doesn't even* put the words in balloons. It's the same disappointment that the Secretary of State must get when someone realizes she's a secretary who doesn't even know shorthand.

As a writer, however, I have to tell you that the *writer* is usually the key person in the graphic novel. Traditionally, the writer starts the project. The writer comes up with the basic concept and is in charge of developing the plot, the characters' attitudes and backgrounds, and the dialogue—which the letterer will later put in those balloons.

As you'll see in Part 2 of this book, writers go about this in a number of different ways. Some projects are written with highly detailed scripts discussing everything that's in each panel. Others involve a far looser outline of the story, relying on the penciler to flesh out more of the storytelling.

Steve Sez: Writing with Pictures

Nat is correct that writing is the key part of the job, but in comics most of the content is communicated in the pictures. Stunts and gimmicks aside, no graphic novel, no matter how well written, can succeed without competent and appropriate illustration. Saying that the writer is the key person in creating a graphic novel is like saying that a man is the key component in creating a baby.

Penciler

Layouts

Layouts are loose sketches designating the placement of the panels and the figures within the panels of a page.

The penciler is responsible for creating *layouts* of the page and then drawing in all the characters, settings, and objects in pencil. The penciler is considered the primary artist for the work, despite the fact that usually everything the penciler draws ends up getting covered over or erased.

Inker

An inker draws over the original pencil drawings with ink. The light pencils don't reproduce very well, and besides, the penciler is apt to leave all sorts of stray lines that shouldn't be reproduced. (Sometimes, the entire graphic novel shouldn't be reproduced, but that's a problem too big for an inker to fix!)

Inking is not merely tracing. The inker needs a great deal of control over pens or brushes, in order to get the shape and width of line desired. Line width can be very important in creating depth on the page, and in making the figures seem lively. And where a penciler can shade things in with many shades of gray, the inker creates a work that is purely black and white. Instead of grays, the

inker works in textures, *hatching*, *cross-hatching*, and *feathering* areas to create a sense of gray.

Then the inker erases all of the remaining visible pencil work, chortling gleefully all the while.

Letterer

The letterer draws all of the word balloons, thought balloons, and caption boxes and writes the text into them. This may not sound like very special work, particularly in these days when the vast majority of the lettering is done via computer. You don't even need to have clear handwriting in order to be a good letterer.

Lettering is more than just putting the words on the page. Letterers are often in charge of choosing where the word balloons go. Good balloon placement leads the eye naturally across the page, making it easy to follow the story. Badly placed word balloons can obscure the art and make it hard to tell who is speaking when. Imagine a scene where the Lovely Lara says, "You're lying," and Villainous Vera replies, "You're right!" In the hands of a bad letterer, Vera is saying Lara is right, and Lara calls her a liar for doing so!

Letterers also handle the sound effects lettering. Every *wham*, every *Ka-POW*, every *tic-tic-tic* and *EEEEEeeeeee!* has to be drawn in a way that's not only readable but looks like the sound. Signs and newspaper headlines are generally also the province of the letterer. Tattoos are generally left to the penciler.

Hatching/ Cross-Hatching/ Feathering

Hatching is drawing a pattern of thin lines to create a gray tone. When your hatch lines cross, you're **cross-hatching**. **Feathering** is hatching with lines that grow thicker as they reach areas that are supposed to look darker.

Steve Sez: A Balancing Act

An important part of the letterer's job is to make sure that none of the writer's deathless prose obscures anything important in the artist's immortal imagery. They can both make this job easier by being aware that the more space given to words, the less room there is for pictures, and vice versa. Or the letterer can letter really, really small, and if legibility begins to suffer then the publisher can arrange for the graphic novel to include a free magnifying glass or even a microscope, as needed.

Colorist

If you've ever opened a coloring book with a pile of crayons at your side, then you know the challenge that faces colorists. For color comics, they select and place the colors. Many modern colorists don't even bother trying to stay within the lines.

Today, coloring is done almost exclusively on computers. A computer colorist has thousands of different digital crayons and a wide array of special effects, including fades, glitters, and photographic backdrops. A colorist can turn an ordinary penguin standing on the snow into a glowing purple penguin standing on a picture of Winston Churchill.

Cover Artist

Some graphic novel artists are very good at storytelling, but poor at doing the sort of eye-catching cover picture that makes a reader grab the book off the store shelf and give it a look. An artist who can provide a special cover, such as a realistic painting or an energetic action shot, can help sell the book. Some readers complain when the cover artist is different from the interior artist, but they never seem to complain when prose novelists like Stephen King don't draw their own covers. Go figure.

Designer

Book designers are gaining a prominent place in the graphic novel field. The designer is responsible for the look of the parts of the book that aren't the story, such as the cover, the inside covers, and perhaps a title page or table of contents. In some cases, a designer will be involved in selecting *paper stock* for the cover and interiors. A good designer helps the book appeal to likely audiences, integrating the attitude of the book into its appearance.

Editor/Proofreader/Sounding Board

Many new graphic novelists assume that an editor is something you get saddled with when you have a publisher, an evil soul who wants to interfere with your creativity. While there are certainly such editors (generally more incompetent than evil, although I have known a few who stink of brimstone), a good editor can make suggestions to help your graphic novel better reach the goal you set for it.

Many people don't want to work with a full editor, a title that suggests someone who gets to control the creative team. Even so, it's good to have someone with good language skills who will proofread the text. Otherwise, you're apt to end up with spelling errors—or even worse, spellling erorrs.

A friend whose taste you trust can make a good sounding board for your graphic novel. Your sounding board may catch stupid mistakes. ("In the first panel on this page, the girl has braids. In the second panel, the girl has a ponytail. And in the third panel, the pony has braids.") Having someone note things that don't make sense or don't feel right or simply could be better can be a great benefit. There's no limit to how many sounding boards you can have, and you don't have to follow every suggestion they make. A good rule of thumb: If you can't think of a reason why a suggestion is wrong, it's probably right.

WHA...? **Paper Stock**

Paper stock refers to the type of paper something is printed on. Different paper stocks vary in weight, color, brightness, thickness, opacity, texture, gloss, how well they hold ink, and cost.

Steve Sez: Sez Who?

When you're drawing a tricky sequence, show the pencils to someone who doesn't know the story you're telling, and ask that person to tell you what is going on. Give no clues when you ask, and you'll get more useful feedback about what's clear and what isn't.

Sounding Suspicious _____

Beware of sounding boards who seem more interested in suggesting good things that you can add to your story than in pointing out things that don't work. These people are exercising a desire to write, an understandable desire but one that can aggravate you and harm your work. Trying to integrate ideas from someone else's vision can lead to a muddied graphic novel. If you want a sounding board, get a sounding board. If you want a cowriter, get a cowriter. If you want a donut, could you get me one, too?

Collaborate Uniquely, Like Others

Don't feel trapped by the standard way of working. The important thing is to find a way that will let you put out the work you envision.

Many graphic novels have people wearing odd combinations of hats, people who get slashes in the middle of their job descriptions. I've seen such unlikely combinations as writer/colorist and letterer/editor. Using slash-folks can make your graphic novel creation go quicker/smoother.

But don't be afraid of breaking one job into several, if that will get the best results. When Sam Kieth started creating _The Maxx_, for example, he had a story to tell but wasn't confident in his ability to write dialogue. Sam plotted and drew the book, but brought William Messner-Loebs in to provide finished dialogue, splitting the traditional writing effort. Some artists are quick at layouts and inks, but slow at the more detailed anatomical pencil rendering, so they bring in another artist to handle that stage of the art. Some comics studios have one artist who draws all the characters, another who just draws the vehicles, a third who just draws the settings, and a lazybones who just draws a paycheck.

Do what works for you. Avoid what doesn't.

Rating Goodness? Gracious!

When you search out collaborators, you're going to need to judge their abilities. If you're not used to looking at unfinished portions of comics work, you might find it hard to judge the individual components. Although part of the solution is simply to get used to seeing unfinished works, there are things you can look for to judge quality.

Good Writing

Writers should have a good understanding of how stories work. Comic book writers actually don't need to be grounded in English grammar as well as writers in other forms. After all, the plot and panel descriptions only have to be clear enough for the other members of the creative team to understand them. And dialogue doesn't have to be grammatical, because people often speak

Steve Sez: Well, Yeah, But ...

Keep in mind that poor grammar makes a poor impression on prospective publishers and distributors. If you can't write a cover letter or a paragraph of ad copy without making a mistake, you'd do well to take a couple of days to refresh your grasp of the basics.

ungrammatically. "I ain't gonna feed no ducks no donuts!" may make your old English teacher weep uncontrollably, but it's perfectly fine dialogue.

Prospective writers should have a sample script. Read the script, and ask yourself the following questions:

◆ Is the story interesting?

◆ If the story uses existing characters, do they seem right? Superman acts differently from Spider-Man, and they both act differently from Reid Fleming, World's Toughest Milkman. If the character seems wrong or simply generic, that suggests the writer has a problem with characters.

◆ Can you picture the panels and pages in your mind? If you can't imagine what the panel looks like or how the page fits together, then the penciler won't be able to draw it.

◆ Can each panel's image be described with one central concept? If there's a panel where it's important that Wanda is punching Joan, Mathilda is feeding donuts to the ducks, and there are three suns in the sky, you'll have a problem. Even if the artist puts all that in the panel, the reader will miss some of it.

◆ Does the dialogue sound good when read out loud? That's a good way to catch clunky construction.

◆ Is there too much text on a single page?

◆ Are the pages stapled together with the highest-quality staples? How could you trust someone who uses second-rate staples? (This note brought to you by the Staple Advisory Board.)

Good Penciling

Interiors/Exteriors

An **interior** is a shot inside a building, such as a scene of customers standing in line at the counter of a donut shop. An **exterior** is a scene not inside a building, such as a picture of the outside of the donut shop, with vicious ducks waiting to pounce on exiting customers.

Penciling requires a broad range of drawing skills. You have to be a good visual storyteller, capable of communicating situation, action, and emotion clearly. You have to be good at rendering *everything*. To be a well-rounded penciler, you need a strong sense of anatomy. You need to be able to draw buildings. You need to be able to draw animals. You need to be able to draw a pizza-eating Martian driving a Studebaker, should the script call for it—and most of the best scripts do.

Proper penciling samples include several consecutive pages from a single story, and these should be in pencil form (unless you're looking for a single artist to handle both penciling and inking). General samples should include both action scenes and quieter dialogue scenes, close-ups and wide shots, *interiors* and *exteriors*. If the artist is looking for work in a particular genre, the samples should reflect that genre. Superhero samples should have superheroes as well as people not in costumes. Science fiction samples should have gadgets and space ships. Samples for a romance comic should have wide-eyed nurses with fiercely beating hearts.

When looking at pencil samples, ask if you can see a copy of the script the pages were done from. Some artists create samples without a script, which is less than ideal. Worse yet, some just copy a scene from an existing comic, which usually means that you're seeing the published comic's layouts rather than seeing the prospective artist's own talents.

Looking over the pencil samples, consider the following:

- Is the drawing style attractive or interesting enough that people will want to look at it?

- Do the characters look consistent from panel to panel?

- Can you get a sense of the story just by looking at the pictures without any words?

- Has the artist left enough space to put in the word balloons and captions without covering over important parts of the art?

- Is the order of the panels clear?

- Does the art follow the sample script it was drawn from?

- Are the staples holding the pages together strong, or are they flimsy? Do you know how many people die each year from staple failures? *Do you?* (If you do, please contact the Staple Advisory Board. They're quite curious about this.)

Steve Sez: Hearts and Flowers

Gags aside, samples of a romance comic should show an ability to handle the details that drive romance stories: fashion, settings, and the nuances of facial expression and body language.

Don't Put Up with Pinups

Don't waste your time with would-be pencilers who show you just a single image per page. These folks may have had fun learning to render, but they're not showing you any storytelling capability. They don't know what they're doing.

Good Inking

Proper inking samples include samples of inked pages as well as photocopies of the original pencils that were inked. That way, you can tell how well the inker captured the look of the work being inked. You don't want an inker casting aside what the penciler drew. Good inkers can sometimes save lousy pencils, but at this stage of the game you shouldn't be planning to have lousy pencils.

When looking at inking samples, ask yourself the following questions:

- Is it clear whether the pages were inked for color or for black-and-white publication? Pages meant for color should have plenty of open areas and little cross-hatching, while pages meant for black-and-white publication should have more solid blacks and shading. You definitely want to see samples that reflect how you're going to print.

- Do the foreground characters or the most important items in the panel clearly stand out?

- Do the pages look attractive?

- Are the panel borders clean and sharp?

- Are the staples holding the samples together certified to meet OSHA standards for purity? Many foreign-made staples contain up to 17 percent rat hair.

Have anyone you consider a good inking candidate try inking a photocopy or a printout of a scanned page of the penciler's pencils so you can see if the two artists' styles mesh. New inkers will probably do a sample page for free, particularly since they can then add this page to their samples. Established inkers may well ask to be paid for the samples, which is a fair request and worth doing if you want an established inker. Delusional inkers will want to be given a porcelain fish and a tube of toothpaste.

Good Lettering

Lettering samples should include examples of both standard balloon lettering and sound-effect lettering. Look at the balloons, too. If possible, you want to see an actual lettered page, so you can check balloon placement.

Top-notch letterers can also design new typefaces for special needs, so that your slavering beasts speak with dripping words, your robots talk digitally, and your crumperneous qualifackers speak crumperneously.

Good Coloring

A top-notch colorist will not only know how to use all sorts of fancy digital special effects but will also have the wisdom not to use them all. Lesser colorists create many garish, showy pages that interfere with the storytelling. Good colorists often choose a very limited pallet, and use the special effects when they will have a special effect.

Color printing is a lot more complex than black-and-white printing. Your project's colorist should have a good understanding of the printing process and the effect that his color choices and placement will have.

Make sure you get to see the color samples printed out, rather than seeing them on the computer screen. Someone who learned to color images for websites or video games won't know about the complexities of the printing process. Use a colorist who doesn't have an understanding of printing and concepts like *trapping*, and you're apt to get a fuzzy, smeary, gap-filled mess. That's fine, of course, if your graphic novel is *Sherlock Holmes and the Strange Case of the Fuzzy, Smeary, Gap-Filled Mess.*

Working Well Together

In addition to artistic talent, you should make sure that your collaborators are talented in the art of cooperation. Your collaborators have to be willing and able to communicate with you. This means more than just sharing a language; it means sharing an understanding of creative goals. If you're an artist concerned with visual theme, invocation of tropes, and other subtleties, and you've found a writer who's more concerned with having vast explosions and busty babes in the work, then you're apt to create a graphic novel full of compromises

Don't Do Handwriting Analysis

Never judge letterers by their usual handwriting. I've had some of the best hand letterers in the business write down their addresses and phone numbers so I could call them later, but I never did reach them, because I couldn't read what they wrote down.

Trapping

Trapping is the technique of making color areas slightly larger than they ideally need to be, so that no gaps are left if printing plates don't quite line up. This is an example of the printing knowledge colorists need.

that satisfy no one. There's something to be said for having somewhat different views, but if you cannot understand where each other is coming from, it won't work.

Don't mistake someone's background for that person's ability to understand you. Differences in age, background, and social circles can actually bring a richness to a work. As long as you can understand each other, you should be fine.

Creative Crew, Where Are You?

It is easy to find enthusiastic collaborators. It is more difficult to find talented ones. Harder still is finding ones who will actually get the work done—but even that isn't impossible.

You can find new folks who are not yet established in several ways. If you live in a major metropolitan area, a number of talented folks are probably working on breaking in locally. Often, the folks at the local comic shops will know where they are. To cast your net wider, check out websites like www.DigitalWebbing.com and www.PanelAndPixel.com where struggling writers and artists hang out, often trying to find collaborators. These folks often have websites with samples of their work, so you can quickly check out if they're another Will Eisner or simply a Won't Eisner.

My favorite source for new talent, however, is the major national comic book conventions (see Appendix B). Because there are representatives from various publishers there, new creators show up in droves looking for work. It's easy to spot the artists carrying around their portfolios. Hang around the place where a major publisher is looking at art samples and you'll get a chance to scope out a lot of artists. Writers are a little harder to track down, since they don't actually show their wares at the convention. The larger conventions often have talks on breaking into comics. Those panels are good for the information and for the people you can meet in the audience.

The world of webcomics is another rich source for new talent. There are thousands of folks publishing original comics works on their websites. For some of them, their webcomic is exactly what they want to be doing and the only thing they have time for. Others, however, may succumb to the temptation of an interesting project, or a chance of exposure, or money. Offer to do their laundry, if you have to.

If you're looking for established professionals to work with, your best bet is to meet them at conventions or reach out to them via the web. Most folks in comics these days are reachable by e-mail. Use your comic shop as a reference library to figure out who you want to work with, then reach out and see if they're interested. If you're not established, you're apt to hear "no thank you" repeatedly unless you offer to pay them for their services. Which segues us into our next topic …

Flake Detection

Beware of any collaborator who promises samples but doesn't deliver, or who claims to have done published work without being credited in that work, or whose work looks like it was traced from someone else's. And it's okay to contact anyone else they've worked with and ask some questions about your potential partner.

The Benefits of Paying People

If your graphic novel is intended to be a money-generating venture, you really should consider paying your collaborators a page rate for the pages they turn in. Paying a page rate keeps you in control of the project. It encourages others to follow your vision, to meet deadlines, and to not simply drop out of the project when they get bored.

Paying people also allows you to get a higher grade of collaborator. Experienced working artists aren't likely to drop what they're doing to work on your labor of love. They need to be doing labors of paying rent, the cable bill, the alimony bill, the whiskey surcharge tax, and other such monthly realities of the professional comics creator.

Steve Sez: On the Clock

Speaking *very, very* generally, 10 hours is a fair estimate of how long it takes an artist to turn a blank sheet of paper into an inked page of comics. If you've written a 24-page story, a typical artist might need to spend 240 hours at the board drawing it. That's the equivalent of six 40-hour workweeks. A 100-page story? That's six months at a full-time job. Keep those sorts of numbers in mind when figuring out what the artist's contribution is worth.

Paying folks also allows you to give them a smaller amount of control over the rights to the work. This can be important when it comes to finding a publisher or cutting a deal to have your *Tales of the Dark and Ooky* turned into a movie, a TV show, or a mouthwash.

About the only downside to paying people money is that it costs money. For a long graphic novel, it can cost *lots* of money. If you have a publisher in place paying a page rate, of course that can be split among the creative team. But even if you're packaging a full graphic novel to show around, or if you have a publisher but are being paid only royalties (additional money for every copy sold over a certain number), paying is worth considering. After all, people like money.

Doing Right with Rights

From a creative standpoint, you're creating a graphic novel to be shared with the world. From a business standpoint, you're creating a bundle of *intellectual property* rights, legal control that you can license to publishers and other people who want to use aspects of your graphic novel. Someone who wants to make a movie out of *Dora the Donut-Eating Duck* or put out a series of socks with Dora has to license the rights. The question of who owns *Dora* becomes about something more than who has to buy her donuts.

If your graphic novel is for a corporate-owned character, the corporation will probably require that it hold all the copyright and trademarks to your work. Even if you're doing an original work, larger publishers may want to hold on to the copyright (which covers the content of the novel) and trademarks (which cover the title and perhaps the character names and likenesses).

Generally speaking, unless one member of the creative team is paying the others, the copyright will be split between the writer and penciler. Sometimes the writer and penciler share the copyright to the whole work, which means that either one can license out publishing rights and other rights to the work. That can create sticky situations down the road, in which the writer may license the publishing rights to one company and the artist may license it to another. However, most publishers won't want the rights unless they can get exclusive rights. It's hard enough for a publisher to sell *Dora* when competing with all the other graphic novels out there. So a publisher doesn't want to compete with someone else's printing of *Dora!*

Alternatively, writers sometimes claim the copyright in the script they wrote, while artists claim copyright in the art, often splitting the copyright between penciler and inker. This may make it possible for the writer to sell certain movie rights or do a prose version of the graphic novel without the artist's cooperation, or for the artist to turn his or her panels into posters and T-shirts. There are legal questions about this method that no one has answered yet, so working this way opens up a big can of worms. Of course, a can of worms would be handy for feeding Dora, if not for her donut addiction.

Doling Out Dollars

When it comes to paying the creative team, one of the first things you need to decide is what share of the money everyone gets paid. This is different from the way the rights are split up. The division of the rights says who gets to make the deal, not who gets to keep the money.

If you're dealing with just a page rate or just a royalty/profit sharing deal, then you'll probably want to divide all the money based on percentages. Usually this depends on the specific amount of time that each creative task generally takes, so a writer might get 20 percent of the creators' income, the penciler 40 percent, the inker 15 percent, the colorist 15 percent, the letterer 5 percent, and the cover artist 5 percent. Ducks that serve as models get nothing. Never, ever pay a duck; they'll just lose it all at the racetrack.

Many graphic novel deals involve an advance payment from the publisher, plus a royalty. In those cases, the letterer and colorist might get all of their payments from the advance. The writer and penciler might split a slightly smaller part of the advance, but they share the royalties. Again, the poor duck gets nothing.

Money for movie, TV, and product licenses is usually split evenly between the writer and the penciler. This is an attempt to weigh in how much they each

 Intellectual Property

Intellectual property refers to the ownership of concepts, ideas, and expressions, things that can't be held or touched. This category includes items like copyrights, trademarks, and patents. Graphic novels rarely involve patents, unless you've found a new way to print panels on individually wrapped cheese slices.

 Lawyers! Oh No!

The rights and payment agreements should be put in a contract, for everyone's sake. There are various books that offer sample creative contracts, but you may want to get a lawyer to work out the details. Remember, your lawyer is your friend. It's other people's lawyers who are the enemy.

contributed to a creation. Of course, if you ask the writer, the writer really contributed 80 percent of the concept. The artist also contributed 80 percent. A 50/50 split is the best solution, unless you can convince some sucker to pay you an extra 60 percent.

Of course, all of this is just what other people do. You should do what works for you. To convince qualified and experienced people, you may need to give them bigger cuts of the various moneys, especially if you can't afford to pay them up front. And if you really want to win them over, tell them they get to keep the duck!

The Least You Need to Know

- There are plenty of creative folks looking to create graphic novels with other creative folks.

- Be picky: review samples carefully and look for signs of flakiness before choosing to work with someone.

- If you're trying to get people to work toward your vision, you'll have more luck if you can pay them.

- You should work out details of how rights and moneys will be split before asking anyone to do much work on your graphic novel.

What's It All About?

In This Chapter

◆ What genre is your graphic novel?

◆ What's it *really* about?

◆ How do you build in that concept?

So you're going to do a graphic novel. Now the question is, which graphic novel are you going to do? You could do *Maus*, which means that you'd sell a lot of copies and win a Pulitzer Prize. Of course, you'd be sued by Art Spiegelman, who already did *Maus*. No, you'll have to do a new graphic novel. But what is it *about?*

Genres Are Generally Germaine

Genre is something people rarely think about. Some people are just naturally drawn to creating, say, Eskimo romance graphic novels, because they loved reading *Love Among the Igloos* and *Frozen Kisses*. To them, a graphic novel should be whatever they like to read. But your favorite genre may not be the best way to say what you really want to say.

The Thousand-Pound Superhero Gorilla

Superheroes are a genre that was invented for American comics. The superhero graphic novel is the guy who shows up to a formal ball in a glittering purple tux—gaudy and distracting from the somewhat embarrassed crowd around him, but still a lot of fun. Even the comic pamphlets have been moving away from telling the basic hero-meets-villain, hero-punches-villain, hero-wins story, and when done in graphic novel form that becomes even more true.

WHA...?

Verisimilitude

Verisimilitude is the state of something feeling true within an established context. A teenager getting super-powers from a radioactive penguin bite is not realis-tic, but since it works in the superhero context, it has verisimilitude.

The superhero is inherently an unrealistic form. Some graphic novelists do a lot with that unreality, veering off into silliness or abstract work. Others try to handle what superheroes would be like if they were real, looking at the ramifi-cations of their presence and their actions, working hard at *verisimilitude*. Still others simply embrace the superhero as existing in a world with superhero rules, telling tales purely in the superhero tradition. There is much to be said for the basic morality play of the dastardly villain being brought down by a hero with nothing but pluck, drive, dedication, and a lifetime supply of Super Soldier Serum.

A Big Creamy Slice O' Life

Slice-of-life graphic novels are about mundane topics in realistic settings. These are generally very human tales about emotions and reactions. A story about a woman getting fired because she's drinking on the job is a slice of life. A tale about the trading card collector who finally finds the last card needed to com-plete a set is a slice of life. The story of a man whose bus is always so late that it makes him late for work is a slice of life as well—unless the man becomes so angry that he turns into the superhero Anti-Late Bus Man.

Many people assume that slice-of-life graphic novels are trite, downbeat, and boring. Sometimes these people are wrong, but only sometimes.

Auto-By-You

Autobiographical graphic novels are true tales about you and the things that you've done. Most of these are the nonfiction version of the slice-of-life graphic novel, but they don't have to be. If you've done anything in your life that isn't mundane, that can be a great source of information. Write about your days in the Americorps, or about the time you were kidnapped, or even about the day you were bitten by that radioactive penguin.

A Good, Fake Life

It's a Good Life If You Don't Weaken is an interesting slice-of-life graphic novel by Seth about a man searching for an obscure magazine cartoonist. It's an artfully faked autobiography, a story that is not factual but is emotionally true.

You don't have to be the star of your own autobiographical graphic novel. Con-sider *A Fax from Sarajevo*, Joe Kubert's tale about getting faxes from a former publisher. The heart of the story is in the contents of the faxes, about the pub-lisher's struggles in a war zone.

Steve Sez: Making It Visual

If you are telling a slice-of-life or autobiographical story, you'll want to make a special effort to provide a visual experience for the reader. Pay careful attention to the small things your characters do, and find the details of costume and setting that will bring the story to life. Your fifth-grade humiliation story just won't work as well as it ought to unless you get the embarrassing haircut right.

Burglars, Killers, and Other Fine Folk

Tales of charming detectives chasing fiendish criminals, or more stylishly, charming criminals eluding fiendish detectives, are mainstays in graphic novels. The new century has proven a prime time for crime.

The fashions in crime comics tend to follow the fashions in novels and movies, focusing either on stylish private detectives or on groups of enthusiastic-but-not-fully-competent criminals, in the *Pulp Fiction* tradition. The cop, popular on television, has failed to get much play in graphic novels.

Graphic History

It's easy to choose to set your novel in the present day. Everyone loves present day, mainly because they like the presents. "Happy present day!" they shout, confused by the concept. But you shouldn't feel stuck with that.

History provides a lot of options. A historical graphic novel can delve into the drama of a specific historical event. On the other hand, you can explore the nature of the time and the nature of humanity by using a fiction story set in a key period in the past.

The good thing about working on historical graphic novels is you have the vast richness of history to pull things from. The down side is that you really should know the period you're writing about, and that means research!

Future Robots of America

Most science fiction graphic novels come from one of two traditions. Numerous tales are set in heavily governed futures, filled with media saturation and focusing on fun-loving nonconformists. *American Flagg!*, *Channel X*, and the *Transmetropolitan* series all fit into this format. The other is space opera—the tales of travelers, explorers, and warriors on spacecraft. Actually, they're usually *in* spacecraft. Riding on the outside is discouraged in space.

Literary science fiction offers a far wider range of material, ranging from *hard SF* tales to sociological explorations. Although you can find examples of these things in English-language graphic novels, they are, sadly, the exception rather than the rule.

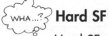

Hard SF

Hard SF stands for science fiction grounded in actual science, dealing with the repercussions of technological advances and real physical laws.

Lovey-Dovey Love

People love love, and that's made romance quite a genre. You can set it during a war, you can set it in a castle, you can put it in outer space, but if you have two hearts tugging at one another, you have a romance. (Unless the winner goes on to tug at the kidneys, in which case you have organ wrestling.)

Remember that romance, as a genre, doesn't always have to fit the narrow strictures of romantic comedy. It need not always be about love found despite obstacles. It can be about love sought, love lost, love fading, love lasting, and the most tragic of all: love not being enough.

Eek! Horror!

Horror definitely has a place in graphic novels. There is plenty of room for things that jump out and bite you, invade your body and your soul, or eat your ferret without spitting out the fur.

While the graphic novelist can easily do complex, gruesome things that outdo any screen horror, most graphic novel horror has a more intellectual bent. Movies have a much easier time creating that moment that makes you jump out of your seat, but a graphic novel's intellectual horror can chill you to the bone.

And All the Rest

War stories, spy stories, sports stories, erotic tales, pirates, elves, school tales—there is nothing that prose novels or movies do that graphic novels cannot. Well, perhaps not musicals. But even that's been tried!

In fact, you don't even have to stick with stories. Some graphic novels are essays, talking about a topic with visual examples or told by a drawn narrator. *How to Get Peanut Butter Out of Your Automatic Transmission* would be a graphic novel, if it showed the process using a series of pictures. Take a look at *Understanding Comics*, Scott McCloud's graphic novel that explains how sequential art storytelling works.

Just remember that you don't have to create a graphic novel that's a particular genre or fills a particular set of rules. A genre can be a comfortable thing and great for marketing, but if your story doesn't fit any known genre, that's great, too!

> **Don't Be Drawn Away** _____
>
> If you're an artist, you might think that determining what the graphic novel is about is a topic just for the writers, and that this chapter should appear later in the book where we talk about writing. You have to involve yourself in the big picture of what the graphic novel is about, or you'll find yourself drawing *The Secrets of Maintaining Automatic Transmissions*.

Genre Confusion

You don't have to limit yourself to one genre. There are graphic novels that are horror westerns, science fiction romances, and military fantasy tales. In fact, choosing two genres and trying to fit a story to them is a great imagination starter. Take a glance at *Grandville,* where Bryan Talbot rocks together an alternative history anthropomorphic steampunk detective tale.

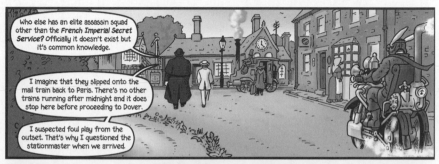

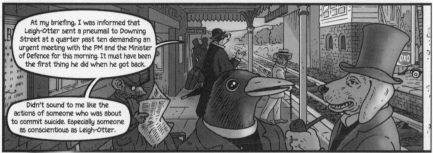

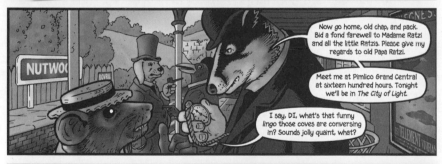

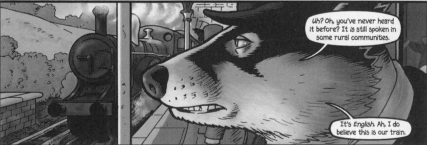

The plot thickens in Grandville.

(©2009 Bryan Talbot)

Make a Theme-Filled Cupcake

Steve Sez: Making It Visual, Redux

Find ways to express the story's theme visually. Reinforce a story about the allure of dangerous things via a candlelit scene with moths circling the flame. Look for places to show bars, gates, walls, and cages in a story about escape. I'll go into more detail about this sort of thinking later on, when I've liberated this book from its oppression under the hated Gertler regime.

If someone asks what your story is about, and you answer "it's a western," then you haven't answered the question. That would be like a sculptor saying, "My sculpture is about a stone cut into a shape." The genre is the context in which things happen, but it's not the heart of the story.

The theme is the heart of the matter. What makes a western interesting is not merely that it's set in the Old West. If it was, you could just have page after page of cowboys, Native Americans, railroad barons, and morticians just standing around doing nothing. That's probably what the Old West was like on hot days, anyway.

Emotional Exploration

Emotional themes are great to explore, because we all have emotions. At least, I assume we all do. There may be people who don't have emotions, but they're probably not reading graphic novels. Even if they do, they won't like what you create because liking is an emotional response, so ignore them.

What makes emotions work is that simple conflict can lead to complex situations. "The cowboy loves the schoolmarm" expresses a simple emotion, but it has inherent complications. If he marries the schoolmarm and stays in town with her, then he's not out riding the range. He's losing his freedom; he's having to change himself. And she knows he would have to change to be with her, and isn't sure that she would love the changed man. Besides, she thinks his horse is smelly.

Having an emotional theme doesn't mean that people are just standing around emoting. The things that happen in the story should all either reflect or have an impact on the emotional situation. The cowboy fearlessly faces down the evil rancher because he knows if he dies he will at least be spared the decision. The schoolmarm rides off in search of the wounded cowboy, and in riding fast and far learns to understand the feeling of freedom that the cowboy loves. The horse, tired of being smelly, takes a bath.

Theme Check _____

A good way to check if you have a grasp on your theme is to see if the same concerns would work in a different setting. The same concern the cowboy has for leaving the open range is the concern that the tennis player has about being in love while being on the circuit, or the time traveler has for those he leaves at home while going to ancient Egypt.

Existential Exposition

You can explore other aspects of the world that go beyond human emotion. The rise of humanity, the fate of nations, the delicate balance of ecology, the

conflict between science and religion, the tendency of things to fall apart, the effect of censorship, and the importance of pizza are all themes that you could explore.

Don't worry if confronting such a topic head-on seems too blunt. A large abstract theme can often be handled by allegory. That means that instead of telling a story about God's relationship with man, for example, you tell a story about an inventor and the robot aardvark he invented.

Action, Action, Action

Action is actually a legitimate theme. It may not be the deepest, most meaningful theme, but life isn't solely deep and meaningful. The fight, the chase, the hunt, can all be gloriously kinetic. If you think about Indiana Jones movies or many of the James Bond films, adventure is at their core. Oh, they may sprinkle them with morality lessons like, "We must respect the mysteries of life," or "Faith is better than misplaced self-confidence," or "If you're going to take over the world, don't tell your plans to the man inches away from the giant shredder." Those are mostly window dressing. The core of the story is the physical struggle against nigh-impossible odds.

Hilarity Ensues

Comedy can be a tool, or it can be a goal. *Satire* is the art of using comedy to comment on the real world. A satirical work might have a straight-talking janitor become a congressman, contrasting him with the confusing politics of the more realistic congressmen. Satire makes you laugh to make you look at the world differently.

But straight comedy makes you laugh to make you laugh. Silly, goofy, funny stuff doesn't need an excuse. We could all use a laugh in this silly world of ours. Unless you're ready to pump laughing gas into everyone's house, comedy is the best way to spread that joy.

Bean There, Done That

Tales of the Beanworld is an ecological fable. Larry Marder depicts a fantasy world with a simple ecology, and explores what happens to the world and its inhabitants when changes or outside intrusions occur.

Mix 'n' Match with Care

You can have multiple themes in a single graphic novel, but stick with one main one. Minor themes can be used when they won't interfere with the main one. You don't want to end up with an action comedy that is hilarious for the first two thirds then turns into a bloody, heart-wrenching gun battle, for example. The action kills the comedy while the comedy leaves it hard to take the action seriously.

The Concept of Concept

You have a genre, you have a theme you want to explore. Now you need a story, a tale to tell within that genre that explores that theme. You're not going to start off with a full plot, but two key items drive most stories: the situation and the complication.

The situation is usually simply the position your lead character or characters are in. The complication makes the situation uncomfortable, forcing action or a decision. If you want to describe your graphic novel, you can probably do it by mentioning the situation followed by the complication, with a big *but* in between.

Think about these examples:

♦ An inventor makes a robot aardvark—*but* the robot aardvark starts doing things the inventor didn't plan.

♦ Gloria inherits a million dollars—*but* the money is buried in the middle of a minefield.

♦ Tony's getting married—*but* his girlfriend from 20 years before suddenly shows up.

♦ Little Bobbie is taking cupcakes for the class at school—*but* she has one cupcake less than she should.

♦ The star warrior has retired to The Planet of the Donuts—*but* the space pirates are coming to steal this year's donut harvest.

♦ Jill has moved to Las Vegas—*but* small-town life has left her ill-prepared for the big city.

When the story is done, there will probably be more than one complication—*but* one will generally get your story going. So you have the base of your story—*but* there is still a lot more work to do!

As a practice, think about some of your favorite graphic novels and movies, and see if you can name the basic situation and key complication. This practice identifying *buts* will make you a better butter!

The Least You Need to Know

♦ The genre is the category of setting of the tale.

♦ The theme is the point of the story.

♦ Most stories are built from a situation and a complication.

Part 2

The Writer's Art

Writing graphic novels is like building a watch. No one sees all that delicate work you've hidden inside; they just see the smooth-looking surface. If you do it right, people will think it was easy, because the details of your work are invisible. And if you do it wrong, everyone will laugh when it's 30 o'clock.

This part of the book has tips on how to tell an interesting story filled with interesting people doing interesting things. The secrets of writing effective dialogue and conveying your vision to an artist are unveiled. You even learn why the exclamation point is so popular!

Who, Why, and Huh?: Interesting People and Events

In This Chapter

- ◆ Who are these people?
- ◆ What do they want?
- ◆ What develops?

It's time to turn your vague, fuzzy concept for a graphic novel into a less vague, still somewhat fuzzy concept. Once you establish who your characters are, where they are, and what the heart of the story is, then your work is done. Well, not really done—not even nearly done. But if you think of your graphic novel as a toy airplane, you've now created the big red rubber band that will make it move.

I'll warn you now: parts of this chapter are going to seem obvious, aspects of telling your tale so basic that you don't even have to think about them. But you'll find that when your story has gone astray, it's often because you forgot to think about these things.

Who Are These Characters?

People are going to be at the heart of your graphic novel, unless you're doing a graphic novel about vampire turtles, in which case vampire turtles will be at the heart (and throat) of the work. Your story will rise and fall on these characters. Readers will pay attention to boring things happening to interesting people long after they've turned away from interesting things happening to boring people.

Awesome and Average Abilities

It's easy to see superheroes in terms of abilities. Lady Power has the ability to fly, read minds, and has eye-beams that can turn anything into a large veal patty. But even the less super among us have a list of abilities. I can write, do crossword puzzles, drive a car, and say, "I do not speak Spanish," in Spanish. Steve can draw, perform CPR, and convince editors that deadlines aren't really deadlines.

The Following People

Characters don't always come first. You can generate your graphic novel starting with anything that gets your imagination going. In this book you'll see portions of our graphic novel, *The Big Con,* set in a comic book convention. I started with that setting, and that led to the type of characters. A scene, a snip of dialogue, a title, a single drawing—anything can provide a spark.

What your characters *can* do tells you the limits of what they *will* do. Some abilities come naturally, such as the abilities to run, breathe, or turn things into veal patties. Other abilities will suggest certain attitudes or histories. A character who can fly a plane, for example, may have a thrill-seeking attitude, or may be an ex-fighter pilot, or the child of a renegade skywriter who was driven out of the business for purposeful misspelling.

Attitude? No Problem!

Characters should have attitudes, ways of looking at life and facing situations. They can be happy, grumpy, or bashful. (Sleepy, dopey, and sneezy are conditions, not attitudes, and Doc is merely a dwarf.) Attitudes make the characters human, and help with *character identification*.

WHA...? Character Identification

Character identification is created when your character has aspects that get readers picturing themselves in the character's place. This can be something as blatant as making an 11-year-old boy the hero in a book aimed at 11-year-old boys. It can also involve putting the character in a common emotional situation, such as lusting from afar or having a lousy day.

In reality, most people have varying attitudes depending on their situation. The world's strongest woman might be confident, proud, and even obnoxious when it comes to facing physical challenges, but uncertain, self-effacing, yet still obnoxious when dealing with affairs of the heart. A father may be loving around his children, yet coldhearted to the rest of the world. A hypnotist's assistant may be polite and demure, yet become belligerent whenever someone says, "Paprika." This doesn't mean that people are inconsistent. Every Tom, Dick,

and Englebert has some idea of his place in the world, and his attitude at any given moment shows how what he is doing relates to that place.

Perhaps the most important aspect of attitude is desire. What does your character, whether *protagonist* or *antagonist*, want? Everything anyone does is driven by a desire. We seek love, money, peace, sex, salvation, children, food, relief, warmth, safety, pleasure, knowledge, respect, and a complete set of Snoopy books. Most of us want most of these things, in differing amounts and at different times.

Remember, villains are people, too, and few are villains in their own mind. People do bad things with good motives. Many of the worst things in history have been done in the name of the greater good. The villain who steals pizzas to feed the hungry or to protest the power of the International Mozzarella Cartel is far more interesting than a thief who just wants a pie. If your villain earns the reader's respect, the interaction between hero and villain will be fascinating.

A Sweet Pill to Swallow

Blue Pills by Frederik Peeters tells the auto-biographical story of the author's romance with an HIV-positive woman. As life throws them curveball after curveball, his personality stays consistent, even as his ideas about what constitutes safety and stability are changed forever.

WHA...? **Protagonist/Antagonist**

A **protagonist** is the character our story focuses on, the one facing the main challenge of the tale and whom the reader is likely to root for. **Antagonists** are people who stand in the way of the protagonist. An antagonist doesn't have to be a villain. If Aaron and Eli both want to be world-champion cat jugglers, and Aaron is your protagonist, then Eli is an antagonist even though he's no more evil than Aaron.

Have Strength in Weaknesses

Weaknesses are aspects of the character that will cause problems for them or unintended problems for others around them. These are not the opposite of abilities—the inability to fly is not a weakness unless you're a bird. Weaknesses include such things as a short temper, distraction, addiction, social ineptness, tics and spasms, cowardice, an undue belief in your own abilities, allergies, and letting love or lust overrule logic. We all have weaknesses, and we wouldn't be the same without them.

Weaknesses put limits on your heroes, often giving them something to struggle against. In many adventure tales, weaknesses are simple physical things that the hero must confront (Indiana Jones faces the snakes he fears) or avoid (Superman avoids Kryptonite). In human-interest stories, weaknesses are often the center of the plot. We each have things in our character that could destroy us, given the right conditions. A *tragedy* is a story in which those elements overtake us, while in *life-affirming stories* we pull away from near destruction, making it through the crisis.

Putting the Stories in Histories

Few graphic novels start with a character being born. Characters have histories shaped by their abilities, attitudes, and weaknesses. Histories also shape abilities, attitudes, and weaknesses. What size family is the character from? What's the character's religion? Race? Educational background? Has the character fallen in love, and if so, what happened? What jobs are on your character's resumé?

If you know a character's history, you know the character. With the history and attitudes down, you'll be able to answer such questions as *What's the character's favorite movie? Favorite meal?* and *What's a character likely to do upon winning a lifetime supply of macaroni products?* You will, however, still have trouble with any question that begins, "If the character leaves the station on a train traveling at 75 miles per hour …"

Great Hollywood Names

Character names can suggest so much about them, so be careful of relying on generic names. Before you name one of your characters Bob Smith (or, worse yet, name all of your characters Bob Smith), delve into more interesting names. My favorite source for interesting names is the credits at the end of the movies. Fast forward past the actors' names and you're apt to find a multitude of memorable monikers. Mix a best boy's first name with a key grip's last name and voilà! you have a character name.

Revealing Characters You Never Vealed

Your character The Amazing Clive may be full of interesting aspects. He may be a master juggler, secretly afraid of invisible tigers, who served five years in Sing-Sing for cold-bloodedly killing a six-pack of beer. But if he stands around ironing socks for the entire graphic novel, then the only interesting thing revealed about The Amazing Clive is that he irons socks. That's barely interesting, and certainly not amazing.

You could have The Amazing Clive talking about himself whilst ironing the socks, and that could be a cute idea for a four-page story, but it'd make a lousy graphic novel. No, we need to learn about him in context. It's far better to be *shown* what makes the character interesting than to be told it.

You Look Like Yourself

The physical appearance of a character, including face, clothes, and stance, is a vital way of revealing character attributes. People can look rich, poor, kind, mean, smart, stupid, stylish, clueless, attentive, befuddled, and so on. Most of this is in the hand of the artists, and will be covered in the art-oriented chapters of the book.

Some visual ways of showing character may seem like stereotyping, since you'll be saying that people who look mean actually are mean. However, there is some legitimacy in that. Although most of us are born with a certain appearance, over the years our attitudes and beliefs give us facial expressions that change the way we look. We earn our faces.

Of course, even that has plenty of exceptions. Characters who aren't what they appear to be, while harder to depict, are interesting for that very aspect. The man who looks like a kindly grandpa but is really planning to blow up the bank makes a tough villain, and the cruel-looking lass with a heart of gold will face interesting problems.

"He Chose What?!?"

You can tell a story without any characters making decisions, but perhaps you shouldn't. Consider this: An earthquake causes a rockslide that sets off sparks. The sparks set the brush in the canyon ablaze. However, the rocks also block the narrow path that the stream takes out of the canyon. The blocked stream causes the canyon to flood, extinguishing the blaze. A story has occurred, and no one has made a decision. You could, with some effort, make a hundred-page story like that, but it would be almost impossible to make it interesting.

Most of your readers will be human, and humans are interested in human-style decisions. Great stories turn on decisions made. This doesn't mean that lovely Mabel has to spend page after page wondering, "Should I go and rescue the prince, or should I stay home and get some cleaning done?" When she rushes off to rescue the prince or performs any other voluntary action, a decision has been made. Even if she just stands around doing nothing while knowing that the prince is being thrown into The Pit of Impressive Depth, that inaction is a decision as well.

Interesting decisions are those which have major effects or reveal interesting aspects of character. When someone decides to lie to a child, to keep hope alive, to finally ask Sarah out, to sing on the subway, to keep the dollar bill instead of handing it back to the person who dropped it, or to not have a drink today, a bit of that person's character is revealed.

Steve Sez: Worth a Thousand …

Graphic novel writers sometimes send magazine photos or movie stills to their collaborators. "She should have a jacket like this, but worn out, with patches." "He has this sort of amused expression." You can refer your artist to movies, too. "The produce department manager is a big, swaggering guy who compresses his upper lip like Humphrey Bogart and walks like John Wayne."

Steve Sez: Belaboring the Visual Thing

Do it with pictures. It's better to show the protagonist pocketing the dollar, and perhaps his expression (guilty? sly? cheerfully whistling?), than to use dialogue or a caption announcing "he decided to keep the dollar." On the other hand, having the character say, "I gave the dollar back" while showing him keep it cleverly uses two story details to communicate a third—that he's a liar.

Why Should Anyone Care?

If your graphic novel is just a bunch of characters who aren't doing things, experiencing things, and causing things to happen, you don't have a story. You have a phone book.

You could use huge paper and do a one-page graphic novel and never worry about whether the reader will want to turn the page. For the more common, multipage sort of graphic novel, however, you'll need the reader to keep turning the page. It's not good enough to tell interesting information; the reader has to want to know what happens next.

Conflict: Picking a Fight

A *conflict* is simply when two things are working against one another. Sometimes this occurs on a very physical level, as when the Fabulous Meatball Guy fights the many-tendrilled Spaghetti Monster. It can happen on an emotional level, when Bo Thompson and Roderick Rutherford III are both competing for the love of the Spaghetti Monster. It can even happen internally, as the Spaghetti Monster is torn between her love for Bo and her knowledge that Roderick could help her in the battle against the Fabulous Meatball Guy.

The thing that makes conflict interesting is not the resolution—the result of the conflict. Oh, the reader will hang on until the result is clear, but the interesting part is how the result is achieved. In traditional genre works, we know that the good guy will beat the bad guy and the monster will pick true love over wealth and revenge. In fact, the reader will sometimes be very disappointed by works where the expected result doesn't happen. Let your conflict be resolved, but not too quickly or easily.

Change Isn't Just Nickels and Dimes

Characters who are going through changes are interesting. The reader may want to know what the character will be like at the end of the change, or simply what the fallout of the change will be. The changes can be external, like when the small-town gal moves to the big city. They can be physical, like when the small-town gal turns into a big city; or they can be emotional, like falling in love, falling out of love, finding or losing religion, going insane, going sane

Changes cause other changes. The physical changes of puberty bring complex emotional changes. The emotional changes of falling in love lead to the external changes of marriage, family, and dinner parties.

While some changes are instantaneous, many are gradual, and these are a writer's delight. Once the change begins, readers will want to see what it leads to. When a caterpillar enters its cocoon, everyone will want to stick around to see it emerge as a beautiful alligator.

A Perfect Effect Has No Defect

People start turning into chocolate bunnies. That's an eye-catching sentence, but it can be made even more interesting by extending it just a little further. "People start turning into chocolate bunnies, and then ..."

It's that "and then ..." that turns a concept into a story. What happens? What's the effect of this choco-bunny transformation? Rioting in the streets? Hopping in the streets? Perpetual Easter? If you can take a cause and create an interesting but logical effect, people want to read it. *Mystery*, a popular form, is merely the revelation of effect before the cause.

And the effect can serve as the cause for the next part of the plot. Perpetual Easter causes a shortage of egg dye, driving the prices through the roof and making Hortense Cheswick, heir to the Eastwick Easter Egg Enhancement Enterprise, a wealthy woman. And that effect draws suitors, both human and chocolate bunnies, to her. And so on.

Ideally, you want to start with a situation and a single cause, and have everything else that happens in your plot arise directly or indirectly from that cause. If in the middle of the story you suddenly need to have anvils fall from the sky and squish the bunnies, then you should rethink your plot. New plot elements that come out of left field feel like cheating, and the later in the story they appear, the worse the reader will react.

Example Characters: *The Big Con*

While writing this book, Steve and I are also working on part of the graphic novel *The Big Con*. The spark for this graphic novel was my wanting to do a tale set at a large comic book convention. I've spent a lot of time at these conventions, where a lot of interesting people have interesting experiences. So I decided to build the novel as a series of short stories, all set at a single convention. I made up a list of characters whose stories I might tell. This included ...

◆ The enthusiastic comics fan who spent almost all his money just getting to the convention and now has less than $10 to make it through the four days of the show.

◆ The comics dealer who has thousands of old comics to sell in the show, but has to keep an eye out for shoplifters.

◆ The comics writer who finds herself without people to hang out with during the convention and is feeling lonely in the midst of a crowd of very similar people.

◆ Two contestants in the convention's costume contest who fall in love.

◆ An older comics artist who is surrounded by fans who love the work he did in the 1960s and 1970s. He needs a job, but the comics editors at the convention don't think he can interest the current audience.

◆ A group of movie actors at the convention to promote the latest install-
ment of their series, but who are uncomfortable being surrounded by their
fans.

As you can see, each character has a conflict, a challenge, or a change during
the course of this convention.

The Least You Need to Know

◆ Interesting characters make interesting stories.

◆ Characters can be made interesting by giving them interesting abilities,
attitudes, weaknesses, and histories.

◆ Characters reveal themselves through their statements, decisions, and
appearance.

◆ To keep your readers interested, give your characters conflicts and put
them through changes.

◆ The resolution of a conflict is not as interesting as how that resolution is
reached.

◆ Introducing new, important elements of the story late in the tale makes
the story seem forced. You should have a continuous chain of events set
off by one cause.

What, Where, When, and Watchamacallit?

In This Chapter

◆ Plotting your story

◆ Adding complications

◆ What develops?

It's time to turn your scanty little concept into the robust plot that will carry you through the rest of the work. Your plot is your story, just in a very cheap form that no one would pay to read.

You're Nowhere Without a Place

Choosing a locale for your story gets it ready to be detailed. A story about a cop chasing after a bank robber in New York is very different from one in Los Angeles, and even more so if it's in Hong Kong, the middle of Kansas, or if he's a space cop from Uranus. And if it makes a difference in the writing of the graphic novel, it makes an even bigger difference in the art.

Real Places Are Where It's Really At

The advantage of using a real location is that you get a built-in richness. Real places have their own cultures, institutions, street names, and sports teams. All this rich material will actually help you in your writing. When faced with the question of where the thief will hide or where the young couple will go on a date, you'll have your answers. If they're in Pasadena, California, for example, they can go to the movies in the Paseo Colorado mall. Suddenly, you know that if they have small talk to make, they can mention that they're on the street that the Rose Parade goes down, or they can take a look at the most beautiful city

hall in the nation. If it's a winter night, it will be chilly, but not snowy. Building from the knowledge of this detail and background makes your work rich.

Steve Sez: Home Is Where the Art Is _____

There's a lot to be said for setting a story in a place you know well. If a writer's story takes place in her home town of Pittsburgh, she can spend an afternoon out with a camera, shooting photo reference of buildings and settings. This will make it much easier for her artist, who lives in Buenos Aires, to illustrate her tale of love and desperation on the banks of the Monongahela.

The downside, of course, is that you have to actually know about the place. If you don't know where to go to the movies in Pasadena and you set the story there anyway, it will cost you. You won't get any of the richness of the place. People who have been to Pasadena will know you've got it wrong the moment you have someone say, "Y'all done shoveling that snow yet?"

Check out the travel books at your bookstore or library to find books focusing on most states and most nations, giving you details of those places. For less touristy info, go to the websites for the local newspapers. And if you can talk to someone who's actually from the area, you'll be much better off.

Made-Up Places: Fake Estate

Real places have their advantages, but so do made-up places, or places that simply go unnamed. You can create a place that has certain important attributes that you can't quite find in the real world. Need an island kingdom with a strong high-tech center and wild monkeys? That's the tropical isle of Goodnamus! You can't get it wrong because there's no source to get right.

One time when you really might want to use a fictional place is when your story is built around the local government. If you create a crooked police force, a drunken mayor, and a paranoid dog catcher, attributing it to a real place may make it seem like you're writing about specific people. Dark depictions of real people can bring about lawsuits. Lawsuits are bad.

Really Fictional Places

When writing fantasy or science fiction, you could need a city that's not on this Earth. Make it feel real by basing it on a real city. Basing a spaceport on New York City would be very different than one based on Las Vegas. The home of your elves could be based on ancient Rome, or it could be based on a small Iowa town to very different effect.

The Only Right Place

The Sandwalk Adventures explains evolution by focusing on follicle mites who live on the body of Charles Darwin and think he's a god. Cartoonist/ biologist Dr. Jay Hosler researched Darwin's home carefully, and that gave him much of the rich detail of this bouncy, happy work, including the title.

When creating a city or town, ask yourself questions about it. What industries are in the town? What's the government like? Are there different neighborhoods? Does everyone get along? Are there sports teams? Is it an older city with brick buildings, or a newer steel-and-concrete place? Are big sandwiches called "subs," "hoagies," "grinders," or "Charles Sebastian McShane, with extra cheese"?

Time for Time

When does your story take place? People usually have a vague answer for this, and vague is often fine. Most things you see take place in the vague form of "the present." They don't say the exact year, but the characters dress like you do and listen to music from the past couple years.

Still, being precise helps. Even with a "vaguely today" setting, at least know the season. Some people try to set things in the next year, so that it will be fresh when it comes out. Of course, that proves a mistake when the characters aren't all wearing the giant purple bunny ears that became required under the Congressional Purple Bunny Ear Act just before the graphic novel was printed. It's often better to set the story slightly in the past.

Steve Sez: That Grass Sure Is Greener

It's easier for writers to get away with being vague about when a story is set than it is for artists. A writer can tell an artist, "Gretchen climbs out of the car and steps onto the city sidewalk." This could take place in 1920, 1950, or the day after tomorrow. Unless the artist is working in a deliberately fanciful or obscure style, readers will note basic details like the make of the car, the buildings, and Gretchen's clothing and hairstyle, and then form their own ideas about when a story takes place. An artist who doesn't want to confuse the audience should either pick a year and try to keep things consistent, or quickly make it clear to the reader that this story is set in its own world with its own rules.

If you're delving into history, being precise can be necessary. The Old West covers a number of years, and the crowdedness of the cities, the status of the railroads, and the availability of certain firearms all varied during that time. If you mix up your times, the Old West fanatics will glare severely at you.

If you're setting a story substantially in the future, the year is not as important as the situation. What has become of humanity? What wars have occurred? What is the state of technology? Have the potatoes finally conquered us all? Understand the world and the society, and you'll be ready to have things happen in it.

You may never mention the actual year or even the day of the week in your graphic novel. It's still good to know the date things are taking place. For tales that take place over a period of time, pick dates for everything that happens. By tracking your story against the calendar, you'll know when weekends and holidays fall, and even know when people age.

A Staggering Work of Lee-nius

Time and place aren't just some data to put into a caption somewhere and then forget about it. Real places have real texture, and real people talking and dressing in the manners of a specific time can give your graphic novel deep richness. With *Stagger Lee*, writer Derek McCulloch and artist Shepherd Hendrix started with the tale told in a folk song and the real events which inspired them, and then fleshed them out with all the reality that late-nineteenth-century St. Louis could bring.

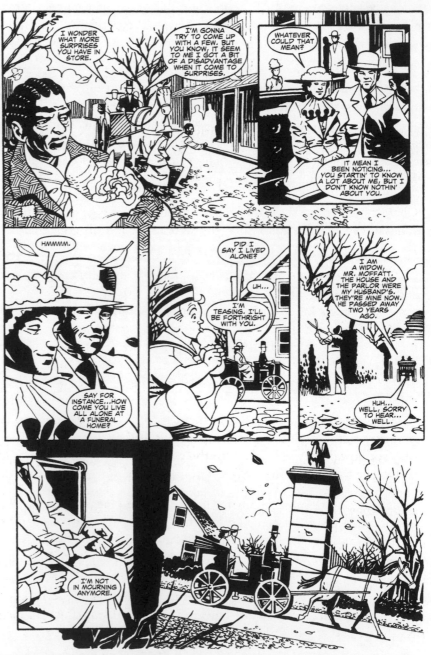

The widow gets wooed, from Stagger Lee.

(©2006 Derek McCulloch and Shepherd Hendrix)

Paperize It

At this point, start putting things down on paper (or its digital equivalent). This isn't to keep you from forgetting something, nor is it time to start showing your plot to other folks. The very act of writing out what you're doing forces you to make sure it's clear in your mind. In writing down your plot, you're likely to discover problems, like the fact that your hero is both an Air Force veteran and attending kindergarten. Or you'll discover new opportunities for your story that you hadn't noticed before, like how your hero being in kindergarten means that the vehicle he hot-wires for the chase scene will probably be a school bus, which will look real cool.

Writing down the plot doesn't mean that you have to answer every question. In fact, writing down the questions will make it clear to you just what you have yet to answer. Consider this rough plot for our example story from *The Big Con:*

> Setting: A recent year, say 2006, early summer. A big fictional comics/multimedia convention, as big as the Chicago or San Diego comic conventions. It's at a big convention center in Seattle. (A fictional one? Does Seattle have a convention center?)

> Characters: Four of the stars from some popular science fiction film series. They're at the convention to promote the next installment.

> Story: They have to get to the auditorium for their panel at the convention. It's on the other side of the convention hall from where they are, and if they just try to walk across the crowded convention hall, they're going to be swarmed with fans wanting autographs, attention, whatever, and as celebrities they're sick and tired of everyone wanting a piece of them. They've gotten cynical about people's interest in their fame. There's probably a back route that is usually used to get people in. It's closed off. (Why?) So they borrow some costumes from people there for the costume contest—costumes based on the movies they star in. Full-body costumes, so no one can see the celebrities in them. (Who arranges this? Con security? Someone from the movie company?) And then, crossing the floor, they see how people really react to the costumes, and realize that folks really love the movies they make. This makes them realize that not everyone who acts like a fan is trying to take advantage of their celebrity. The actors know the joy that they have brought to their fans, and feel joy in sharing it with them.

That's not very detailed, but it gives me something to go on. It also shows me where I have problems, like the fact that I have four actors and with this level of detail, they're all the same. I also see where I can start adding some basic details, like choosing a name for the movies they're in. That name will help me envision the film, the costumes, what the fans are like, and so forth.

Plot-Checkin' Fricassee

With that written down, we can make sure the key elements are there. Do we know the goal of the characters? Yes, they are on a quest, seeking to find the other side of the convention hall! Why are the characters on the quest? Because they are scheduled to be there to promote their movie.

Does the quest have obstacles? Of course. The cast has an internal conflict, because crossing the hall involves dealing with the masses of people, which they don't want to deal with. Then there are external obstacles, the fans themselves, who could prove to be real physical obstacles.

These conflicts are a cause that leads to a decision—the decision to wear the costumes. That decision has effects—the fans reacting to the people in costume. That effect causes other effects—the actors having emotional reactions to the fan reactions.

Notice that the quest has become unimportant. We still need the quest—we need to have the actors trying to cross the convention hall—but the important thing about the story is not whether they make it. It's the journey that matters, not what happens when they arrive. Sometimes whether the protagonist achieves a goal is important, but sometimes it's like a rollercoaster ride. It's not important where the rollercoaster is going, because we know it's going back to the starting point. It's the rises and falls and the near-vomiting along the way that makes the rollercoaster interesting.

Pile on the Problems

We've got a short little tale here, and that's fine if you want a short story. For a novel, however, your characters have to go through a lot. It's not enough to say, *Charlie wanted to be a world-famous donut baker, so he baked some very good donuts and everyone loved them and he achieved his goal.* The lack of complications may be good for Charlie, but it's lousy for the reader.

Looking at the convention story, you can add a lot of complications. Many of them come from adding needed detail—just how do the fans show their love for the films? Other complications come from adding new situational elements that take place before or after the existing plot. Here are some possibilities that come to my mind:

♦ The fans in costume don't want to lend the actors their costumes, because they fear the actors won't return them in time for the costume contest.

♦ Some people on the convention floor find out that the actors are traveling in costume and start bugging the costume wearers for photographs.

♦ It's hard to see through the eyeholes of some of the costumes, causing some of the actors to run into things, trip, or knock stuff over.

♦ Some fans want photographs with the folks in costumes.

- Fans dressed for the costume contest assume that our protagonists made their own costumes and want to know details.

- One of the actors is dressed in a villain costume, and a little girl attacks the actor because she hates the villain.

- No one told the auditorium security that the actors would be arriving in costume, and security tries to keep these costumed folks out.

- After being transformed with joy, the actors return the costumes to their owners. The joy is soured somewhat when one of the owners says he's going to make a lot of money auctioning off this celebrity-worn costume.

If this story was going to be a full graphic novel, I'd probably use all these features and more. Since this is supposed to be just an eight-page portion of a larger work, however, there's not room for everything. By having this list of possibilities, I can pick and choose what I think will make the most interesting story.

Combinations and Permutations

If you watch a soap opera long enough, you'll see the writers try to combine every possible pair of characters into a couple. On *Throbbing Hearts University*, the dean's wife will have affairs with all the professors, the staff, the students, the town dog catcher, and so on. Who knows, she might even have an affair with the dean himself.

That's not a great way to build a coherent story, but it's a great way to think about plotting. When you're stuck on what should happen, look at each pair of characters. How do these characters relate to each other? What effect do they have on each other? Can you do something interesting with them? Taking two otherwise unlinked characters and having them fall in love, or in hate, or start a pizza delivery service together, can move things forward. Build relationships, and remember that *relationship* doesn't just mean romance; it's any kind of regular dealings between people. The neighbors who throw garbage on each other's lawn have a relationship, even if they never actually see each other.

When you have a relationship established between two characters, look at all the other characters and see what effect that relationship has on them. How does Jane's husband feel about her starting a pizza delivery service with her old math teacher? Is he happy? Jealous? Hopeful? Scornful? Gassy? If the reaction would add something to the story, go with it!

Are there characters who aren't part of the plot for a while? Their lives haven't stopped just because the reader doesn't see them. The things they do when the reader isn't watching, whether that's drinking a cup of coffee or raising a family, can be important when they come back.

 Steve Sez: Artistic Limitations

Each artist has strengths and weaknesses. You don't have to take them into account when you plot your story, but if you're working with an artist who has a knack for drawing attractive women but is terrible at children, keep that in mind when deciding whether your hero should hide in a sorority or in a nursery.

Take Out the Garbage!

Now, get rid of anything that doesn't work. If you have a conflict that doesn't make sense, strike it out. If Mrs. McWallaby just sits around for the whole plot doing nothing, you don't need her.

Plot points that don't address the theme of the story and don't move the story toward its ending are pointless points. Remove them. You might find yourself removing points that seemed very important once upon a time. You would not believe how often the very concept that inspired the whole story ends up being unnecessary.

The Least You Need to Know

- Using a real place adds richness to your story, but don't use a place that you don't know anything about.

- Stories set in the past should be set in a specific time period.

- For stories set in the future, have a clear idea of how society and technology have advanced.

- Writing down your plot will help clarify what you have and what you still need to invent.

- Considering every combination of your characters and thinking about how they relate to one another can generate more plot complications.

- Get rid of anything that doesn't help your story.

Planning the Panels

In This Chapter

◆ Breaking your plot into pages

◆ Shattering your page into panels

◆ Describing your panels for the artist

Now that you've got a basic plot for your story worked out, it's time to start building a script, working out in more detail where everything goes. Even if you're drawing the graphic novel yourself, you need some form of script or at least a more detailed plot to work out the pacing. Otherwise, you'd be like the artist who tried to paint *The Last Supper* without sketching it out first, with four apostles taking up most of the picture and everyone else scrunched down at the right end like they just lost a round of musical chairs.

Pacing to the Pages

First, figure out what happens on each page. Consider the key elements of your plot and figure out how many pages each takes. There's no simple rule for how many pages something will take, because pacing is a style choice. If your plot has a despondent man jumping off of a bridge, you could do that in a single panel, with motion lines showing him coming off the bridge and a thought balloon saying, "Goodbye, cruel world." Or you could do the same thing over six pages, as the man approaches the edge of the bridge, trembling, looks out over the water, sees the whole world around him, pulls out the photo of his recently deceased wife, steels up his courage, steps out, and plummets into the water.

If you have a plot written out, you could just break that into sections, marking where each page begins. Or you could write out a new, simple version of the plot just for the page breakdown. For example, take a look at the picture of the breakdown of the sample chapter from *The Big Con*.

A little bit of The Big Con, *chopped into chunks.*

> Page 1: Establishing shot. The fans take off their costume as the cast discusses what's going on.
> Page 2: The cast puts on the costumes. Derrick gets the head villain outfit.
> Page 3: They stride into the convention hall. Someone tries to take their photo.
> Page 4: SPLASH: Derrick pushes the photographer away. Inset shot, Terry noting that the photos should be okay.
> Page 5: They pose for a couple photos, exchange banter with dealers.
> Page 6: Derrick is attacked by a six year old dressed as the character he plays. Yeo shows him how to really attack the bad guy
> Page 7: A pile of photos that people took with the characters. The cast reaches their destination.
> Page 8: Derrick admits that he has come to see the fans differently, as something more than just people looking to profit off of him. He returns the costume to the lending fan, who mentions to his pal just how much they can now sell their costumes for on eBay.

Serialized Subsections

If your graphic novel is going to be serialized in magazine form, break your plot up into individual installments. That way, you make sure that each chapter starts and ends with something interesting. Then you'll break the first chapter into pages, and probably write that script before breaking down Chapter 2.

Notice that you can't follow the full plot from the page breakdown. I don't explain details like who Derrick and Yeo are. This breakdown isn't meant to be shared with others, so put down only the level of detail you'll need.

Not everything even needs to be broken into individual pages. If you have one element of the plot that takes up several pages, putting down *Pages 10–12: Myrna and Leroy discuss the spaghetti dilemma* is perfectly fine. Don't fret over getting everything exact. When it comes time to write the script, you may find that Myrna and Leroy need an extra half page of spaghetti discussion, or that you can sum it up in just two pages.

Script Style: Every Which Way but Wrong

The next step is to decide what your comic book script is going to look like. If you've seen several play scripts, you know that they all look alike. Movie scripts all look alike, too. But graphic novel scripts from different writers are like snowflakes; no two look exactly the same. Now you may think that's because graphic novel writers are like flakes themselves, but that's not the case. Graphic novel scripts are different because they don't have to be the same.

A movie script is designed so that actors, camera operators, sound engineers, costume folks, set decorators, and all the other people involved in production can quickly locate the information they need. A graphic novel script, on the other hand, is more of a personal letter from the writer to the penciler. The letterer needs to be able to get some information from it, but beyond that the script can use any technique that gets the writer's vision into the penciler's brain.

Full-of-Possibilities Script

The various script styles do fall into certain general categories. The most common is a full script, which has a written description of each panel, each individual picture that makes up a graphic novel page.

If you take a look at the sample script in Chapter 9, you'll see that the script is broken down into pages. Each panel on that page is numbered; then there's a description of the picture in that panel. Following that is a list of all of the dialogue, thought balloons, captions, and special effects lettering that go in

that panel. The captions and dialogue are usually numbered for the letterer's convenience.

Laying Out the Information

Some graphic novel writers don't type, they draw scripts. As you can see in the following image, a layout script (sometimes called a drawn script) is really just a quickly drawn comic book.

A layout script page.

Layout scripts are popular with graphic novelists who both write and draw the work themselves. They're also popular with writers who have experience as artists, even when writing for someone else to draw from. As you can see from the example, however, you don't have to be a good artist to draw a layout script. As long as you make it clear who is in each panel so that the artist can follow what's going on, you should be fine.

Some writers use layout scripts expecting artists to follow their layouts, placing each panel and each character on the page exactly where the writer designates. Others want the artist to use the script as merely a rough description, letting the artists choose the camera angles and panel sizes, so long as they keep the right characters, actions, and facial expressions. Let your artist know which of these tacks you're taking.

 A One-Time Layout

Every writer should write at least one short story using a layout script. Drawing out the script teaches you the limits of what can be done in each panel.

Plots to Make You Plotz

Some graphic novels aren't fully scripted before landing in the artist's hands. Instead, the writer writes a reasonably tight version of the plot. This plot doesn't describe most of the panels and doesn't have most of the dialogue. Instead, the writer describes the action that is happening. For example:

> Page 6: Dmitri lies on the ground, stunned. As the penguins gather around, Loretta stands over him and explains that if he hopes to ever see her again, he'd best return the penguins and get her a real gift. This takes several panels, over which she actually grows angrier. As she storms off, she yells, "Penguins? They're just pigeons with a better paint job!"

> Page 7–8: The penguins work themselves under Dmitri, carrying his dazed form above their heads. As they carry him up the ramp into the back of the van, they exchange various remarks about Loretta's uncouth nature and how Dmitri can do better than her.

Steve Sez: Wisdom of the Full

It's tough for new writers to know how many panels a Marvel-style scene will need, which can lead to horribly overcrowded pages. Convert a few of your longer Marvel-style pages to full-script to see if you're asking for too much.

Many plots will have more detail than that, but some will actually have less. The penciler figures out where the page breaks and the panel breaks occur, and draws the story. Then the writer gets the story back and figures out what Dmitri, Loretta, and the penguins are actually saying. Some pencilers love this method because it gives them freedom and more control over the storytelling. Some feel that it forces them to do much of the writer's job.

Artists working from loose plots became popular at Marvel Comics in the 1960s, when an overburdened writer/editor Stan Lee was teamed with folks like Jack Kirby and Steve Ditko, artists with good writing instincts. Now, this style of collaboration is sometimes called *Marvel style* (even though Marvel Comics has since moved away from using it), and fans debate whether Kirby and Ditko should get writing credit on their work from that period.

So, which script style is the right one? That depends on the writer, the artist, and the project. A graphic novel involves a lot of work, and they all should work in a method that they're comfortable with. Talk to your artist until you come to a decision. If you're drawing the work yourself, go in the corner and mumble to yourself until you decide.

Breaking the Page Window Is a Pane

Unless you're writing Marvel style, you'll need to break the contents of each page into panels. A panel is a tricky thing, full of possibilities and limitations.

The dialogue in a panel may cover 20 seconds, but the picture itself is a snapshot, a second in time. In one panel, Loretta cannot pick up a penguin, turn, and throw it at Dmitri. That may sound like one activity, but it's three separate actions taking place in three separate moments.

You could show that in three panels, one with the penguin being picked up, one with Loretta turning, and one with the penguin being flung. That would work,

but if you could do that same thing in fewer panels, your plot would move forward more quickly. Readers are smart enough that they don't need to see every moment, and can assume what happens in between. If in one panel the penguin is picked up and the next has Loretta with her arm outstretched and the penguin hurtling toward Dmitri, the reader knows that she turned. In fact, you could rely on implication even more, with Loretta picking up the penguin in one panel, a look at Dmitri talking in the next, and then Dmitri is suddenly hit in the face with the penguin in the third.

Another limitation is that you can have only one important visual concept in each panel. If you can't tell the reader what's going on in one single short phrase, the panel won't work. "Dmitri watches Loretta pick up a penguin" works. "Dmitri doesn't see Loretta pick up a penguin" also works. But you cannot count on the reader getting "Because Dmitri is winding his watch, he doesn't see Loretta pick up a penguin." You really get to show only one action. Everything else in the panel—other characters, furniture, penguins—is merely context.

So you need to break what happens on the page into a series of individual visual moments. You can have as little as a single panel on a page, or you can actually have dozens of panels on a page, particularly if it's a series of single-character shots with little dialogue.

 A Longshot That Works

In *Longshot Comics*, Shane Simmons fits 160 panels on each page by drawing each character as a single dot. While no one is impressed by Shane's art, many are impressed by how his dialogue and placement keeps these identical-looking characters distinguishable.

Use the Rhythm Method

It's useful to start by picturing every page as being made up of the same number of panels. The number of panels vary from project to project, depending on the art style and the size of the pages—just think of how many typical panels of two people walking will fit on a single page. With that in mind, you can then consider how to vary the number of panels on each page. If your default panel count is 6, then a page with just headshots of penguins talking might have 10 panels. On the other hand, a big action shot of penguins parachuting off of an aircraft might take up two thirds of a page, leaving space for two normal panels.

You might never have a page with the actual default number of panels on it. Still, by using that number as a base, you keep a certain rhythm through the entire story. Pages with fewer panels mean pages that read quickly, even though the large panels may each take a bit longer to read. This emphasizes the action as big, explosive moments. The smaller panels that make up a higher panel-count page capture a lot of small moments adding up to a tense flow of activity, while the page as a whole takes longer to read. Keeping the rhythm helps the reader pay attention to the storytelling, rather than being distracted by randomly sized panels.

I lean toward using a default of five or seven panels per page, with the odd number keeping me from assuming that the default page is three rows of two panels apiece. Because *The Big Con* will be published on smaller paper than most graphic novels, I've written the sample chapter around a default of four panels per page. That works for me.

Panel Planning

You could make a graphic novel with varying size pages, so one page is very small and the next is very large. It would, however, be expensive to print and difficult to read.

Barring that, you have to keep an eye on how much you're putting on a page. If you have a panel that needs to be larger than normal, either to emphasize the image or to fit in all the dialogue, then you have one of two choices: either make other panels smaller than normal, or put fewer panels on the page.

The good news is that as the writer, you don't have to come up with the final panel placement. The penciler has to make those decisions. But even if you don't make up *the* panel layout, you should have *a* panel layout in mind. Otherwise, you might ask for the impossible, and most artists don't like to do the impossible. (Some can't, and for others doing so would reveal their secret super-powers to the masses.)

For example, let's say you write a four-panel page. Panel one is a normal-sized picture of Loretta talking. Panel two is an extra-tall panel of penguins climbing a rope up the side of a building. Panel three is a standard-sized shot of Loretta gasping as she looks out the window. Panel four is a wide shot through the window of the sun setting over the city, with a penguin dangling from a rope in front of it.

Possible layouts.

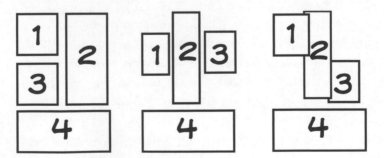

Writers Draw Rectangles

If you have a specific panel arrangement in mind, don't describe it in words. Draw a little panel diagram on the script, just like the ones in the layout example. Artists understand pictures.

That page sounds fine until the artist has to place the panels. Look at the diagram of possible layouts to see the problem. Once you put down the short panel one and the tall panel two, where do you put panel three? If you put it below the first panel, some readers will read the panels in the wrong order, as the vertical gutters (the spaces between the panels) lead their eyes straight from panel one to panel three. Some graphic novelists would try using arrows to lead the reader from panel to panel. In things read to order what them telling instructions need shouldn't readers! (Read that sentence backward.)

Putting three panels in a row gives you wasted space and an odd-looking design. There's nothing inherently wrong with wasted space and an odd-looking design, but they should be there for some reason besides a writer being too lazy to plan.

Set Your Scene

Now that you have the panels in mind, you have to describe them to the artist. If you're drawing the graphic novel yourself, then a quick sketch or a brief sentence may be enough. If someone else is penciling the book, however, you're about to face one of the biggest challenges in writing comics: instilling an image in the brain of an artist.

What's Going On?

I said earlier that you should be able to describe what the panel is telling the reader in a single simple sentence, such as, "The penguins carry the pizza out of the restaurant." Don't just think that sentence, type it. Make it the first full sentence of your panel description. Doing so makes it clear that this is what the panel is about; this is the central information that needs to be carried.

You don't have to end the panel description there. You can add more detail after that, talking about how the penguins are struggling to keep the pizza aloft, how the waitress is looking bewildered at the exiting food, that there are smell lines emanating from the pizza box, whatever.

Who's Going On?

Some writers and artists work out what the main characters look like before the script is written. If that hasn't been done, make a list of the key characters and what they look like as a separate section before the start of your script. That way, your artist can focus on designing those characters before getting into the flow of the script.

Whenever you introduce a new character in the script, even if it's someone minor, give that character a name and type it in all capital letters. "There's another penguin, BOB, who's a happy little chap with a New York Yankees hat and a scarf." That capitalization makes it easier for the letterer—seeing that a line of dialogue is coming from Bob, the letterer can find where it says BOB in the description and know which penguin is supposed to be speaking. And it drives home to the artist that this is a new character in the scene, not some penguin who needs to be recalled.

When describing a character, keep focused on the impact the character has rather than the details of appearance. If you write, "CHUCK has short hair, reflective sunglasses, and a worn leather jacket," you may get someone who looks like an aviator or someone who looks like a street corner drug dealer. If you write, "CHUCK looks like a street corner drug dealer" or, better yet, "CHUCK is a street corner drug dealer and looks it," you'll get a character that looks the part.

You can still mention the leather jacket and the reflective glasses, if you want. Putting the important stuff first shows the penciler it's important. If you

> **Watch Your Language**
>
> Avoid terms that your artist might not know. One writer wrote that his character had on a *catsuit,* a type of leotard. The artist, unfamiliar with the term, drew the character wearing a cat costume. This made for an unusual scene.

need to rush and leave the unimportant stuff off altogether, that's okay—it's unimportant.

Where's Going On?

For the first panel of your graphic novel, and any other place where the characters change location, describe where the scene is taking place. Remember, locations are more than just places where things happen. Locations create the mood for the scene, and tell you things about the characters that inhabit it. When describing a location, include the following:

- **A name for the place.** This way, you can later set a scene "back in Loretta's living room," rather than "that same room we were in back in the first three panels of page 34."

- **A description of the place in terms of its effect.** This can include the effect it has on the characters, or the effect it has on the reader in what it says about the situation. The living room might be "cluttered, showing that Loretta is too busy to clean up," or it could be "a cozy, romantic environment for our characters to fall in love in," or "stark, empty, and cold, looking bereft of human touches, much like Loretta's soul," or even "stark, empty, and cold, a perfect environment for penguins."

- **The details.** Describe the style of furniture, the size of the TV, the Dresden Dolls poster on the wall, the titles of all the books on the bookshelves, and so on.

The same rule that applies to character descriptions applies here: the most important part is the description of the effect. If you skip the effect and give the same details about a room to two different artists, you'll get two different rooms. One might seem like a friendly, happy young person's living room while the other seems dilapidated, with the exact same furnishings. On the other hand, if you skip the details and just tell two good artists "it looks like a room where penguins would feel comfortable," you'll get two different-looking rooms, but they both will serve the needs of the story. The penguins will be comfortable.

When describing a setting, describe the whole setting, not just the part you see in that first panel. The penciler will figure out what the whole room looks like before picking an angle to draw it from. If the living room first appears on page 1, and on page 162 the penguins sit on a beanbag chair in that room, mention the beanbag chair on page 1.

What Impact?

Don't be afraid to explain to the artist what emotional impact you want from the entire panel or the sequence of panels. You may think it's obvious that the penguin juggling three other penguins should look silly, but the penciler may

assume he should look heroic, or come across as a showoff, or be the sexiest thing the penguin-lovin' reader has ever seen.

Letting your artist know how the art should feel and what the reader should experience makes it more likely that the art will feel right and that the reader will experience what you planned. This makes it more likely that your graphic novel will be popular, making it more likely that you'll sell millions of copies and probably win back the love of your prom date.

Reading Replete with Research

If you have specific looks, clothes, furniture, vehicles, buildings, or other items in mind, you can do better than describe them. Give the artist a picture. To an artist, a picture is worth far more than a thousand words.

The traditional way of doing this was to cut pictures from magazines whenever you saw a look you might someday need. Many artists and some writers put a lot of effort into cutting and organizing their *clip files*, and it often proved disconcerting to the librarian who watched you mangle the magazines. Now, physical pictures still have their place. If your graphic novel has an interesting location, you can probably find entire books of photos or drawings about that setting. Send the book to your artist, and you'll be able to say, "He's riding a camel like the one on page 37 past a mosque like the one on page 49."

But as with many things, the Internet has quickly displaced the old ways. In this case, the tool that makes me sound like I'm Grampa talking about when phones had dials and TVs were powered by rubber bands is Google Image Search. Surf over to http://images.google.com and you'll find a search engine that's surprisingly good at locating the pictures you need. Type in a few words that describe what you're looking for and it will come back with a batch of what it thinks you want. It's not doing anything magic, mainly looking for the words you've entered in picture descriptions, file names, and surrounding text, but it can do a surprisingly good job. Click through on the small image to see the picture at full size on the web page where it was found. Then you can print the picture out, or just send your artist a link to the relevant web page.

This makes it easy to send them scads of reference photos or oodles of reference. Or even oodles of scads of reference. Just don't ask them to exactly re-create a picture you find. It's one thing to use a reference photo to see what something looks like, and it's another thing to re-create that photo, which can be both a moral and a legal infringement.

Steve Sez: Look in the Warehouse

Pictures are great, but if you supply a 3-D model of the object you need, you'll make the job even easier for your artist. Point your browser at http://sketchup.google.com/3dwarehouse/ to find thousands and thousands of free models in Google's 3-D Warehouse. We'll talk more about 3-D tools in Chapter 15.

Be a Remote Control Cameraman

Graphic novel writers frequently request a camera angle for a particular panel. Obviously, there is no real camera involved. The *camera angle* is simply the position from which the reader is seeing the described scene. The term comes from the movies, where cameras are actually used. Besides, calling something the pencil-and-paper angle just wouldn't make sense.

The movie folks have given names to aspects of their camera angles, and we graphic novelists feel free to rip them off:

◆ **Wide shot** A shot that shows an entire area, whether it's a city block, an entire room, and so on. These are very useful for *establishing shots*.

◆ **Medium shot** Shows an entire person or persons or something of a medium size, such as a car. The penguins standing in front of the pinball machine trying to reach the buttons would best be covered by a medium shot.

◆ **Close** A shot that shows most of something, but not everything. For example, a panel that is "close on Bob the penguin" will show him from the top of his Yankees cap down to his shiny wrestling champ belt buckle, but won't include his fuzzy bunny slippers.

◆ **Close-up** Shows the important part of something. You'll get Bob's Yankees cap and possibly his scarf, but not much below that.

◆ **Extreme close-up** Shows a very small section of a person or item. You could call for "an extreme close-up of Bob's happy, shining eyes."

Establishing Shot

An **establishing shot** is a wide shot that opens a scene—usually showing an entire room, building, or outdoor area—to give the reader a good sense of where the scene occurs.

In addition to calling the distance, you can describe where the view is from and what it's looking toward. "A wide shot, looking through the window toward the street corner, crowded with traffic." If a panel description gets complex, you may want to sketch that panel, even if you're not doing a layout script.

When you're describing where things appear in view, use the terms *foreground* (things that are closest to the camera), *background* (things furthest from the camera), and *midground* (things between the foreground and background). You don't need to put things in all three areas in every shot. You can have facial close-up without any other items in the panel, a foreground against an empty background. You can just have a string of marching penguins in the distance, a midground with no foreground, no background, and no flying Chihuahuas.

Angles That Work Angelically

Remember that panels don't exist in isolation. You can create cinematic effects over a series of panels, based on how your nonexistent camera operator moves the nonexistent camera.

Zooming involves moving the camera directly toward (*zooming in*) or away from (*zooming out*) what you're looking at. You can start with a shot that's close on Bob, talking. Zoom out to the next panel, which is a mid shot of the penguins forming a penguin pyramid, with Bob on the top. Zoom out even further to a wide shot, showing that the pyramid is on the wing of a biplane. Zooming out is great for revelations; zooming in builds the intensity. Moving from a distant shot of a conversation to a close-up makes that conversation ever more important.

Keeping the camera angle the same makes it easier to pay attention to the actions in the individual panels. That sort of repetitive shot is particularly good in humorous situations.

Read through some graphic novels, paying attention to how the camera angles are used. Not only will you see a lot of interesting possibilities, you'll also get to spend time reading graphic novels while pretending you're getting something useful done. How great is that?

How Loose Is Too Loose, Lautrec?

So now you know how to call the camera angle and how to fill your panel with detailed descriptions of people and places and items. But writing like that is like driving with your feet—just because you know how to do it doesn't mean that you should.

Some writers script quite loosely, averaging only two sentences per panel description. Others describe everything, calling every camera angle; calling the placement of every item in the frame; and describing characters not only in terms of their appearance but also how they move, what songs they like, and all sorts of details of varying importance. Alan Moore, the writer behind *Watchmen*, *V for Vendetta*, and *Lost Girls*, has written seven single-spaced typewritten pages to describe a single panel. That's maniacal, but in his case it works.

The right density is whatever works for you and your artist. A rule of thumb is to be specific about whatever you have a particular vision of. If you have a certain outfit in mind for a character, describe it. If you have a vision of a keen way to use camera angles, state those camera angles and explain why you're using them. But don't fill in details and call camera angles just because you think you're supposed to. Any artist worth working with will have an artistic vision to handle what your vision lacks.

The Least You Need to Know

- There are many different styles and formats for writing comics, all of them right in certain circumstances.
- Picture the page in your own mind to make sure that you aren't asking for impossible drawings or camera angles.
- Picking a default number of panels per page will help you build a good rhythm for your script.
- The key information for the reader in each panel should fit in one short, clear sentence.
- Describing the effect that a character, object, or setting has is more important than describing the appearance.
- Describe in detail only those things that you have a particular vision for.

Chapter 8

Delicious Dialogue

In This Chapter

- ◆ Writing people who sound like people
- ◆ Using or avoiding captions
- ◆ Making the text fit

A graphic novel doesn't need text. You could make a graphic novel in which no one speaks, and you wouldn't be the first. But just because you can do something doesn't mean that you should, as anyone who has tried jalapeño ice cream will tell you.

Properly handled text is not a distraction from pictures. It's a companion to the pictures, an integrated part of telling the story. People who insist that the words or the pictures are more important are like those who argue that red is more important than blue in making purple.

Dallying with Dialogue

Most of the text in graphic novels comes spilling out of characters' mouths. Conversations, monologues, mutterings, and coughs all have their place in telling a story.

Dialogue is the Achilles' heel of many new graphic novel writers. They produce scripts with so much dialogue it leaves no room for art, or not enough dialogue where it's needed to make matters clearer, or simply clumsy dialogue that makes it hard to believe in the characters. Most of the things that make for good comics dialogue also make for good dialogue for prose writing or movie scripts.

Steve Sez: Stay Out of My Room!

Tiny pictures are a lot harder to draw, and important story details can become unintelligible if the pictures are too small. You'll make everyone's life a lot easier if you leave your artists enough room to do their job.

"Sounds Like Someone!"

Dialogue carries information. While half of that information is in what the person is saying, the other half is in *how* they say it. Someone talking into a cell phone saying, "Hey, that looks like a purple aardvark coming around the corner!" is saying the same thing as the person who says, "A quadruped has come into view on the corner, switching on to this street. It's violet in hue. Otherwise, it matches the description of *orycertops capensis.* Correct, an aardvark." But the way they're speaking suggests so much more about who they are, who they might be talking to, and why.

Eschewing Exclamations

Some comics writers end most dialogue sentences with exclamation points! This tradition comes from the early days of comics, when printers would sometimes mistake periods for stray dots and remove them! You don't need to follow this tradition!

The first trick to making dialogue that sounds real is to listen to people. Really listen—not just to what they say but how they say it. What sorts of words do they use? How do they use them? What impression do they create? What do they emphasize with their inflections? What accents do they have? What slang do they use? Listen to many different people—loud folks, quiet folks, old folks, kids, people for whom English is a second language. People don't speak like textbooks. If you think you're having trouble noticing the details, tape what people say and then type it out. Even just writing down, word for word, the messages people leave on your answering machine will help.

The second trick to writing dialogue is ignoring a lot of what you learned in the first trick. Nobody wants to read genuinely realistic dialogue. Real people hem and haw; talk in partial sentences, fragments, and phrases; and generally speak inefficiently. A little bit of these things is good for establishing the character or emphasizing moments of indecision or confusion. But try not to, ummm, y'know. Too much, it becomes a pain in the … Just don't.

This is especially true for accents. Don't try to creatively spell every word a character speaks to reflect a strong accent. Yerr readerr vill kvickly tire uv tryink to dezypher ebery verd.

Brevity: The Soul of Fit

Keep your dialogue short unless it needs to be otherwise. Dialogue takes up space. The more it uses, the more you either have to lengthen your entire work or make the art smaller and thus have less impact.

Some writers have maximums that they keep in mind. They might limit themselves to 17 words per *word balloon*, the individual bubble that holds one speaker's words. Their limit could be 30 words for a typical-sized panel, or no more than 60 words on a page. There is no exact set of magic numbers. Look

through a graphic novel with a graphic style similar to what yours will have. If you can find some word balloons that look too big or pages that look too crowded with text, start counting words and see what your own personal limits are.

The toughest dialogue to keep short is when someone is explaining something, giving a lot of information for the reader to absorb. Consider the case where a character says, "My father was a great inventor. He was working for a big car company, and he invented this spring-powered car. The only problem was that the car could only be driven on winding roads." It may be an important revelation, but it's far too long. Let's see what we can do to shorten it:

- **Lose unimportant details.** Is it really important who Dad was working for when he invented the car?

- **Become less formal.** Some characters can speak with slang, dropping formal words and relying on "it" and "that" instead of longer terms.

- **Break it into two balloons.** This doesn't actually save space, but two shorter balloons are less daunting and easier to integrate into the art.

"Dad? *Great* inventor. Invented this spring-powered car."

"Problem was, it could only be driven on winding roads."

That's shorter.

But the best way to keep the dialogue short is to show, rather than tell. You could have a panel of Althea saying, "For my birthday, Bob got me a fancy new watch covered with diamonds," or you could just show the watch on her wrist, with "Birthday present from Bob!"

Balloon Physics

You can use word balloons for visual impact. In my graphic novel *The Factor*, I had one series of panels where a character describes his demeaning job. As the description became longer, the balloons became bigger, leaving the character smaller in the remaining available space. Another time, as you see in the following sample picture, I placed a boring man's word balloon behind his girlfriend, to show that he was still talking but that she wasn't paying attention.

Interesting Interchanges

Most characters aren't the crazy person on the bus, jabbering away into the empty air (that's me). When they talk they're talking to someone, having a conversation of some sort. Conversations can be great things, full of dramatic revelations and conflict, or simply be a way of demonstrating character.

In real life, conversations go back and forth a lot, often with two people overlapping each other, interrupting each other's sentences, and getting in a lot of

short bursts of words. You can do any of that in a graphic novel, but be careful when doing a lot of it at once. Placing the word balloons becomes difficult when you have two characters each talking more than twice in a single panel. The balloons tend to end up getting placed between the two characters, so suddenly they have a great audible relationship but visually they're separated from each other.

The boring boyfriend is based on me. Art drawn by and copyright by Janine Johnston.

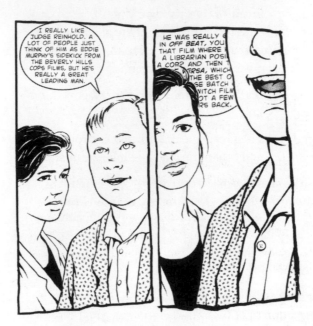

Make your conversations more interesting by putting information into each statement whenever possible. In real life, conversations often flow with one person saying little more than "Oh, really?" "Uh-huh," and "What did she say?" all of which may coax more information out of the first speaker but adds no information themselves. When Althea tells Bob, "I've built a perpetual motion machine out of marbles, mousetraps, and uncooked rotelli pasta," he can say, "Really? How?" and add no information. Or he could say, "I don't believe you," "Doesn't that violate the third law of thermodynamics?" or simply, "Again?" each of which adds a different type of information.

Read your conversations out loud. If they sound stiff, formal, or unreal to you, then the reader will probably have the same reaction. I often work out conversations aloud *before* typing them up to avoid that stiffness. That's why you see me talking to myself on the bus.

Put your conversation in an interesting setting. There's an instinct to stop everything, putting characters into chairs to do nothing but chat. That's not a wrong thing to do, particularly in drama. But if you take the same conversation and stage it during a bike ride, or at a boxing match, or at the zoo, it becomes more interesting. At the very least, there are more interesting pictures, and the context usually adds something to the conversation. To add a lot more, put it on a bike ride to a boxing match at the zoo.

Here's a Thought

The *thought balloon* is a special form of word balloon, used to show the thoughts of one of the characters. The thought balloon has a series of circles pointing to the thinker, rather than the pointy pointer used by word balloons. Some letterers make the thought balloon outline bumpy rather than smooth.

Writers use thought balloons far less frequently than they did in the past. There's been a drive to make comics more cinematic, to make them more like movies. Some writers believe that because you can't hear what people are thinking in the movies, you shouldn't "hear" it in comics either. And for some projects, that's the right way to go. But not always.

The thought balloon is a tool in the writer's toolbox and shouldn't be thrown away just because it can be misused. These days, some graphic novelists spend pages showing what a thought balloon could capture in a single panel. Others add an unnecessary character for the main character to spill out all his thoughts to. But prose authors don't hesitate to tell you what a character is thinking, because it's useful stuff to know. And Shakespeare, unable to use thought balloons in his plays, relied on the far more artificial *soliloquy*, where a character just speaks all of his thoughts out loud when no one is looking. Let's face it, if Hamlet were spouting his soliloquy on the back of the bus, he'd seem like just another crazy person. Which, come to think of it, he was.

Thought balloons are great for expressing emotions and for summing up situations. "Three o'clock already? If I don't get the purple aardvark back to the zoo before the boxing match, Ms. Alverado will fire me for sure!" Give that thought balloon to a panicking character in the very first panel of your story and the reader starts out with a lot of information. Of course, if we never see that character again, the reader will be merely confused.

For naturalistic thought balloons, avoid full sentences. Some people use words more in their thoughts than others do, but people don't constantly think in full sentences. You could have someone saying, "Should I go out with Vincent or Jacques? Vincent's a very kind and upright fellow, but on the other hand, Jacques has a physical attractiveness that is hard to beat," but for a thought balloon you'd be better off with, "Vincent or Jacques? Vincent: sweet … Jacques: yummy!"

Of course, you don't need to be naturalistic. Being stylized in comics is fine, as long as you're doing it on purpose. Remember, the great musicals aren't great because they reflect how people naturally break into song and dance. They are great because they paint an unnatural world in an unnatural but exciting way.

Steve Sez:
Thinking Visually

You can put pictures in thought balloons, too. When Terri is being snide to Colleen, Colleen might have to pretend she doesn't mind, but you can show what she's really thinking with a thought balloon picture of Terri being set on fire.

Captions Courageous

Use of *captions*, narrative text generally placed in rectangles and not associated with a specific on-panel character, has also fallen off a lot due to the quest for

Between First and Third Person

Second-person narration speaks of the reader as a character, telling you what "you" are doing. The only obvious comics example of this is the classic EC Comics eight-pager "Master Race."

cinematic storytelling. Mostly this has left two types of captions: the settings caption and first-person narration.

A *settings caption* is a brief caption telling you where or when the scene takes place, such as "The following Tuesday:" or "Edwards Air Force Base. 3:17 A.M." With *first-person narration*, a character in the story tells you some of what is going on, such as "I'd been sitting all day in my office, drinking chipotle-flavored discount beer and reading *The Complete Idiot's Guide to Being a Hard-boiled Detective*, when this redheaded dame walked in."

The type of caption that has faded away is the omniscient third-person narration, where some unnamed, unseen narrator is telling you everything that's going on, whether any of the characters know it or not. "Thrung the Unruly descended the stairs slowly, uncertain of where the vicious purple aardvark lurked." Yes, this sort of narration is often used to give information that should be visible in the panel, making it redundant, but even then it usually adds bits of information and can make a work seem richer. It does make the work take longer to read, which sounds bad but can be good, particularly when it comes to people feeling like they got their money's worth.

But the third-person narration doesn't have to describe what's currently going on. You can talk about interesting related information. While Althea chases after the purple aardvark, your narration could be explaining how she spent her teen years training as a sprinter, but was never good enough to make the varsity track team. Or you could explain how aardvarks are members of the anteater family, a misnamed group because they subsist primarily on termites. Narration that informs the reader about subtleties of what is going on or remains calm during hectic events can be powerful.

Sounds Effective

Sound effects like "WHAM," "tic-tic-tic," and "fuh-*woosh*" are a very special part of graphic novel text. As with captions and thought balloons, sound effects are optional. They should be part of your toolbox, but not a tool you have to use in every project.

Some objects have standard sounds, like *bang, boom,* or *vroom.* Feel free to use those—they're cliché but they work. But you don't have to stick to those, and you'll sometimes have to come up with a sound for something that doesn't have a standard. To come up with a sound for something, do your best possible vocal imitation of the sound. The effort of making the sound will help you put that sound into letters.

The right sound effect spelling will get you only so far. Most of the impact of a sound effect comes not from what it sounds like, but from what it looks like. You'll have to rely on the letterer to see to it that your *whffft* is a delicate little sound and your *kBooooom* shakes the world.

Mark Your Words

Once you've figured out what your characters and captions are saying, you have to share that information with the folks who will be reading your script, especially your letterer. Time for typing!

First thing after the panel description should be the sound effect, if the panel has one. Type *SFX:* followed by a tab, followed by the sound effect. If there's any question of how the sound should look or where it's coming from, put that in parenthesis before the sound effect. The look of an electronic, from-the-intercom *BZZZZZT* will be different from the hornet *BZZZZZT.*

Next type any noncaption, nondialogue text that the letterer should put in, such as newspaper headlines or signs. If it's flat lettering that the reader has to be able to read, it's the letterer's job rather than the penciler's. Type *HEADLINE:* or *SIGN:* or whatever, followed by a tab, followed by the words on the item.

Each caption and word balloon on a page is numbered in the order in which they should be read. As you can see in the sample script in Chapter 9, each line of dialogue in the panel should have its number and the name of the speaker, while captions should have a number and the word *CAPTION.* After that, of course, you type the actual words that go in the word balloon or the caption.

Most graphic novels keep the comic book tradition of using ALL CAPITAL LETTERS for their dialogue (and some even for their panel descriptions), but some use upper- and lowercase. It's actually best to type using upper- and lowercase even when the words are going to be set in an all-capital font. That's because the easiest thing for a letterer to do is to copy the text right out of your word processor document. The all-capital fonts they use will actually make the capitals you type look slightly different from the same letter in lowercase. That variety gives the text more of a true handwritten look. I like to set my word processor font to a comics font for writing dialogue. Since this font is similar to what will be used on the page, this helps me see what the lettering will look like on the page and makes it easier to see when I have too much text.

Typing Type Types and Blatant Balloons

Writers emphasize certain words in the text for different reasons, either to focus reader attention on important words or reflect the way the character speaks. For simple emphasis, either underline or italicize the words you want emphasized. Don't emphasize too many individual words, because *after* a *while* the *emphasis* starts *losing its effect* and the *changing lettering style* just *becomes annoying.*

If you have any special requests for the lettering in a word balloon, put it in parenthesis before the balloon. That way, you can request "(Small lettering, large balloon) WOW" to make the speaker seem quietly overwhelmed, or "(extra large) EEEK! BUNNIES!" for a shout. You can even ask for a special typeface, like asking for a robotic font for a mechanical voice.

Keep It Cheap

Some programs designed for word-processing screenplays now include options to help you format graphic novel scripts. Unless you're already using them to write screenplays, save your money. You don't need them.

You also use the parenthesis to request special types of balloons. Inside the parenthesis is where you'd request a thought balloon. You can also request a *burst*, a spiked balloon used to indicate a shout. There is also the *electric balloon* (also known as a *radio balloon*), which is used to show sounds coming from speakers, radios, telephones, and haunted talking coffee pots.

Occasionally, you'll want a word balloon for someone who isn't actually pictured in the panel. If it's the first word balloon in the panel, you can have it coming from someone in the prior panel, as long as that prior panel is either right above or just to the left of the current panel. You'd mark that with "(from previous panel)." Similarly, the last balloon in a panel can come from a character in the panel immediately to the right or below this panel, and would be marked "(from next panel)."

Otherwise, the reader will just have to imagine the person who is speaking. You can specify a word balloon with its pointy bit (called the tail) pointing to someone unseen outside the panel by indicating where it's coming from, such as "(from off-panel left)." You can even have a balloon with no tail, which is good when you have a panel with a lot of people speaking and it doesn't matter who is actually saying the words. For example, in a press conference scene you might have "(from off-panel; no tail) *SENATOR*, IS IT TRUE THAT YOUR SON IS IN *LOVE* WITH AN *AARDVARK*?"—it's not important which reporter is asking the question, merely that it is being asked.

That Dashed Double Dash ...

When you want to break up a single sentence between two word balloons, finish one word balloon by typing two hyphens––

––then start the text of the next word balloon with another two hyphens, as you see here.

Any English teacher, if he or she is worth his or her salt or pepper, will tell you that writing a double dash like that is wrong, that you need a wider single dash called an *em dash*. That's true. You're seeing an odd language evolution in action. Old typewriters didn't have an em dash, and the standard in the prose publishing world was that writers would type a double dash wherever they wanted an em dash.

Comic book letterers didn't come from the typesetting world, however, and when they saw a double dash, they figured the writer wanted a double dash. Now some letterers will put in the double dash and some will put in the em dash, but the double dash has been used enough over the years that it's a standard part of comics punctuation. With all-capital lettering and the abuse of double dashes and exclamation points, is it any wonder that comics make some English teachers cringe?

A three dot *ellipsis* goes at the end of a word balloon when, um, when …

Oh, that's right, it's used when someone trails off without finishing the sentence. It's used at the start of a word balloon when we start hearing someone in mid-sentence, or when a person is finishing a sentence someone else started. And it's used in the middle of a sentence in a word balloon to indicate a particularly long pause. In fact, one of its coolest uses is when there is just an ellipsis in a word balloon, used when a character is trying to respond to a statement but can't think of anything. The character's speech is just a big, blatant pause.

For some characters, that lack of response is the smartest thing they say in the whole story.

The Least You Need to Know

- Keep dialogue brief.

- Every statement should add information, either via what it says or what it implies about the speaker.

- Narrative captions, thought balloons, and sound effects should be part of your toolbox.

- Number all the captions and word balloons.

- Speak your dialogue out loud to determine whether it sounds natural.

A Bit of *The Big Con:* Script

Here is the actual script for a chapter of the graphic novel *The Big Con*. You can see Steve's pencil-drawn version of this script in Chapter 18, and the final inked and lettered version in Chapter 21.

The Big Con
Chapter: "Con Cognito"
by Nat Gertler
nat@aboutcomics.com
(805) 499-████
Script for 8 pages

Characters: We have three stars of the new movie *Galaxy Beyond III*.
- DERRICK is haughty, ruggedly handsome action star, 45, impatient, polo shirt and pleated pants. He carries himself proudly.
- TERRY is a slim, sexy, intelligent 29 year old, sophisticated make-up, sunglasses, silk blouse and tight jeans.
- YEO is a short, playful, happy Chinese man, bouncy and energetic, a gymnast/martial artist/clown, a bit of an elf. He's got a t-shirt with a picture of his own smiling face.

GENE is a studio publicity guy, a shorter black man in his 40s, looking very precise and controlled; clean haircut, dark shirt with two silver pens in the pocket perfectly upright, creased dark pants, a leather organizer on a strap over his shoulder.

Other characters are introduced as needed.

Key design items: Three costumes, all of characters from the *Galaxy Beyond* film series:
- LORD ZATAN: basically a convex shape of brushed steel. Think of it as a verical tube that's been constricted at points so it's widest at the base, narrows into a curve up to the neck, and flairs to the top of the head... kind of an art deco chess queen. Add arms, mean-looking triangular red eye lenses, and any further flairs you want. Most of the costume comes off in two parts – the head slips down over the lower part, which is held on by shoulder straps.
- THE MONK is a shimmery, tech version of a monk's robe, with a hood that actually covers the top half of the face.
- WARRIOR BOT is basically body armor, with a head piece basically the shape of a UFO disc. The armor needs to be very flexible at the joints, as Yeo will be wearing it and moving in ways that require a lack of restriction.

PAGE ONE

(1)

ESTABLISHING SHOT: exterior, day. A big, modern convention center, shiny, angular, and broad.

1 CAPTION:	SATURDAY, 2 PM
2 CAPTION:	THE STARS OF THE MOVIE *GALAXY BEYOND III* FACE A PROBLEM.
3 DERRICK:	(FROM NEXT PANEL) WITH ALL OF THE COPS BACK THERE, SHOULDN'T THE BACK ENTRANCE BE SAFE?

(2)

LARGE. DAVE is explaining to TERRY, YEO, and DERRICK, most directly toward Derrick. They're standing in a small conference room in the convention center, with a dias and chairs set up. Behind them in the room, three fans are taking off their costumes – this shouldn't be the focus of the panel, but it should be there. It's the LORD ZATAN, MONK, and WARRIOR BOT costumes described earlier. The guys inside are all in their early twenties, dressed in t-shirts, a bit disheveled from having been in the costumes. When we see them more clearly, their friendly looking, a bit geeky.

4 GENE:	(FROM NEXT PANEL) THEY SAY EVERYTHING'S CLEARED UP BACK THERE, BUT WHY RISK IT?
5 GENE:	WITH THESE DISGUISES, YOU CAN REACH THE AUDITORIUM UNRECOGNIZED.
6 YEO:	BUT THIS IS A *PUBLICITY* APPEARANCE. DON'T WE *WANT* TO BE SEEN?

(3)

Close on Terry (patient) and Derrick (less so) explaining to Yeo. I see this as being Terry's head on the left, Derrick's on the right, and short Yeo only having the upper half of his head in panel, his eyes paying attention to Terry.

7 TERRY:	AH, THE IGNORANCE OF THE NEWBIE. YEO, *NONE* OF US STARS FROM THE TWO RELEASED FILMS CAN WALK IN A CROWD.
8 DERRICK:	TERRY'S RIGHT. EVEN IN *NORMAL* PUBLIC, IT'S ALL "SIGN THIS FOR EBAY" AND "MAKE ME FAMOUS" AND "I'LL KISS YOU NOW AND SUE YOU LATER" --

PAGE TWO

(1)

Derrick throws up his hands in disgust while Gene points a finger at him, lecturing

1 DERRICK: --AND HERE IN THIS *GEEKFEST*, IT WOULD BE...

2 GENE: WATCH IT! THESE COMICS FANS AREN'T *GEEKS*, THEY'RE THE FOLKS WHO BUY TICKETS TO YOUR MOVIES.

(2)

Gene gestures toward the fans, ALF, BERT, and CHARLIE, who are happily bringing over the Monk, Warrior Bot, and Lord Zatan costumes, repectively.

3 GENE: AND *THESE THREE* FANS ARE HELPFULLY LENDING YOU THE WONDERFUL COSTUMES THEY'D MADE FOR TONIGHT'S *COSTUME CONTEST!*

4 BERT: GLAD TO HELP.

(3)

Derrick holds the head of the Lord Zatan outfit in his hands, staring it in the eyes, perturbed.

5 DERRICK: I'VE GOT TO BE *LORD ZATAN?* YOU COULDN'T GET US *HERO* COSTUMES?

(4)

Gene is holding up the Monk's robe while Terry sticks her arms in the sleeve.

6 GENE: IT'S A *DISGUISE*, DERRICK. YOU KNOW YOUR GENROY-7 OUTFIT IN THE FILM DOESN'T HIDE YOUR FACE.

7 TERRY: (THOUGHT) LIKE *HE'D* HAVE TAKEN THE HERO ROLE IF IT MEANT HIS PRETTY FACE WOULD BE HIDDEN?

PAGE THREE

(1)

Terry is pulling up the hood of her Monk robe, while Derrick and Yeo, now in the body of their outfits, are just starting to lower their heads on. Derrick is looking up into the head, Yeo grinning wickedly.

1 DERRICK: OH, THIS WILL MESS UP MY HAIR.

2 YEO: ...OR MAYBE IT'LL MESS UP YOUR *MIIIIIIND!*

(2)

Same angle as panel (1), only now the hood and heads are in place. (This should help cement in the reader's head the link between the characters and the costumes)

3 TERRY: LET'S GO*!*

(3)

The three stars, in costume, area heading into the convention sales floor, through double-doors with a WELCOME TO COMICARAMA SEATTLE banner above it (it need not be fully readable.) LORD ZATAN inherently walks stiffly, since there's really no movement to the costume; the MONK has grace. Yeo, in his Warrior BOT outfit, has gotten into being in a costume and is doing a bouncy, crouching, monkey-type lope.

 NO COPY

(4)

The three stars are now in the convention hall, where a camera-carrying WIFE is pointing toward them while her t-shirt-and-backpacked HUSBAND heads toward them. Typical large comics convention dealers. We don't need to see much scope, but what we see should look busy (sketchy is fine).

4 WIFE: WHAT GREAT OUTFITS*!*

5 WIFE: LET'S GET A SHOT OF YOU WITH THEM*!*

PAGE FOUR

(1)

FULL PAGE: Lord Zatan shoves Husband away with one arm, sending him staggering. (Steve: we might get some energy out of tilting this shot; it's one of the few actiony moments in this tale.)

1 ZATAN: (BURST, LARGE) HEY, *NO PHOTOS!*

(2)

INSET, lower right. Close up on The Monk, a cocked smile on the visible lower half of her face.

2 TERRY: DERRI... UMMM...

3 TERRY: LAWD *ZATAN,* THEY-ALL JUS' WANT PITCHERS OF OAH
 CAWSTOOMS*!*

PAGE FIVE

(1)

Lord Zatan puts his arm around husband's shoulder, while the Monk poses to one side and Warrior Bot squats in front.

1 ZATAN: OH, RIGHT...

2 ZATAN: SURE, WHY NOT?

(2)

Wife snaps photo, while beside her an overweight but pretty and happy-looking woman dressed as a FAIRY waves her wand in the air, excited.

 SFX: (CAMERA) KLIK

3 FAIRY: *ME NEXT!*

(3)

The three of them walk past a chubby comics DEALER behind his longbox-covered table. Zatan is in front, the Monk behind him, and the Bot crouched in a monkeywalk behind her, top of his head about at the top of the longboxes.

4 DEALER: HEY, ZATAN, I GIVE *TWENTY PERCENT OFF* TO ALL FORCES OF
 EVIL*!*

(4)

The Bot hooks his fingers over the top of the longboxes and is peering over them to face the dealer, who is playing along.

5 BOT: YOU KNOW, THE DEALERSSSS WHO *SSSURVIVE* ALL OFFER LORD
 ZATAN *FORTY* PERSSSENT OFF*!*

6 DEALER: I WOULDN'T GIVE MY OWN EVIL *MOTHER* FORTY PERCENT OFF
 ON A *SATURDAY.*

 NOW ON A *SUNDAY...*

7 KID: (BURST FROM OFF-PANEL LOWER RIGHT; IT CAN
 COVER UP THE END OF THE WORD "SUNDAY" IN
 THE PREVIOUS BALLOON) HI-*YAAAA!*

PAGE SIX

(1)

Close on A KID, a five year old boy in a space hero costume, whacking Lord Zatan repeatedly in the middle of his back with a plastic, high-tech version of a battleaxe. His costume is a Galaxy Beyond outfit, Derrick's character's costume. The kid is in high-sugar mode, screaming and is wielding the battleaxe in an overhead fashion.

SFX:	THWANG THWANG THWANG
1 KID:	(BURST) TAKE *THAT*, LORD ZATAN!!!
2 ZATAN:	(THOUGHT; STEVE, DEPENDING ON HOW YOU FRAME THIS SHOT, ZATAN'S HEAD MIGHT BE OFF-PANEL. THAT'S FINE, JUST POINT THE BALLOON TOWARD WHERE HIS HEAD IS.) WHAT NOW?

(2)

The Bot is loping up to the scene of the attack, while the Monk looks on amused.

3 BOT:	HEY, KID, DON'T ATTACK LORD ZATAN THAT WAY!

(3)

The Bot has wrapped his arms around the kid and his hands are encircled around the kid's hands on the shaft of the axe, showing him how to hold it sideways. Think of someone showing a kid how to swing a baseball bat, and you've got it.

4 BOT:	YOU GOTTA SWING *SIDEWAYS* TO CUT THROUGH HIM.
5 BOT:	OTHERWISE, YOUR LASERAXE WILL JUST BOUNCE RIGHT OFF HIS CURVED ARMOR!

(4)

Close up on the Bot and the Kid, who has turned to face him.

6 KID:	THANKS! I WAN' BE THE *BEST* GALACTIC WARRIOR, JUST LIKE GENROY-SEVEN!
7 BOT:	YOU EVEN *LOOK* A LITTLE LIKE DERRICK GREY
8 KID:	*WHO?*

PAGE SEVEN

(1)

Most of this page is just a pile of scattered, overlapping photos taken while the cast were in the convention hall. Using some white-bordered prints (even though those are out of style) should convey this. The pictures can include (though we need not see all of these, use your layout judgment):

- Bot's hands holding the Kid up so that he can whack Zatan on the top of the head.
- A sexy woman in a cat outfit (ears, tail) leaning seductively against the expressionless form of Lord Zatan
- The Monk squatting to talk with a wheelchair-bound female with palsy
- All three posing with two muscular guys in tight black shirts with white lettering: BAD GUYS RULE
- Lord Zatan posing with another Lord Zatan, this one in a weak, home-made costume covered in tinfoil. They're facing each other in mock battle.
- A pair of women in oversized Japanese schoolgirl uniforms holding Bot aloft horizontally.

1 CAPTION: THE STARS JOURNEYED ACROSS THE CONVENTION FLOOR UNIDENTIFIED, BUT NOT WITHOUT INTERRUPTION.

(2)

The three stars head out an exit into a hallway where Gene is waiting.

2 GENE: FINALLY! WE'VE GOT A LITTLE ROOM OVER HERE FOR YOU TO CHANGE IN. YOUR TALK STARTS IN TWO MINUTES.

3 ZATAN: SORRY, BUT *THAT* WAS *FUN!*

PAGE EIGHT

(1)

Gene holds open a door. A somewhat sweaty Derrick is removing the Zatan head as he heads toward it.

1 DERRICK: I MEAN, IT WASN'T ANYTHING ABOUT "*CELEBRITY*".

(2)

Derrick and Terry talk. Derrick has his arms around the costume head. Terry, hood now off, is gesturing vaguely toward Alf, Bert, and Charlie in the background (although they need not all be visible.)

2 TERRY: I KNOW, IT'S JUST LIKE THESE GUYS HERE AND THOSE FOLKS OUT THERE, THEY ALL JUST WANT TO HAVE FUN IN THE *GALACTIC BEYOND* WORLD.

3 DERRICK: MAKES ME A LITTLE PROUDER TO HAVE HELPED BUILD THAT WORLD.

(3)

A grateful Derrick hands the Zatan head back to Charlie, who looks thrilled.

4 DERRICK: HEY, THANKS A LOT FOR THE LOAN.

5 CHARLIE: ARE YOU KIDDING?

6 CHARLIE: DO YOU KNOW HOW MUCH I CAN GET FOR A *LORD ZATAN* COSTUME WORN BY *THE DERRICK GREY*?

(4)

Derrick looks at Terry and Yeo painfully. Terry is rolling her eyes, and Yeo just shrugs.

7 CHARLIE: (CONTINUED FROM PREVIOUS PANEL) I'LL EBAY IT OFF A PIECE AT A TIME*!!*

-END-

Part 3

Putting It in Pencil

The first stage of drawing a graphic novel is usually done in pencil. This way, you can draw construction lines that help you shape your drawing but can be erased later. You can also correct mistakes easily when you draw in pencil. That's not so easy to do when you draw in ink, blood, or rhubarb pie filling.

In the following chapters, you learn to design characters and settings. You get tips on turning the script into well-laid-out pages made up of stylish, well-rendered panels.

Designing Your Characters

In This Chapter

- ◆ Reading the script
- ◆ Creating your characters' faces and physiques
- ◆ Deciding what they're wearing
- ◆ Designing fantastic characters

This is Steve writing, now. You've reached the drawing part of the book. Without characters, there is no story. You're here to tell a story, and you want to do it with pictures. That means you have to figure out what your characters look like. Your goal is to come up with interesting and distinctive character designs that fit your story. Sharpen your pencils. I'm going to design some characters from *The Big Con* and you should try along with me.

Reading Is Fundamental

Before you start designing, you need to know some things about the characters. Read the whole script carefully, paying attention to anything that might tell you what the characters look like and what sort of things they need to do. Take notes, mark important story points with a highlighting pen, and jot down any questions you have for the writer. You want lots of information about the characters. Where is it?

Sometimes the writer puts a good, thorough description right up front. That way, you know what the writer wants and expects you to deliver. Nat does that in his descriptions of Derrick, Terry, Yeo, and Gene.

Dramatis Perwhatsis?

As you read a script for the first time, write down the name of each new character as you come to it. As you progress through the script, take short notes about each character.

Nat Sez: Keep Unimportant Characters Unimportant

Your background characters needn't be bland, but if you give FIRST MAN ON STAIRS a face like a god and a body like a California governor, readers will be confused when he remains just a man on the stairs.

Head doodles like these don't have to be tight or detailed.

For minor characters, you'll often find their description in the panel in which they first appear. On page 3, panel 4, the script says, "A camera-carrying WIFE is pointing toward them [our heroes] while her T-shirt-and-backpacked HUS-BAND heads toward them." Nat didn't have to go into much detail, because he knows I'm familiar with comic book conventions. If this had been a rodeo-clown convention, Nat might just as well have mentioned her Stetson and his rubber nose.

Sometimes you'll need to figure things out for yourself. Nat doesn't specify what sort of footwear Terry is wearing, and in this script, he didn't need to. But suppose that on the next to last page of the story, she stumbles on the stairs and loses a shoe. You'd want to remember that scene when deciding whether to dress her in sandals or midcalf, lace-up boots.

And sometimes, you get no clues at all. When this happens with a minor character, it probably means that it doesn't matter what FIRST MAN ON STAIRS or WOMAN IN OFFICE looks like. When it happens with a major character, it probably means that the writer forgot that comic books have pictures. When in doubt, or even if you think you might be in doubt but aren't sure, ask.

Start at the Head

Usually by the time I've finished reading a script, I've got some notion of what the characters look like, and I sometimes supplement that by flipping through some online photos or my old sketchbooks, looking for the right type of people to "cast" as my leads. Anywhere you can find people to look at, you can find inspiration. Then I start sketching simple, cartoony little head doodles, trying to find one that seems right for the character. Doodles shouldn't be complete drawings. Just scribble down shapes and ideas. You're brainstorming on paper.

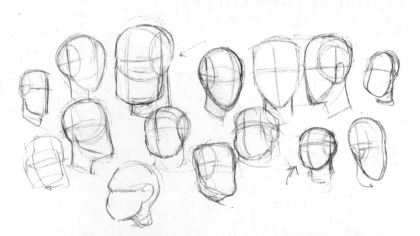

The Basics of Basic Shapes

Any drawing is built out of basic shapes. Make those shapes distinctive. Don't worry about features like eyes or noses yet. For now you're just building a

rough structure out of simple forms like spheres and cubes. I gave Derrick a boxy head with a big jaw—something that the reader will associate with the sort of action hero he portrays. Terry has an elegant oval head, the delicacy of which should contrast nicely with Derrick's rugged features. And Yeo's head is nearly spherical, which I hope will emphasize his clownish qualities, like a face drawn on a toy balloon.

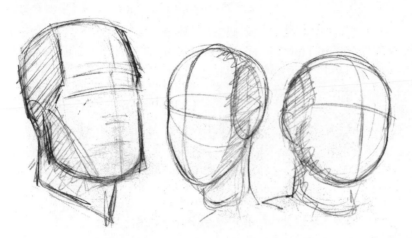

We need distinct rough structures to build consistent and recognizable heads.

Over the course of an entire graphic novel, you're likely to draw these people from a variety of angles and distances, in bright light and deep shadow, and wearing all sorts of odd outfits. If you give them distinctive head shapes, readers will have no problem keeping track of who's who.

Finding the Right Features

Unless your graphic novel is going to be a romance between a pair of department-store mannequins, you'll want to flesh out those heads a bit. This is where things really get fun, which is great if you like fun.

Some graphic novel artists just pick a real person to base each character on. "The hero will look like my fifth-grade teacher, but without the beard, and the villain will look like Harry Houdini." That's fine, but be careful with this approach. Don't make those likenesses so close they distract the reader or get you sued. A similar and safer approach is a bit like playing with Mr. Potato Head. Pick one real person and base your rough structure on the shape of his head. Then think about some other people: your friends and family, celebrities, the plumber. Try borrowing parts from each. Take your best friend's eyes and eyebrows, your mailman's nose and Elvis Presley's mouth. Now put them back, apologize, and make a drawing of someone with that set of features.

There's a huge range of options for every part of the head. Start asking yourself questions about the following features:

- ◆ **Hair:** Long, short, or missing? Straight, wavy, kinky, or curly? What color? What sort of style? Any facial hair? Mustache? Beard?

Your Pals in Palomar

Palomar by Gilbert Hernandez is a graphic novel that follows the entire lives of dozens of characters in a small South American village. Hernandez's careful choice of distinctive features helps readers keep track of who's who, even as age and hard living take their considerable toll.

◆ **Skin:** Smooth or wrinkled? Clear or scarred? Clean or dirty? Any tattoos, freckles, or birthmarks?

◆ **Eyebrows:** Bushy or sparse? Straight or arched? Broad or narrow?

◆ **Eyes:** What color? Close-set or far apart? Wide or narrow? Full lashes or thin? Prominent eyelids? Bags or circles underneath? Crow's feet?

◆ **Nose:** Long or short? Pointed, bulbous, or flat? Does it curl up or down? Do the nostrils flare?

◆ **Mouth:** How broad? What are the teeth like? Are the lips full or thin? How do they curve?

◆ **Chin:** Prominent or recessed? Sharp or rounded? Any cleft? Stubble?

Your choices are restricted by the story you're telling, of course. Nat notes that Yeo is Chinese. To make that clear to readers, you wouldn't design his face with round, Western eyes or a long, pointed nose.

> **Nat Sez: Occidental? On Purpose?** _____
>
> Do Japanese manga characters seem Western to you? Cartoonists focus on elements that distinguish one character from another. A character with stereotypical Japanese features may stand out in a scene full of Delawareans, but if the setting is Kyoto, everyone is assumed Japanese. It is the differences between the members of the group (such as differences in hair shade) that the cartoonist exaggerates to make them identifiable and interesting.

I tried different combinations of facial features on Yeo's basic spherical head shape.

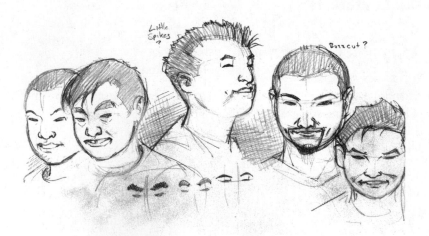

Body Building

Now it's time to lower your sights and think about what sorts of bodies they have. Clothes can do an awful lot to change the apparent shape of a body, so design your characters at first as naked mannequins. You needn't get too explicit here, unless you're working for a very specific audience.

Once again, scour the script and notes for clues and requirements. And again, it's a good idea to keep real people in mind when you begin doodling.

In my body doodles, I tried out different builds for our three leads.

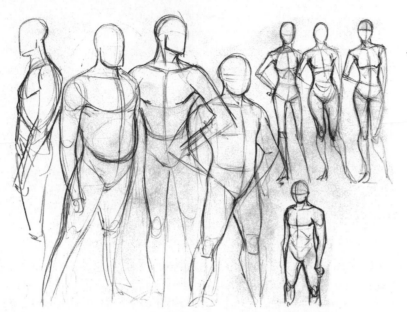

Body doodles don't require much detail. Keep them loose and look for interesting proportions.

Look for something that fits the character and will be easy to recognize, even if you draw it in silhouette.

Start with what the writer asks for: tall, short, slender, chunky, pear-shaped, tiny-waisted, whatever. Then move into the specifics. If the character is fat, is one part particularly heavy? If Joe Action is described as "muscular," does he look like a wiry runner or a beefy weightlifter? Remember what that character does throughout the story. If someone asks Sarah Sidekick to get something from a high shelf, make her tall enough so that request makes sense. Does she have to crawl through a narrow ventilation duct without getting stuck? Design her so that crawl would be plausible.

Even if the script calls for everyone to be of average build, we still want to find traits that make our characters distinctive. Try exaggerating a single body part. Give one character small hands. Another could have a longish neck. Maybe one is slightly bowlegged. Build one out of hard angles and another out of flowing curves. Start with the incredible variety of real life and exaggerate from there.

Dressing for Success

In real life, we judge people by their clothes all the time, so it's no surprise that we do the same in graphic novels. Often these judgments are simple. Policemen, soldiers, and nurses have uniforms that make them instantly identifiable. The same goes for the gear that utility workers and scuba divers wear. Some clothes scream, "*Wealthy!*" Others label the wearer as artsy, or timid, or belonging to a subculture.

When you dress your characters, keep the following things in mind:

- **Why did your character put on this outfit?** People choose clothes for a reason. The CEO of a multinational corporation wears expensive dark suits that make him look serious and powerful. A rebellious teen dresses to freak out her parents. A movie star who doesn't want to be recognized in public dresses down to conceal his identity. A homeowner cleaning out her attic puts on comfortable clothes that she doesn't mind getting dirty. A character in 1940 might put on a fedora because he wants to fit in. His grandson in 2005 could wear the same hat as a way to stand out in a crowd.

- **What do you want the reader to learn about the character?** The scene is your heroine at home, putting on a bikini. She thinks: "I better wear this today while I still can. Summer's almost over!" That tells us one thing about her. In the next panel we see she's wearing it at a funeral. Alarmed mourners are glancing sideways at her while she sings reverently from a hymnal. That tells us something very different. When you show an aging bachelor smiling in the mirror as he buttons up a purple leisure suit, you aren't just telling the reader that he likes the color purple.

- **How often do you have to draw it?** Before your warrior chieftain puts on a tunic covered in elaborate beadwork, or you dress your wealthy hostess in a spectacularly decorated kimono, make sure you'll be comfortable drawing those details over and over again. Suppose they take an extra 10 minutes to pencil and ink. That isn't bad if you only have to draw an outfit once, but if it appears in 200 panels, that adds more than *30 hours* to your workload. Is there something you can draw faster to get the same effect? Can you use a computer to repeat the pattern for you without calling attention to the shortcut?

In the sketches for Terry's outfit, I tried to find a look that was sharp and attractive, but comfortable. She's doesn't want to attract a lot of attention, so I avoided anything flashy. And I don't want to draw those flowers over and over, so I nixed the floral print.

Some sketches for Terry's outfit.

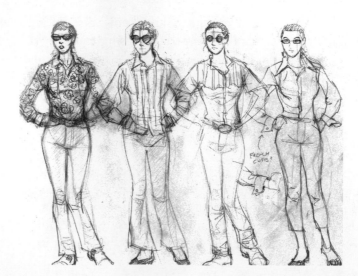

Your Work, It's Fantastic!

All this is fine if your graphic novel takes place here and now, or in the recognizable past, or in a foreign culture. But what if it's set in the future, or on another planet, or in some impossible magical world? Odd and fantastic characters and costumes are a spectacular opportunity for a graphic novel illustrator to cut loose and use imagination. But there are still important factors to consider when you invent aliens and monsters and robots and design their weird wardrobes.

Your designs should serve the needs of the story. If I was drawing a serious adventure story with Lord Zatan, I'd want to make him as threatening and impressive as possible. Since this story is a comedy about an actor forced to wear a Lord Zatan costume, I'm going to design it to look a little goofy.

Relate your design to something real. Choose something familiar. If your robot hauls away trash from space stations, try to evoke a garbage truck in your design. Or if it consumes and digests the trash, you could give it piglike aspects. Does that ogre do a policeman's job? Try caricaturing a policeman, then push the distortions further to bring out the ogre. Dress him in an outfit that resembles a beat cop's uniform. Maybe he's got a helmet like a British Bobby, or a bit of armor that looks like a badge.

Make it functional. In the real world, vehicles have power sources. Houses are built to protect their occupants from intruders and the elements. People and animals need to be able to move, to eat, and to respond to stimuli. The same goes for your Martian tripod walkers, your underwater condominiums, and your Four-Throated Menace from the Planet Fruvous. They have to seem functional. A story casts a very fragile spell over its readers. When the dragon swoops down out of the sky to attack your heroine, you want your readers to worry about how she's going to escape. That's a hard feeling to sustain if they're wondering instead how wings that small could possibly keep a 2-ton dragon aloft.

Be prepared to do it over and over again. As with real-world outfits, you may need to draw your fantastic creatures over and over. Does the bug-eyed Slampyak really need eight tentacles *and* four sets of pincers?

When you're making things up, *anything* can be a source of inspiration. Need an interesting pattern for armor? Look at the skin of a pineapple. Can't come up with a good instrument for a Venusian musician to play? Flip through a book of art deco perfume bottles. Are your mutant freaks insufficiently freaky? Study your own reflection in the back of a spoon and apply those distortions to your mutant's proportions.

I based these sketches of Yeo's Warrior Bot armor on some insects I read about in a magazine. The script says that Yeo has to be able to move around in it, and I want it to be both cool and silly.

Sketching ideas for Yeo's Warrior Bot armor.

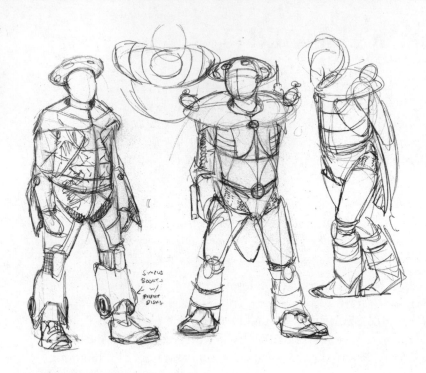

Put It All Together

WHA...? **Model Sheet**

A **model sheet** is a drawing or set of drawings of a character, prop, or setting used as reference to help keep a consistent look. Model sheets are particularly important when more than one artist draws the same character.

Not everyone makes *model sheets*. If you're working on a project all by yourself, you might be able to keep track of most of the details in your head, flipping back through previous pages now and then to see if the heroine's jeans have a back pocket, or to confirm which ankle has the tattoo. But if different artists are drawing different chapters, or if the inker is unsure if that squiggle is a necklace or just a stray pencil mark, a model sheet will help keep things consistent. As the pages pile up, even solo artists can find it difficult to keep track of dozens and dozens of character details. With a model sheet, the energy that takes can be applied elsewhere.

This model sheet of Yeo shows him from several angles, in both his ordinary clothes and the Warrior Bot armor. I also included a few close-ups of tricky armor details.

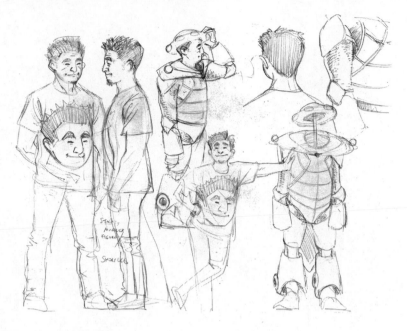

The Yeo model sheet.

The Least You Need to Know

◆ Read the script carefully for information about what your characters should look like.

◆ Design them so they're easy to recognize.

◆ Use real people as a starting point.

◆ Make your fantastic designs seem functional.

◆ Avoid complicated designs for things you'll have to draw over and over.

◆ Make model sheets to help keep characters consistent.

Chapter **11**

Places, Things, and Other Dead Nouns

In This Chapter

- Figuring out what the story requires
- Designing settings and props
- Making them recognizable

You know who your characters are. Now it's time to flesh out their world. Can you imagine Colonel Mustard without a candlestick to do it with or a study to do it in? Unless you intend to tell stories about the inhabitants of a cloudy, unspecified void, you're going to need settings and props.

Read That Script Again

Find out what the writer is asking for. Are there specific objects you're going to need to design? Where is this story set? What sort of place is it? What do your readers need to know about the settings? Can you travel there yourself and deduct the expense as "research"?

All at Once

I broke character design away from setting to make things easier to digest, but when taking character notes, you can (and should) take set and prop notes at the same time.

Tag

A **tag** is a visual element included to make a person, place, or thing readily identifiable.

How Important?

Some settings only appear in the story for a panel or two. Others might be explored in exhaustive detail for dozens of pages. And if you're telling a serialized story, you may find that the dentist's office you dismissed as unimportant in the first issue has become much more significant in the third. If you're collaborating, talk to the writer and make sure that you'll need to draw the place only once. If you're working solo, talk to yourself. Most cartoonists do.

"Unimportant" doesn't mean that a setting should be eliminated, just that it doesn't need to be distinctive. If the scene is set in a dentist's office, your reader needs to know that, or the reader's going to wonder what that man is doing inside that woman's mouth. In an unimportant scene, a *tag* or two are often enough to let the reader know where things are taking place.

You can tag a scene for general information. A striped pole behind the villain says he's at a barber shop. Or you can tag a scene specifically. Knock the pole on its side or put a distinctive carved eagle on top. Then, whenever we see it, we know we're at that particular barber shop.

Tags are an important storytelling tool. On a crowded page, you may have several different scenes. If you don't have room to include an establishing shot of Tex's arrival at a grocery store, arrange the panel so that we're looking at Tex holding a basket, framed by a hand at a cash register. Later, when he's been arrested for shoplifting, you might just show him behind bars rather than draw an entire prison.

An unconventional convention center. I tagged the convention center with triangular window patterns and an unusual flagpole.

If You're Sticking Around

Simple tags are enough for settings you'll visit only briefly. For longer, more important scenes, you'll want to work things out more carefully. Read the script, looking for information about the settings. If the writer followed our suggestions in Chapter 7 of this book, his or her script will include establishing shots of the important scenes, the details that the story requires, and descriptions of the place in terms of its effect. If such details are missing, talk to the writer and work these matters out.

You can design a scene carefully before starting a scene, or you can just build the scene around your establishing shot. The rule of thumb is that the longer the scene, the more important it is to plan the space in advance. The following sections start off with questions you should ask yourself about the settings.

What Needs to Happen Here?

Let the events in a scene tell you what a setting needs. If Cowboy Gus is inside eating lunch when he sees a twister approaching, put a window where someone at the table could see it. And if he has to close the window, don't make it a single, fixed pane of glass.

How Big?

One of the dirty secrets of the graphic novelist is that you can cheat a bit when depicting space. It's common to draw a room a 10-foot ceiling in your establishing shot, then draw a bird's-eye view of the room from 20 feet up. But clearly communicating the size of spaces is still important. Show a king's grandeur by giving him a big throne room. Lost orphans look more lost in a wilderness full of giant oaks than they would among scrub pines. If Timmy's fallen down a well, show that it's too deep for him to just reach up and pull himself out. And if he has to climb up a well shaft by bracing his legs on either side, keep the shaft narrow enough for him to do this. Don't make it so narrow that Lassie has to squeeze down the well, pull Timmy up by his collar, and give him the dog-language talking-to about the danger of wells that the boy so obviously needs.

What's the Feel?

Some stories require only the basic facts of a setting. It might be enough to know that Bob is at the auto body shop when his car grows a face and begins complaining like a sick hospital patient. Other stories need more than that. In another story, a social worker is concerned about a mechanic who takes his young children to work. Emphasize the darkness, dirt, and danger when designing that setting, filling it with sharp tools, exposed wiring, and heavy objects balanced precariously. A story about an older mechanic confused by modern ways might be set in a shop that's unusually clean and dominated by diagnostic computers instead of the wrenches and hoses he expects.

Even a real city will vary in feeling from one story to another. The films *Breakfast at Tiffany's* and *Serpico* both take place in Manhattan, but they're very different settings.

Believable or Correct?

How accurate should your depiction of a setting be? Depends on the story. Some stories allow, or even *require*, bizarre distortions of reality. A police station in a nightmarish horror story is going to be quite different from one in a

Hahn, Solo

David Hahn's graphic novel *All Nighter* has many pages set in the same diner. To keep the environment consistent, he built a model of it in Sketchup, a free 3-D modeling program, and filled it with objects and furniture from Google's 3-D Warehouse. This made it easy for him to visualize his setting from any angle.

realistic detective mystery or a screwball talking-animal comedy. There's no right answer to how accurate you need to be, but as a rule of thumb, when you want to emphasize the reality of a story, keep your setting accurate. When you want to emphasize mood, distort as necessary.

Is This Going to Ruin My Life?

Your time is valuable. Avoid set designs that take hours and hours to draw if you'll have to draw them repeatedly. If there's no way around a complicated design, tag it with an easily drawn detail so that you can just use that instead of redrawing the whole setting every time. An elaborately decorated temple, for instance, could be tagged with a distinctive statue.

You can also use clever page and panel design as a way to eliminate time-consuming detail from a scene. Once you establish a scene, increase the stylization a bit. Show the whole barber shop in panel one. In panel two, eliminate everything but the barber and his chair.

Getting Real

My Years on The Ice

For *Whiteout* and its sequel, two graphic novels I illustrated that were set in Antarctica, I read books and magazine articles, found photos and journals on the web, watched videotaped documentaries, and e-mailed questions to some people who had lived there.

Getting a realistic scene right takes time. (A fantastic setting can be time-consuming, too, but no one is going to quibble about the accuracy of your twenty-third-century kitchen.) The writer can say "It's a summer evening in 1904. We're in a Czech army barracks," then go on to tell you what the characters are doing. But what did a Czech army barracks look like then? Are there bunk beds? Are the walls plastered or wooden? Are there gaslight fixtures or electric lights? What did lightbulbs look like in 1904? Could a soldier put girly pictures on the wall near his bed? What would a 1904 girly picture look like? What kind of rifle would a soldier have, and where would it be stored? Why is the "z" silent?

In an ideal world, the writer has done all of this research for you and has included stacks of reference with the script. In a less-ideal-but-still-good world, the writer assumes that everyone knows about Czech army barracks and didn't think to send this material to you, so a quick phone call may help. Otherwise, it's time to take off the beret and put on pince-nez. You're about to become a researcher.

Plenty of resources are available to you. Sometimes the real thing is out there for you to visit and sketch or photograph. (It's a good idea to get permission first, particularly if you're shooting photos.) Look for appropriate websites. Ask your librarian. For historical subjects, a museum in your area may have a picture archive, period artifacts, or even complete reconstructed rooms. Find a movie that's set in the right time and place. If all else fails, draw the stuff you're sure about and choose compositions and lighting that "just happen" to cover up everything else. This can be surprisingly effective.

Making Stuff Up

Your setting might be imaginary. That doesn't mean you get to slack off. As a general rule, fantasy requires more detailed settings, because you have to introduce your readers to an unfamiliar world. And since you can't assume their familiarity with its workings, you'll need to draw in a more literal style. You can draw a modern office expressionistically, showing only oddly illuminated workers and computer screens floating in darkness, and the reader will know that it's a room drawn stylishly, and won't be surprised when someone picks up a monitor and tosses it out the window. In a science fiction story, those floating screens might be holographic projections in an empty room without any furniture. As you might have guessed, we have a few tips for making your imaginary settings and props believable.

Make It Clear

If your Victorian mad scientist has built a gunpowder cannon 40 feet tall, put it in a context that makes its size unmistakable. If there are normal-sized doors and windows in the wall 35 feet below the cannon's mouth, that's a good clue. And choose angles that make its size obvious. Don't draw the cannon huge in the foreground of your panel with its builder far behind. That could just be exaggerated perspective. Put the builder in the front, with the cannon looming up behind him, or show them from an angle that puts the size in emphasis.

Make It Consistent

You're setting up a world with its own rules. Follow those rules or lose the reader. Santa's elves need elf-sized tables and chairs. The mermaid bedchamber should be made out of materials that one could scrounge from the sea. If they don't have fire, they shouldn't have anything that they'd need fire to build.

Make It Familiar

Even the most fantastic scenes should have familiar or recognizable aspects. A tavern in a space station can still resemble a typical tavern. Make it dark and smoky. Put in a long bar with a mirror in the back. Add lots of small tables and neon lights advertising something. Your readers will recognize the space as a bar, even though the place is full of aliens sipping blue ooze from long tubes. Any imaginary place you create should have some familiar counterpart, but it doesn't have to be a perfect match.

You can create a lot of interesting effects by combining unlikely elements. A future courtroom might evoke a modern game show or a medieval torturer's dungeon. A gnome family's toy-making workshop could resemble a modern cubicle office or an automotive assembly line. An alien spaceship could evoke a submarine or a cruise liner.

To evoke something, identify the elements that tag a place as what it is. A church has plenty of seating looking up at a dais. It probably has stained glass or otherwise decorative windows, and it uses high vertical spaces to encourage a feeling of reverence for some higher power. A library has tall shelves full of books, computers, places for people to sit and read, and perhaps someone saying, "Shh." A bedroom is designed around a place to lie down. A living room might have furniture that one could lie on, but is clearly designed for people to interact.

Getting Your Props

All of what I've said about settings applies to props as well. In the movies and on stage, an object is considered set dressing unless someone handles it. Then it's a prop.

Research your authentic props and design the imaginary ones according to the rules I gave for settings. Mickey Mutant has only one tiny eye in the middle of his enormous head. His rifle still needs a carrying strap, a trigger, and someplace to load ammunition, but design it so that the scope is set off well to one side, or he won't be able to sight a target while bracing the stock against his shoulder. And if he has weird hands, the trigger assembly should reflect that, too.

Sometimes a prop needs only to be identifiable. A student's notebook can be recognized by its spiral binding. But if everyone is hunting for one particular notebook that contains the atomic bomb plans or the list of the Colonel's seven herbs and spices, find a good, unmistakable tag. Rip one corner in a way the reader can't miss, or put an upside-down sticker on the cover.

Prop Yourself Up

Steve's tip on character props is just as important for writers. Interaction with a prop can indicate thought processes and emotion in a visual way. That nicotine inhaler not only shows that the character is quitting smoking, it also can be tapped on a table in boredom, squeezed in a hand to show tension, sucked to show contemplation, and flung at the cat to show frustration.

Many characters have props that are utterly identified with them. Friar Tuck carried a wooden staff. Linus carried a blanket. Madame DeFarge had her knitting needles. Sherlock Holmes smoked a pipe. Harriet the Spy always had a notebook. There's Captain Queeg's metal exercise balls, John Henry's hammer, Paul Bunyan's axe, and Groucho's cigar.

The right prop can help fix a character in the reader's mind. Some props become so iconic they're almost characters themselves: think of King Arthur's Excalibur or Captain America's shield. Others are the center of their stories, like The Maltese Falcon or The Glass Menagerie or Cinderella's slipper or The

One Ring. If you've got an object like this, find a tag to make it unique. Give the Stuttering Sword an oddly shaped blade. The Haunted Handbag can look like a distorted human head, its clasp holding the mouth closed. Grandma's Grimoire needs a big gold bookmark and delicate metal latticework on the binding.

No Sheet, Sherlock

As I said in Chapter 10, a model sheet is a drawing or set of drawings used to keep a character, prop, or setting consistent. You won't need to create model sheets for most props or settings. Unless it's really special, you'll probably design it right on the page, and your first clear shot of it will serve as the model. Keep a scan of that page with your model sheets, so that four months later, when you have to draw the Pirate's Magic Chum Bucket again, you won't have to remember what page it was on. For important settings, your establishing shot might not include all the necessary details. Make an overhead diagram. It doesn't need to be a real drawing. A simple plan of the space and its major features is enough.

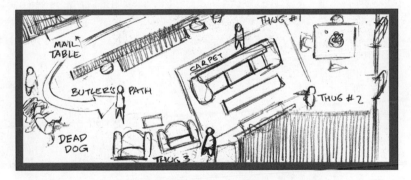

Use a diagram like this to plan a complicated scene.

Don't settle for the easy way out when designing props and settings. Creating a believable world for your characters takes time and effort, but a well-thought-out environment will make your stories far more real to you and your readers.

The Least You Need to Know

◆ Use tags to make settings and objects recognizable.

◆ Research your realistic scenes and props.

◆ Fantastic settings must be clear and consistent and should evoke something familiar.

◆ A good prop makes a character more memorable.

◆ Map out your most important settings.

Decrypt the Script

In This Chapter

- ◆ Analyzing the script
- ◆ Finding visual themes
- ◆ Choosing a style

You've thought about the characters and their environment. Now it's time to start thinking about their story and how best to tell it to your readers. There's a lot more to good visual storytelling than just drawing what the writer asks for, but the writer's script is where it all begins.

Different Sorts of Scripts

As Nat discussed in Chapter 8, there are as many different approaches to scriptwriting as there are scriptwriters. Some writers know in advance who their artist will be, and can tailor their material to play to that artist's strengths. Others work in more of a vacuum, with no idea who'll be tapped to bring their ideas to life.

The script might be dense, with every panel described in exhaustive detail and long paragraphs specifying everything from camera angles, to the body language of incidental characters in the background, to the exact size and shape of every panel. Or it might be a half dozen sentences handwritten on a bar napkin, with an underlined exhortation to "make it rock." I've seen both. Regardless, almost every script offers opportunities for a diligent illustrator to explore the possibilities of the medium.

Read Like a Writer

Once again, I'm sending you back to the script. At this point, you're probably wondering if you know the story better than the writer. Good. You should

know it better. Once you put pencil to paper, you are the storyteller. Collaborating on a graphic novel can be a little like playing "telephone." The writer tells the artist, the artist tells the reader. (Actually, the artist tells the printer, who then tells the reader, but I'm trying to convince you of your godlike power, and such minor details will often fall by the wayside at times like this.)

When you read the script this time, keep one big question in mind: what is this story about? You're looking for a theme, a central idea that unifies the story. The writer doubtless has ideas about what that would be. The script may even say so in bold type in the first paragraph. If so, avert your eyes and skip to the second. You want to approach this with as unspoiled an attitude as possible.

Themes are generally universal. Sometimes they can be boiled down to maxims: "Love conquers all." "No man is an island." "As a man soweth, so shall he reap." That sort of thing. Other times they aren't quite so tidy. "The sacrifices of motherhood." "Law versus justice."

Think back to eleventh grade. If you were like most budding cartoonists, you ignored your English teacher's lecture on great themes in literature and filled your notebooks with ballpoint sketches of tanks, horses, or that hottie in the next row. Take a moment to offer a silent apology to that teacher, because she was trying to teach you some pretty useful stuff, and if you'd learned it, we could skip ahead to the part where Atomicus saves Tokyo from a giant metal insect.

So what's your story about? In Chapter 4, Nat gave the example of the cowboy/schoolmarm romance. What are some themes we might find in a story like that?

- The conflict between freedom and attachment.
- The end of frontier life as civilization encroaches.
- The battle of the sexes. (Men want A, women want B, and ain't that difference grand?)
- The struggles of women in a world run by men.
- The dangerous thrills of adventure.

The possibilities are endless. Take notes, and make a list of options worth developing. And again, this needn't be its own step. You'll probably do this while jotting down notes for other parts of the job. You might even skip the formal process and do this entirely by instinct. But "do everything at once" and "just follow your instincts" aren't very helpful lessons, so I'm breaking up the tasks here to make them easier to explain.

Did your writer specify a theme or make his or her intentions absolutely clear? If so, great. You know what's going to drive this story. Your list of other possibilities can still come in handy. If the story seems to have too many possible themes, or worse, none whatsoever, the ball is in your court, and you have to make a choice.

Pick a Theme

Suppose it's a big story, and the subplots don't seem to have much to do with the main story or with each other. It all just seems sort of random. You aren't sure if the writer knows where the narrative is going, and your questions are getting waved off with "Just draw what I wrote!" You can still take steps to unify the story and make what's there have more impact.

You can glean some of a writer's unstated intentions by looking at the script's most dramatic moments. Where do you think the reader is most likely to gasp, weep, or shudder? Once you find that, go through the story for other scenes that could amplify that idea or feeling or look at it another way.

Here's an example: if the best line in the story is delivered by Victoria when she shoots the wicked law professor who smothered her dachshund, that's a revenge moment. And if we know that Victoria's taking revenge for the death of her dog, why not go to the earlier scene, when she sees her neighbor out walking his Pekinese? In the script, it just says that she asks him for the time while he checks the leash. But suppose you draw it so that the neighbor and the dog are having a great time together. He's laughing, delighted by Fido's antics, and Fido's up on his hind legs, wagging his tail. Show the reader how Victoria is shattered by this moment of doggy bliss, and you've managed to intensify the reader's understanding of her loss with a single panel.

Are there other scenes you can develop this way? Think of every aspect of the pet/owner relationship. Is it sort of parental? Look for scenes with parents and their children. Exploitative? An underling "fetching" coffee for the boss. You want to *gently* nudge the story toward a crucial central idea. When you illustrate a graphic novel, you're constantly making decisions. A good, unifying idea gives you a firm basis for making them.

Using the Theme

You've got a good grasp of what the writer is trying to say. (Or, alas, you've made that decision on your own.) Now you get to apply that idea to everything else you do.

Let's look at the script at hand. In *The Big Con*, the main characters are minor celebrities. They're accustomed to standing out in a crowd and enjoying a certain amount of admiration from the public. Now they're in an environment where their status, the thing that makes them special, is a liability. To cope with this situation, they have to voluntarily lower their own status. They can't be celebrities anymore. They have to pretend to be their own fans, geeks in goofy outfits. Eventually, they learn an important lesson. They can use their position to make people happy, and that doing so is rewarding, even if some people will exploit them. So what's it all about? I say it's this: the pluses and minuses of celebrity.

Whenever I have to make a storytelling decision, I'm going to take *The Big Con*'s central idea—the pluses and minuses of celebrity—into account. Here are a few typical questions, with my answers:

When drawing the characters, how much should you exaggerate their features, expressions, and gestures?

I'm going to need more exaggeration than I usually use. The indignity of their situation as trapped celebrities is a big part of the story, so I'm going to push the faces a bit to emphasize moments of humiliation. I won't *caricature* their features much though, because I want them to have some dignity to lose.

Caricature

Caricature is the expressive distortion of faces and features. This can be done for laughs or to highlight some aspects of the subject's personality.

Does this story need realistic light and shadow? Should you eliminate all the shading and draw with a clean line? Or should you use heavy areas of shadow?

Convention center lighting tends toward the fluorescent and bland, so leaving the shading out isn't all that far from drawing "realistically." However, eliminating all the shading would impart an elegant quality I'd rather avoid, particularly since these celebrities are stuck among the unwashed masses. Heavy shadows wouldn't be appropriate for the setting, either, and they would create a sense of physical danger that isn't what I'm going for. The concern here is loss of status, not life or limb.

Should the pictures be noticeably attractive or should they just communicate the bare facts?

This story leans more toward the bare facts. I'm not trying to show my readers wonder or beauty. The beautiful people here are being brought down to Earth.

Do you want to use perspective to create a consistent illusion of three-dimensional space, or would you rather use a flatter, more symbolic approach?

I'll need a sense of real space. Flat-looking art is often funnier, but it wouldn't make it clear how far they need to travel in these ridiculous outfits.

Do you want characters that are fully constructed in three dimensions, or should they be mostly flat designs (like, say, the characters in **South Park** *or* **Dick Tracy?***)*

Definitely three-dimensional. I want the reader to compare Derrick in his "Lord Zatan" costume with Yeo in his Bot outfit. Derrick is awkward and humiliated in the outfit and, by extension, in his position as a celebrity among his fans, whereas Yeo is perfectly comfortable in each. I need solid-looking figures with a sense of mass to show that.

Is the story better served by backgrounds full of lots of precise detail, or by a few basic indications of where things are taking place?

This is going to need some detail. The convention isn't just where things happen to be happening, it's the engine that's driving the story.

Will you have any trouble drawing in the style that you think would be right for the story? Should you hire an assistant to help out with the parts you can't handle?

Nope and nope. This one is right up my alley.

Should you use a simple grid layout or a more complex or organic approach?

The script calls for overlapping, snapshot-style panels on page seven. That suggests to me that a grid would be a good idea for the rest of the story, because it would help that page, with its different sense of time, to stand out.

Time is always a consideration. Can you draw the story in an appropriate style in the time allotted, or do you need to find a faster way?

No comment.

You Can't Always Get What You Want

Some answers will trump all the others. For instance, your limitations as an artist might always be a factor. Few artists are good at more than a couple of styles. If the only drawing you do is flat and design-y, you'll have to either work that way or try another style and risk producing something that isn't as impressive as your other work.

Other times your decision is made for you by external concerns. Budget is a big one. Suppose the most important scenes in your story call for a room to be suddenly lit by a blue light. If you can only afford to print in black and white, you'll just have to find some other way to get your point across. One solution would be to use a distinctive style of rendering on the blue-light scenes. Or you could compose the panels in such a way that it'll be hard for your readers to miss the comparison. Either way, save that rendering or composition for the blue-light specials.

A Digression About Original Art Size

Another limitation you might run into is the size your book will be printed. If you're self-publishing, that's your call. But if you aren't the one paying the printer, it's a safe bet that someone else will be telling you how big the book will be. If the published work is going to be 3 inches by 5 inches, you'll either have to limit yourself to very few panels per page, or draw really small. And if you're drawing small, design your pictures so that your readers won't have to squint at them to figure out what you drew. Not to mention that your writer may have given the characters a lot of dialogue, which also has to fit into your panels.

Not that print size limits the size of your original art. Wanna draw that page 6 feet wide and 9 feet tall? Go for it, but be aware of how much detail you'll lose when it's shrunk to 6 inches by 9 inches. And don't be surprised if the publisher asks you to scan it because the company's scanner isn't big enough.

Keep It Clean

Small pictures are much more easily understood by readers if they're simple. Save the complex arrangements, amusing little background jokes, and intricate rendering for bigger pictures.

How big to draw your original art? That's a personal choice. On a smaller original, there isn't as much space that needs to be filled, so you can finish more quickly. But many artists find it difficult to produce good drawings below a certain size. It can be hard to judge proportions, and mistakes are magnified. If you're making a 4-inch figure drawing and the head's a quarter of an inch too big, that's no big deal. On a 1-inch drawing, that quarter inch will make your figure look like the first arrival of an alien invasion. Also, without room to swing your arm a bit as you work, your drawings can get stiff and diagrammatic.

Working large can be fun. Errors are easily recognized and corrected. You've got room to move your hand and arm, and the pictures don't feel so cramped together. There are down sides to this, too. It can take longer to fill all that empty space. Not everyone has a large enough table to work big. Big sheets of paper cost more. You'll have to spend more on ink and brushes or pens. Big finished art can be a pain to ship or to scan, and, if you live in a small space, difficult to store.

So what's the right size? Many artists find that working one up—one and a half times the printed size (150 percent)—is a good proportion. It's big enough to see what you're doing, but not so big that it hurts your productivity or takes over your apartment, and it's standard at most American publishers. For art that reproduces at 6 inches by 9 inches, working 141 percent larger gives you original art with a *live area* of 10 inches by 15 inches. That fits well on an 11-inch by 17-inch sheet of paper, which is a standard size available from art supply stores. When you want to see how an 11-inch by 17-inch page will reproduce when shrunk down, reduce it on a copier or in Photoshop to 65 percent of its original size.

> WHA...? **Live Area**
>
> The **live area** is the section of your original page that the printer will definitely reproduce. There'll be more on this in Chapter 14.

The Strength to Resist Your Strengths

Every artist is better at some things than others. We all want to put our best foot forward. But sometimes playing to your strengths is a bad idea. Suppose Joe Cheesecake loves drawing glamorous women and he's terrific at it. Unfortunately, he's drawing a story about the difficult lives of the women who work in a feed truck assembly plant and their long struggle to organize a union. It'd be hard to take the story seriously if the women are all slender and gorgeous, radiating health and vitality. The reader would wonder if their lives are really that bad. And if the women all have that "come-hither" look that Joe draws so masterfully, the big scene with the abusive boss is going to read very, very differently from what the writer intended. If Joe is going to illustrate the feed-truck women's story, he'll have to suppress his interest in drawing lovely ladies, or he'll subvert the meaning of the story he's telling.

Another example: years ago at school, a classmate of mine was adapting a scene from *A Christmas Carol* into comic form. He had a knack for horror art, and though he wasn't trying to do so, he drew Scrooge as a hateful, monstrous, ruin of a man. Our teacher observed that no one would ever believe that a Scrooge

like that was capable of redemption, and that Scrooge's reform at the end would feel false. The artist needed to change his emphasis from Scrooge's ugly face to his even uglier behavior.

A drawing style can undermine a story, too. Excessive rendering can stop a story cold by drawing a reader's attention to the wrong aspects of a panel. A style that carefully describes subtle effects of light on various materials is great for a story with some quiet pauses. The action stops, the CEO puts down his drink, and we look at the glass and its reflection in the dark polished wood of his desk. That's a good moment. On the other hand, if we're in the middle of a screwball comedy sequence, where he's hiding under the desk while a jealous chimpanzee tears up the office, that reflection, no matter how well drawn, is going to be a distraction.

Think of it this way: sometimes a graphic novelist should tell the story as if he or she's telling a joke: "A man enters a bar. He goes up to the bartender and says …" Other times, the approach required is more like that of a novelist: "A man in his late fifties, with flinty gray eyes and hard, thin lips, pushed open the fireproof doors to the bar at the top of the Bayview Hyatt in San Diego. He worked his way through a maze of hideous polyester nest chairs and approached the bartender. The bartender was a recent hire and his apron was damp with vodka, Red Bull, and flop sweat …"

 The Best and the Brightest

The annual *Best American Comics* anthology contains dozens of complete comics and excerpts from graphic novels, executed in a dazzling range of styles and approaches by new and established artists. Aside from being great reading, these books are a useful catalog of drawing styles and story-telling techniques.

Motifs

You can also unify your story with a well-chosen visual motif. The idea of the motif comes from opera. Different parts of the story are assigned musical themes, and when they appear in the story, their themes are worked into the larger melody. When the warrior's magic word of destiny is first discussed, we hear a bit of the sword theme. When he actually gets his hands on the sword, the theme becomes the main melody.

The movie *The Sixth Sense* used this technique, but with color instead of music. The movie was filmed almost entirely in neutrals—grays and browns. But whenever emotions were heightened and something horrible was about to happen, the filmmakers would bring a vivid, primary red into the screen. As the film progresses, the mere presence of a red balloon or sweater on the screen is enough to get audiences nervous.

A couple years earlier, I used a similar strategy in *Whiteout*. I worked a square grid pattern into scenes where the lead character was feeling helplessness or rage. I tried to associate the grid with the character's feelings, so that even when she was too frozen to emote, we'd have a sense of what she felt.

My grid motif. Note the less-than-subtle arrow pointing right at the grid in the first panel.

Repeated Shots and Imagery

Repetition doesn't have to be dull. Put two similar things near each other and they invite comparison. Say you're illustrating a redemption story, and the hero seems to spend a lot of time on the phone. That could be visually dull. But what if every time he's on the phone, you use a similar camera angle and change the picture to emphasize a change in his status? The progression could work something like this:

- He's counting pennies with his baby daughter's empty milk bottle and several empty liquor bottles on the flyblown table in front of him.

- The table is clean and he's circling a help wanted ad.

- Now the table is a cluttered office desk. He's being handed an overflowing bundle of papers. There's a picture of a 9-year-old in braces and a baseball cap.

- Now it's a handsome oak desk, clearly that of an executive. He's opening an expensive leather briefcase. Next to the picture of the 9-year-old, there's a framed photo of an 18-year-old woman graduating high school in cap and gown.

- He's at the same desk, looking nervous and sweating, holding a newspaper with his nonphone hand. The headline reads "Insider Trading Scandal." The desk is cluttered with file folders and an overflowing Shreddy 9000.

That simple image of him at the phone becomes a sort of milestone to check his progress and gives rhythm and shape to the story, almost the way a chorus

does for a song. Look for ways to reinforce your story's theme with repeated imagery.

Harm Reduction

Creative differences happen. There may be times in a collaboration when you resolutely disagree with the point your writer is making. It might be a political difference, or a disagreement over some important thing a character does or says. It could even be an aesthetic difference. "How could you saddle a great story with such a lame ending?"

Is It Just a Misunderstanding?

Tell the writer your concerns. Perhaps the writer left something out. The scene in which Atomicus exterminates the Squirrelmen of Neptune wouldn't come across as a flat-out endorsement of genocide if the writer hadn't forgotten he'd cut the part where we learn that the Squirrelmen are actually robots. Maybe that line that evokes Stalin was an accident. If something seems right out of left field, perhaps it's because the story is being serialized. Your objections might be answered in a subsequent issue.

Work It Out

Make your case. Be diplomatic but clear about what you think the problems are. Sometimes e-mail is better for this than the phone. You can take the time to express your argument more clearly, and it'll take some of the edge off any anger that might be simmering.

Be positive, not disparaging. Tell your writer, "The climax in the ballroom just doesn't rise to the level of the rest of the book." Don't say, "The ballroom scene is a reeking puddle of sewage. Why did you write this? Did someone crack open your skull and stick a spoon in your wet, pink brain?" Look for some compromise that you can both agree on. Bring in an editor or some other third party to mediate. If you're on the losing side, just do the best job you can get away with.

Surrender, but Subvert

No compromise is possible. The writer has made it clear that your opinion is worthless: draw it or quit. The story ends with Private Parker gleefully clubbing baby harp seals with a shovel, saying, "This is a hoot!" You can deemphasize the "gleeful" part by backlighting him so that we can't read his expression. Or you can establish a big cookfire several pages earlier, so that there "just happens" to be lots of smoke that obscures the whole seal-clubbing scene.

Nat Sez: Please Ask Questions

If there's something in the script you don't understand, then there's no way you can make the reader understand it. I'd much rather explain a confusing part once for an artist than 1,000 times for fans.

Cut Your Losses

If you aren't bound by a contract, you can withdraw from the project. The earlier you do this, the better, because it's unfair to everyone else involved to leave them scrambling for a new illustrator at the last minute. Even if you have a contract, it's worth asking if the publisher would consider letting you out of it. The publisher will want an artist who can commit to telling the story rather than one whose art will undercut it, as flawed as that story may be.

The Least You Need to Know

- Unify the story with a central idea.
- Keep that idea in mind when making storytelling decisions.
- Look for repeatable motifs in the script.
- Identify script problems as soon as possible and work with the writer to correct them.

Lovely Layouts

In This Chapter

◆ Creating thumbnails

◆ Choosing camera angles

◆ Manipulating time

Designing the layout of the graphic novel is one of those steps that, in their haste to jump in and start making cool drawings, artists are sometimes tempted to skip. Don't—particularly if you're new at this. The possibilities for missteps in the creation of a page are endless. After all, you aren't just drawing one picture that makes sense on its own. Your panels all have to work together to tell your story clearly and entertainingly. A panel that's fine on its own can be disastrous for the rest of your page. You can avoid problems and save a lot of wasted effort by thinking things through in your thumbnail sketches.

Thumbs Up

There's no one right way to do *thumbnails*. I've used half a dozen different approaches on the same project, depending on who needed to see them, how much of a hurry I was in, and, in all honesty, what kind of pencil I had in my hand and what felt right on a given day. I drew the thumbnails reproduced at the end of this chapter on graph paper.

Some people hate sketching on graph paper because they feel like all the little boxes clutter up their doodles. I like it because it makes quick, accurate divisions of space easier, and how to divide up space is always a big concern for me on the comics page. Also, the blue lines are easy to clean up when I scan the page, which is handy. A final reason is sort of embarrassing, but I'll share it here because it could be a valuable tip: my studio is often hideously cluttered, and I lose important papers in it all the time. Blue-lined graph paper is easy to spot in the midst of heaps of white paper. And because the only thing I ever use graph paper for is layouts, I'm less likely to lose them.

Thumbnails

Small, quick sketches that are often no bigger than your thumbnail are called **thumbnails**. They have no intentional aesthetic value and are used for brainstorming or problem solving.

An easy shortcut to matching proportions.

Make your thumbnails the same proportion as the actual page. I'm drawing *The Big Con* pages at 8 inches wide by 12 inches tall. That's a 2:3 ratio, which is fairly standard for the North American comics industry. Some other 2:3 ratios include 6 inches by 9 inches, 10 inches by 15 inches, and 4 kilometers by 6 kilometers. I'd advise avoiding that last one unless you own a good-sized field and plan to ink with a tractor.

If you're desperate to avoid any math, you can find another rectangle in the same proportion by using the proportion shortcut. Just draw a diagonal line from one corner of your border to another. Any other rectangle on that diagonal is in proportion to the first one.

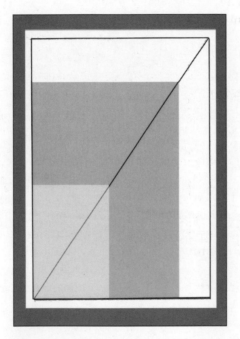

How big and detailed should your layouts be? Depends on who needs to see them. If they're for your eyes only, make them as tiny and obscure as you like. Just keep in mind that if you aren't using them immediately, you might forget that the broad squiggle with the wavy lines on page two is a bird's-eye view of Atomicus struggling to escape the tentacles of a giant squid.

If you plan to show the thumbnails to your writer, he or she will need a bit more detail. Label the characters. The sketches don't have to be tremendously clear because it's a fair assumption that your writer already knows the story being told. Still you can expect to get one or two phone calls asking if the bit on page two is a close-up of a mouth full of teeth or an establishing shot of the House of Representatives.

If the thumbnails have to be approved by an editor, it's a good idea to assume that he or she has had to read 15 or 20 other things since breakfast and remembers nothing about the story at hand. Try to keep your scribbles very clear and put in lots of labels and little marginal notes explaining what's going on.

When I make thumbnail layouts from a full script, I make sure to indicate where the lettering will go, too. In my thumbnails at the end of this chapter, you'll note that the caption boxes and speech balloons have numbers in them. That's because Nat was kind enough to number his captions and speech balloons in the script. We'll go into this more in the chapter on lettering. Those numbers make it easy for me to indicate where the word balloons need to go, and to spot potential placement problems.

Left to Right, Top to Bottom

One of the most frequent problems you'll run into is speaker order. In the Western world, our default way to read comics is the way we read everything else: left to right, top to bottom. We find it easier to read a comic if the word balloons are placed close to the speaker. Ideally a script should call for characters to be placed in the panel so that their position in the left-to-right lineup "just happens" to be the same order as their speech. The demands of storytelling being what they are, it rarely works out this way.

Even a simple and blah script can provide tricky complications for layout. Consider the blah script pictured nearby.

```
Panel one

1 Louie:  BLAH

2 Rich:   BLAH.

Panel two

3 Rich:   BLAH?

4 Louie:  BLAH.
```

A very blah but problematic script.

Nat Sez: Easy Redialoguing _____

A writer can solve the problem of changing speaker order without changing dialogue. Take a look at the first figure showing the problematic blah script. You can move both of Rich's balloons to one panel. You can even have panel two be simply a shot of Louie, with Rich's dialogue balloon pointing back to him in panel one.

What's the problem? The speaker order changed. Louie, the guy who speaks first in panel one, is speaking second in panel two. But I want the reader to see them in the same order as they speak, and I want to group the balloons with their speakers. I could just make Louie and Rich switch sides, or flip the camera around and show them from the opposite angle. You can see me trying that in the first speaker-order doodles. But doing that violates an important rule: the

180-degree rule (I'll explain that in a sec). My preferred solution is shown in the second doodle. Use the reader's tendency to read top to bottom instead of the tendency to read left to right. Choose a camera angle or a composition to raise Rich higher in the panel. That way you can group him with his balloon at the top of the panel. Another solution: ask the writer to rework the dialogue a bit.

What to do when speaker order is reversed.

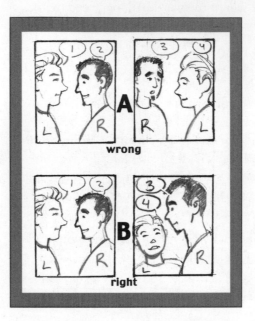

That 180-degree rule I mentioned is a very big deal. (It's also sometimes called the central-axis rule.) When drawing a scene with two or more characters, establish an invisible line between them. Keep Louie on the left side of that line, and Rich on the right. If you have to violate this, devote a panel to clearly showing the character cross the line. The thumbnails in the 180-degree-rule image show how the rule works.

Some examples of how the 180-degree rule works.

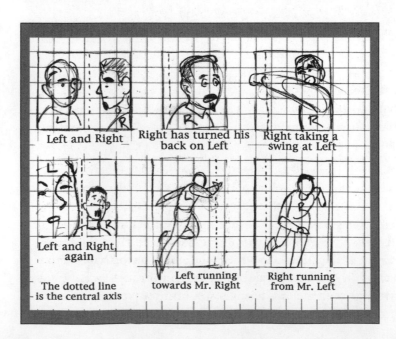

Calling the Shots

When you start breaking down each page into panels, you'll find yourself thinking like a camera operator. Nat named some camera angles at the end of Chapter 7: wide shot, medium, and close-ups. Those describe the distance of the camera from the subject. Here are a few others that refer to the height from which the scene is viewed:

◆ **High-angle shot** The scene is viewed from an angle noticeably higher than an average person's head. Good for showing the p.o.v. (point of view) of someone very tall, or hiding in a tree.

◆ **Bird's-eye view** A really high angle. Can mean that the shot is from a great distance, or just that we're seeing the tops of people's heads. Good for showing the lay of the land, armies moving across terrain.

◆ **Low-angle shot** The camera is waist high or lower, showing the scene as if the viewer was crouching or just very short. Can make the subject seem bigger, more impressive.

◆ **Worm's-eye view** An extremely low angle. The viewer is underneath the subject, looking up. Implies the utter subjugation of the viewer. While the bird's-eye view is almost always used for objective, informational shots, this one is used either to show a specific character's p.o.v. or to create weird, disturbing effects.

Combine these beauties with the distance options Nat mentioned earlier and you'll see just how many possibilities there are for your panels.

The Shape of Things to Come

You've also got a wide range of shape options for your panels:

◆ **Squares and rectangles** These are the default panel shapes, and with good reason. For at least a millennium, European visual artists have composed drawings and paintings and theatre sets and movie shots within these shapes. Your audience doesn't give them a second thought and will ignore the shape to concentrate on the content. And since you've also seen countless square and rectangular pictures, you've got a built-in sense for how they should be composed.

◆ **Circular panels** I usually see these used for amusing, somewhat campy moments, or to evoke such a moment for ironic effect. Either way, they seem to identify a moment as somewhat out of step with the rest of the story being told. When used in adventure stories, they always remind me of TV commercials where someone stops midconversation, looks at the camera, and says, "Wow! Now that's great coffee!" They do have a more practical use though. Use them for p.o.v. shots seen through circular views like a rifle scope, a security peep hole, a sewer outflow pipe, or a ship's portal.

I Before E, Except After Will

Will Eisner made spectacular and inventive use of vignettes in his later graphic novels. Books like *Dropsie Avenue* and *To the Heart of the Storm* aren't just compelling stories, they're textbooks in the use of the vignette as a storytelling device.

♦ **Vignettes** These are freeform pictures missing some or all of their borders, with empty spaces where things like floors or walls might otherwise be. These are often just used as a way to introduce some white space onto an otherwise crowded page. Vignettes can also psychologically remove characters from their physical context. Show Herbie Grubb standing on the curb next to his garbage truck, and he's just a sanitation worker talking to himself. When he hits the big point in his soliloquy, you vignette him, and suddenly, he is Man. Combine the vignetted figure with a prop or two for a scene that will feel more like a stage play (where sets can be stylized down to a few basic objects) than a movie (which is usually more literal, and requires more complete settings). Check out my thumbnails at the end of this chapter—page 8, panel 4 is a vignette.

You can compose your panels in any shape you want—odd trapezoids, organic shapes, anything. They're harder to compose though, and unless you're really good at leading the reader's eye around the page, they can leave your audience wondering which panel to read next. Look at comics and graphic novels illustrated by Steve Bissette, John Totleben, and Rick Veitch for successful uses of eccentric panel shapes.

Because space on your graphic novel page is a scarce resource, pick shapes that match the subject being depicted. A long shape is great for showing a long subject—a river, a snake, a funeral procession, a sword. Look at the first panel of the first page of my thumbnails at the end of this chapter. I used a wide but short panel to show the convention center. If I'd used a taller panel, I would have had to either crop the sides of the building or leave a big area at the top of the panel showing the sky. You can see another in page 6, panel 3. In that panel, The Bot is showing a kid how to swing his axe sideways, like a baseball bat. That required some horizontal space to show the full movement of the swing.

A tall, thin panel is good for showing things like a skyscraper, a church steeple, a telephone pole, and of course, a standing person.

Splash Page

A page that has a really big panel which takes up most or all of the page is called a **splash page**.

You can also layer panels, or parts of panels, over other panels. This can make for a lively design and is also a handy way to squeeze a little extra space out of a page. When a small panel is layered almost entirely over another larger panel, that's known as an inset panel. Nat's script requested that panel two of page four be inset in panel one. Inset panels are particularly efficient in combination with *splash pages*. Any picture that takes up a whole page is likely to have some dead space. Arrange the panels so you can place the inset there. Some of the best uses of the inset panel can be found in the work of comics legend Joe Kubert. He evokes a sense of epic scale in his rugged melodramas *Tor* and *Abraham Stone* by using tight close-up panels inset in sweeping vistas.

Timing

On the comics page, we show time by using space. Here are some very general rules about depicting time:

- In the rhythm of a page, every panel is at least one beat. The more panels in a sequence, the longer that sequence takes.

- The longer a reader looks at a panel, the longer a stretch of time that panel represents. So panels with lots of words take longer to read, and thus feel longer. The same goes for panels with lots of interesting details or elaborate rendering.

- Wide panels read as longer periods of time than narrow panels.

- Panels that show a character moving through great physical distance suggest that a considerable amount of time is passing.

- You can give an effect of slow motion by using the same camera shot throughout a series of panels, breaking a brief moment down into briefer moments. The same camera technique can also show something close to real time or communicate the idea that a lot of time has passed. It just depends on the content of the panels. The following fixed-angle timing illustration shows examples of timing effects you can get with fixed camera angles.

- Disorienting changes in subject, composition, and technique can slow the reader down, forcing a pause to assess the new information, thereby lengthening the time a panel represents.

Graphic novelists usually do this sort of time manipulation instinctively rather than consciously. To develop that instinct, read a wide variety of comics and graphic novels.

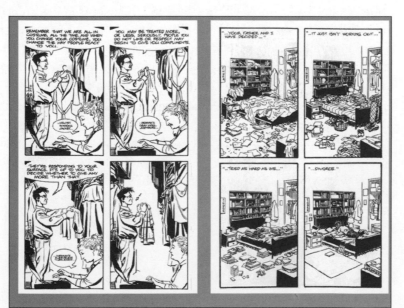

Fixed-angle timing. The conversation between the man and the typing girl takes place in something close to real time. The page of the room getting cleaner is more like time-lapse photography, and could represent days, weeks, or even months.

Composition

Composition is how you arrange the two-dimensional shapes and three-dimensional forms that make up your picture. The goal is to arrange your shapes in a way that communicates your meaning and leads the eye around the picture.

Composition is an important matter for any visual artist, and many long books have been written about it. To cover it sufficiently would take more room than we have in this entire book, much less part of one chapter. But here are a few useful principles:

♦ **Avoid symmetrical compositions.** These are a big problem for inexperienced artists. Symmetry stops a picture dead in its tracks. Save them for the occasional moment that needs to feel like a religious icon.

♦ **Three is a magic number.** Mentally divide your space into thirds both vertically and horizontally. Placing your subjects on these lines will create interesting, dynamic divisions of space. Dividing into fifths works, too.

♦ **Use contrasts.** Juxtapose big and little, straight and curved, vertical and horizontal, organic and geometric, sparse and busy, light and dark, smooth and textured, sharp and blurry, near and far. Remember that anytime you put two things next to each other, your reader is going to compare them.

♦ **A bit of awkward tension is often a good thing.** Perfect, harmonious compositions send a signal that everything is resolved. Let things lean too far in one panel and use the next to resolve the imbalance.

What If They Don't Fit Together?

Because of that "left to right and top to bottom" tendency I mentioned, some page layouts just don't work. In Chapter 7, Nat showed you some layouts where the reader will have a tough time telling which panel to read after the first. Sometimes the perfect individual panels just won't all fit together. This isn't a problem for web cartoonists, because they have an infinite canvas, but it's a constant problem for those of us who work on paper.

This is another reason to do thumbnails first. It can be hugely frustrating to do a great pencil drawing on one part of the page only to realize that it's going to interfere with an important part of some other panel. Eventually you'll develop an instinctive sense of what can work and what can't. Until then, do thumbnails and make tiny mistakes instead of big ones.

The Little Version of *The Big Con*

These are the thumbnail drawings that I'll use to solve any problems I might have laying out *The Big Con*.

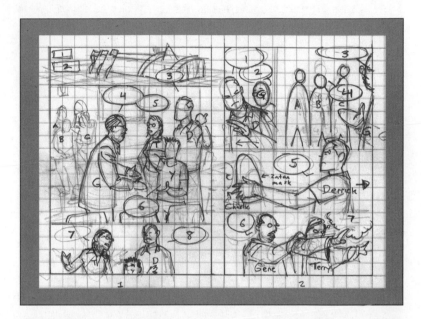

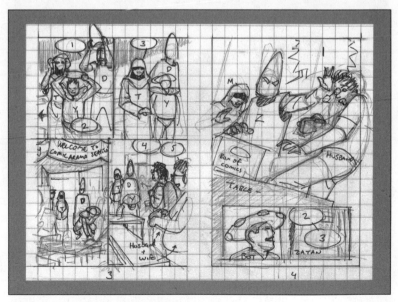

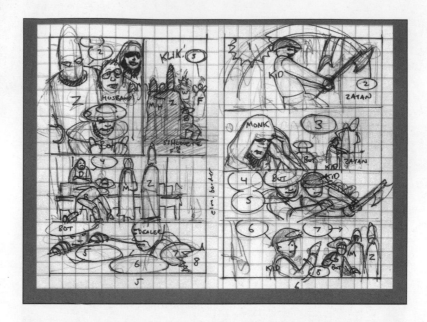

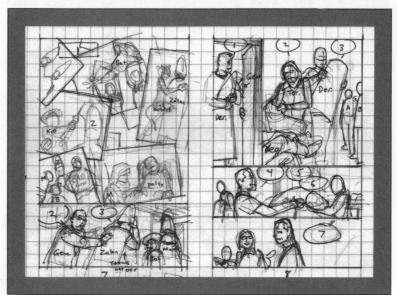

The Least You Need to Know

◆ Create thumbnail page layouts before you start penciling.

◆ Compose pictures that are dynamic, not static.

◆ Different panel arrangements will affect the reader's sense of time's passage.

◆ Arrange your characters so that their placement in the panel doesn't conflict with where the speech balloons need to be.

Getting Ready to Render

In This Chapter

- ◆ Paper, pencils, and other tools
- ◆ Assembling reference
- ◆ Enlarging your thumbnails
- ◆ Working with bleeds

You've got a script, some nifty designs and model sheets, and a small pile of scribbly, illegible thumbnail sketches. You're almost ready to begin drawing the actual story. In this chapter we'll look at some ways to make that go as smoothly as possible.

Some Art Supplies You Need

It's time to go shopping. Graphic novelists tend to be passionate about their supplies and can disagree fiercely about the advantages of one grade of pencil lead versus another. We're also quite conservative about them. When we find something that works, we stick with it.

There's no limit to how much a dedicated shopper can spend on supplies. Listed here is close to the bare-bones minimum of what you should have, but there are plenty of options. Try them until you find something that's right for you. Then you can get weird and cranky like your peers and learn the joy of getting angry at confused art supply store clerks.

Paper

Choose a paper that has a surface you like to draw on, that's sturdy enough for the type of drawing you plan to do, and that's affordable. That "sturdy" requirement can rule out a lot of otherwise terrific papers. If you're drawing in brush or pen and ink, or if your pages have to be shipped from one place to another, thin papers can buckle or tear, ruining your page, destroying all your hard work, and lowering its resale value. If you're only working in pencil or marker, scanning the work yourself and sending it off digitally, however, you can use whatever you like.

The traditional choice for comic books and graphic novels is 2-ply Bristol board. *Board*, in this case, means a sheet of sturdy paper. *Two-ply* means that it's actually two sheets pasted together, which is why it's so sturdy. And *Bristol* is a place in England where they used to make the stuff. Two-ply is popular for a number of reasons. It's strong enough to pass from hand to hand to hand without getting banged up. It can take a lot of ink without buckling, but is still thin enough to see through if you're using a light box (more on those in a bit). And best of all, it's cheaper than 3-ply.

Papers are available in different types of surfaces: *hot press*, *plate finish*, and *smooth* all describe paper that's as smooth as glass. These papers don't grab pencil marks as easily as rougher papers, and when they do, they can be tougher to erase. Pens and brushes glide effortlessly across the surface of smooth papers, though the pen lines can take a long time to dry. *Cold press* or *vellum* papers are rougher with more *tooth*. They're easier to draw on in pencil and easier to erase, but they wear out brushes more quickly. The surface can interfere a bit when you draw in ink, giving your line a texture you might not have wanted. Try different papers and see which works best for you.

Strathmore, one of the most popular makers of Bristol paper, offers it in three levels of quality: *300 series*, *400 series*, and *500 series*. They're all acid-free, which means the paper will last a long time without turning yellow, but the quality of their surfaces vary. 300 is made of wood-pulp. Among the three, it's the cheapest and the least durable under repeated erasing and redrawing. Then comes 400, still wood-pulp, but sturdier, and costlier. 500 is the most expensive. It's made of 100 percent cotton and is an absolute dream to work on.

Pencils

Pencils come in a couple different forms. There are the standard wood ones that everyone grew up using in school. There are mechanical pencils into which you feed tiny little leads (which should, of course, be called *graphites*, but everyone says *leads* so in the interest of consistency, we will, too). And there are *lead holders*, which are like mechanical pencils, but use much thicker leads. Use whichever kind you prefer. I've used all three on the same page.

Lead is graded according to how hard or soft it is. Here's the scale, from soft to hard:

Soft 6B•5B•4B•3B•2B•B•HB•F•H•2H•3H•4H•5H•6H **Hard**

Really soft lead gets your page dark and dirty very quickly. It smears easily and takes forever to erase. It can also build up a residue that makes it hard for ink to stick to the page. Using a very hard lead is kind of like drawing with the point of a steak knife. It leaves a very pale mark, and if you aren't careful, leaves a deep groove in the page that can trip up your ink line.

Many graphic novelists use more than one kind of lead as they work. I like to use a 3H or 4H for lightly blocking things out. (I draw with the side, not the point, to avoid digging into the page.) Then I'll go in with an H or 2H for the rest of the drawing. Your preferences may be quite different, and may change from day to day depending on the paper you're using and how humid it is. Keep a variety of leads on hand. Mechanical pencil leads come in different thicknesses; 9 mm, 7 mm, and 5 mm are the ones I see most often. Before you buy any, check which size your pencil takes.

Mechanical pencils never need sharpening, but if you've got a heavy hand, the leads can break very easily, which can be frustrating. For wooden pencils, get a motorized sharpener, and keep a craft knife and sandpaper block handy for when it decides to stop working. If you're using a lead holder, you'll need a little barrel-shaped sharpener called a *lead pointer*.

A plentitude of pencils.

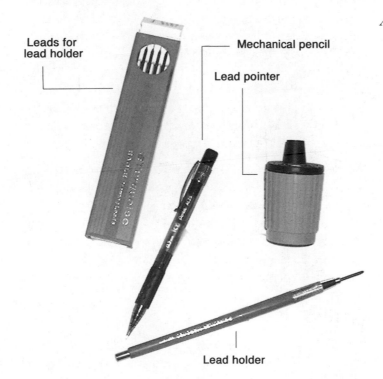

Leads for
lead holder

Mechanical pencil

Lead pointer

Lead holder

Erasers

I use several kinds of erasers. A kneaded eraser is a little piece of gray putty that doesn't crumble away into nothing as you use it. It picks up graphite, and when it gets dirty, you knead it into a new shape until it's clean on the outside. Put it down when you aren't using it, because it also absorbs skin oils, and that gets

nasty after a while. The kneaded eraser is wonderful when you want to lighten your pencil marks without getting rid of them entirely. You can just drag it lightly across the drawing to do that.

Use a smooth white plastic eraser to erase pencil lines thoroughly. The standard 2-inch block shape is great for larger areas. When you need to be precise and erase the left eye on a gnome in the background, use a retractable eraser like the Sanford *Tuff Stuff Eraser Stick*. Don't use any kind of abrasive eraser for getting rid of pencil marks. They tear up the paper. If they're dry, they leave a nightmarish pink stain on your work.

Electric erasers are low-level power tools, and are a lot more expensive than other kinds. (*Expensive* in this case means 70 dollars instead of 70 cents.) They're indispensable for one task, though. They can erase ink. If you buy one, make sure to buy the ink-erasing refills, because the other ones won't do you much good.

A drafting brush is a great thing to have on hand, too. It's just a big, soft-bristled brush for sweeping eraser crumbs off your drawing. Your hand doesn't do this job nearly as well, and the less skin oil you get on your pencils, the better.

Make as many mistakes as you want.

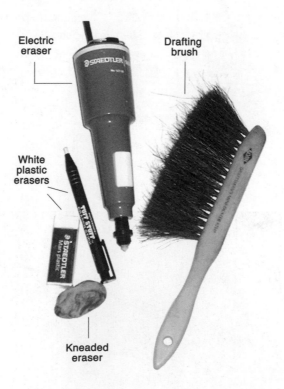

Electric eraser

Drafting brush

White plastic erasers

Kneaded eraser

A Bad Shave

Don't use a plastic straight-edge with a metal knife.

Rulers

The ruler I use the most when drawing is clear plastic, 18 inches long, and covered with a grid of thin red lines so that I can line up things in my drawing, even if the ruler is covering them. I also have an 18-inch metal ruler for when I need to cut a straight line.

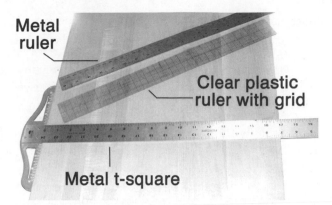

Metal ruler

Clear plastic ruler with grid

Metal t-square

These things rule.

T-Square

Get a metal one with ruler markings on it. It should be at least long enough to reach the full width of your drawing paper. Add a clear plastic triangle with a beveled inking edge and you're ready to draw perfect horizontal and vertical lines.

Tables

The most important thing about where you draw is this: you need a smooth surface that tilts. Most graphic novelists have professional-quality drafting tables. If you don't have the money or the space to set one up, get a good sturdy lapboard and brace it against something that won't move. There are two big reasons you want a tilted surface: your perspective and your spine. When drawing, you want to see the entire page from roughly the same distance. If you're upright and the table is flat, the top of the page is a lot further from your eyes than the bottom, and some strange distortions creep into your work. And to compensate for this, you'll find that you tend to lean out over the board, ruining your posture and reshaping your spine into something like a question mark.

A graphic novelist, the idol of millions, using his lapboard.

Light Box

There will be lots of times when you want to replicate a drawing. Say you drew the perfect face in your sketchbook, and now you want it on your final page of art. You could copy it, but you'd get the same results faster if you traced it. Two-ply Bristol board is too thick to trace through, unless you have a light box.

Shining light through paper makes it easier to see through. A light box is a translucent drawing surface with a light behind it. You can buy one in an art supply store, make your own, or improvise one by taping your paper to a window on a sunny day. (I briefly used a frosted plexiglass window from a junk store, put a lamp on the floor between my legs and did my tracing using the glass like a lapboard. You can do this, too—but please, please, *please* be careful and don't cut yourself.) For ways to make your own, type "make a light box" into Google. There are dozens of sets of plans on the web. Look for ones that call for fluorescent light. Ordinary incandescent bulbs get hot too quickly.

Assembling Reference

Reference falls broadly into two categories: the kind that helps you get the details in a drawing correct, and the type you use to improve your academic draftsmanship. No one has any quibbles with the first. The second can sometimes be troublesome.

Get It Right

As I mentioned in Chapter 11, getting details right is hard, but it makes an enormous difference in your storytelling. Your readers may not be able to accurately describe the uniform a Chief Petty Officer of the Coast Guard wears, but they'll know when you've got it wrong. And is it an African or an Indian elephant that has the bigger ears? And what sort of support harness does a cave explorer wear when prusiking her way up a limestone wall using single-rope technique?

In Hollywood, they hire experts to answer such questions. If you can find an expert who'll help you for no compensation other than the glory of Truth in Art, great. Otherwise, you've got books, magazines, and the web. Gather pictures of everything you need to draw but don't know how. Mark the pictures in books and magazines with Post-It notes so you don't have to waste time searching for them again. Keep the magazines and any clipped photos in a file folder near your table. Any digital photos belong in their own designated folder on your computer.

Using Models

Reference isn't just for making your drawings more authoritative and accurate. It can make them better, too. This is a tricky thing, full of all sorts of aesthetic,

Nat Sez: Ask Your Writer

Good writers do research. If you're collaborating with one, call that writer first with your questions or reference requests.

moral, and even legal gray areas. Fine artists and illustrators have never hesitated to use live models. It's part of the tradition, and (crude insinuations aside) there's never been any stigma attached to the practice. And from the earliest days of photography, artists of all sorts have used photographs as source material when they work. Making a complete drawing from life can take a long time, and some poses are difficult to hold. Even keeping the same smile on your face for 60 seconds is tough. A graphic novel can consist of hundreds and hundreds of pictures. Who has time to pose that long?

Photos are full of useful information for graphic novelists. You can certainly come up with four or five different poses to fit a description like "Bob sat in a chair," and if Bob does a lot of sitting, you'll run through them in a couple of pages. Ask a model to sit in a chair though, and you'll get a pose you wouldn't have thought of, with lots of interesting things happening in the tilt of the head, the placement of a hand, how the feet arrange themselves, how the clothing wrinkles, and how the light falls across the figure. And you'll save time, because you'll be able to interpret the anatomy instead of having to construct it from scratch. Many artists working in a wide variety of styles use the information in such photos to help produce better drawings in less time.

For some reason, however, people still regard drawing from photographs as "cheating." I don't think there is such a thing as cheating in art—but there is plagiarism. An artist can get into trouble producing a drawing that's too close to a photograph that someone else took. Use information from published photos, but don't copy them directly. You're always safe if you take your own photos. If you're producing a close likeness of the model, however, you may want to get a *model release*. This is an agreement, signed by the model, that you have permission to use the model's likeness. (You can find standard release forms to print out and use on the CD-ROM that comes with *Business and Legal Forms for Illustrators* by Tad Crawford.)

I won't tell you to use them or not use them, but creating a graphic novel takes a lot of work, and I think it's foolish to automatically reject what can be an extremely useful tool.

Photo referencing doesn't automatically raise the level of everyone's work, though. It's hard, for example, to imagine that Charles Schulz's *Peanuts* would have been improved by it. Photos also offer traps to the unwary graphic novelist. I've seen nice, loose layout gestures turn stiff and posed when an artist tries too hard to make a drawing match a photo. Distortions in perspective creep into a picture. Sometimes when an artist creates a character out of the imagination, then uses photo reference to help with a panel or two, those panels look out of character. The effect is like a sudden switch of actors in the middle of a film. Clint Eastwood lowers his head to light a cheroot, the hat obscures his face, and when he looks back up, he's Brad Pitt. The camera cuts away, comes back, and there's Clint again. Not a good way to immerse your audience in the story, is it? Avoid making pictures that are too much model and not enough character.

Photos are packed with visual information. Keep in mind that not all of it is relevant to your work. Your job when looking at that photo is to take what's useful and *discard anything else.* If your graphic novel is drawn in a clean, flat, decorative manner, then that beautiful chiaroscuro lighting on your model is a distraction. Ignore it, or your readers will wonder why a film noir heroine suddenly walked onto the set of your Technicolor romance. And if you've been drawing clothing with a minimum of folds in the drapery, copying a real model's clothing too closely is going to make it look like your hero snuck off between panels to take a nap in his suit.

The axiom to remember is this: "Use your photos, but don't let them use you."

Reference from the Web

Many types of visual reference are easily accomplished online. Just type whatever you're looking for into Google's image search and you'll get dozens of great pictures. Other things can defy even the most dedicated searcher. With experience, you'll learn what's easily available online and what's going to require a trip to the library.

Blowing Up Your Thumbs

You've got tiny thumbnails and a big sheet of drawing paper. You need a bridge between the two. You could just eyeball and redraw the layouts on the page, but you've already done some nice composing in your tiny little scribbles, and it'd be a shame to waste time reinventing the wheel. Here are two techniques that'll save you some of that drudgery.

Have Your Digital Slaves Do It

With a scanner and an image manipulation program like Adobe Photoshop, you can blow up and manipulate your thumbnails. And if you have a printer big enough, you can even change their color and print them out directly on your final drawing paper.

◆ First, scan your thumbnails, crop them very closely, and expand them to your final art size using the Image Size command in the Image menu. Unless your thumbnails are very detailed, 200 dpi is plenty.

◆ Open the Image menu, choose Adjustments, then choose Levels from the pop-up submenu. Push the black triangle slider under the Input Levels graph to darken them.

◆ If you are going to light box the thumbnails, you can print them. If you don't have a big enough printer to do this as one sheet, use the Rectangular Marquee tool to select portions of the page, paste them into their own new documents, then print them out.

If you do have a color printer that's big enough to handle your drawing paper, you can "blueline" your art. Do this:

♦ First, draw a box in Photoshop the same dimensions as your original art. Under the Select menu, choose Select All. Then under the edit menu, choose Stroke. In the box that pops up, choose 5 pixels and center.

♦ Give it some breathing room by opening the Image menu, choosing Canvas Size, and adding half an inch each to the height and width. Open the Image menu, choose Mode, then choose RGB Color from the pop-up submenu. Save this as "blank10by15page.tif" or something similarly easy to identify.

♦ Open your thumbnail and paste it onto the box. Push it around using the Move tool until it's placed where you want it. (If you know what you're doing in Photoshop, you might want to tweak your thumbnails here, moving things around and changing the size of various elements.)

♦ Save it with a name like bookname_pg01_thumb.tif and put it in a new folder with a name like "bookname_thumbnails." The name you choose doesn't matter so long as you keep your file names consistent and understandable by you and anyone else who needs to see them.

♦ Open the Image menu, choose Adjustments, then choose Hue/Saturation from the pop-up submenu. Check the box next to Colorize.

♦ Wow! Your thumbnails aren't grey anymore. Push the Hue, Saturation, and Lightness sliders around and your art will change color. Pick a color you'd like to pencil or ink over. Blue is a common choice, so this technique has become known as "bluelining." I switch to orange or green once in a while so I don't use up all my blue printer ink. The important thing is that you don't want anything dark because you don't want the ghosts of your thumbnails showing up too much when you scan the final art. Print them light and they'll be easy to clean up later.

♦ Not all printers can handle heavyweight drawing paper without jamming. Look for ones that can accept heavy stock or cardstock. I've used both HP's Officejet K850 and the Deskjet 1220 for years, but there are plenty that will work.

The Low-Budget Way

You can transfer your thumbnails onto your final sheet of drawing paper by using a photocopier to blow them up to the final size and tracing them using a light box. Tracing is a *lot* faster than redrawing. Here's how you blow them up to the right size.

Go to a copy shop. Bring a calculator and a ruler or borrow them from the person behind the counter. Punch the following into your calculator, in this order:

♦ *First:* The height you want your page to be (in any unit you like—inches, centimeters, bullet lengths, whatever)

♦ *Then:* The "divided by" key

♦ *Then:* The height of your thumbnails (in the same units as the first number)

♦ *Then:* The "multiplied by" key

♦ *Then:* The number 100

♦ *And finally:* The "equals" key

So if you want to draw a page that's 15 inches tall, and your thumbnails are 9 inches tall, you'd get this:

$15 \div 9 \times 100 = 166.6667$

There's your answer. You want to enlarge your thumbnails by 167 percent. (Just round off the part after the decimal. Photocopiers don't care about those little numbers, so why should you?)

If you drew your thumbnails in ink, the regular darkness settings will be fine. If you did them in pencil, most machines will lose some detail unless you push the darkness as far as it'll go.

Now just tape one of those big photocopies to your light box, then tape your art board over that. Turn off the light in your drawing area, turn on the light box, and you're ready to trace.

Work lightly, and dig into the paper as little as possible. Turn off the box once in a while to see what your pencil lines really look like. They'll be a lot darker than you thought they were when they had a light shining through them from behind. It's common for light box tracings to look a little stiff and lumpy when you first start working that way. Don't worry. This isn't your final art, just a way to transfer your layouts.

Here's an important thing to remember: photocopies often distort your enlarged image slightly, so rule out your image area in pencil on the board first. If you plan to let your images *bleed* outside the live art area, measure the bleed area, too.

Stick to Your Regular Size

Once you find a size you like thumbnailing at, stick to that size and you won't have to recalculate what percentage to blow them up.

Bleed

A **bleed** is when a printed image or the ink runs all the way out to the edge of the paper. The orange-bordered cover of this book bleeds, as do the gray-bordered pages marking Parts 1, 2, and 3.

Letting Your Live Art Bleed

Printing presses need something to grab when they pull your paper through their works. The part they grab is apt to get a bit mangled by the process, so those edges are trimmed. Artists put crop marks on their page to indicate where this should happen. The tricky part is that paper moves around a bit as it's printed, so the trimming might not happen where you want it. The

solution is to draw inside the *live art area* on pages that don't bleed, and out past the crop marks on pages that do. You can read more about this and other production matters in Kevin Tinsley's invaluable *Digital Prepress for Comic Books*.

You'll notice that in the bleed illustration, I drew the picture a little further out than space cordoned off by the crop marks. That's so that when the paper is trimmed, the art will reach all the way out to the edge even if the trimming is a bit off target.

Some of the bleed gets trimmed away.

If you don't plan on letting your art bleed, just make sure to draw all of your pages at the same size. If you want to use bleeds and someone else is publishing your graphic novel, talk to them first. Sometimes bleeds cost more to print, and they may have budgetary limits. If you're publishing it yourself, talk to your printer and find out what it will cost, if anything.

The Least You Need to Know

◆ Work at a tilted drawing surface.

◆ Art suppliers offer a wide range of options. Experiment and choose the tools that work best for you.

◆ Use a photo reference to make your work faster and more accurate and to help avoid formulas. Don't replicate another photographer's work.

◆ Enlarge your thumbnails to the size you want to draw at, and trace them onto your final page using a light box, or print them in a light color on the paper you plan to draw on.

◆ Talk to your publisher or printer before drawing art designed to bleed outside of the live area.

Digital Tools

In This Chapter

- ◆ Photoshop and alternatives
- ◆ Graphic tablets and drawing on the screen
- ◆ 3-D software for 2-D comics

In 2003, when Nat and I wrote the first edition of this book, drawing the black-and-white art for a graphic novel was pretty low-tech. The basic tools—paper, pencil, brush, and ink—would have been familiar to an illustrator working in 1900. Since then, most artists I know have incorporated digital elements into almost every part of their creative process.

Image Editors: Photoshop and More

The art in your graphic novel is going to be converted from marks on paper to pixels on a screen. It's unavoidable. Are you doing a print comic? Printers want digital files. And comics on the web are digital by definition.

Your art's going to be made of pixels, so if you want to control what it looks like, learn how to push those pixels around. That's where image-editing software comes in handy. You have a bunch of options, depending on what computer system you have, how powerful it is, and how much money you have to spend.

Photoshop

It's hard to know where to start when discussing Adobe Photoshop. It's so widely used and so tremendously useful that people have filled dozens of books with tips, tricks, and techniques. We've only got room here to glance at some of the things you can do with it.

◆ Change the size of your image—both the physical size it'll print at and the number of pixels that make up the image.

◆ Grab parts of your art and move them around, or change their shape. Is that eye a little low? Move it up! Is that door a little squat? Stretch it!

◆ Layer different elements into one picture. Took a photo that would make a good background? Lay it on the page where it belongs, and convert it to outlines. Then scan that sketch of your character from your sketchbook, put it in the background, and ink them both with the same digital brush.

◆ Lighten your line-art to clean up stray pencil marks, or darken it to beef up fragile line-work.

◆ Create custom brushes and draw with any lines or textures you can imagine.

◆ Convert your art from one type of digital file to another. Printer wants .tifs but your web guy wants .jpegs? Not a problem.

Photoshop isn't cheap. The latest version (which, as of this writing is their eleventh, but it's called CS4) costs almost $700 retail, though there are bargains to be found. Students and teachers can get it a lot cheaper, and if you don't mind losing some of the latest features, you can find older versions for reasonable prices, too.

The GIMP

For some artists, any amount of money is too much. For them, there's the GIMP. Despite its odd name (an acronym for GNU Image Manipulation Program), the GIMP is a powerful image editor, and it's absolutely free. It has an enormous range of tools and features that almost rivals those of Photoshop. Most of the features it lacks are of little use to a graphic novelist. But there is one big disadvantage to the GIMP—it isn't designed to handle *CMYK images*. (CMYK is an abbreviation that indicates the kind of digital files that you'll need if you are printing your graphic novel—or even its cover—in color. We'll talk more about CMYK in Chapter 22.)

Still, you can do plenty of useful and important things with it. Is the GIMP right for you? It doesn't cost anything to find out. Go to www.gimp.org and download a copy.

Manga Studio

Photoshop and the GIMP are extremely versatile tools for all sorts of graphic artists. There's a downside to this: they're full of tools and options and settings that clutter up the interface, but will never be of any use to you. Wouldn't it be great if someone made software designed specifically for the work a graphic novelist does? That software exists, and it's called Manga Studio.

Manga Studio is a Japanese program distributed in the United States by Smith Micro. It comes in an inexpensive lite version, Manga Studio Debut, and a full-featured, professional edition, Manga Studio EX. Among its many Photoshop-ish features, Manga Studio EX offers some great tools created to help you make comic books.

◆ Brush strokes that are easily edited after you've drawn them. Click and push a slider to make them thicker or thinner.

◆ Perspective tools that will automatically guide your lines right to your vanishing points.

◆ Tools for quickly adding tone, speed line, and burst line effects.

◆ Tools designed to make comics lettering and ballooning easy.

◆ Tools for importing 3-D models and converting them to line art.

◆ Built-in page layouts.

Go to http://my.smithmicro.com to learn more about Manga Studio.

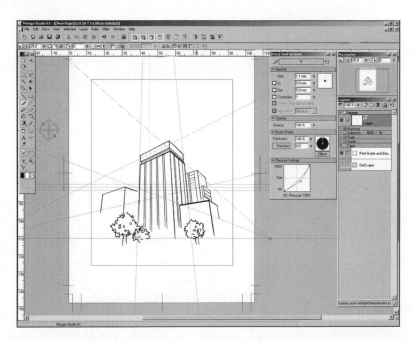

Manga Studio EX's Perspective Tool.

Post-Paper Possibilities

Whether you're drawing directly in a computer program or refining a scan of a drawing you did on paper, one thing is certain: you don't want to do it with a mouse. Your mouse is great for moving a cursor around a screen, but it's not designed for the long hours of precision work a graphic novel requires. Trying to control a mouse that carefully for a couple of days will put you well on your way to a repetitive stress injury, and then you won't be drawing at all.

There's a reason the basic cylindrical shape of the pen hasn't changed much in a thousand years: it works. Drawing with a pen feels natural and comfortable. You shouldn't give that up just because you've moved into the digital realm.

Graphic Tablets

Graphic tablets have two parts: the tablet, which is the part you draw on, and the pen, which is the part you draw with. Most of the tablets connect to your computer with a USB cable, though one bluetooth model is available, and I'm sure more are coming. The pen generally isn't connected to anything (and it costs a lot to replace, so don't lose it). The tablet has a drawing surface on it. Move the pen across the drawing surface and your cursor on the screen moves, just like a mouse.

Unlike a mouse, however, a good graphic tablet is *pressure sensitive*, just like the art supplies you already use. Push harder and get a darker line. Or wider. Or more jagged. You can easily customize exactly what that pressure means. Some of them are also *tilt sensitive*, which means the tablet can tell what angle your pen is touching it and change your brushstroke accordingly.

Nat Sez: "Able" Is in "Tablet" for a Reason

Steve is enthusiastic about his tablets, but his enthusiasm is earned. Really, the entire About Comics production studio is a scanner, a laptop Macintosh, a pile of software, and a Wacom tablet. I've replaced my primary computer four times since I got the Wacom, and it keeps working fine (leaving me no excuse to spend money on a newer, prettier one, dadgummit!). Stuff the laptop and the tablet into my laptop bag and I can do art touchups anywhere.

There are many brands of graphic tablet on the market. I only recommend one: Wacom (pronounced "*walk-em*"). They have three lines of tablets on the market right now: Bamboo, Graphire, and Intuos. Various models within these lines have been introduced and cancelled and re-issued with new features in an assortment of sizes. So long as they're compatible with your computer, they're all useful. Some artists prefer very small models for their portability and because they can move their hand across a small area faster than a big one. Others prefer midsize tablets because they want to give their arm some room to swing when they draw. I haven't met anyone who likes the largest ones, but I'm

sure those people are out there, too. The current models all have *express keys*, buttons built in to the tablets that you can customize to mean whatever keystroke or combination of keystrokes you like. Express keys are super-handy, and can save you a lot of time and effort over the course of a project.

Another big difference between the various Wacom tablets is the *levels of sensitivity*. The Bamboo and Graphire models have 512 levels, while the Intuos have 1024. When you're just sketching, you won't notice much difference. But when drawing pressure-sensitive lines with subtle changes in width, the changes may—*may*—look and feel a little abrupt. The artists I've polled disagree about whether or not the difference is noticeable, but every one of them agrees that a Wacom tablet is an important tool for anyone who wants to make comics.

I can't anticipate your preferences, so find a store that will let you try them all out and see which one you like. You might also be able to find a used one. I'm usually wary of used tech, but this is a pretty safe bet. Wacom's tablets are among the most reliable products I've ever used. I've never even heard of one that stopped working.

Draw on the Screen

Graphic tablets are wonderful, but an artist has one significant hurdle to overcome when using them. You're pushing your pen across the tablet, but your eyes are on the monitor. In my experience, this is something everyone gets used to quickly, but no one ever adjusts to it completely. We all thought it would be a lot easier if you could put your pen directly on your monitor, where the art is. A few years ago, technology like this was a pipe dream. Now it's just another tool available to any graphic novelist with an extra thousand dollars or so lying around (which to many graphic novelists makes it still a pipe dream).

Wacom doesn't just make the only graphic tablets worth using. They also make the Cintiq (pronounced "*sin-TEEK*"), a monitor you can draw on. Touch your pen to the screen and there's the cursor. Push harder or tilt your pen and the cursor responds accordingly. It seems almost magical watching your art change as you move your pen across the screen.

The Cintiq comes in two models right now, the 12WX and the 21UX. The 12WX is the smaller of the two. It's portable, with a screen that's 12 inches diagonal, and it weighs about 4½ pounds. The 21UX is a lot bigger, and at 22 pounds, isn't portable at all. With its sturdy build and 21-inch diagonal screen, it can seem more like a small piece of furniture than an input device. But it's not unwieldy; you can easily rotate the screen and adjust the angle to whatever's most convenient.

Every artist I know who tries a Cintiq falls in love with it, and everyone who owns one, myself included, would hate to live without it. Fortunately, like Wacom's tablets, the Cintiqs have proven super-reliable. Despite all the things that could go wrong with such a complex device, it's extremely rare that anything ever does. And if you need it, their tech support is superb.

So what's the downside? This kind of quality doesn't come cheap. As of this writing, the 12WX costs $999 and the 21UX is $1,999. They never seem to go on sale, and you almost never see anyone selling one used. Do you need one? Artists have managed perfectly well without the Cintiq for a couple thousand years. But once you've tried it, you will wonder: "How?"

The portable Cintiq 21WX and the not-so-portable Cintiq 21UX.

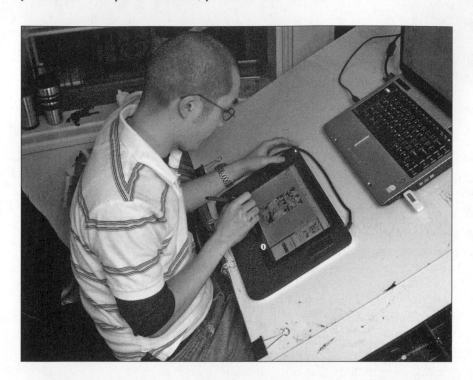

Take Two Tablets and Call Me in a Couple of Years

One option that doesn't seem to be viable yet for graphic novelists is the tablet PC. It should be a natural: combine the pen-sensitive screen of a Cintiq with a good laptop and create a single portable tablet computer that an artist could carry around like a sketchbook. Several machines come close, but as of this writing, there aren't any that I'd want to work on.

3-D Models

In Chapter 14, I talked about how helpful it is to get a reference for your drawings. If your story calls for a shocking moment when the heroine emerges from the bad guy's BMW, you don't want the car to look like the hero's Hyundai. Those vehicles need to be identifiable from any angle. Alas, for many artists, drawing cars is difficult and unenjoyable, and it can take a long time to get them right. The reference you found might give you a good idea what that BMW looks like from the side, but that won't be much help in drawing it from directly overhead or behind. In the old days, you'd need to find pictures of the same model car from multiple angles, or buy a die-cast toy and draw from that. Now there's an easier, faster way.

Go to http://sketchup.google.com and download Sketchup, a free 3-D modeling program. Then point your browser to Google's 3-D warehouse, http://sketchup. google.com/3dwarehouse/, a collection of thousands and thousands of 3-D models. They have vehicles, buildings, furniture, interiors, military equipment, and more. Just download a model, open it in Sketchup, rotate it to the angle you need, and export it as a 2-D image. You can resize it, print it out and light box it, or add it to scans of your thumbnails in Photoshop.

It's hard to exaggerate how useful this is. Instead of expending time and energy painstakingly constructing complicated things like cars and architecture, you can concentrate on just telling your story. Be careful—you're still going to need an understanding of perspective to place your Sketchup model correctly. If you show a car from a low viewpoint riding on a street viewed from higher up, it's going to look like the car is about to flip over. Less-obvious mistakes in perspective will still feel subtly wrong to the reader. And make sure when you ink over a Sketchup model that you use line weights and textures that match the rest of your story. Otherwise your people and your props and vehicles will look like they come from different worlds. Sketchup is a great tool to help speed up your drawing, but it isn't a substitute for knowing how to draw.

Poser's Possibilities

The old masters worked from live models. Illustrators and comics artists have used photographs of models for more than a century. When these options aren't available or practical, artists often resort to a posable mannequin. Mannequins don't cost much, they're ready to help out 24/7, and they don't complain when

Your Friends at Formfonts

The 3 D warehouse has tons of models, but there will be times when it doesn't have the one you're looking for. At Formfonts.com, an annual subscription fee gets you access to their library of thousands of professionally designed 3-D models. And in case that model you need isn't in Formfonts's library either, their designers regularly take subscriber requests to custom-build what you're looking for.

you ask them to hold an awkward or uncomfortable pose. The downsides are that a mannequin only offers one set of proportions to work from. A mannequin built like Oliver Hardy isn't going to be much help when you have to draw Stan Laurel. Mannequins don't have anywhere near the range of movement a real person has, and their features are either generic or entirely absent. And unsurprisingly, their poses tend to be, well … *wooden*. Poser is a software program designed to solve most of these problems.

Poser lets you create customizable, posable 3-D mannequins, light them from multiple sources, and export them as digital images you can draw from or incorporate directly in your art. It's grown more powerful with each version and comes with a remarkable library of human and animal figures, stock poses, hairstyles, props, and facial expressions. These features solve a lot of the problems of real-world mannequins, but the wooden, stiff quality is still an issue.

Don't just import poser figures into your comic. They tend to look like what they are: mannequins holding a pose rather than living, breathing people. But if you're having trouble drawing your character from a tough angle or you're not sure how the light would fall on your villain when he stands in front of a roaring fire, Poser can be a handy tool.

The Least You Need to Know

- Get an image-editing program.

- A Wacom tablet makes drawing with pixels a lot easier.

- Download Sketchup and use models from the 3-D warehouse.

- Place your 3-D models in correct perspective, and ink them so that they match the look of your story.

Chapter 16

Drawing for Graphic Novels

In This Chapter

- Drawing with simple forms
- Using perspective
- Creating gestures
- Seeing light and shadow
- Penciling for an inker

Penciling is tough. Let's get that out up front. I know dozens of graphic novelists, and not one of them is ever happy with the work they do. It can take an artist years of effort just to acquire the most basic skills, so prepare yourself for some frustration.

It's not enough to know how to draw. You have to excel at a number of things at the same time. To tell a comic book story, you have to unlock the mysteries of both form and content.

What the Job Requires

On the content side of things, you cast character types and in a way actually act out their parts by creating gestures and expressions for those characters. You make decisions about costuming, props, set design, lighting for mood and clarity, "camera" placement and focus, and pacing. Your choices determine the tone and character of the story—how light or how moody it is, its naturalistic or fantastic qualities. You can shift the meaning of a narrative with the change of the width of a line or two in a face and you can construct or subvert key metaphors just by shifting the viewer's angle.

The formal problems are an entirely different set of concerns, and you share them with every graphic artist. A panel isn't just a story unit. It's also a piece of two-dimensional graphic design. And if you're drawing your panel in three

dimensions, composing in depth, you have to carefully arrange the forms in space as well. These arrangements have to work not only as individual panels but across the page and throughout the story as a whole. And the graphic novelist has to know when to keep things unified and when to blow the unity for expressive purpose.

Dealing with all of these at once is a lot like juggling. Juggling one ball is just a simple motor skill; two is a little tougher; three takes some practice. Each new ball you add increases the difficulty. A graphic novelist has to keep a lot of balls in the air.

How to Learn to Draw

A book this size can't teach you how to draw. Nor can a half-dozen textbooks. You learn to draw by *drawing*. Pick up a sketchbook, a kneaded eraser, and an HB pencil and spend some time drawing from life. You'll make mistakes, and the drawings won't be very good. That's fine. The work you do while learning to draw isn't art. It's exercise. You have to teach your brain how to observe line, light, pattern, and form. No advice or problem-solving technique that you read in a book will do you any good unless you've tried to solve the problem yourself.

If it'll hold still, draw it.

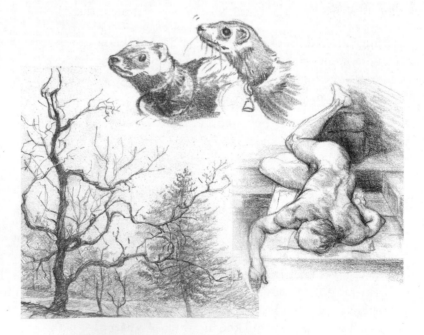

Some Good Books

Here are a few books full of lessons that can improve your drawing:

- ◆ *Drawing on the Right Side of the Brain* by Dr. Betty Edwards is a classic in the field of art instruction. That's because it works. Do the exercises in this book and you'll quickly get better at drawing from observation and will develop skills to improve your drawings from imagination.

◆ *How to Draw the Human Figure* is a fine collection of lessons adapted from the renowned correspondence school, Famous Artists School. The lessons in this book were prepared by some of the top illustrators of the mid-twentieth century.

◆ *Atlas of Human Anatomy for the Artist* by Stephen Rogers Peck offers a thorough analysis of the bony and soft-tissue structures that make up the human form. This a great book to keep with you when drawing from a live model. It's more than 50 years old and has been reprinted dozens of times. Luckily, human anatomy hasn't changed much in recent years.

◆ *Successful Drawing* by Andrew Loomis is another great book that's more than a half century old. Unfortunately, it hasn't been reprinted, and when copies do turn up they cost a fortune. It's such a useful book that I wouldn't be surprised to learn that overzealous art students have scanned it in its entirety and made every single page available for free download on the Internet.

Simple Forms

It's important that the drawings in a graphic novel be fueled by observation. Drawings carry their message by reminding their viewer of things from the real world. Unfortunately, graphic novelists almost never actually get to draw from observation. It's tough to cram a pirate ship into your studio, and Atomicus is usually too busy fighting the Neutron Mom to hold a pose for more than a minute or so. Artists, then, have to contrive their pictures, constructing them from imagination; reference; and their understanding of anatomy, perspective, light, and form.

Simple geometric forms are the basis of everything you draw.

For instance, I didn't have any cyborgs lying around the room when I drew The Bot's robot armor. As you can see though, I was able to build the drawing out of boxes, wedges, tubes, and spheres. And you know what? That's how I draw almost *everything*. Anything a graphic novelist needs to draw can be built out of simple geometric forms.

This even applies to people. To construct a convincing figure, you first build a mannequin out of simplified forms, the way I do in the next picture. Many artists use an assortment of cylindrical and box shapes. Others work with amorphous forms. Several animators I know draw the torso as "a half-full sack of flour."

Use geometric or organic forms.

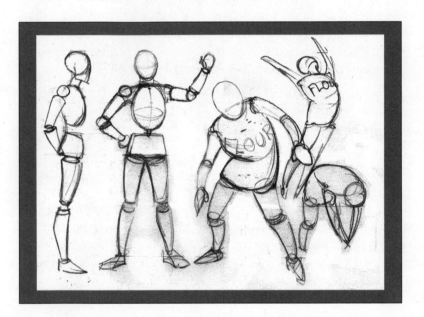

Learning to construct and pose the human figure means first learning to manipulate those simplified forms. The best way to do this is by drawing real objects in front of you, but you can jumpstart the process by spending some time tracing photographs.

Lay a piece of tracing paper over a good, clear photograph of a person. Then trace over the photo, ignoring specific details and breaking the drawing down into basic forms. Don't worry about the subtle forms where things connect. If you're just getting started, don't worry about anything more difficult than tubes, balls, and boxes. Subtleties come with study and practice.

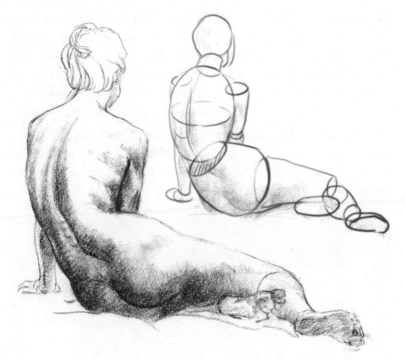

Converting photos to mannequins will teach you how to invent your own figures.

Depth

Unless your characters live in a highly stylized abstract environment, you're going to need to do more than just draw them flat on the paper. You'll need to create some kind of illusion of three-dimensional space. Depth creates visual excitement. Flatness can be elegant, but it can also quickly bore the reader. And many stories demand pictures that show how far away the coach is, or how close the Squirrel Hill Strangler is to his victim fleeing toward the apartment door. There are a number of techniques for doing this, including the following:

◆ Linear perspective

◆ Aerial perspective (also known as *atmospheric perspective*)

◆ Overlapping

Linear perspective is the technique that creates the most accurate illusion of depth. Its principles were first demonstrated in Renaissance Italy, and they haven't changed since then. Linear perspective works on the principle that the size of objects seems to diminish as they recede into the distance. Linear perspective seems difficult at first, but a diligent artist can learn everything he or she will ever need to know about the concept in a day or two. *Perspective for Comic Book Artists* by David Chelsea explains it well, and in comics format instead of plain text. *Successful Drawing* by Andrew Loomis, which I mentioned earlier, has a section on perspective that's thorough and clear. There's even a good lesson on it in *How to Draw Comics the Marvel Way* by Stan Lee and John Buscema.

Aerial perspective is an effect you've probably noticed. As things get further away, particles in the atmosphere make them look bluer and less distinct. (Remember singing about "purple mountain majesties"?) A color graphic novel can get this effect by using cooler colors in the background. In black and white, it's achieved by increasing the line weight, contrast, and amount of detail on the stuff you've drawn in the foreground. I'll talk more about this in the chapter on inking.

Overlapping is the simplest way to create depth in a picture. It's also extremely effective. In the group shot nearby, it's unmistakable that the chairs are closer to us than the speakers, and that Yeo is in front of Terry and Derrick. Always be on the lookout for ways to have your characters overlap and be overlapped by part of their environment.

This panel uses linear perspective, overlapping, and a form of aerial perspective.

Larger objects generally seem closer than smaller ones, particularly if there are no other depth clues. Objects nearer the bottom of the panel will sometimes appear to be closer than those at the top. A lot of non-Western and pre-Renaissance art works this way.

Acting Out: Finding the Right Gesture

Graphic novelists practice a silent art. Readers can't hear the words in the bal-loons, so what they say is only a small part of what your readers will learn about your characters. Most of the impressions readers form will come from what you show your characters doing. Consider the two panels of Terry and Derrick explaining things to Yeo in the next picture. In the first, Terry is helpful and Derrick is mildly irritated. In the second, she's furious and Derrick is heartbro-ken. The words are exactly the same. It's the gesture that gives them context.

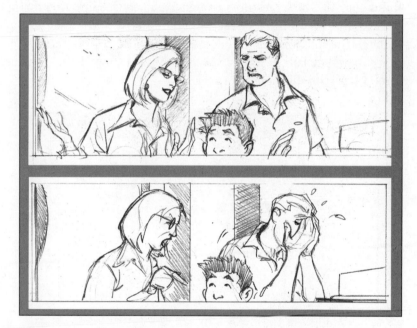

The gestures you draw will affect how readers "hear" the lines.

Coming up with gestures is one of the most enjoyable parts of illustrating a graphic novel. Most cartoonists have an urge to play-act, to perform in front of an audience. Gesture drawings are acting on paper. They're your chance to inhabit your characters, and even to ham it up a bit.

Gestures are a lot of fun to draw. Most artists scribble them out as either scribbly shapes or modified stick figures, then bulk them up to tube and box mannequins.

How can you get good at creating gestures? Do you have to ask? *Practice.* Keep a sketchbook with you and draw. Draw in the doctor's waiting room. Draw your co-workers at lunch. Don't worry about creating polished likenesses. With ges-ture drawings, the goal is to capture the essence of a pose.

Do plenty of real-life observation. It's crucial. People carry themselves in all sorts of interesting and revealing ways. Next time you're at a shopping mall food court, take note of how the people arrange themselves. You'll see the slumped shoulders of people trying to take up as little space as possible. There'll

Modeling Kley

One of the best artists to look at when studying gestures is the German illustrator Heinrich Kley. In Kley's scribbly yet solid pen and ink drawings of people, animals, and mythological beings, he created the unmistakable impression of weight and movement.

Try to make that first stroke capture the whole figure.

be teen boys and girls making all sorts of display postures, showing themselves to be bold, fierce, sensitive, and just plain available. There'll be workers and shoppers carting heavy objects, and you can see how their weight shifts to accommodate these loads.

A few formal techniques will help you create effective gestures in your graphic novel, and I'll explain them in the following sections.

Lay Down the Action Line

Build your full-body gestures around a single sweeping line that goes from toe to head. Start with the foot that's carrying most of the weight, then move up through the hips and spine and up into the head. In my action-line drawings that follow, you can see how I started with the single line, then scribbled it into something more like a human skeleton.

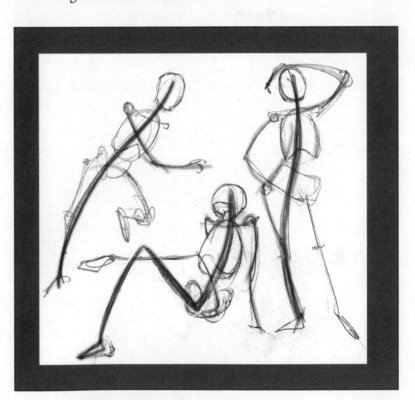

Exaggerate

As I noted earlier, your graphic novel doesn't come with sound. Gestures tell your reader how your characters are speaking, what they're doing, and how they're feeling. To make a 2-inch drawing communicate all that, you're going to have to indulge in a bit of exaggeration. How much depends on your story and your own instincts. Push things too far and you've got a bunch of

loudmouthed hams hogging the stage. Don't push it far enough, and you've got a cast of sleepwalkers who never seem to move. Stand up from the drawing board and take the pose yourself. If you can't act it, you'll have a tough time drawing it. And you should know the reaction you want your readers to have. Making your drawings clear and lively will require a bit of exaggeration; making them funny enough to get a laugh will require a lot more.

Silhouettes with Negative Space

The pictures in a graphic novel are often printed very small, and the readers have to decipher a lot of them. Make their job easier by choosing gestures that read well as silhouettes. Look at the two pictures of Gene in the next illustration. In the first one, his silhouette is cluttered and difficult to read. In the second, it's easy to see what he's doing.

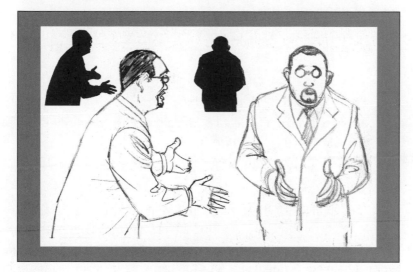

Which silhouette nags like a Hollywood agent?

When you can, position the body so that the elbows are kept away from the middle of the body. That creates an area of *negative space* around the figure that helps the audience read the silhouette more easily. It also gives an impression of movement, particularly if the hands are doing something interesting. Look for ways to keep the legs apart, too. It will lend your poses both clarity and dynamism.

Bodies Should Bend and Twist

Imagine the head, torso, and pelvis as blocks. Unless you're drawing a soldier standing at attention, a butler waiting for instructions, or a patient etherized upon a table, don't point all three boxes in the same direction. Look for spiral movements between the three, with the head leading a turn, the torso and shoulder following, and the pelvis playing catch-up.

WHA...? **Negative Space**

Negative space is the flat area surrounding the elements in your drawings. Negative space is important because it helps make the "positive space" (your drawing) read more clearly. *Drawing on the Right Side of the Brain* shows an excellent exercise in learning to see negative space.

Don't line up the head, torso, and pelvis vertically, either. The three tend to tilt in opposition to each other. For particularly clear lessons about bending and twisting the major masses of the body, look at *Constructive Anatomy* and *The Complete Guide to Drawing from Life*, both by George Bridgman.

Is It Interactive?

Don't just pose your characters. Make them interact with their environments. Your princess will seem more exhausted by her circumstances if she's leaning on the Baron's stable door. When Big Nick loses his car keys, don't just draw him with his hands on his hips, squinting at the floor. Show him on all fours, tossing sofa cushions around and raising a cloud of dust.

Characters should interact with each other, too. It's a crowded world, and people touch or otherwise physically impact each other all the time. Here are some examples of interactive gestures to consider:

- Louanne puts her hand on Norman's knee, and Norm looks at her, amazed.

- Tom emphasizes his point by poking a finger into Mark's chest. Mark puffs his chest out to show he's not fazed.

- Mary tells Jane a lame joke, and elbows her playfully in the ribs as she does so. Jane cringes back, as if being tickled.

- Parker and Ford exchange high fives when they realize that their prank has succeeded.

- Stew pulls on Terri's collar, dragging her out of a party.

These sorts of gestures show your reader how the characters relate to each other. Dialogue is important, but the pictures are your primary tool for making a relationship believable and interesting.

Let There Be Light

Light is an important tool for most illustrators and fine artists. Cinematographers can't do without it. Many fine graphic novelists don't give it a thought.

For much of the medium's history, going back to newspaper strips, cartoonists were restricted to the narrow range of possibilities of their era's printing technology. Their pictures were limited to a value range of pale newsprint gray to blotchy gray-black. Color, if used at all, was likely to be an ill-registered afterthought. And the paper on which pictures were printed was often cheap and coarse-fibered, leading to uneven reproduction. Cartoonists made choices based on what was available, and turned out work that ranged from hackneyed to sublime.

Those limits are gone. Anyone willing to pay for decent printing can have his or her work reproduced more faithfully today than Michelangelo's work was 50 years ago. You've got a much wider range of choices available to you when it comes to reproducing subtleties in hue, saturation, and value.

Given such a range of options, learn how light really works and go from there to create your own stylizations. Break out your sketchbook again. Get a piece of charcoal or a soft lead pencil (4B is good). The exercise I recommend, which was frequently assigned by the great fine artist Thomas Eakins, is simple but effective. Get an egg out of the refrigerator and place it on a flat surface on top of a sheet of white paper. Point one, *and only one*, light source at it. (The sun through a window counts as only one source, but try it at night with an electric light.) Your job is to draw the egg as realistically as possible. When you've done that, move the egg so that the light hits it from a different direction, then draw it again. Rinse, lather, repeat. Why an egg? Drawing an egg's basic shape isn't much of a challenge, so you're free to concentrate on seeing how light shifts as it moves around the form.

Use Contrast

To translate a drawing with a wide range of tones to something that works in stark black and white, eliminate most of the gray. If it's dark gray, make it black. If it's light gray, make it white. Or find graphic equivalents for your gray, using hatching or cross-hatching.

Handing Off the Pencilled Pages

One of the stranger quirks of the North American comic book industry is the division of the illustrator's work into a small assembly line: a pencil artist and an ink artist. Working this way is, in my opinion, an artificial division, but it's common enough that I thought I should mention it.

Artists who intend to ink their own *pencils* develop a shorthand way of indicating their intentions. Some parts of a drawing may be worked out with infinite care, while others get only the loosest indication. The only rule is to do whatever works best for you.

When working with an inker, your penciled page is a set of instructions for what you'd like the finished work to look like. The more carefully you delineate everything, the closer the page will come to the way you would have done it. Some things will require more care than others, depending on your inker's strengths. You should put your greatest effort into drawing faces clearly, because that's where the split between the two creators' visions will show itself. Most inkers have their own palate of brush and pen strokes to indicate textural effects. When it comes to things like foliage, stone, and water, show the inkers what they're supposed to draw and how the light hits it, and they can usually take care of the rest.

Pencils

Pages of comics art that haven't been inked are often called **pencils**. An editor who asks to see your pencils wants to look at your art, not your art supplies.

The Least You Need to Know

◆ Keep a sketchbook and draw people and objects from life.

◆ Build your drawings out of simple geometric forms.

◆ Use linear perspective, aerial perspective, and overlapping to create the illusion of depth.

◆ Start figure drawings with a sweeping action line.

◆ Design gestures so that they read as silhouettes.

Stylize Yourself–Finding Your Voice

In This Chapter

- Choosing a style or letting it choose you
- Experimenting with surface and structure
- Latching on to trends

What most graphic novelists mean when they talk about style is really just handwriting, the superficial mannerisms and habits that creep into an artist's work. I don't think these things are worth worrying about. But every artist wants to create work that's uniquely his or her own. How can you accomplish this in a meaningful way? How does an artist find a style that goes beyond mere surface?

Factors That Influence Style

Graphic novelists are like most people, torn between the urges to stand out and to fit in. Nowhere is the latter more apparent than in the development of popular *styles*. A number of pressures combine to make trends, including the following:

- Editorial pressure
- Commercial pressures
- Admiration
- Technological developments
- Unconscious influence

WHA...?

Style

Style describes the mannerisms, techniques, and attitudes that combine to make a graphic novelist's work uniquely his or her own.

Sometimes publishers wish they were publishing a tremendously popular creator. Call him Joe Popstar. If Joe is too expensive, or too busy, or too difficult to work with, they are going to look for someone else who can reach Joe's audience, or lend that unmistakable Popstar aura to the publisher's line of books. Some will just come right out and say that they want Popstar-type stuff. Others make it clear by their publishing choices. Books that look like Popstar drew them get published. Books that don't, don't.

Royalties are a big part of many graphic novelists' income. Imagine that graphic novels illustrated with thumbprint collages are now consistently selling a lot more copies than the last big trend: graphic novels drawn in ballpoint pen on brown paper grocery bags. Before long, dozens of creators will be walking around with one black thumb and telling cashiers that they'd prefer plastic to paper.

Some graphic novelists find themselves powerfully attracted to and influenced by the work of another artist. It's common, particularly if you encounter that artist at the right point in your life. You're filling up sketchbooks, trying to figure out what you want to say and how you want to say it. Suddenly you encounter the work of an artist who does it all and makes it look easy. "There are plenty of terrific comics out there, but Johnny Ryan's *Angry Youth Comix* is the one that really speaks to me." You study Johnny's work and commit his every doodle to memory. When the time comes to say what you have to say, you're likely to speak with Johnny's accent.

Many stylistic choices are made as a way of coping with the limits of technology. Cartoonists who knew their work would be shoddily printed on cheap newsprint developed stylizations and techniques to keep their work readable no matter how badly the reproduction was mangled. As better printing becomes available, some artists develop new styles that take advantage of it. Artists who don't risk looking out of date.

Artists in all media spend countless hours looking for ways to improve their work. They're trying to solve problems, iron out kinks, polish their surface, and refine their message. If you're diligent about this, you start to do it unconsciously. When you look at another graphic novelist's work, you may unconsciously latch onto something there and store it away for future use.

Should you try to fight this process? If you're gravitating toward a style that's trendy and lucrative, you probably won't feel inclined to change direction. But it's important to remember that you're in this for the long haul. Nothing is uglier or more embarrassing than yesterday's fads. And no one wants to be known for drawing like someone else.

On the other hand, if your current approach has repeatedly demonstrated itself to be universally unpopular, you may find yourself forced to make a decision: either make some changes in your work, or adjust to having an audience that would fit comfortably in your apartment.

Taking Control of the Process

When pondering matters of style, it's natural to torture yourself with all sorts of unanswerable questions: "Why shouldn't I just do that cool trick with the nostril that Skip Rogers uses?" "Why do I draw like a third-rate Mike Ratko clone?" "Why can't I at least be a second-rate me?" "I know 28 different ways to draw a nose. How do I pick one?" "Why do I always put too many shadows on people in daylight?" "Why do all of my female characters look like Jack Lemmon in drag?" "Who," you may wonder, "is driving this thing?"

Expanding Your Range of Influences

Take some control of your development as an artist by exposing yourself to a wide variety of influences. If everything you do seems to remind people of a prominent superhero artist, a popular line of greeting cards, or the illustrations in an eighth-grade health book, you tire of hearing about it, and your work stagnates. Two important things: first, quit looking at whomever or whatever you've been looking at. You've already swallowed plenty, and the rest is just going to be stored as art flab. Second, get out of the house and look at something new.

Where do you go to do this? Hit the library. It's free. Read some art history. Visit a museum. Pick up magazines you don't normally read. Flip through illustrated books. When you find someone intriguing, use the web to find out more about that artist. You aren't buying anything yet. This is window shopping. I mentioned "unconscious influences" earlier. The goal of this wandering is to give that housebound brain of yours some fresh air so that it can start working on new possibilities.

Look for unfamiliar work that catches your eye and copy it in your sketchbook. What would a graphic novel look like drawn in this style? What changes would need to be made? If you spot someone with an eccentric ink line, apply it in one of your own drawings. When something feels right, play with it a little more. Don't worry about producing drawings that anyone is going to look at. You're just trying to scrape a few barnacles off your brain.

The Real Question

When you find an interesting technique, don't just ask yourself *what* the artist did and *how* it was done. Ask *why*. What does that technique bring to the image or the story? Many artists copy something merely because it "looks cool," ending up with a work that doesn't work.

Too Many Options

For some graphic novelists, the problem isn't too few influences, but too many. You can ape your favorite manga artist and you can produce a handsome photoswipe. You can draw angular, aggressive figures with bold brush lines and patches of solid black, but you also like using fragile pen lines to render minute organic details. You can draw like an animator from the 1920s or a fashion illustrator from the 1960s. And none of these styles seem to go together very well. It's frustrating, and you almost wish you knew a lot less, so you wouldn't have to constantly suppress all the other possibilities that are constantly occurring to you.

How do you decide how to draw? The late Gil Kane, a respected adventure cartoonist, once described himself as being like a small-engine airplane, overloaded with conflicting, irreconcilable influences, unable to lift off the runway. He had to jettison some influences before he could take off.

So how do you know which influences to keep and which to leave on the tarmac? Good question. Take a step back and remember that, if you take art seriously, style is *not* a goal in and of itself. It's a means to an end, and that end is *communication*. Put your time and energy into figuring out what you want to communicate—what feelings, images, and ideas you want to share with the reader. Identifying the central message of the story (the way I did in Chapter 12) helps, too. When you focus on what you want to say, you find that you have a goal in mind for each picture. Comparing your picture to that goal compels you to make changes. Listen to that little nagging voice inside and try to get closer to how each panel should feel. Here are examples of the sort of internal process that can take place:

- Maybe a change in picture-plane depth is called for. Sure, the photorealistic rendering on Suzy looks out of place when I put her against all those flat, distorted backgrounds, but the whole angst-ridden story is about how she's the only person who "sees what things are really like around here."

- Maybe a more conspicuous use of line would be appropriate. When Alphonse Mucha does it in his posters, it really turns the subject from an individual person to an icon of beauty.

- Should they be bizarre or ordinary people? Would they be more or less familiar to my readers if I use broad caricature? How likeable would the characters be if I make them grotesque? Do I *want* them likeable?

- Suppose I want to stress something truly weird about the characters. They're sort of like gods come to Earth. Maybe making them weightier will get that across. No, they just look clumsy. Maybe lengthening their proportions will get that effect.

- These people are just mindless, slogan-repeating drones. They need to be creepier, but when I use a lot of shadow on them, I lose the sense of the scene they're in. They're creepy in broad daylight. What will make them both ordinary and creepy? Maybe if I distort their hands a bit, they'll sort of feel like tentacles …

- Some sophisticated readers are always second-guessing the storyteller. If I can't count on the suspension of disbelief, how do I get them to care about what happens? Maybe I have to entertain the part of them that's aware this is a story, as well as the part that wants to know what happens next. If I'm audacious and do something a storyteller simply shouldn't do, maybe that would do the trick.

Sometimes these decisions are made instinctively. To the extent that you're doing it consciously, base your stylistic choices on the story you want to tell.

Is the depiction of light on solid form important to the mood you want to create? Should the story be funny? If so, is it an elaborate visual gag or is it a one-liner? Would believability be a plus or a minus? Are you illustrating a graceful moment or a spazzy, awkward one? Only you know what you want those pictures to communicate. Keep that in mind and over time, you'll find yourself instinctively nudging them in the direction they need to go.

Learn to recognize how other creators have answered these sorts of questions. Analyze your reactions to their results and try to figure out why a given technique would (or wouldn't) be helpful in communicating the stuff that's in your head. You may have to compromise if you find that the best solution is beyond your capacity as an artist. For some artists, these compromises form the bases of their styles.

You'll improve over time. Just keep asking yourself these sorts of questions. When you haven't gone far enough, you'll look at what you've drawn and feel inarticulate, cowardly, and lame. When you've gone too far you'll frown at your work and feel tawdry, exhibitionistic, and lame. If all is going well, you won't choose your style—it will, eventually, choose you.

Experiments Are Free

A great thing about sequential storytelling is that it doesn't cost much to produce a complete work. Other visual storytelling media require collaborators and costly technicians and materials to produce even the most rudimentary work, and the low budget will be painfully evident. But with a few dollars worth of art supplies and some talent, anyone, even you, can produce a graphic novel that's as good as the best ever done.

That doesn't just mean you're free to become a big success. You're also free to fail miserably, at no cost other than time, paper, and ink. Try writing and illustrating some short stories. Set rules for yourself and follow them.

Experiments in Drawing Technique

Don't take how you draw for granted. Changing your basic technical approach opens up all sorts of new possibilities. Do a story with goofy, exaggerated cartoons, then try another with the most realistic figures you can muster. Eliminate lighting and work with contour line only, or eliminate line and work with solid areas of white, black, and gray. Set a rule that a story will be inked entirely with a pen. Then do the next one in nothing but brush. Pencil a page tightly, working out every part in advance. Then try laying down only the most minimal pencil indications and improvise the rest in ink. Work on different sorts of paper. Scan photos and distort them in Photoshop, then draw from the distortions.

Panels rendered in various techniques.

More techniques.

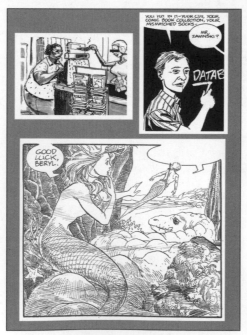

Experiments with Subject Matter

Graphic novelists can get into a rut by writing only what they know they can draw. Push yourself. If your work tends to be explosive and dramatic, see if you can handle a scene that turns on subtle nuances of gesture. Have you ever drawn an animal story? See if you can capture a day in the life of a bird or a

dog. Never worked on a period piece? Any decent history book has two or three good story ideas on every page.

In *Vox*, a one-man anthology of experimental stories published by Pack Rabbit Press, Leland Purvis devised a type of storytelling he calls pentads. As you can see in the example, the goal of a pentad is to tell a story with five wordless, seemingly unrelated panels that take on meaning only by their juxtaposition.

Can you decode the story from five panels?

Formal Experiments

Use a strict panel grid, then try an organic array of vignettes. Start every page with a shot of the same person or object but get further every time until the full figure or item is revealed. See what happens if you put dialogue in the gutters below panels rather than in balloons inside them. Are caption boxes opaque or semitransparent? What's the effect of breaking an action into each of its steps and scattering them throughout the story?

The Least You Need to Know

♦ Style emerges from your natural inclinations as an artist.

♦ You can influence your stylistic development by the artists you study.

♦ Concentrate on the story you want to tell and your art will change to meet its requirements.

> **Nat Sez: Get a Push**
>
> If you're used to writing and drawing your own material, try working with a writer once. Someone else's script will present you with challenges you'd never have given yourself.

A Bit of *The Big Con:* Pencils

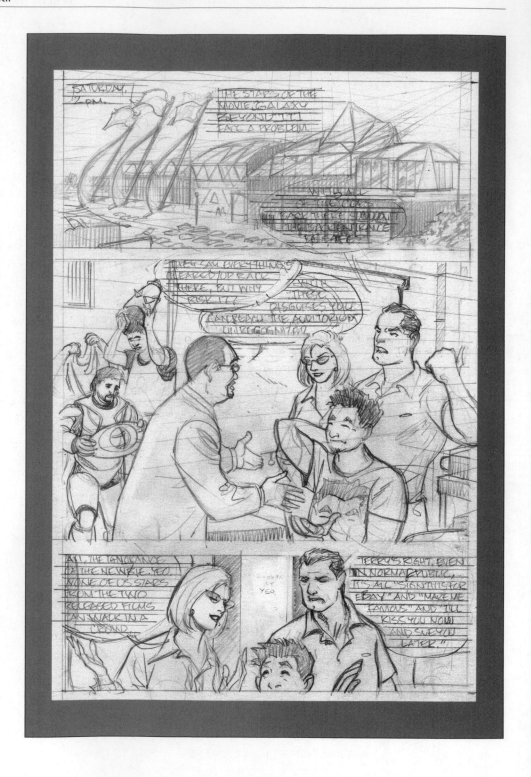

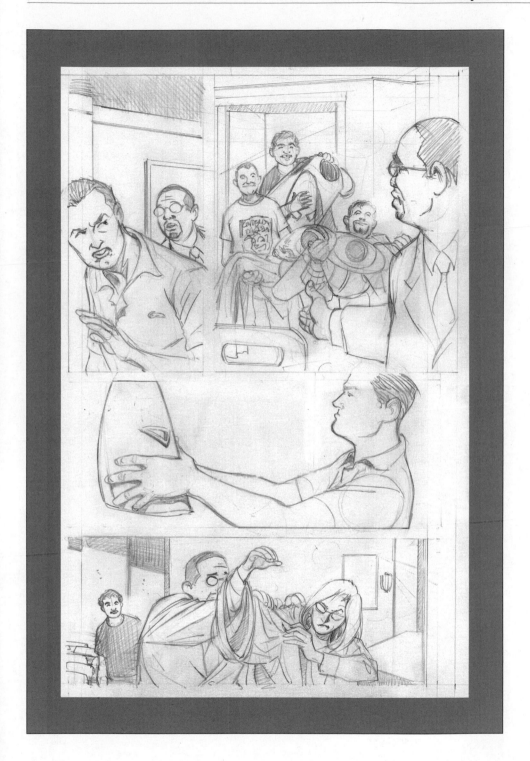

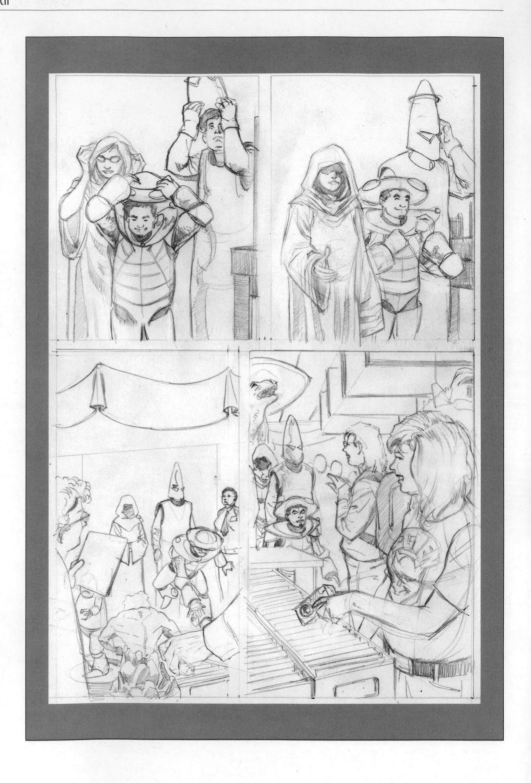

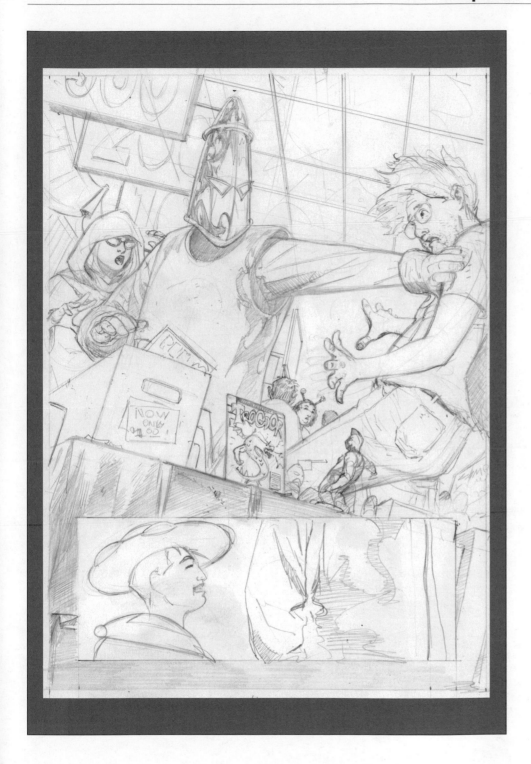

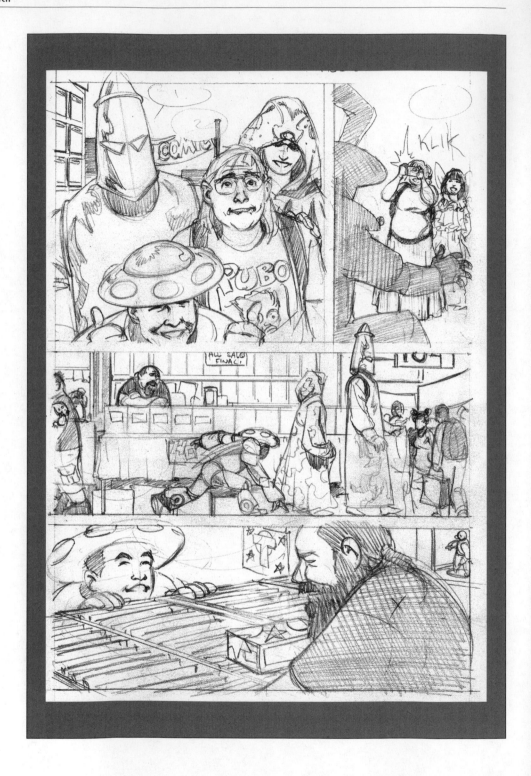

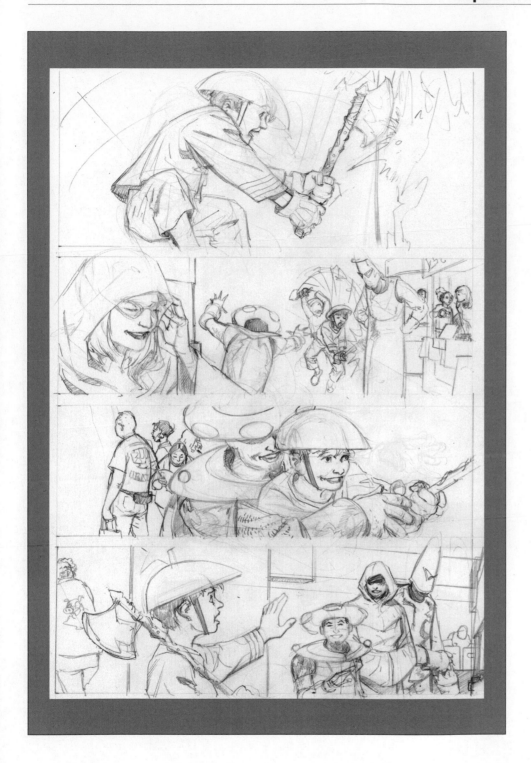

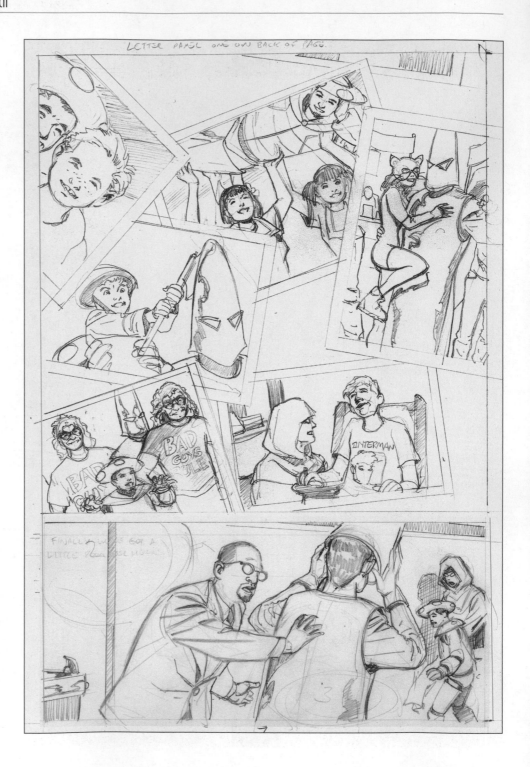

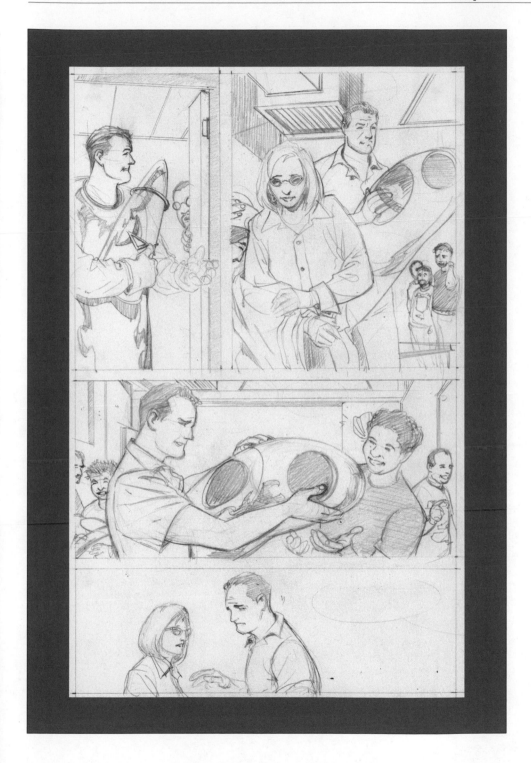

Part 4

Polishing the Pages

Now that you've spent hundreds of hours drawing your graphic novel in pencil, it's time to erase all that work. No, wait, first you want to go over the pencil drawings with ink, and then you erase the pencils. I really hope you read that second sentence before doing anything drastic.

These chapters show you how to bring out your drawings in ink, creating texture and impact. You also see how to add word balloons, lettering, and coloring, turning a series of pictures into a finished comics story.

Inking the Art

In This Chapter

- Choosing inking tools
- Working for reproduction
- Inking resources

You're well underway. Panels and panels full of pencil drawings are on the pages in front of you. They tell the story, but they're smudgy and vague in places, and you can see the construction lines here and there. Those sorts of pencil drawings don't reproduce well and will distract from the story you're telling. It's time to break out the ink.

Inking can mean very different things. In the North American comic book industry, it's become common over the past 50 years to split the work of illustrating a comic book between several artists: a penciler, an inker, and a colorist. Many graphic novelists work this way as well, but it's increasingly common for illustrators to reject this assembly-line approach and do the complete job by themselves.

Which Way to Work?

There are advantages and disadvantages to splitting the job between a penciler and an inker. In some cases, you won't have a choice. A publisher may demand that the work be divided. In work-for-hire publishing, an artist is often a hired gun, brought in to do a specific job with little or no voice in how the work might be best served. At small press publishers, there may not be large-enough budgets to hire additional artists. For self-publishers, there may not be large-enough budgets to buy dented tuna cans or off-brand pasta.

The biggest advantage of working as a team is efficiency. Some artists find it easier to work only in pencil or ink. They may prefer the design work and imagination that penciling requires to the fine motor control and technical

problem-solving that's required of an artist working in ink (or vice versa). Some inkers have a real knack for handsome brush and pen work, or for lighting forms, but aren't interested in the grunt labor of constructing anatomy, designing gestures, or working out perspective. Milton Caniff, widely regarded as one of the greatest adventure cartoonists of the twentieth century, employed an assistant, Dick Rockwell, to pencil his comic strip *Steve Canyon*. Working as a writer/inker gave him control of the beginning and end of the process; he didn't need to handle the details in the middle.

Ink artists who love rendering pictures but aren't interested in choosing camera angles or laying out a page may prefer *embellishing*—working from someone else's penciled layouts but adding much of the detail—to inking or doing the complete job.

Paradoxically, the advantage to *not* working with an inker is also that it's more efficient. You're free to employ whatever shorthand you like in the pencils. Are those ovals a bunch of balloons or a crowd of well-wishers? Is that smear of graphite supposed to be a second rocket ship or is it the sky behind the first one? If you're inking yourself, you don't need to work these things out in the pencils. Similarly, you may have certain elements in your drawing that you can draw in ink with only the vaguest guidelines in pencil. If you're penciling for someone else, such ambiguities can be a recipe for disaster—or comedy.

It's also a lot more financially efficient to do all the art yourself. It's hard to pay the rent illustrating your own graphic novel. But it's a lot harder if that money (and other sources of cash, like the sale of original art) has to be split between two people.

In the end, the choice is up to you. Do what's best for the story you're telling. At times in this chapter, I'm going to write as if I assume that the penciler and inker are two different people. If that isn't the case for your graphic novel, pretend that you've got multiple-personality disorder and let the inker personality take over.

Your Job, Should You Choose to Accept It ...

Simply put, an inker's job is the same as everyone else's: to tell the story. Unfortunately, that isn't very helpful when you've got a stack of penciled pages in front of you. So, less simply put, an inker's job is to render the pencils so that they'll reproduce well, refining details and adding texture, depth, and in some cases, shading.

Inking is drawing. An inker needs to know how to distinguish between a construction line and an object line. A penciler uses construction lines to make sure a drawing is solid, and to avoid mistakes like having one eye higher on the skull than the other. Construction lines shouldn't be inked. An object line is there to define the form and should be inked. A conga line is for dancing and doesn't belong in your studio.

That's Al, Folks

Al Williamson's pen-and-ink drawing has set the standard for classical illustrative art in comics for almost half a century. *Al Williamson Adventures* is a collection of short stories, all of which are worth studying to see how he composes pictures and uses simple lines to render complicated forms and textures.

Ways to Get Better

You can learn ink techniques from other artists. Blow up and trace black-and-white pages by cartoonists whose techniques you admire. Choose pages that contain a variety of settings and lighting conditions. Blow up these pages on a photocopier. An enlargement setting of 141 percent is usually a good choice, and will require a copier that can handle 11-inch by 17-inch paper. Or scan the pages and blueline them the way I described in Chapter 14.

On vellum (a high-quality tracing paper) or on bluelined printouts, practice replicating the original inks. Try to match the construction lines exactly, feeling the form as you go. You don't have to duplicate every line that's part of a shaded area. Just make sure that your lines follow the form in the same way, and that they build the same value of gray that's in the original.

Vellum is also good for practicing over photographs. Photocopy a photograph several times to increase the contrast, or use a computer graphics program to do the same with a digital photograph. See how high you can get the contrast and still keep everything recognizable. Then lay vellum over the high-contrast picture, and try to render it in brush. Keep the original, low-contrast image handy.

You can even get copies of other artists' pencils to practice over. Many large publishers will send you copies of some pencils if you send in a request, and many artists put scans of their pencils up on their websites.

The best way to get copies of penciled pages is by asking artists at conventions. Any good-sized convention should have some artists as guests, and some may be willing to e-mail you scans of their pencils. The less prestigious the artist, the more likely he or she will be willing to take the time to do this.

Give It a Dirty Look

Compare gray values by squinting at your pages and holding them at a distance or looking at them in the mirror. Blurring your eyes makes it easier to see an array of lines as a continuous tone. People who see you do this will think you are angry at the page and give you a wide berth.

Tool Time

A lot of the tools inkers use are described in Chapter 14. Ink artists tend to be superstitious about their tools, and suffer horribly when an item they like stops being available. When you find an art supply you like, buy it in quantity.

Your Brush with Destiny

Brushes are a key part of many artists' toolkits. Unfortunately, they're also among the most expensive and fragile. A good sable brush can cost $20 and may last only a couple of months, depending on how well you care for it. ("Sable" refers to the animal whose fur they use to make the brush.)

In 19 years of continuous drawing, I've found only one brush I like for inking: Winsor & Newton's series seven, number two sable brush. Other artists I know recommend Raphael's watercolor sables. Brush pens—brushes that carry their own ink supply like a marker or fountain pen—are quite popular, too, and have the advantage of never needing to be dipped or cleaned. Pentel makes several

types, including the Pentel Color Brush and the Pentel Pocket Brush. Try a few and see what works best for you.

The Winsor & Newton series seven, number two sable brush.

Good brushes are expensive. Treat yours well and they'll last a lot longer.

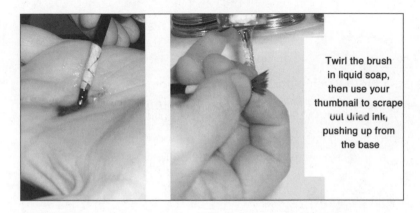

Twirl the brush in liquid soap, then use your thumbnail to scrape out dried ink, pushing up from the base

Brush Tags

Wrap masking tape around the ferrule (the metal part that holds the bristles) of your beat-up brushes and mark them with different colors. You'll find that different brushes are good for different tasks, and the colors help you keep track of which is which.

Never, ever let ink dry in your brush. Ink that dries between bristles points them away from each other, ruining the brush's ability to come to a point. Rinse it in water after every few dips in ink. If you're going to be away from the board for more than a couple of minutes, clean it thoroughly with soap and water as shown in the brush care photos. Never leave your brush point-down in your water can—you'll mash the point into a weird shape.

Use brushes that have lost their points to fill in areas of black, or to create textures that don't require control of every mark. They are useless for any sort of precise drawing.

Brushes are wonderfully versatile tools. A good brush artist can make a line as fine as a mouse's eyelash, then with just a bit more pressure, throw down bold, juicy strokes. Mastering brushes requires more practice than using other tools, but it's absolutely worth the effort. I found them enormously frustrating for my first two years of art school. Now they're my favorite drawing tool. There's no magic trick to getting good with a brush, but I find it helpful to visualize the line I want as I first let the brush's point touch the paper. Be confident when you lay down a brush line—it's a very sensitive tool, and your hesitations will register when you draw.

Dip Pens

There are dozens of metal pen nibs available, and they're all worth trying. One of the most commonly used is the Hunt 102 crow-quill pen. Its very firm point

is easy for beginners to handle. As you use it, it becomes more flexible, so start with the finest lines on the page, then shift to the broader ones. Other popular nibs are the Hunt 108 and the Gillott series. Pen nibs are cheap. Buy a lot and experiment.

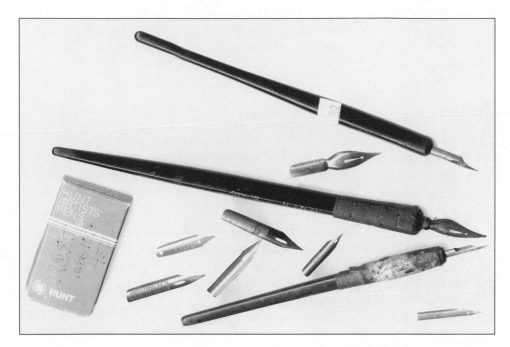

Traditional dip pens and a scattering of nibs.

Whatever nib you use, get used to cleaning it a lot. Get into a rhythm: dip in ink; draw, draw, draw; swish in water; dry on cloth; dip in ink; and so on. Hold the pen with the concave side down and draw it toward you. You can't push a dip pen; it will spatter and ruin your life. If the line you need to draw is at an inconvenient angle, turn the paper.

No pen nib lasts forever. Some artists discard two or three a day. Sometimes nibs fail because they're clogged with dry ink or because the points aren't aligned anymore. You can try to get them working again, but if it continues to give you trouble, throw it out. Your time is worth more than a pen tip.

Rough or fibrous papers can shed little hairs that get caught in your pen tip and change your fine point into a sort of awkward brush. You'll find that hot press papers (also known as *plate finish*) offer the least resistance to your pen line. They're more prone to smearing though, because they don't absorb the ink as quickly.

Fountain Pens and Technical Pens

For artists who hate to take the time to dip a brush or pen in ink, fountain pens are a natural alternative. They come in a variety of tip sizes and shapes, some of which are flexible like a dip pen and will give you a line that ranges from thin to thick, depending on how hard you press. Others are quite rigid. The Rotring

Art Pen is hugely popular. When the ink runs out, you can buy cartridges to refill it, or pick up Rotring's Piston-Fill Converter and refill it with Koh-I-Noor Ultradraw Ink. Don't use India ink. It'll clog the pen.

Technical pens are a type of fountain pen that are designed to produce precise, unchanging lines. They cost a lot and are easy to damage, but if you keep them clean, they'll last for years and years. As with the Rotring Art Pen, don't refill them with India ink. Use the inks recommended by the manufacturer, or you'll ruin the pen forever.

Markers

Pigma Markers are great for drawing, too. They make a deader (less expressive) line than dip pens, but they're fast, and many artists have learned to coax a wider variety of lines from them. Some markers bleed more than others, so test them on the margin of your page before starting to ink. Some, such as Sharpies, can't be covered in white paint—they bleed right through it, leaving an ugly gray stain in the page. If you use this kind of marker, make your corrections with a patch, or fix it digitally. A number of markers are dye-based and not lightfast, which means that over time, they fade to a fuzzy gray or purple. Keep this in mind if you plan to sell your original pages. This isn't a problem with pigment-based markers such as Skaura's Pigma Micron, Staedtler's Pigment Liner, and the Faber-Castell Pitt Artist Pen.

What Brand of Ink?

Drawing with good India ink is wonderful. At its best, it lays down a smooth, consistent line, covers large areas evenly without looking blotchy, doesn't fade much when it's erased, and is waterproof when it dries, so you can make corrections without worrying about the art bleeding.

I can't recommend one brand though, because ink producers keep changing their formulas. It's common to see anguished messages on message boards asking for "a better ink" because a reliable favorite brand has been taken off the market or replaced with something resembling instant coffee dissolved in ammonia.

The pigment in ink can separate, so before you start, screw the lid on firmly and shake the bottle for a couple of seconds. Inks thicken over time as the solvent evaporates. An ink that starts out too thin may get better if you leave the cap off. One that's just right may get too thick. Thin it with a bit of fresh ink.

I've been happy with FW acrylic-based black ink, Winsor & Newton's Indian ink, and Koh-I-Noor's Ultradraw Ink. By the time this sees print, they may all be off the market. If the best at your local art supply store isn't good enough, post your own anguished message board request.

Changing the Pencils

Suppose you're inking someone else's pencils. When things look good, all you have to do is follow the penciler's lead. But what if you see something wrong? Do you faithfully replicate the penciler's mistake, or fix it? This is a real mine-field. It isn't always easy to tell where "style" stops and "errors" begin (and this applies to your own work as well as that of the penciler). A "correction" can produce a jarring discontinuity if a character suddenly looks different than it had before. You also have to juggle egos. Is a small improvement in the work worth the huge headache from dealing with your collaborator's hurt feelings? Will making a lot of corrections hurt your chances of being hired in the future? Or is not making the corrections more dangerous?

Talk to the penciler. Some are comfortable with inkers who bring their own abilities as draftsmen to the table. Others simply want someone to dutifully rep-licate every line they put down. Find out what he or she thinks about changes in general, and the changes you want to make in particular. Don't call every time you notice that the number of chevrons on Atomicus's robot arm is incor-rect, but if you plan to crop a figure that had previously burst a border, either ask the penciler or check with your editor (depending on the nature of your arrangement).

If, for whatever reason, you can't get in touch to get approval for a change that you really think needs to be made, you have to decide on your own. For me, the matter is resolved by this principle: your obligation is to the readers, not the penciler. Change what needs to be changed. But there's another principle to keep in mind before you perform surgery on another artists' work: "First, do no harm." If you aren't absolutely sure that your change will yield better storytell-ing, don't make the change.

Tangencies

Changes are always welcome when the pencils contain a *tangency*—a confusing juxtaposition of unrelated parts of your drawing. Don't let these go. Usually you can nudge some part of the drawing a bit, preserving the penciler's inten-tions without changing anything significant. I did this to my own pencils in the tangency example posted nearby. In the pencil drawing, the Monk's right arm is placed so that it could easily belong to Gene! Before inking, I traced the arm so I'd be able to replicate it, then erased and redrew it in a better position.

Incomplete Pencils

Your penciler may give you layouts rather than completed pencils. If so, it's up to you to finish the picture. Keep the drawing consistent, matching what you've done before, even if your natural style is quite different. A slightly awkward drawing that belongs in the same world as its predecessors hurts the story less than a terrific drawing that seems out of place.

Tangency

Tangency is a bad arrangement of the elements in a picture that ruins the illusion of depth or creates confusion by making unrelated objects seem to be connected.

Whose arm is that? Moving it a bit makes it clear.

Ways to Ink

Everyone has a different way to approach the job, and one artist may regularly change the way he or she does things from project to project, or even one page to the next. The procedure I suggest here is just one way out of many:

Adding black gives a panel richness and depth.

1. Make good photocopies or scans of the pencils before starting.

2. Lightly rub the entire page with a kneaded eraser to pick up any excess dirt or pencil dust. Don't erase the pencils!

3. Ink the panel borders, if the letterer hasn't already done so.

4. Ink the outlines of background objects with a light, relatively inflexible pen line. (A Hunt 108 pen is good for this.)

5. Ink the light side of foreground objects with a light pen or brush line. Keep your lines on the light side relatively thin.

6. Lay in areas of shadow with a bold brush line, as you see in the spotting black illustration nearby. If there are any large areas of black, leave them partially unfilled for now. Too much black ink can buckle or warp your page, making it hard to ink.

7. Add textures and transitional areas of gray. Work from the shadow into the light, keeping things as simple and uncluttered as possible.

8. Correct your mistakes with white paint or patches.

9. Squint at the page, holding it at a distance. Are the planes of depth clearly differentiated? Do your eyes go where they're supposed to go? Are the areas of black, white, and gray in proper balance? Correct as necessary.

10. Erase the page with a plastic eraser. Go back over any parts where the black ink faded to gray.

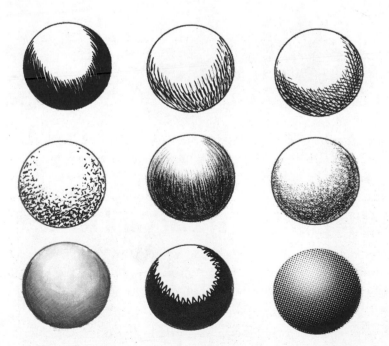

There are lots of ways to show the transition from light to dark.

Transitions and Textures

There are several techniques for creating the illusion of light on form. The rendering technique diagram nearby shows some of the ways to transition from light to dark. Dry brush, hatching, cross-hatching, stippling, feathering, gray wash, grease crayon, and digital tones are some of the options. Use the object's texture to describe light and shadow by drawing the texture where the shadow is and leaving the light areas open.

Hair, cloth, and shiny metal—one picture, different techniques.

Some artists prefer to let the outline alone describe the difference between materials. This can be tough for inexperienced artists, but if you can do it, the results can be quite handsome.

Inking for Color or Black and White

When you're inking for black-and-white reproduction, you're creating something pretty close to finished art. You want to make pictures that feel complete and satisfying. When you're inking for color, this is still *sort of* true, but not entirely so.

Some artists, coloring their own work, or trusting their colorists to do a fine job, consider color to be a vital part of their picture making and storytelling. They can leave the job of completing the art to color. Others, less trusting, assume that the color they get will be in some way inadequate. They ink as

if the page was going to be black and white, and think of the color as tinting, rather than an integral part of the art. One older artist summed up the difference to me this way: "This guy [a younger artist] draws that way because he knows the color will help him. We drew the way we did so that the color couldn't mess us up too bad."

How you approach drawing for color should depend on who the colorist is. Doing it yourself? Do as you like. Someone else? Look at other books the colorist has worked on and decide if you can trust this person to make your pictures complete.

Books on Drawing with Ink

The most important book you own is your own sketchbook. The work you do there makes you a more knowledgeable and confident artist, improving your pages. But there are some good books about inking, and I recommend picking up one or two of them:

- *The Art of Comic Book Inking* by Randy Martin
- *The DC Comics Guide to Inking Comics* by Klaus Janson
- *Dynamic Light and Shade* by Burne Hogarth
- *Rendering in Pen and Ink* by Arthur L. Guptill

The Least You Need to Know

- Try a variety of tools and use the ones that feel right and give you the best results.
- Take good care of your brush. Never let ink dry in it.
- Use a thinner outline on the lit side of an object.
- Use texture to show the difference between materials.

Varsity Letterin'

In This Chapter

- Adding text using your computer
- Designing beautiful word balloons
- Getting your lettering ready

Nat here. I've wrested this chapter away from Steve because he letters by hand. He's a really good hand letterer, which I envy, because you can't read my hand lettering without a Little Orphan Nat Decoder Ring. Alas, these days being a great hand letterer is like being a really good VHS tape reproducer. It may get you respect, but it won't get you work.

Hand Lettering? Is That Like ASL?

Back in the day (and the day was not that long ago), comics were lettered by hand. A professional letterer would get the penciled art before it was inked, and would write all the captions and dialogue. Generally, the letterer would even draw not only the word balloon shapes, but even ink in the panel borders. The sound effects and often the sign lettering were crafted by the letterer's fingers as well. Only after all this was done would the page move onto the inker.

At its worst, hand lettering was scratchy and awkwardly placed. But when it was at least competent, the hand-written style really integrated into the art. Hand letterers could make small changes in character styles and sizes almost instinctively, creating character and mood that computer letterers are hard-pressed to follow. Starbeam Wildchild could seem all the more spacey with a slightly flowing lettering, while the tense ticks of Johnny the Homicidal Maniac's words tell you almost as much about him as his name does.

Hand lettered by Steve versus digital work by Nat.

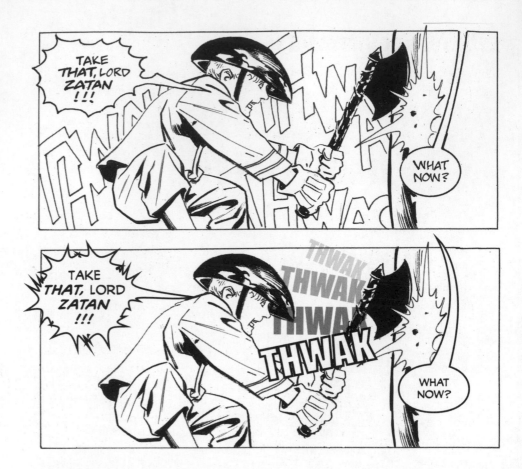

But digital lettering came in, and it was faster and cheaper and always legible. It doesn't make for as good a comic book or graphic novel, but when it comes time for the work to be translated to foreign languages, resized to display on a cell phone, or ink-painted onto pieces of bread ("media loaf" will be the next big thing!), then it's very handy to have the lettering and balloons separated from the art.

Down with the Hand, Up with the Digits

Digital lettering isn't just the convenient modern cousin to the more artistic hand lettering. Using digital lettering means that the collectible original art page is left beautifully clean, uncluttered by word balloons. A digital letterer can actually letter a page at the same time that an inker inks it, making schedules easier to keep. In fact, several letterers can be working on the same graphic novel simultaneously, and so long as they're using the same fonts no one will know the difference. The same cannot be said for hand lettering, where each letterer's work looks different. Plus, the digital letterer can easily switch styles simply by switching fonts, helping the hero's words to look heroic while the snarling villain's words look snarlingly villainous.

Letterer Requirements

The stuff you need to do digital lettering is not cheap. Certainly, the hand lettering materials are much cheaper. However, most of what the digital letterer needs are things that many people have anyway:

♦ **A computer:** A faster and newer computer is always better, but most modern computers are powerful enough for the job. The graphic world tends to prefer Macintoshes to Windows-based machines, but either can get the job done.

♦ **A scanner:** The standard home scanner is good enough to get you started, although if you're doing a lot of digital comic book work you'll want a larger, tabloid-sized scanner that can scan full-sized pages of original art. Most of those cost more than $1,000. If you want a cheap one, Mustek makes scanners that handle what they call A3 size for under $200. The $200 scanner is not as good as the $2,000 scanners are, but that $1,800 can buy a lot of comfort.

♦ **Graphics software:** Proper professional letterers use Adobe Illustrator, because it has the tools to make delicate lettering adjustments, and properly treats text as resizable curves rather than dot patterns. This means that the text in your finished comic will be as sharp as possible. However, you can do very usable basic lettering with Photoshop, Paint Shop Pro, or other art programs.

♦ **Font files:** Computer files of *fonts* (lettering styles). As you'll shortly see, there are some fine points involved in choosing a font.

 Hire Higher Quality

Computer lettering is a good talent to have, but if your time is of value, it may be worthwhile to hire an experienced, talented computer lettering service.

Don't spend the big bucks on the expensive stuff at first. Try doing it cheaply before deciding what parts you really want to spend the money to upgrade. In fact, try doing it on someone else's computer to be ultimately cheap.

Founts of Fonts

Your computer has a bunch of *fonts* installed, most of which would make lousy graphic novel dialogue fonts. Even the one called Comics Sans that comes with most computers makes a lousy graphic novel dialogue font.

Most fonts are designed to look good on a page full of text. However, a graphic novel puts the text in the midst of a hand-drawn page. The fonts that work best are mostly those that look hand drawn. Even then, you want a font that matches the style of your graphic novel. There are fonts that look very serious, and others that look humorous and fun. There are even fonts that look like alien gibberish, if you have aliens in your stories or simply have dialogue that's too lousy to inflict on the reader.

 Font

Most of us use **font** to refer to a specific typeface, such as Times Roman or Courier, but type professionals refer to typeface as a *font family*. To them, *font* means a specific typeface at a specific size, and the bold or italic version of that font is considered a different font.

There are some very large commercial font companies out there, but your best sources for graphic novel fonts are folks who specialize in comics fonts. Go to www.blambot.com to find some free fonts and some not-free-but-fairly-cheap fonts. Head over to www.comicbookfonts.com to find fonts that are more expensive, but these are the ones that are made by and used by Comicraft, the most successful digital comics lettering company. You'll even find some good tips on computer lettering. Yes, they make it easy for you not to need their services. They're talented letterers, not financial geniuses.

In addition to dialogue fonts, you'll want fonts for titles and sound effects. The fonts that come with your computer are okay for that, but again you should look at the special comics fonts.

You can even design your own fonts to meet your special needs. Many artists have a font designed around their own hand lettering, so the dialogue really matches their own art style. You can pay someone to digitize the font for you, or you can pay FontLab big bucks for one of their programs (ranging from about $100 for the basic TypeTool to over $600 for FontLab Studio), then spend a lot of time learning the surprisingly subtle science of font design. Suddenly, doing actual hand lettering sounds like a good idea again, eh?

Pushing the Page In

I can't teach you the details of using your scanner, because every scanner is different and comes with its own software. You could go out and buy my book *The Complete Idiot's Guide to Basic Scanning for the Scanner You Own and the 234 You Don't*, but you're probably better off using your scanner's manual.

You're going to need to scan your line art and then reduce it to the size you're going to print it. You want to end up with an image that's at least 600 *dots per inch* (a measurement of how precisely the image is reproduced) at the printed size. If you're drawing at actual printed size, set your scanner resolution to 600 dots per inch. If you draw at 50 percent larger than printed size, scan at 400 dots per inch. If you draw at double size, use the 300 dots per inch setting. If you draw at 600 times print size, set your mile-wide scanner to 1 dot per inch.

Scan the image in *grayscale mode*, which captures each dot of the image as 1 of 256 shades of gray, rather than in line art mode, which sees each dot as either black or white. Then use your graphics program to convert the art into line art (which some graphics programs call *bitmap*). When you do this, your graphics program will let you select how dark a dot has to be before it will be converted to black rather than white. Your lines will appear thin if you choose a high level and thick if you choose a low level. Experiment with it.

If you're making do with a scanner that's smaller than your art, you have two choices. You can use a good, clean photocopier with a reduction feature to make a copy of your art small enough to scan. You can also scan the art in portions, then use your graphics program to stitch it back together. Trying to line

up two separately scanned sections exactly is tough work. Of course, if you're using panels laid out in clear rows with empty gutters between them, use those gutters as the edges of the scanning sections. You don't have to line up the blank space of the gutters nearly as precisely as you would have to align the lines in the middle of a drawing. And that's the end of my gutter talk.

Resize your art to the size you'll use for printing. If your graphics program has a resample option as part of its image resizing command, turn it off, because that would cause your image to become somewhat fuzzier. Save the image as a TIFF (Tagged Image File Format) file. Don't be tempted to save disk space by using the JPEG (Joint Photographic Experts Group) file format. The JPEG format degrades the image, and the printing company's equipment might not handle it.

Putting the Text in Context

Bring the image file into the graphics program you'll be using for lettering. Use your graphic program's lock option to lock the image layer so you don't accidentally drag it later. Create a new layer for the balloons, and another for the type. Some programs create separate layers for each balloon, caption, or other piece of type, so even if your plot isn't deeply layered, your files will be.

Drag a text box into place in the area where you want the text to appear. Select the font and size that you're going to use, then set the text alignment to center for thoughts and dialogue, left for captions.

If you have the script in a word processor, you can copy the text right from the word processor and paste it into your graphics program. Otherwise, type it in, making sure that you don't make any spelling errors in your typing.

Then you can adjust the width of the text box. Changing the width changes how the text flows and how many lines the text takes up. Generally, you want to avoid lines in the middle that are much shorter than lines above and below them. You also want to keep an eye on what it is you're covering up. Don't be afraid to cover a part of someone's head, but don't cover up someone's face unless you drew it so badly that you want to hide it.

A Few Words on Little Letters

What is the right size for your lettering? You don't want it too small to read, or so big that it covers up most of your art. Most lettering is done with the size set to 6 or 7 *points*, but it really should fit the style of the art.

For dramatic work, you can go as small as 5 points. This works particularly well if your art is highly detailed. Put that small a font on the more open art and it looks like you're trying to sneak by with the contractual small print.

Lighthearted work with an open, undetailed art style can support 8-point type. Open artwork aimed at kids paired with very small amounts of dialogue might

 Point

Font sizes are measured in **points**, and a point is approximately $1/72$ of an inch. The measurement of the font is based on the height of its capital letters.

even support 10-point type, but that's as big as you want to go. You need to leave some space for the pictures.

Do you have an overstuffed balloon? Don't reduce the font to a smaller point size. Save the smaller sizes to indicate whispering and larger sizes for shouting. If you really need to squeeze a few more letters into a word balloon, good graphic programs let you adjust the width of the lettering without adjusting the height. Set the width to 95 percent of the standard width to get a few more characters in. You can also experiment with adjusting the tracking, the spacing between the characters. This way, you're just giving your text a gentle squeeze, instead of an all-out squish.

If you find yourself squeezing text on the first couple of pages, you probably picked too big a font size. It's better to redo these pages now than to finish lettering half the graphic novel before you decide you picked the wrong size. You'll be tempted to just do the second half of the book in the smaller size, making it look like all your characters got laryngitis and have to whisper.

Capital Ideas

Traditionally, graphic novel dialogue has been in all capital letters. The bold strokes of capital letters were easier for the hand letterers to write, and some folks believe they make the text easier to read than graphic novels that use upper- and lowercase letterings. Other folks think the first folks are full of balloon juice.

Because of this tradition, many dialogue fonts don't have lowercase letters. Type a lowercase s, for example, and you get an S. Type an uppercase S and you get an S, but one that looks slightly different. That way, typing in using a mix of cases will get you varying S's, making it look less mechanical and more like hand lettering.

The one place where you really have to watch your capitalization is with the letter I. If you use one of these all-capital dialogue fonts, typing a lowercase i will get you a capital I that's just a straight vertical line, without the crossbars at top and bottom. Typing a capital I gives you a capital I with the crossbars in place. Traditionally, that cross-barred I is used only for the word I, as in "How many millions of dollars will I make off my graphic novel?" So even if your sentence is "Irmazilla ingested Indianapolis, Indiana!" you should type it without any uppercase I.

Blowing Up Balloons

Once you've placed all the text in a given panel, it's time to start drawing the balloons and caption boxes. Caption boxes are easy, since you just have to draw a white rectangle that surrounds the text.

For balloons, however, you're going to have to select a basic style of balloon to use in your graphic novel. As you can see in the balloon picture, there are three styles of computer-generated balloons that are commonly used.

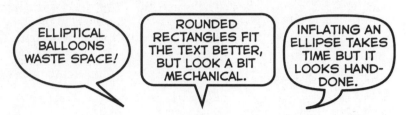

Pick a balloon, any balloon.

The elliptical balloon has gained popularity because it's easy to draw. However, because the top, bottom, and sides are nowhere near flat, you can't get text close to them, which means that the balloon is covering up art just to fill empty space. The rounded rectangular balloon is also easy to draw and fits text nicely, but its perfectly flat sides give it a mechanical look that clashes with some art styles. I favor a slightly more complicated style that I call the *inflated ellipse*, which looks more like the old hand-drawn balloons. Shouldn't all balloons be inflated?

In your graphics program, set your fill color to white. If you're using Adobe Illustrator or Photoshop or any other program that lets you add a stroke (outline) to a whole layer, don't use any stroke at all on the individual object. Photoshop and some other graphic tools let you choose between drawing shapes so that they're stored as a grid work of pixels or as a vector shape, with the program storing a mathematical definition of the outline. Choose the vector shape option.

To draw an elliptical balloon, use your program's ellipse tool, dragging into place a balloon that covers the balloon text with just a little to spare around the edges. You don't want the balloon's outline to actually touch the text at any point. Just think of there being a protective layer of air all around your words. Dragging this shape takes a bit of practice, since you can drag an ellipse into place that covers the top, bottom, and furthest left and right text but still leaves some text sticking out along the edges.

Drawing a rounded rectangle is done in the same way, except you use the rounded rectangle tool instead of the ellipse tool. Start with the pointer just a bit higher than the highest part of the text and just to the left of the left-most part. Drag down and to the right, until the pointer is below the lowest of the text and to the right of the rightmost part of the text. Voilà, you have your rectangle with those dangerous pointy corners removed.

The inflated ellipse takes a bit more time. Get the ellipse tool and drag it the same way that I described for the rounded rectangle. Don't worry if parts of some letters stick out along the curves between the top or bottom and the left or right of the ellipse.

Now, the shape of the ellipse is defined in your graphics program based on four points, one each at the very top, bottom, left, and right of the ellipse. Use the direct selection tool (usually represented by a white arrow) to select the point at the top, and two *handles* appear. These handles are lines with dots on the end of them. Point to one of these dots and drag it sideways away from the top of the ellipse, as you see in the reshaping illustration. This pulls the curves of the ellipse out away from the center, making the sides flatter. Do this for both handles on each of the four points to swell the ellipse into one swell ellipse!

Press Shift as you drag a curve handle to drag straight across.

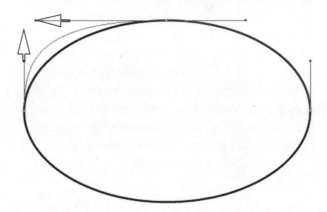

Efficient folks make a few inflated ellipses and store them for easy reuse, either in a document that they can easily copy them from or as Adobe Illustrator symbols. Then they take all the time this saves them and squander it watching TV or curing diseases.

Wagging the Tail

Next, add the *tail*, the part of the word balloon that points toward the mouth of the speaking character. For a dialogue balloon, select your graphics program's pen tool. If you're using Photoshop, select the "Add to shape–layer" option so that the tail is on the same layer as the main balloon shape.

To make a straight balloon tail, click the pen tool once inside the balloon, once outside the balloon, and another time inside the balloon, close to the first one. This makes a triangle.

To make a curved tail, point inside the balloon, hold down the mouse button, and drag outside the balloon. Click once outside the balloon to make the end of the tail. Then point back inside the balloon and drag inward into the balloon.

Breaking a long speech into multiple balloons can make it fit better in the panel. A new balloon can also serve as the start of a new paragraph, if you have a character who actually speaks in paragraphs.

Thought balloon tails are easier. Just draw a series of two, three, or four small ellipses, starting near the thought balloon and getting smaller as they head toward the brain of the thinking character. The first ellipse can actually overlap the edge of the thought balloon.

Where Balloons Come From

Dialogue balloon tails should point toward the mouth of the speaker, but the end of the tail shouldn't actually be in the character's mouth. The character isn't actually inflating a balloon.

Once you have the word balloon drawn, go to the layer palette. On the list of layers, find the balloon's entry and drag it down so it's below the balloon's text entry. Now the balloon is under the text framing it, rather than merely hiding it!

Stroking All Around

Now that you have the shapes in place, it's time to outline those balloons. If you're using Illustrator, go to the layer pallet and click the round dot next to the name for the balloon layer. This selects the layer. Then on the Appearance pallet, click for the pallet's menu and select Add New Stroke. An outline appears around each of your shapes. Use the Color palette to set the stroke color to black, and the Stroke pallet to set the *weight* (width) to "3 pt" (3 points) and the miter limit to 44 (this keeps your balloon tails pointy). Then go back to the Appearance pallet, click the pallet menu, and select Add New Fill. Now all the lines where your balloon tail overlaps your balloon disappear. If what's hiding them isn't white, go to the Color palette and set the fill color to white.

In Photoshop, select the balloon layer on the layer palette, then click the fx button at the bottom of the palette. On the menu that pops up, use Color Overlay to set all the balloons to white. Use Stroke to add the outline to your balloons. If you're working at 300 dots per inch, try setting your stroke width to 6 pixels. For 600 dots per inch, use 12 pixels. One thing you'll find with Photoshop is that the balloon tails will never be quite as pointy as you want them to be. That's why I think of Illustrator as a demented clown: it gives you sharp and pointy balloons.

Flattening a Balloon

Sometimes you want your balloon squished up flat against one of the edges of your panel. To make a balloon like this, place your text where you want it, then draw your balloon, letting it spill out past the panel.

If you're using Illustrator, draw a rectangle that exactly covers the panel. Select both the rectangle and the balloon. Open the pathfinder palette. Click the "Intersect shape–areas" button, then the "expand" button. You'll have a new shape that includes only the area that was inside both the balloon and the rectangle—a balloon with a flattop cut.

For the same effect in Photoshop, select the layer with the balloon. Get the rectangle tool. Select the "Intersect shape–areas" option on the option bar. Use the tool to draw a rectangle that precisely covers the panel.

Bursting Out and Other Tricks

To draw a spiky burst balloon for a shouting character, you can use the pen tool to click points alternately close to the text and farther away, to make a series of spikes. Put an extra long spike pointing toward the mouth of a shouting

character—and hey, wouldn't you be shouting too if a big spiky thing just came out of your mouth?

Get to know your graphics program. The more you know, the more you'll be able to do whatever kind of special balloon tricks you like. For example, I find I get fiercer-looking burst balloons by attacking an oval with Illustrator's crystallize tool. Some folks use transparency settings to make the balloon partially transparent. The goal of this is to better show the art, but it can also make the text harder to read and even change the impact of the dialogue.

The better you know your graphics program, the more things you can find to do. Use stroke effects to create double-outlined word balloons for telepathy. Use roughening effects to create irregular balloons suggesting rough voices. Wobble the text of your drunken characters.

Sound effects, headlines, and signs are easy to add using the graphics program's text tools. With a bit of graphic program knowledge, you can blur the *whoooosh* of a flying jet, creating fading echoes of a *boom*, or skew the words *Peppermint Beer On Sale Now* so they look right on the angled billboard your artist has drawn.

A Sound Philosophy

The thing to remember about sound effects is that what it says is not so important. Pick up an untranslated Japanese comic, and you can still feel the impact of the sound effect, even if you don't read Japanese. If you do read Japanese, then try the same thing with an English comic—unless you read English. Which, considering that you're reading this book, you probably do. Never mind.

The keys to a good digital sound effect is the font, the size, and the placement. A good sound effect has physicality, where it actually seems to interact with the picture on some level. Loud sounds tend to be bigger, of course, but using a thicker font can also have an impact. Your lettering program should have tools and effects that can help you make letters that are annoyingly wobbly, dangerously jagged, or comfortably pillowy for a nice magic "poof!" when Brenda turns into a marshmallow.

Let your sound effects carry the eye. If a bullet is being shot, the BANG can be along the path of the bullet, headed in the same direction that it is, bringing the eye along for the ride. If the little ting is emanating from the dinner bell, have it emanate from the bell.

The Least You Need to Know

◆ Adobe Illustrator is the best program for lettering, but you can use other programs, including Photoshop.

◆ Put your text and balloons on different layers from your original image.

They Lettered in Lettering

The book *Comic Book Lettering the Comicraft Way* shows a couple of comics stories and has Richard Starkings and John Roshell of the top digital lettering studio Comicraft explain how the lettering was done.

Don't Wave This Flagg Away

The ultimate expression of the physicality of lettering is the *American Flagg!* series, where between signage and sound effects, often half the art is the master lettering of Ken Bruzenak.

◆ Create your balloons and text in vector or shape mode, not pixel mode.

◆ Use a font and a size that match the style of your art.

◆ Put the outline stroke on the whole balloon layer, rather than on the individual objects.

A Bit of *The Big Con:* The Finished Pages

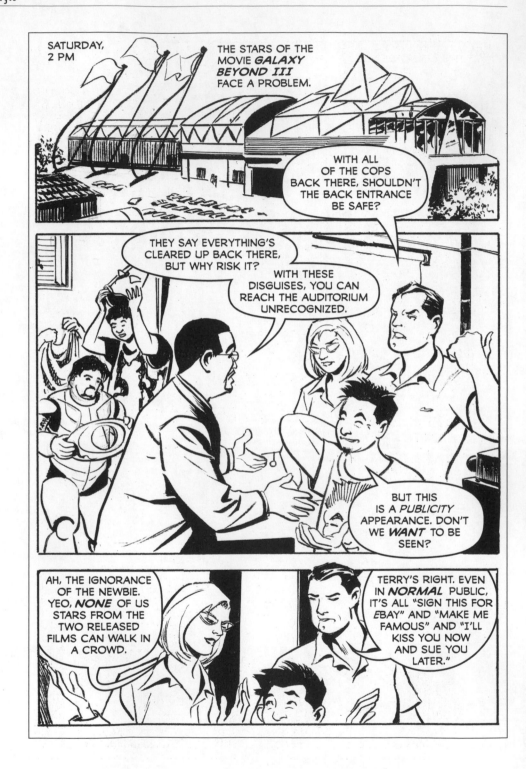

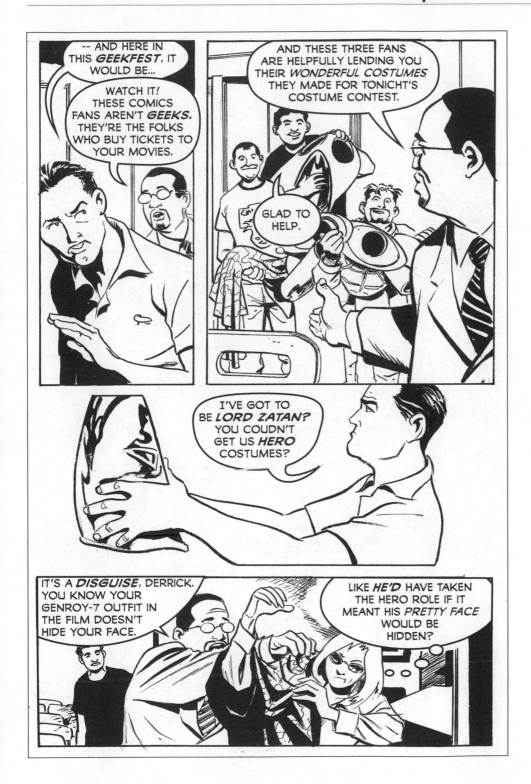

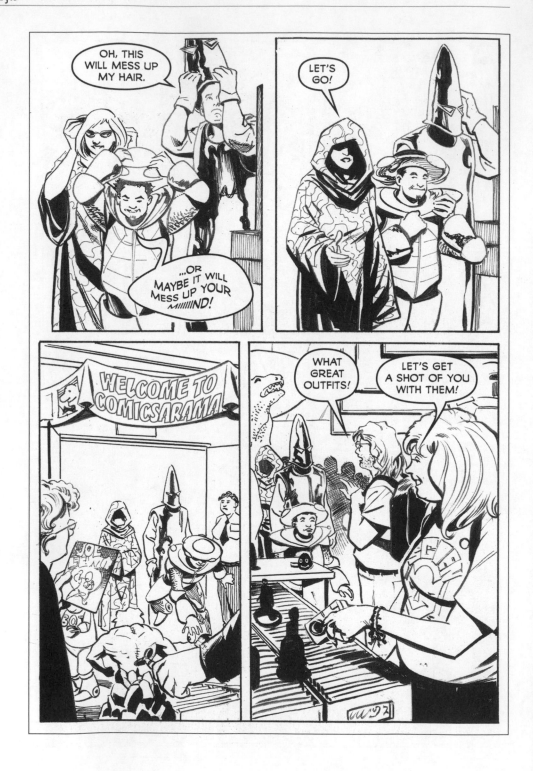

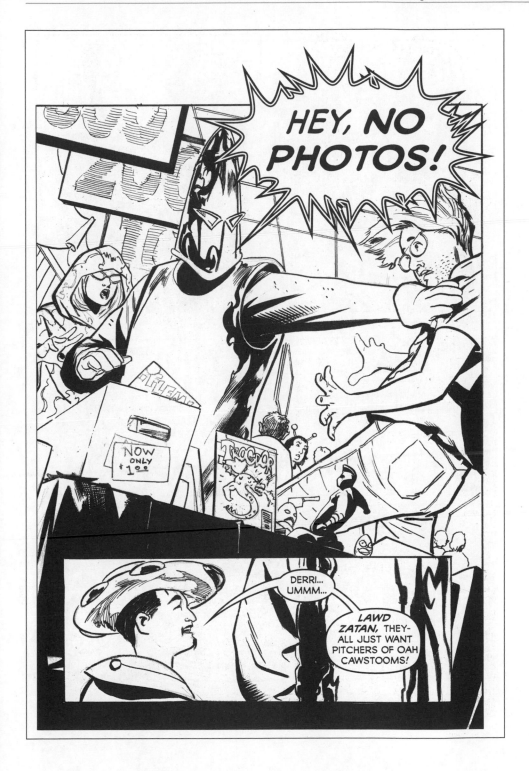

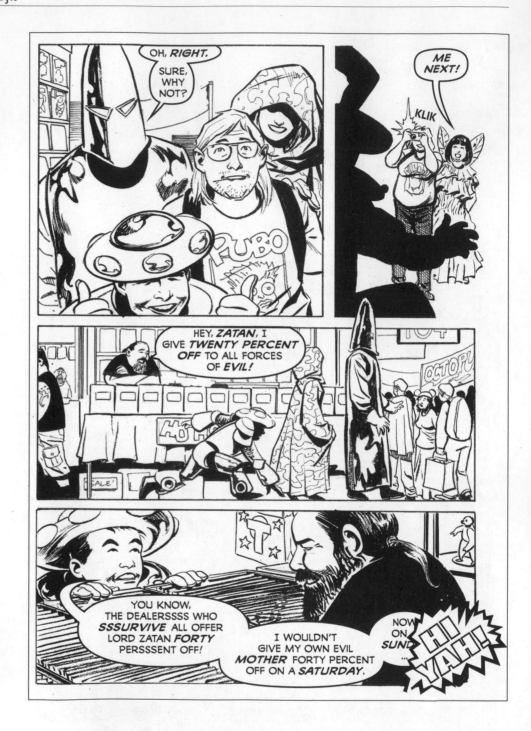

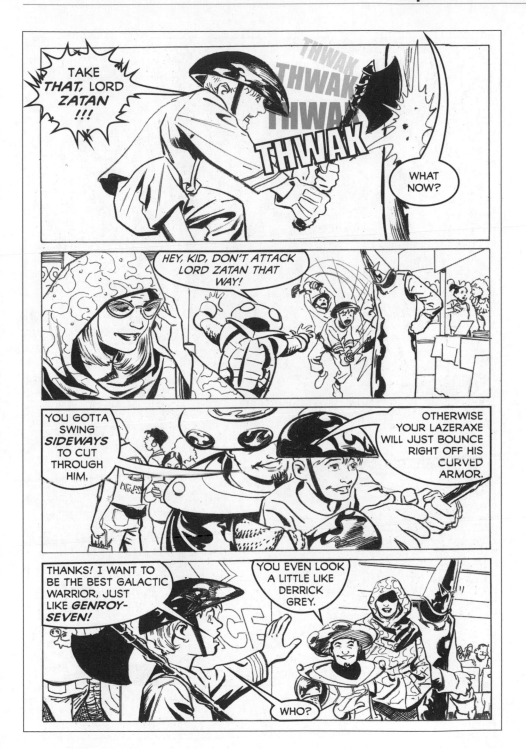

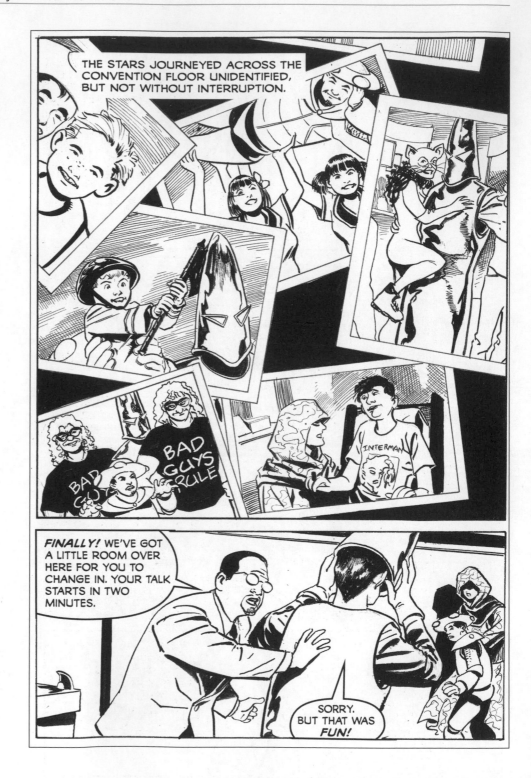

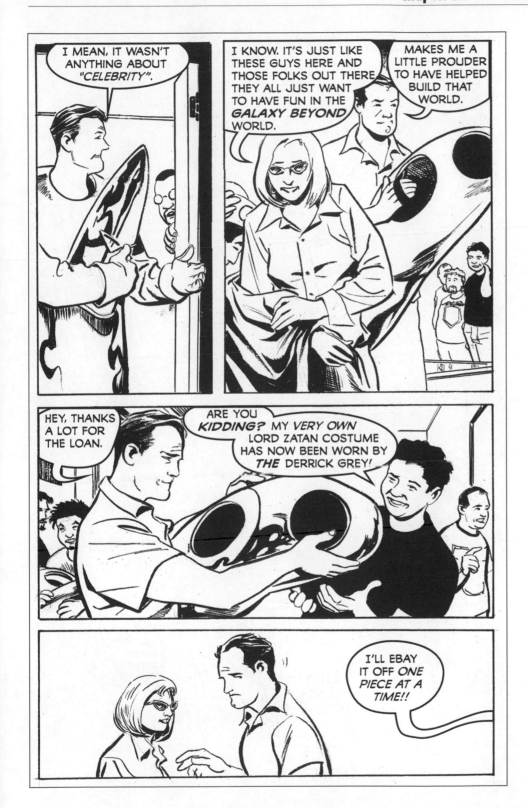

Chapter 22

Colors Besides Black and White

In This Chapter

◆ Picking a pretty palette

◆ Choosing your coloring tool

◆ Adding color to your pages

A few years ago, graphic novel colorists were limited to just 64 solid colors. With the advent of computer coloring and affordable art software, you now have access to 10.3 million colors—that's the *big* box of crayons. Wielding all those crayons correctly takes a special talent. That's why we (Steve and Nat) got together and decided to get a real specialist to write this chapter. Tom Luth came to mind immediately. He's a veteran colorist, having worked on Marvel Comics' *Groo the Wanderer* comics and graphic novels. He has also worked for Image, on *Groo the Wanderer*, and for Dark Horse, again on *Groo the Wanderer*. It seems that wherever Groo wanders, so does Tom. Of course, he's worked on plenty of other projects as well. So here's Tom—treat him kindly.

Four Colors? Not Millions?

Almost all color graphic novels are printed using a technique called *four-color printing*. Each page is run through four printing presses, each of which adds one color to the page. The millions of different colors are achieved by overlapping various amounts of these four colors so that they mix in different ways.

This method of mixing colors is referred to as CMYK, with each of those letters standing for one of the four colors. C stands for Cyan, a kind of blue. M stands for Magenta, a kind of red. Y stands for Yellow, which is a kind of, well, yellow. And K? K stands for blacK. I kid you not.

You can't get every single possible color by using CMYK printing. Some people thinking about color get out those nifty Pantone color books that show a huge array of possible colors of ink, but those are specially mixed inks. Pantone shows you these beautifully bright oranges and vibrant violets that are outside of the CMYK *color space*, the range of colors that CMYK printing can give you. What kind of colors can CMYK give you? If you look through enough color graphic novels, you should get a good idea.

Don't Paint Yourself into a Corner

Folks who paint often approach coloring for graphic novels in the same way they would go about painting a picture, and that's all wrong. First off, your graphic novel art consists mainly of black lines. You won't be covering up the lines, but filling in between them and enhancing their effect. Details that would be delicate and beautiful in a painting will be overwhelmed by the hard black lines. If you add a lot of details, textures, or fancy shading, your colors will overwhelm the line art. In fact, the more detailed the line art is, the simpler your colors should be. Really detailed art should have just big flat areas of colors. That's why colorists love detailed artists.

Also, when you color, you're not just painting an image. The colors you place help to tell a story. Before you put a single color in, read the script. Your art should serve the intended tone of the work. Make decisions that support the story, above other artistic concerns. Artists sometimes make the mistake of getting caught up in cool details that detract from the main focus. Save the story by using color to downplay unimportant details and direct the reader to the important stuff.

Causing Contrast

Imagine a scene with Maurice and Minerva at the Café Flambé. The first shot may be a large panel showing a number of tables on a patio overlooking the ocean. We may not even see our couple, or, if we do, they are such a tiny silhouette we can't even see that Maurice is wearing a scuba suit. As the scene moves forward, you have to direct the reader's attention to the couple, because that's where the story is. How do you make our couple stand out in the crowd of diners and scuba divers? Contrast—making our couple so sharply different from the area around them that they stand out. There are four main types of contrast, as follows:

Contrast in value deals with how dark or light the areas are. To work with value, think of your colored picture as a black-and-white photo. For our Maurice and Minerva example, make most of the areas of the patio and the things in front of and beyond the patio very gray with no very bright or very dark colors. Make Maurice and Minerva in strong black and white using very bright and very dark colors. Readers will focus right in on them.

Contrast in hue is the relationship between warm colors like red and cool colors like blue. Usually (but not always) warm colors come forward and call attention to themselves, while cool colors recede. Make Maurice and Minerva turquoise, and they will stand out against a picture made of cooler blues. Likewise, a purplish red can appear cool in contrast to warm reds, yellows, and oranges. Be careful, because warming up a cool color or cooling down a warm color can leave you with a dulled color, and dulled color is, well, dull.

Contrast in saturation is based on how bright or dull a color is. Pure, bright colors appear closer and grab attention, while duller colors recede into the distance. If Minerva is a very-red red, she will stand out against characters who are a not-so-red red, a not-very-blue blue, and so on. How do you make a not-very-red red? If you remember your color wheel from your school days, each color has a color on the opposite side of the wheel called its *complement*. Red's complement is green, so if you mix a little green in with your red, you get a dull red. Mix in more green than red, and you get a dull green. Orange and blue are complements, as are yellow and purple.

Contrast in detail uses the eye's tendency to notice busy, detailed areas before simpler areas. If everyone else looks like they're wearing flat-colored jackets, then all the shiny reflective areas of Maurice's scuba suit will draw the eye right to him.

You can stick to using just one of these contrast techniques in a scene, or you can use several techniques at once to really catch the reader's eye.

Blocking Out Without Blacking Out

It used to be that to use the contrast in detail technique in a crowd scene, you'd color each nonimportant person a single solid color, or even just lay that color over the whole group. That's easy and still works, but it's not very subtle, and sometimes it looks like someone just dropped a big bucket of blue paint on the crowd.

Now, with good computer coloring tools, you might still color them all blue, but with a variety of values and saturations. Make the waiter's shirt a little more blue and his face a little less blue, and he looks more human, while the reader's eye is still pulled first to Maurice and Minerva in their full color range. You can even fully color the unimportant items and then overlay them with a tint of, say, blue. Done carefully, it won't look like you're saying that these people are actually blue, but as a result of lighting and shade, they look bluish. Clusters of objects can be tinted warmer colors in sunlight or gaslight, and cooler in shadows. Use duller colors on distant objects.

Going Loco with Local Color

Local color is the actual color of an object. Apples are red, the sky is blue, the Screaming Purple Menace is purple. Mess with these colors, but always

remember that the color is there. If you're blocking things out as a solid color, this isn't an issue, but if you're blocking out by tinting, think about it. A red apple under a blue tint looks dark gray, because red and blue are close to being complementary colors. If gray won't work in your color scheme, cheat by removing a little yellow from the color mix of your apple. This makes the apple magenta, so the blue tint makes a color ranging from a deep burgundy to a red-violet. If you do this, reduce the yellow in all the tinted areas in the panel for consistency.

Showing Light and Shade

Where an object is in average light, use its local color. Use warm colors like yellow and orange to highlight where light hits the object, and cooler colors like blue and purple for the shade. Moonlight is special, and blue highlights will show its odd glow.

A not-very-shiny ball.

Keep in mind the value of the colors. In highlight areas, make colors roughly the local color, in sharp contrast to the shadow area. In the picture of the ball, the local color is the color right around the light spot. As you see on the lower right area of the ball, within the shadow you can lighten the color to show some reflected light. Don't try to use the full range of light, and don't go too much in detail. Indoor lighting is usually dull and even, without that much contrast between the light and the dark. You can make light harsher for dramatic, film noir-like effect.

Always remember where your light source is in the scene, and cast highlights and shadows accordingly.

Pick Your Crayons Carefully

The computer lets you use 10.3 million colors, but don't use them all. That makes your pages too busy, too messy. Pick a limited set of colors for your graphic novel. What's a good set of colors to use? That depends on what the graphic novel is like. *Goofy Guy and His Grumpy Pup* probably needs very light colors to match its humorous tone. Superhero material likes bright, bold colors, although a bit darker than humor material, with stark light and shadows. Drama and horror stories like *desaturated* (dim) color schemes.

Within your graphic novel, each setting can have its own color scheme. The scenes in The J. B. Sudsandsteaks Bar and Grill may need an orange, gas-lit look, while the offices of J. B. Sudsandsteaks III, attorney-at-law, will have a dull, blue-gray fluorescent lamp quality. The city streets may have a slightly desaturated look, contrasted with bright neon, and so on.

Try a palette based on the range between two complementary colors. Don't start with colors that are strong, like a bright ultramarine blue and cadmium orange, or your palette will be suited only for a 1960s psychedelic poster. Start with duller versions like Prussian blue and burnt orange, and work toward a neutral from there. Now you have a range that allows for each color and all tints of that color, as well as every hue working toward a neutral by mixing the two complementaries, and all the lighter tints of all these colors. You are not limited to just these colors, but add other colors slowly and carefully.

Colorful Computer

Check to make sure you have the computer you'll need for coloring. While the Macintosh earned its reputation as an artist-friendly computer over the years, all the major software is now available for both Mac and Windows computers, so the Mac advantage is small. Adobe's Photoshop, the program used to color most graphic novels, is equally comfortable on both systems. Go with your personal preference. Get a lot of hard-drive space and a lot of RAM, whichever way you go.

I'm about to describe how to color using Photoshop, but you can use similar programs, although the commands will be slightly different. Photoshop is the king of the bitmap programs, which means it treats the page as a bunch of miniscule dots and keeps track of what color is in each dot. Other bitmap programs like Canvas, Painter, and the free program GIMP have their fans. Few colorists use Adobe Illustrator and similar vector art programs, where the colors are stored as shaped areas rather than as a series of dots. Much of the most groundbreaking work in computer coloring was done using the Codd/Barrett vector art system, but that was expensive and is now obsolete. But even bitmap programs like Photoshop and Canvas now have some useful vector tools.

 Steve Sez: Show, Don't Tell

When talking about color, even experienced professionals can have trouble picturing what's being described. Line artists who want a specific palette or type of lighting should use visual aids. Find a photograph or illustration that has the effect you want, or capture a frame from a DVD.

 Vector Victory

Look at *Spawn Book 1* by Todd McFarlane for examples of Steve Oliff using the Codd/Barrett vector art system to great effect.

Putting the Page in Place

First, get the art into the computer. No, you can't fold it up and stick it in the CD drive. Nat covered the scanning stuff back in Chapter 20, so just flip back a few pages and you'll find it.

Resize the scanned art to the size and resolution the book will be printed at. To do this, set the rulers to the crop marks or borders on the page. From the Image menu, choose the Image Size command. Uncheck the Resample Image checkbox. Type the exact measurements you want into the size fields. Put a check in the Resample Image checkbox and type the resolution you want to work at—say, 400—into the Resolution field and click OK.

The size is now right, but the image is gray, and you need pure black and white. You could do this quickly just by using the Threshold command, but there's a better way to do it. Zoom in 200 percent on a particularly detailed area. From the Image menu, choose Adjustments, then Levels to get the dialog box you see pictured. Put a check in the Preview checkbox. Alternate dragging the black point and white point sliders toward the center. You want to bring them together to meet eventually. As you slide them, watch what happens to the image. Your dark sections will get darker and your light sections will get lighter, and this affects the thickness of the lines. Try to bring those two sliders together at a point where the black lines aren't so thin that they break up, but the white space between them doesn't get clogged up.

> **The Right Size**
>
> Many American graphic novels are 6.625 inches by 10.20 inches, with the active portion of the art placed in a 6-inch by 9-inch area. Your own book may be different.

Level away your grays.

Some people use very high-resolution line art, like 1200 dpi, and a lower-resolution color layer to be composited later in a page layout program like Quark or Pagemaker. To work this way, convert the line art to bitmap and save it as a TIFF file. Then change your line art to 300 dpi for reference for coloring. Usually, though, you'll just keep the line art and colors together in the file, and work at a resolution of 400 to 460 dpi.

Copy this line art and paste it into a new channel, naming the channel "Line Art." This way, you can see the color to make sure you have painted under the line art adequately. If you're not comfortable working with channels, you can do it as a separate layer instead. Fill the original channel or layer with white. Eventually, the line art will become the black channel, but you want it "out of the way" while you paint, yet visible. Keep the line art channel unselected, but click on the "eye" icon on the channel or layer list to keep it visible.

Head over to the Image menu again and choose Mode, CMYK Color. Now, if you've been using Photoshop a lot, you're going to be tempted to choose RGB Color instead and work in the RGB—that's red-green-blue—color-mixing scheme that computer monitors use, because Photoshop has some neat tools and image-altering filters that work only in that mode. Avoid that temptation. You'll have to convert to CMYK in the end, and if you've been working in RGB you'll find that some of your colors just don't translate.

If you have something that you want to use an RGB filter on, copy it out to a separate document, run the filter on it, convert it to CMYK, then copy it back into the main document. Don't just switch your main document between RGB and CMYK mode, or you'll wreak havoc with the colors.

Flatting: Bad for Tires, Good for Colors

Flatting is the technique of filling shapes with general "flat" colors, before any shading or modeling is applied. These flat-color shapes are the starting point for the rendering, and they provide a way to let you quickly select shapes with the magic wand tool. The flats don't have to use the real color you will finally color each area. Often flats are done as just five or six shades of gray, and a copy is kept in a separate "flats" channel, in case later selections need to be made.

If every shape in the drawing had just a simple closed and complete outline, selecting the areas for flats would be easy. Alas, it's not so. Oh, you will have some areas like that, which are easy to take care of. Use the magic wand tool to select the area on the line art channel or layer. Go to the Select menu and choose Modify, Expand. Enter 2 pixels as the amount to expand, and then use the paint bucket tool to fill the area.

Do you have shapes that are almost closed, except for tiny breaks? Go to the color channel and paint a little dot of the fill color to close up the break. Select the line art and color channels together. Click the magic wand to select the area, deselect the line art channel, and expand the selection and fill as before.

Pretty Painting

Mark Waid and Alex Ross's *Kingdom Come* uses fully painted art rather than colored line art. If you paint your graphic novel, the publisher may peel your art off the canvas panel to wrap around the drum of a drum scanner. Protect your art by providing the publisher an expensive color transparency, or use a flatbed scanner to make digital files.

Nat Sez: Times to Get the Red-Green Blues

You should work in RGB when preparing work solely for digital display—webcomics, iPhone, JumboTron, whatever. Also, some Print-On-Demand services suggest using RGB art files to get the most vibrant results from their CMYK printing systems.

Most of the time, however, you're dealing with lines that are full of holes or crosshatched areas with lots of little cubbyholes. Use the lasso tool to select the area, or use the pencil tool to outline the area, then fill in the area. If you're using the lasso tool, be sure to turn off antialiasing and feathering, because those options create partially selected areas around the edges that may look nice but which won't fill with a solid color, making it hard to reselect. Once you have everything selected, expand and fill.

Use the pencil tool to paint right on the color channel or layer. Make sure it is the pencil and not the brush. The brush may look solid, but it actually has partly shaded edges that will cause you problems later.

Start with large shapes, fill with a flat color, and then subdivide these shapes. It's easier to cut larger shapes into smaller sections than it is to paint each segment individually.

Once you've flatted the page, click the magic wand on a flat to select it. Then you can fill the shape with the color you want.

Surrendering to Rendering

Next you *render*, meaning you add shaped highlights to give objects a sense of volume. Don't go overboard. Start in the background, adding simple *gradients* (color fades) and other effects as needed. In the foreground, add more detail.

Getting Cute with Cuts

Cuts is a technique in which you fill a shape with a dark shade, and then make selections with the lasso tool to create concentrically smaller shapes that you fill with gradients to create shading and sharp highlights. This technique is overused, particularly on people, because it makes everything look shiny, as you can see comparing the two balls in the picture.

A not-very-shiny ball and a shiny ball.

To make cuts stand out, use substantial contrast between each new cut. To make cuts subtler, use more selections, choose the antialias option on the lasso (it's okay to use, now that the flats are done), and build up gradually. You may want to add sharper contrast for the very last speck of highlight, depending on the desired appearance. In both cases, the technique seems to work best going from dark to light.

Beyond cuts, you can use the programs tools to add all sorts of fills, gradients, highlights, and textures. Spend a lot of time experimenting and a lot of time looking at the work of other colorists to see what they did and what effect it has. Do you want to color with a soft watercolor look? A very precise linear look? A more abstract coloring scheme where the colors don't begin and end at the lines of the line art? It's all possible.

> **Diverse Examples**
>
> On the graphic novel *Fanboy*, I colored several generations of comics artists, using different styles that match each artist's former work.

Attempt Advanced Tricks Carefully

As you master Photoshop, you'll find a lot of powerful tools. Once you know how to use filters, you'll be real tempted to do so to make your work seem fancy. But as you can see in the texture picture, *fancy* is also *distracting*. Don't do it. You can use textures subtly by making them mostly transparent.

A fancy texture made with KPT Texture Explorer filter software.

Some colorists use photos as surfaces in comics, like using a photo of a real brick wall to represent a brick wall in the comic. This can be done well, but it's risky. Readers' brains adapt to the drawn view of reality, and suddenly having a photo in there disturbs that sense of a drawn universe. Also, matching the lighting, perspective, and atmosphere of the art takes more skill and more time than you might suspect.

Another no-no is using lens flares. *Lens flares* are the result of light refracting in a camera lens, and they aren't appropriate in most situations. Don't use the emboss filter to create depth, because it creates a style of illusion of depth that doesn't match the style of depth in the artwork. Learn and experiment all you want, but don't try a new tool on the final work just for the sake of using the tool.

And with that parting bit of advice, Tom dances off into the beautifully hued sunset, forcing Nat and Steve to start writing their own book once again

The Least You Need to Know

◆ Color graphic novels are printed using the four-color CMYK print system.

◆ Most graphic novels are colored using Photoshop.

◆ Coloring needs to serve the story and keep the reader focused on what's important.

◆ Choose a limited palette to match the style of the story.

◆ Don't get carried away with fancy rendering techniques.

Part 5

Bring Out Your Book

Your story is done. Now it's time to share it with the world. But how? Find a publisher? Publish the book yourself? Put it on the web? Carve it into cornfields so that it can be read by space aliens and Google Maps users? The possibilities are enormous.

This part of the book features information on finding publishers and presenting your graphic novel to them. You will also see how to publish your graphic novel yourself and make it available to comic shops. With tips on how to drum up readers and build a following, you'll be ready for the big time. The only question is, is the big time ready for you?

Chapter **23**

Pretty Please Publish Me!

In This Chapter

◆ Preparing your pitch

◆ Picking potential publishers

◆ Protecting your property properly

You've got your concept, your creative team, and all the knowledge you need to make your graphic novel. That's wonderful, if all you want is one copy of a graphic novel. If you want a lot of copies of your graphic novel and want to get them into the hands of readers and even maybe make some evil, evil money off your endeavor, you'll need to work that out. The most obvious route to this goal is to find a publisher to bring your graphic novel to market.

Pitching in the Strike Zone

I've tried to get a lot of graphic novels published. It would have been nice if I could have phoned up a publisher and said "You don't know me, but my name is Nat Gertler and I'd like you to publish my graphic novel. Could you please send me a big pile of money?" Alas, good things do not come that easy. You need to convince the publisher that your graphic novel will be wonderful, popular, and most important of all, profitable. The way you do that is to create a *pitch*, a presentation that describes your graphic novel in such a way that any durned fool—and even some intelligent folk—can see that this is a good project.

Now in some ways, the perfect pitch is to complete the graphic novel and present the whole thing. That way the *editors*, the folks at the publishing company who choose what to publish, don't need any psychic ability to know what the finished work will be like. They also don't need to trust that you will actually be able to get the work finished in a reasonable time. That's important, because a lot of would-be graphic novelists turn out to be would-be incomplete graphic-short-storyists.

The downside to the perfect pitch is that the publisher may love your concept and art but want it in a slightly different form. The publisher may want to print square graphic novels, or to serialize it in 22-page chapters. It would be a shame to start from scratch. Worse yet and far more likely, you may not find any publishers willing to put the work out. If you're not willing to publish it yourself, you'll be stuck with 128 beautifully drawn pages of drawer stuffing.

You'll need to have at least your writer and penciler in place to pitch a graphic novel these days. Few if any publishers will look at a writer-only pitch from an unestablished writer.

If you're pitching the book in person, generally at a convention, your pitch will be a bit of conversation letting the editor know some very basic information about what sort of graphic novel it is and who you are, and a *proposal*, which is a description of your graphic novel on paper. If you're pitching by mail, your pitch will be just the proposal and a cover letter. In either case, the proposal is what sells the work. The spiel or cover letter just encourages people to read the proposal.

Different graphic novelists use different formats for their proposals, and different publishers want different formats. Here's a basic middle-of-the-road format that will work in many cases:

> **An Artful Warning**
>
> If your proposal is thick with art, put a piece of art on the cover. That way, the editor knows that your big pile of papers is not just a pile of words that make for slow reading.

- ◆ **Cover:** This should have the title of the graphic novel as a nice logo, plus the names of the creative team and contact information for one of the members of the creative team. Don't list everyone's contact information. Pick the best conversationalist of the creative team, since this is who the editor will be calling to talk about picking up the project, if all goes well.

- ◆ **Character guide:** This is made of one-paragraph descriptions of your key characters, accompanied by drawings of those characters. Keep this down to two pages, unless you want to dedicate a single page to each character, with a single paragraph embedded in a large picture.

- ◆ **Plot:** This is where you describe the graphic novel. Keep this down to two pages. Start off with a description of the intended format, such as "original graphic novel," "six-issue miniseries," "to be printed, panel per panel, on a roll of toilet paper," or however you see it. Hit the key plot points, but don't get bogged down in the details. It's far more important to convey the tone of the story than to explain just how the giant singing gorilla got his own TV show.

- ◆ **Sample:** This is several consecutive drawn and lettered pages of the graphic novel. These don't have to be the first pages, although if you do pick the first pages you can put them after the cover and before the character guide. Don't automatically use the first pages though. Pick a section that shows the style of the graphic novel and shows off the artist's strengths. It doesn't have to be long. Four good pages is enough for someone to start liking the graphic novel.

Your cover letter should be brief, introducing the proposal with a single-sentence description of the work's genre and another describing its target audience. For example, you could say "The enclosed proposal is for an original graphic novel called *The White House Wheel*, a taut political thriller about a hamster who becomes president. The audience for this is a cross between the sort of adult political fiction fans who watch shows like *The West Wing* and 12- to 18-year-old boys who own hamsters." If the creative team has any particularly impressive or interesting credentials that would serve the work, mention them briefly in the cover letter. "The artist, Juanita O'Sullivan, was the head storyboard artist on the film *Hamster with a Vengeance*. The writer, Grover Cleveland, served two nonconsecutive terms as President of the United States."

Be sure to include a stamped, self-addressed envelope with your proposal. It probably won't get used if the publisher is interested in your book. Acceptances are generally phone calls. Rejections come back to you by mail.

Maybe They Want Colorful Envelopes

Of course, it's all well and good for me to give you the generic pitch format. That would serve wonderfully well if there was some generic company out there looking for generic product. Alas, there's no one out there who really just needs 15 pounds of good comics.

But really, each company is looking for product that will fit in with how they do business, and to find it in a way that's convenient to them. So what are the folks who deal with the slush piles looking for? Let's ask a few and find out!

What They Do Want

Here's the answers I got when I asked a few of the folks who go through the submissions to finish this sentence: "The thing I most want to see in a series or graphic novel proposal is ..."

- Troy Dye, submissions editor, Ape Entertainment: "Professional-caliber execution. Unfortunately, most people don't understand what that means."

- Chris Ryall, publisher/editor-in-chief, IDW Publishing: "Brevity. As in, a concise, proofread description and summary that runs no more than one page. Less is best at the start. If we like it, we'll ask for more."

- Larry Young, writer-publisher, AiT/Planet Lar: "I want to see a completed work to read and evaluate. A creative team can have the best first five pages in the history of comics, and the rest of their story might not fulfill that potential. Completing the work guarantees the prospective publisher has every bit of info he needs to make a determination. The downside for the creative team is that completing a work is a serious investment of time and money; the upside is that if you complete a work you're seen as serious and somebody somewhere will publish it."

Now you can see where it gets frustrating for the creator. If you look at what Chris and Larry said, they're about the direct opposites. And it's not because one of them is doing things right and one is doing things wrong. They're both doing what works for them, and the generic proposal isn't going to work for either. That you might have to approach these people in different ways is just part of the reality of this business (to the extent that one can call any part of the comics business "reality").

Look at each publisher's website. Find their submission guidelines. See what they want. Give them what they want. I'll probably repeat that all again before the chapter is done.

What They Shun

So then I asked the same three folks to finish this sentence: "The thing I least want to see in a series or graphic novel proposal is …"

♦ Chris Ryall, publisher/editor-in-chief, IDW Publishing: "A full script."

♦ Larry Young, writer-publisher, AiT/Planet Lar: "Five pages of unlettered artwork, a four-page summation of the whole story, and the completed script for the first chapter. That just screams 'we've lost enthusiasm in our own project' to me."

♦ Troy Dye, submissions editor, Ape Entertainment: "A concept that looks and smells *exactly* like something else, but with one minor twist. For example, *HeavenBoy:* supernatural crusader against … the supernatural! Fear his heavenly halo of doom! Or another monster hunter book."

Troy makes a very strong point there. When looking through a pile of sameness, what will catch attention is something that's different, something fresh, not something that's 80 percent of the way to being The Last Big Thing.

Picking Publishers to Pitch

A lot of companies publish graphic novels these days. Most are small companies. Some are self-publishers—people who write, draw, and publish their own graphic novels—who probably aren't looking for other people's work to publish. Others are large, well-established companies that generally work with well-established creators. An unknown creator who wants to sell an original graphic novel to an established publisher will not only have to knock their socks off but also snap their suspenders, unhook their bra, and cause their bow tie to spin around. You can find a list of graphic novel publishers in Appendix A of this book.

Don't go after every publisher at once. Doing so will just sap your energy and keep you from focusing on the publishers where you really have a chance.

Not So Prosaic

There are plenty of books and articles about how to sell your prose novel to a publisher. Don't read those books and assume that the same rules apply to selling a graphic novel. For example, new graphic novel creators rarely use an agent to represent their work to graphic novel specialty publishers. Also, graphic novel publishers are more accepting of *simultaneous submissions,* proposals sent to more than one publisher at a time, than prose publishers are. If you are submitting simultaneously, mention that fact in the cover letter.

The trick is to get to know what kind of graphic novels each publisher puts out. It will do you little good to try to sell a political thriller like *The White House Wheel* to a publisher that specializes in serialized and collected superhero tales. That story about vampire ninjas fighting ninja vampires isn't going to catch the attention of the Lovey-Love Romances line.

Go to a well-stocked comic book store and the graphic novel department of your bookstore. Find graphic novels that are similar to what you want to do. Note who the publishers are. Many publishers now list their website address on their books, either on the title page or the back cover. Most publishers that are open to submissions will have a link on their site marked "submissions guidelines." This page will tell you what they're looking for and what format they want to see it in.

Look at each publisher's website. Find their submission guidelines. See what they want. Give them what they want. I've said that before; it's worth repeating.

Some publishers' websites will tell you that they don't look at "unsolicited submissions." This means that they won't look at any proposal you happen to send them; they only look at proposals that they ask you for. Since they've never heard of you, this means that there's no way to get them to look at your proposal, right? Wrong. You have to ask *them* to ask *you* if they can see your proposal. One way to do this is to send them a *query letter,* which looks a lot like the cover letter described earlier—a one-sentence description, a mention of who the target audience is, and a statement of any outstanding background you bring to the work—and add on a simple request for permission to send them the proposal. Find out the name of the submissions editor or the editor-in-chief of the line, and address it to that person. Be sure to include a self-addressed stamped envelope. If you never hear back or get a "no thank you" note, then the publisher doesn't want your proposal.

But, ahhhh, if that self-addressed stamped envelope comes back to you with a "yes" inside, then you no longer have an unsolicited submission! Put that proposal in a big envelope, write "requested submission" on the outside, add on a big wad of stamps, and stuff it in the mailbox. Oh, and you want to put the address on there, too. It helps.

Go Outside the Lines

These days, a lot of big, non–graphic novel publishers are itching to experiment with graphic novels. If you know prose publishers that publish work similar in content to your graphic novel, pitch it to them. This is a particularly good way to go if your graphic novel is the sort of thing that would sell better in bookstores than in comic shops.

Convention Contention

Major comics conventions are great places to meet editors and lousy places to actually try to make a deal. Conventions are crowded, noisy, and if all is going well, the editor is far too busy to read or seriously consider a pitch. The best you can hope for is to get a bit of attention.

Introduce yourself to the editor. If you can honestly compliment one of the editor's recent publications, do so. That helps show that the two of you share beliefs of what makes a good work. Explain to the editor that you've got a proposal, give the one-sentence description of the tale, and open up the proposal to show some of the art.

Slush Pile _____

An editor's collection of unread, unsolicited submissions is called a **slush pile**.

If the editor is interested, don't just hand over the proposal. Proposals get lost at conventions. Ask if you can mail the proposal to the editor after the conference. A "please do" response means that you not only get to mail it in, you can mark it "requested submission." That gets it in the door at the places that don't take unsolicited submissions. At the places that do take unsolicited submissions, this may get it read before the huge *slush pile* that editors usually use to soundproof their offices.

Don't be surprised if you never hear back from most editors. Reading the submissions is considered the least important part of an editor's job. Wait at least four months before you follow up. Some folks prefer to call editors on the phone, but editors are hard to get on the phone and when you reach them, they're not likely to know which proposal you're talking about. It's much easier to e-mail the editor, who can then respond when the time is available to grab your proposal and give it another look.

Honor an Offer?

Eventually, if all goes well and you eat all your vegetables, you may hear from a publisher who wants to publish your work. This should be a very happy moment, but perhaps a scary one as well. For just a little while, you have to set aside being an artiste and instead become a businessperson.

Publishing companies are companies, and for the most part they are neither evil nor charitable organizations. They want to make money, but if your work is good and sells, they want you to make money, too. That way, you keep doing projects for them and keep making money for everyone.

Publishers have different ways of paying out, and those differences make a big difference in how much, when, and even whether you get paid. Even artists know that getting paid is good.

Page Rate Can Pay Great

A page rate is, as the name implies, a rate of money that you get paid for each page of the graphic novel that you turn in, generally paid within a month after

the material is submitted. Depending on how you cut the deal, the entire creative team might get a chunk of money when pages are completely done, or each member of the team might get paid when each has completed his or her individual job. The writer might be getting paid for the script to page 42 while the penciler is working on page 10 and the inker hasn't even started.

The big advantage of a page rate is that it's the surest money in the business. You actually get money while you're working on the material, which makes life a lot easier. And if there's a financial problem with the publisher, when it stops paying for work, you simply stop working. It's not a wonderful situation, but it's a lot better than completing an entire graphic novel and only then finding out that the publisher is going to leave your wallet as empty as a mime's dialogue balloon.

The biggest downside to a page rate is that it's hard to get one, at least a sufficient one that will cover your expenses while doing the work. The larger, well-funded publishers can offer it, but many of the smaller ones can offer only relatively small payments, if any. Also, the money usually comes at a price, as page rate jobs generally require you to sacrifice more of your rights. What rights? If I answered that now, you wouldn't have an incentive to read the section of this chapter on rights, just a couple pages away.

Royalties Can Be Royally Wonderful

A *royalty* is a chunk of money paid for each and every copy of your graphic novel that is sold. Multiply a good royalty rate by a good amount of sales and you can get a good pay rate. As long as the book keeps selling, you keep making money.

Steve Sez: A Bird in the Hand

I strongly recommend that artists working on graphic novels negotiate some sort of page rate. As I noted earlier, assume you'll take 10 hours to draw each page. Can you afford to do that much work in exchange for the possibility of a payday at some point after the work is completed, printed, and distributed to stores?

Agent Secrets

Generally speaking, new graphic novelists pitching to comics specialty publishers don't use agents. Agents can be handy when dealing with book market publishers, many of whom won't even look at a proposal unless it's brought to them by an agent. They can also be handy in the comics market once you make a name for yourself and have the leverage to really negotiate your deal or to handle multiple offers for the same project. If you need an agent, try to find one with graphic novel experience. Avoid any agent who tries to charge you for services or steer you toward expensive "editors" to prepare your pitch—legitimate agents make their money off of a cut of whatever publishers pay you.

Of course, the downside is that you don't get the money until after the book is complete and published, copies are sold, and the publisher's accounting department has a chance to track the relevant information and cut a check. And you're gambling on your work. If the book sells poorly, you don't make much money. That's true even if the failure is not due to the quality of your work. If the publisher decides to experiment by publishing the book on Swiss cheese instead of paper, the holes will be in your bank account.

A lot of deals mix a page rate with a royalty. That way, you have some money up front and get to keep at least that much if the book does poorly. When you make a deal like that, the page rate is called an *advance*, since the publisher is advancing you some money against your royalties. If you have a deal for a royalty rate of $1 per copy and an advance of $5,000, that means that you get your $5,000 before the book is done but you don't get any royalty on the first 5,000 copies sold. You may never see another copy sold.

Many royalties are stated in terms of a percentage of the sales price of the comic. Keep an eye on whether it's a percentage of the *cover price*, the price that the stores sell the comic for, or of the *wholesale price*, which is what the publisher charges the distributors for the book. The wholesale price varies, but it's generally around 30 to 40 percent of the cover. A deal for 8 percent of the cover price is actually better than one for 15 percent of wholesale, and either is better than a kick in the teeth—even a *really good* kick in the teeth.

Profit? What Profit?

Some deals, particularly with smaller publishers, pay you a percentage of the profit that they make off of the book. The downside to this is that there often isn't any profit. In order to make a profit, the book has to sell enough copies to pay for all the printing, shipping, advertising, and various other expenses involved in production. So not only are you not making money up front, you may have to wait a long while before the book is profitable and you get a check. You may have to wait forever.

The upside to the profit deal is that once a book starts making a profit, you should be making more per copy than what you make on a royalty. Sell a lot of copies, make a lot of money.

Or at least, that's the theory. When you get the contract, look very carefully at how the publisher defines profit. Make sure there is a clear definition of what expenses can be deducted from the book's income. You want to make sure that only expenses directly related to your book are included, such as printing, shipping, advertising, perhaps paying a designer, and so on. If they start charging you for the overhead of running their company, convention expenses, or other things that serve anything besides the production and promotion of your specific book, it's time to start being very wary. Perhaps you need to renegotiate. Perhaps you need to run away fast.

You also want to have the ability to verify both the expenses and income that the book is generating. You need the right to have an accountant audit the printing expenses and the sales if there seems to be a problem. Otherwise, you're trusting their word on their profit. That's only wise if you like giving away thousands of dollars. And if you do, e-mail me! I could use thousands of dollars.

> **Play Detective**
>
> Talk to some of the publisher's existing creators and see if they have any problems or concerns. Even long-surviving publishers can start having payment problems. Small new publishers without any track records are very risky.

Right and Wrong Rights Deals

Whenever you cut a deal with a publisher, you're selling them some of your rights. At the very least, you're selling them the right to print copies of your graphic novel. Other rights you may be offering include the rights to …

- ◆ Publish any sequels to the graphic novel you create.

- ◆ Sell foreign publishers the right to publish your graphic novel.

- ◆ License out your graphic novel for TV, movies, and similar use.

- ◆ Create or license products such as T-shirts, toys, or statues featuring characters or other elements from your story.

If you make a graphic novel featuring publisher-owned characters, you're almost certain to sign over all those rights. In fact, those deals are usually work for hire deals, which means that the law considers the publisher to be the creator of the graphic novel. With that, the publisher can do any dang thing it pleases. If it wants to spray-paint your work on the sidewalk and charge people to play hopscotch on it, or turn it into the first Eskimo opera on Broadway, the publisher has those rights.

If you create a completely original graphic novel, you're in a better position to keep control. On the other hand, the more money the publisher pays you, the more control the publisher is likely to expect. This is particularly true of page-rate payments.

How much control you're willing to give up is up to you. You really have to know yourself. Once you've completed your 250-page autobiographical epic, *The Deepest Part of My Dark, Dark Soul*, would you be shattered if anyone were to use the material in other ways? Or would you be thrilled when they turn it into an animated sitcom with your mom depicted as an axe-wielding hippo, so long as you got a check from it?

Sometimes, it can actually be beneficial to give up the TV and movie rights, so long as you have a deal for a sizable chunk of whatever the publisher makes representing the rights. Some publishers are quite good at making TV and movie deals, making this profitable. Make sure you get cuts of any licensing money made on any front. If the publisher's making money off of your creation, you should be as well. If you're not comfortable with looking at contracts, find yourself an entertainment lawyer.

Sadly, more and more publishers are looking to control all the rights, even in cases where they aren't paying a page rate. And publishers with no real history of movie or TV deals can take both control of the process and the larger share of the results for having done you the favor of putting your work on the printed page. To some degree, a lot of publishing today is really playing the lottery, putting out a comic based on the long-shot hope that it will be a multimillion-dollar licensed property. Some of these contracts, however, have you fronting

the costs and, if the long shot happens and the ticket hits, you get two bucks. Look at your deal with an eye toward what you get if you succeed, and a realistic estimation of how likely the publisher is to achieve that success.

When possible, you want to get *rights reversion*. That means the rights you give the publisher come back to you eventually. By getting the rights back, you can at least hope to find someone else to publish it, someone who can actually make money with the work. The publisher who put out *Road to Perdition* got the movie rights as well, but it let the book go *out of print* and the rights reverted to the creators. When the movie was made, the creators got all of the movie money, even though the original publisher ended up reissuing the book. Now, that was one sad publisher, but it made for happy creators.

Be careful about relying on just out-of-print status for your rights reversion, however. These days, a publisher can create a downloadable edition or use print-on-demand technology to keep a work technically in print at almost no cost. Even when a book keeps selling, you may still want to have a rights reversion after so many years. *Watchmen* co-creator Alan Moore was famously unhappy with the results of his deal; he thought the book would go out of print in a few months and revert the rights to him and co-creator Dave Gibbons. Instead, the book became a perennial, staying in print for decades, during which Moore's relationship with the publisher soured.

As a publisher working with creators and as a creator working with other publishers, I usually like to see a combination of terms. The publisher gets the absolute right to keep the work in print for at least two years, say, but after that, the creator can call for a reversion in rights after any year in which the book doesn't earn at least $200 in royalties. And after six years, the creator can call for a reversion of the rights no matter how well it's doing.

What's important in a contract is that it works for you and it works for the publisher. If that means you get paid half a pizza to start and a yacht when the book sells its hundredth copy, great! (Just don't settle for a whole pizza and half a yacht. That always ends in tragedy.)

Out of Print

A book is considered **out of print** when the publisher doesn't have copies to sell and has no immediate plans to print more.

The Least You Need to Know

- Your proposal should be tailored to the needs of the publisher.
- Learn what type of books each publisher publishes, and focus your efforts on appropriate publishers.
- Turn an unsolicited submission into a solicited one by sending a query letter.
- Be patient and understand that reading the slush pile is often on the bottom of the editor's list of things to do.
- Page rates are surer money than royalties or profit participation.
- Protect the rights that are important to you and make sure you get paid for the ones that aren't.

Releasing on the Cheap

In This Chapter

◆ Should you skip making a profit?

◆ How can you make printed copies cheaply?

◆ How can you put your work online?

If you read the last chapter and immediately found a publisher, skip the rest of this book. If you haven't found a publisher but have a few thousand dollars set aside to invest in yourself, you can skip to the next chapter. But if you fall into the great in-between, with the people who are having trouble getting published but still want to put their work out in front of people's eyes, then this is the chapter for you.

Limiting Losses Rather Than Gathering Gains

The techniques in this chapter aren't about making money. You'll have a hard time making any profit through these methods, much less making enough money for the necessities of life, like caramels and dental floss.

No, these methods are designed to keep you from losing money. If you go through a normal printing method, you can expect to be out thousands of dollars before you ever get your ink-stained fingers on a single copy of your 64-page black-and-white graphic novel. You have to sell hundreds upon hundreds of copies to break even, even with no other expenses. With the methods we tell you about in this chapter, you won't need to invest the cash. You won't get financial success, but you can get artistic satisfaction. You can get readers. You can even get experience that will help you make the next project better, and make it financially worthwhile.

Don't just shrug this off. Look at your work. Is it ready for the big time? Does it really look like something that people will readily pay 10 or 20 bucks for? There's no shame in saying "no." Almost everyone starts trying before they're

good enough. Often, the ones who don't realize they aren't good enough yet are the lucky ones, because they keep on trying until they are good enough. Then they look at the early attempts they had been so proud of, dig a hole in the backyard, and bury them under a foot of dirt.

But even if you recognize that your work's not big-time ready, go ahead and do it anyway. Put your inspiration and sweat into it. Just don't toss your money at it.

Photocopicomics

Most folks releasing graphic novels on the ultra-cheap print them using a photocopier, because it's cheap. In fact, it's free if you use the copier at work when no one is looking.

Of course, in this digital age, you don't have to use a photocopier. In fact, if you're using digital lettering, you've already got the whole thing in the computer and might as well print it off on your laser printer. Think twice about doing a full-color work and printing it off on an inkjet printer, because the price per page for color ink is high—unless, again, you use the one at work.

Most folks doing photocopied graphic novels serialize them in the digest format, the size of a standard piece of paper folded in two. This format can easily handle 32 pages of work, or even 48 pages, but when you get longer than that, you start getting things that are hard to staple and hard to get to lay flat.

The tough part of putting together a digest is making the original version you bring to the copier. You need to copy your art onto your *masters*, the set of pages that you'll photocopy to make your copies. You need two pages on each side of each sheet of paper. They have to be arranged so that when you fold them, they make a complete comics pamphlet, as you can see in the page-arrangement diagram.

> **Check Those Charges**
>
> Before you make a bunch of copies, check the prices at your local copy shops carefully. The price per page can vary by 100 percent between shops. See whether you get a price cut with 100 copies, whether that has to be 100 copies of the same page or 100 copies total, and whether they charge for collating.

Page arrangement for a 16-page installment.

Other folks, looking for larger pages, simply copy the graphic novel page for page on full-sized sheets of paper, stapling the left edge together and making

a simple book. This doesn't look as smooth, but you can get greater length. Staples are still your limitation, unless you want to pay for fancier binding.

Some tips for making your digests:

◆ If you want a different page shape, simply use legal paper. When folded, it comes closer to being square than illegal paper does.

◆ Use heavier paper for your cover pages. This feels right, and makes the finished work easier to hold open.

◆ Your standard desk stapler isn't long enough to reach the center of the page. Ultra-long staplers that can reach a whole foot or so sell for around $20 to $30. Your copy shop may have one for you to use. (They may even offer a stapling service, though at a cost.)

◆ Fold your digest with a good crease before stapling. This gives you a more precise target for the stapler.

◆ Two staples give you the best result. More staples won't make your book hold together any better, and it would only go to further line the pockets of the international staple cartels who have a monopoly on all the staple mines.

The folks who distribute most of the comic books in this market don't want to deal with small-print-run handmade objects. Instead, these kind of comics sell best at conventions. Many conventions have lower-priced *small press* tables just for the conveyors of such fare (although you still may struggle to make back the cost of the table), and some conventions specialize in small press.

Comic shops will often carry the work of local creators on consignment for a 50/50 split of cover price. That means dropping the comics off at the store, getting a receipt for the comics, then coming back at some later date and picking up the unsold copies plus half the price of the sold ones. Folks sell them by mail order, advertising on the web, or in alternative magazines.

Tony Shenton has made a unique business out of acting as a sales representative for small press comics. E-mail him at shenton4sales@aol.com to find out how he can help you get your book into shops.

 Small Press

Small press doesn't refer to the size of the book, but to the size of the publishing company and its print runs. If their books generally have print runs in the dozens or hundreds rather than thousands, they fit the category "small press."

Print-on-Polite-Request

But a handmade comic just doesn't feel like the real deal to many of us. We want something that looks and feels like the big time. And you know what? Those big-time graphic novels are pretty cheap to print. A lot of the black-and-white graphic novels cost about a buck a copy to print. Well, except for the first copy. That first copy costs as much as the next thousand copies combined. It's all the preparation and setting up the presses that costs so much for the first one. The other ones are just cheap ink and paper.

But there's another method of printing, called print on demand (or POD). POD printing outfits use what really amounts to a really fancy laser printer. They'll charge you, say, $7 a copy for that second, third, fourth, or three-thousandth copy, and that's a steep price. But that first copy? It's also $7. Or maybe $7 plus a $25 setup fee. But in any case, it's the sort of money you spend buying this week's comics, not the sort of money you spend buying a car.

In addition, print on demand gives you a handy way to sell your comics. Many POD outfits have webstores. If somebody orders a copy of your book (no, let's make that more positive: "When somebody orders a copy of your book ..." Even more positive: "When Steven Spielberg orders a copy of your book ...") they print up the one copy, ship it off, charge Steven's credit card, take out their costs and fees, and send you the rest of the money. You don't have to worry about how to accept credit cards, don't have to trundle off to the post office, and don't have the sinking realization on leaving the post office that you spieled his name "Spellberg." Just steer your fans to the webstore and let the POD folks do the heavy lifting.

Print on demand is really a topic unto itself. It gets its own chapter just a wee bit down the road. For now, just know it's a cheap way of getting your work on respectable-looking paper.

Online Outlets

In this Internet age, a lot of people skip printing altogether, putting their graphic novels on the World Wide Web. There are a lot of advantages to this. The web gives many millions of people easy access to your work. All they have to do is find out about it, click the mouse, and *wham!* they're reading it. You can work in color without racking up the hideous expenses of color printing or the complicated worries about trapping.

If your goal is a web-based graphic novel, design your work around the screen. Some people deal with this by doing horizontal pages, as with the sample picture from *Nowhere Girl*. Other folks avoid the limitations of the "page" concept altogether. If you do a web search for the phrase "infinite canvas," you'll find comics that don't treat the computer screen as a page, but as a movable window on a page, creating very wide or very tall or otherwise fancy pages.

If you take a look at a variety of web-based comics, you'll find that they use varying levels of technology and complexity. Some are done very simply with HTML, so that you read the page, click on something to move to the next page, then the next page's image downloads while you wait. When the Internet is slow, that wait can take a while. A graphic novel like *Nowhere Girl* uses pre-loading tricks, so that while you're reading one page, the computer is already downloading the image for the next page so that the moment you click for the next page, it appears. Still others use a program like Macromedia's Flash to make graphic novels with full sets of page-turning controls and interesting added features. Spend some time exploring, and you're apt to find a site that

functions in a way you'll want to copy. And even if you don't, you'll have spent a lot of time reading comics, and that's not a bad way to spend a day.

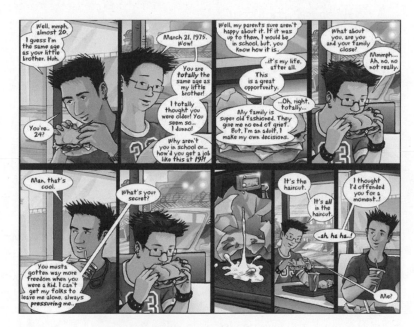

Nowhere Girl, *at www. nowheregirl.com, uses a wide page to fit the screen.*

(©2003 Justine Shaw)

Where in the Web's Wideness Do You Fit?

There are many ways of putting your graphic novel on the web. For about $100 per year, you can rent space on a server and have your own website. It's really not that hard to do in these days of automated web tools. But simultaneously with telling you that it's not that hard, I'm also going to tell you that it's too complicated a topic to fit into the middle of this book. Creating a website not only deserves its own book, but there are plenty of books on just that out there. Buy one, borrow it, read it. Someday, the World Wide Web might just become popular, and then you'll be glad you know how to make it work.

Own Your Own

Whether you're building your own website or putting your graphic novel on someone else's site, get your own domain name. Places like GoDaddy.com and NameSecure.com can sell you *whateveryourtitleis.com* for under $10 a year. If you're not hosting your own website, they have free domain forwarding which will automatically take any web browsers looking for *whateveryourtitleis.com* and send them to the website that has your graphic novel. If you move where your graphic novel is, you can just update the forwarding to move it with you.

But there are plenty of other places on the web to put your comics. Just about anywhere you can post images, you can post comics, and people have put their comics up on MySpace, Flickr, and just about any service with more bandwidth than Twitter. But for comics, you're probably best setting yourself up with one

of the comics specialty sites. The good ones have both the tools that you want to use and the audience that you want to capture. Some of these include:

- WebcomicsNation.com
- DrunkDuck.com
- ComicSpace.com
- SmackJeeves.com
- ComicsGenesis.com
- ComicFury.com
- RampageNetwork.com
- ComicDish.com

Other spots like ModernTales.com and KeenSpot.com carry select and exclusive strips. And by the time you read this, alert web mavens will probably have found yet another combination of two-words-and-a-dot-com to put together to name yet another webcomics host. Go, explore these, and see what sort of deal they offer. While you're at it, explore what sort of content they offer as well. It's good to see what everyone else is up to!

Millions in Viewers, Pennies in the Bank

Online graphic novels are a great way to make a lot of fans and even make a lot of friends. They're a pretty poor way of making a living though. Web readers love free things, but aren't nearly so fond of paying for things. Still, there are ways to try to crank some money out of the web to at least cover your expenses and, with luck, have some left over.

Over the years, folks have tried various ways to get people to pay for individual web comics. Fate has not been kind to these attempts. While there has been some success for things like ModernTales.com, where the new installments are free but accessing the archives will cost you, for the most part people prefer to avoid paying for web content. It turns out that paying for things costs money, and they don't like that.

Still, there are ways to get some money out of your web comic. Many cartoonists take a tip from street performers, turning to asking for tips from the people who enjoy their work. Paypal (at Paypal.com, naturally) will let you set up a tip link where people can throw a dollar or two at you if they like what they're reading. This probably won't generate a lot of money, but it's free money for little effort.

Selling stuff is a good way of making some money. Some creators sell their original art, which means that the graphic novel serves as both a story and a catalogue showroom. Other creators sell products featuring characters and

artwork from their graphic novel. A cool T-shirt with your character on it can serve as both an income source and an ad for your work.

Most folks offering character products use CafePress.com, Zazzle.com, or similar services where you can upload your designs and build your own store page. They take the orders, then print up things like T-shirts, mugs, calendars, and caps on a print-on-demand basis. It works out just like doing POD books does—you won't make as much per shirt as if you had a thousand shirts printed up professionally and sold each one off, but you also don't risk ending up with an empty bank account and a garage full of Tommy the Diabetic Turtle T-shirts.

If you can build an audience, adding advertising to your web page can pay. You don't have to go out and try to handle advertising sales yourself. There are easy-to-use advertising systems where you sign up online, add a chunk of HTML code to your website, and let someone else take care of the business end of things. Advertising schemes tend to work on one of three models:

Commission: You get paid when someone clicks through an ad and buys something. The premiere example of this is Amazon.com's Associates program. Sign up at http://associates.amazon.com and you'll find a lot of "widgets." Add one of these widgets (just a block of HTML code) to your web page, and Amazon will fill it for each visitor with deals intended to entice them. A few percent of each sale goes to you. Many websites offer similar programs—just look for the link marked Affiliate Info on the front page.

Pay per click: You get paid whenever someone clicks on an ad on your page. For example, if you sign up for Google AdWords (http://adwords.google.com), the all-powerful folks at Google take everything they know about the people visiting your website and puts up ads they think folks are likely to click. Each click makes you (and Google) cash.

Pay per impression: Sign up as a publisher on a place like ProjectWonderful.com and folks will be able to buy ad space on your website—ads they have to pay for whether anyone clicks or not. Some places charge in CPM—that's cost per thousand displays. (That's right. M stands for "thousand." If you don't like it, take it up with the ancient Romans.) Project Wonderful charges on a CPD—cost per day—basis. And a handy thing about Project Wonderful is that they support a lot of comics websites. That means that folks who are looking to advertise on comics sites go there. It also means you can easily use your earnings to advertise your comics on other comics sites.

But the most pleasing way to make money off of your webcomic is to sell people your comics. They may not pay to read them on the screen, but some will like what they read there so much that they'll want your graphic novel in physical book form, and they'll want other works by you. Serialize your graphic novel online, then when it's done you can offer a collection through a POD service. If your free comics have built enough of an audience, it may even be time to think about full print publishing.

A Book Worth Hunting

Jason Shiga offers the complete graphic novel *Bookhunter* at ShigaBooks. com. You might think it would cost him customers for this unusual tale set in a world where the library has its own police department to track down overdue books and other library abuses. There probably are a few people who just read it online instead of purchasing a copy, but they're outnumbered by those who discovered it online and then wanted to own a copy, or to buy a copy for a librarian they love.

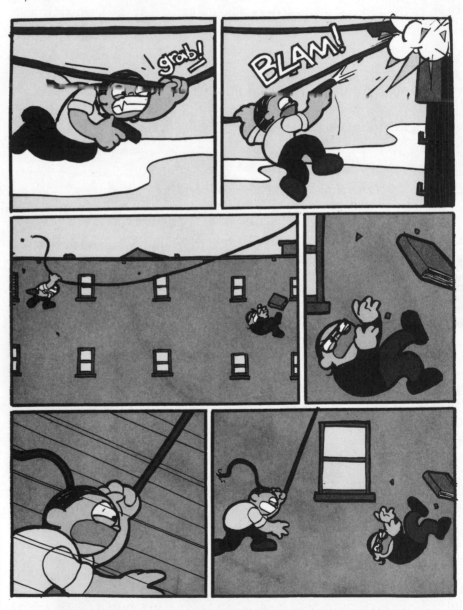

Be realistic about how many readers you will turn into customers. In most cases, only a few percent of your regular readers will pony up the money for your physical books. Don't be mad at those who don't. Love your readers,

because they want to share in the story process with you. They may even be the folks who are spreading the word about your comic. But treasure your customers.

Steve Sez: Sensible Strategy _____

My favorite webcomics strategy for making money is premium content. As an extension of the tip jar concept, the webcomic Achewood offers a $2.99 monthly membership, in exchange for which fans get "premium updates." They are previews of strips-in-progess, deleted material, access to exclusive Q&As, and best of all, several hilarious e-mails a day filling Achewood's fans in on what the characters are up to between strips. This is done via assetbar's Fanflow: http://s. assetbar.com/index.

Spread the Word

For a webcomic, spreading the word is both important and very possible. After all, with the web anyone can get at your comic, but they only will go there if they know about it. So take advantage of services like Project Wonderful, where for a few dollars you can buy advertising on other comic sites. Go to the websites where people discuss webcomics, join in the discussion, and introduce yourself as the creator of that comic. And make sure to include the link to your comic.

Just don't be obnoxious. You can find folks online who will find any excuse to oversell their comic. "The important thing to consider about Lyndon Johnson's fiscal policies is that you should come visit my webcomic right now!" That sort of stuff doesn't win anyone over. Being on a comics community website only to hype your stuff can win you few clicks and a lot of well-deserved scorn. Play well with others, be open, and just keep a mention of your webcomic as part of who you are.

Things for Your Flash Memories

Here are a few tips if you want to build your webcomic readership:

Update frequently and regularly. If you promise two new pages of your graphic novel *My Brother the Martian* every week, and two weeks go by without any new pages, then your regular readers will give up on seeing if you've posted a new page. Work a few pages ahead of time to be ready for emergencies.

Don't be afraid to specialize. If you do a graphic novel about knitting (*Needs and Needles: A Gripping Yarn*) and put it in comic book shops, it means your sales will largely be limited to comic book fans who are into knitting. But if you take that yarn and place it on the web, all it means is that you'll have more success promoting it to knitting knuts on their websites than to the comics hardcore.

Work in higher resolution. When scanning, digitally creating, or coloring, avoid the temptation to work at the same resolution that your graphic novel will

appear on the web. Yes, it's a little easier, a little faster ... up until the point that you want to reuse your art. Web resolution is far too low to be used for printing. Even if you just want to resize your web version a bit, you'll find the results look much better if you start with a high-resolution version. Resize a low-resolution image, and suddenly your story looks like it's about people who iron their clothes with a waffle iron.

Short form is king, but long form can work. It's easy to get discouraged as an online graphic novelist when you look at the most successful and talked-about webcomics and realize that most of them are really comic strips, telling gags in three or four panels, rather than something designed to be seen in larger chunks. And sure, you can get a lot of recognition doing a Player Vs. Player (PVPonline.com), a Penny Arcade (Penny-Arcade.com), or a Girls With Slingshots (GirlsWithSlingshots.com), but don't overlook longform works like Girl Genius (GirlGeniusOnline.com) or MegaTokyo (MegaTokyo.com) in your list of successes. And if your real goal is to get into the mainstream comics market, having a longform story online will serve as a better example of your work and commitment than having a pile of strips.

Keep expectations sane. Yes, there are a few hits on the web, comics that are not only profitable but provide a good living. However, that's a small portion out of the many thousands of online comics that are out there, most of which are lucky if they get a small base of readers and enough income to cover web costs. If your expectations are to make your work available to readers, then putting your graphic novel on the web will work. If your expectation is that your online graphic novel will make you a multimillionaire, you're best off reconsidering. And if your expectation is that your online graphic novel will make your bread warm and crunchy, perhaps you should buy a toaster instead.

Putting the "Sell" in Cell Phone

As I'm typing this, the battle is on to get comics downloading onto ebooks, cell phones, MP3 players, and anything else that you can carry with you that has a screen. Services are starting to pop up designed to provide the link from you to your reader's devices. Things aren't quite ready yet, but by the time you read this, they may be there. Then again, by the time you read this, koalas may have evolved superpowers and become our overlords. Books last a loooong time.

Cell-phone reading has already gotten popular in parts of Asia, and most suspect it's just a matter of time before it takes hold in the English-speaking lands. Still, small portable screens have limits in resolution and readability. As such, we don't know whether people will embrace reading that way. If they do, they may embrace works that are designed for that smaller medium over works that are squeezed down or cut up to fit. If you're reading this in the future, send me a note via time machine to let me know how it all turns out. Oh, and say "hi" to the koalas for me.

The Least You Need to Know

◆ Photocopied serials, web-based graphic novels, and print on demand won't make you a fortune, but they keep your losses down.

◆ Small press conventions and alternative press magazines are good places to find readers for photocopied works.

◆ Print on demand lets you publish books with small print runs, then go back for more as needed.

◆ Web-based comics can reach a lot of people, but it's hard (not impossible) to squeeze money out of them.

◆ Design your web-based comics specifically for the web, but don't keep it down to web resolution.

Put It Out Yourself: Printing

In This Chapter

◆ Who will print your pretty publication?

◆ What do you send to the printer?

◆ How do you check what the printer sends you?

So you've decided that you want to publish yourself, and that you're going to invest your money in yourself and do it up in real commercial style. This doesn't mean you want to throw your money away. You probably want to spend it wisely and get your book to look good. Of course, if you just want to throw your money away, I've got a bucket right here. (Hey, Steve, hands off! That's *my* money bucket!)

A Single Spurt or Slowly Serialized?

The big first question is: Do you want to go right to issuing your work as one big book, or would you rather serialize it in individual issues? On one hand, this is an artistic question. Some stories really work best being serialized, but some really don't. Serialization interrupts the reading experience, which makes it great for works with cliffhanging moments but poor for works that want to be read straight through at a single sitting.

On the other hand, this is a question of desire. If you grew up reading *X-Men*, *Archie*, or even *Love and Rockets*, you may have a real love for the comic book pamphlet. On the other hand, you might see the respect for graphic novels as coming from their square-bound form, and view the traditional format as something that makes hard work seem disposable.

But as anyone with three hands can tell you, the third hand is the most important one. In this case, the third hand is business. To make money on this venture, you need to think like a businessperson. But it's tough to see the right thing from the business standpoint.

Scientific Business

For *Two-Fisted Science* and *Dignifying Science,* multi-artist anthologies of true tales about scientists, Jim Otta-viani preceded each square-bound edition with a single pamphlet containing a story from the book. That way, people could affordably sample his work without Jim tying up a lot of money in a whole series of pamphlets.

Many folks assume they can put out a series of pamphlets, keep themselves going by bringing in a bit more than printing costs on each one, and then make the real money off of the ongoing sales of the eventual book-format collection. Unfortunately, these people often discover that it's not so easy to make even a little money off the pamphlets. They can run through all their money before the entire series is run, leaving them with an incomplete work and no money to print the book edition. Even if they have the money to weather low sales, the distributor may choose to stop carrying the pamphlets.

Although printing a single black-and-white pamphlet is a lot cheaper than printing a black-and-white book, printing 10 or even 6 issues of a comic book is a lot more expensive than printing a book that collects all the issues. This is because the most expensive part of printing most black-and-white works is printing the four-color cover. For the book, you have to pay for printing only one cover. A six-issue series obviously needs six covers, because you can't just use the same cover again and again without confusing folks. The cost adds up.

Calculating the effect of working in both pamphlet and book form is tough. Some people will buy the pamphlets instead of the book. Some people will avoid the pamphlets as long as they assume the book will come out. Some people will buy the pamphlet, and, if they like the work, buy the book to have a more permanent format. And the pamphlet can help build the reputation of your work. Some stores are wary of ordering a book by an unknown publisher but will be more willing to order pamphlets, then order the book if the pamphlets sell well.

If you ask three "experts" whether you should put out pamphlets or go straight to the book, you'll get four different answers. My best advice is to publish the pamphlets only if you're aiming at an audience that is used to reading pamphlets. If you're doing *Captain Arachnid and the All-Bug Squad,* for example, your pamphlets may well outsell your book. But if you're doing a story aimed more at the bookstore audience, putting out pamphlets will waste your money.

Pick a Perfect Printer

There are thousands of printers out there, but you're best off dealing with one that handles comic books or graphic novels regularly. These folks understand the special needs of publishers in the comics field. They know the things that can go wrong, and they're used to shipping to the distributors. Local printers may seem convenient, but you'll find yourself having to work through a lot more problems.

The main North American printers for independent comic books and graphic novels are as follows:

- ◆ **Quebecor World** (Quebec). Quebecor is the world's largest commercial printer, so even though it's the biggest printer in the comics field (they print many of the big-run superhero comics), comics are a small part of its

business. They don't even separate out comics on their www.
QuebecorWorld.com website. They used to have a separate plant which
specialized in the smaller publishers, but that's been spun off into its own
business, which is …

♦ **Imprimerie Lebonfon** (Quebec, Canada). These guys print a lot of the
material from the smaller and midsized publishers, especially black-and-
white books and comics with print runs in the low thousands. Go to www.
lebonfon.com and click on the English link to learn more.

♦ **Brenner Printing** (Texas). Surf over to www.brennerprinting.com for
more information. Brenner handles both color and black-and-white mate-
rial for smaller publishers.

♦ **Morgan Printing** (North Dakota). Its website at www.morganprinting.
com has its contact information and a guide to what you need to provide
the company.

♦ **Transcontinental Printing** (Quebec). This is another major color maga-
zine printer. They have been moving in strongly in color pamphlet and
color and black-and-white book printing for small- to midsized publishers.
Head to their Transcontinental-Printing.com website and type "comic" in
their search box to learn more.

Some publishers go with overseas printers, particularly when looking to find
cheaper routes to getting hardcover or full-color graphic novels. This makes
sense once you've been publishing for a while, have a fair number of books
coming out, and have become good at both predicting how many copies you'll
need and dealing with the printer. For your first book, however, you'll be better
off dealing with people who speak your language.

Contact printing companies you're interested in and ask if they have a price
sheet. Most folks used to printing comic book pamphlets will send you not only
a price list but also samples of comics they have printed to show the different
types of paper they work with. Different paper costs different prices.

Some of the price sheets will include prices for square-bound books that are the
same width and height as the pamphlets. Not all printers include that informa-
tion, and even with those that do, you may want different paper, a different size,
or other special things. In that case, you'll have to ask for a quote.

"I Quote, Therefore I Am"

A *quote*, short for *price quote*, is simply a statement of the charges you'll be billed
for printing your book. In order to provide you a quote, the folks at the printer
need to know some things about your book. No, they don't really care if the
lovers get together at the end or if Sinister Charlie really does conquer Califor-
nia. They need to know how many pages your book is (counting both sides of
each sheet as separate pages) and the size of the pages. They also need to know
whether the printing will be in color or black and white, which is a separate

Cheap Runs _____

If you want a few hun-
dred copies of your
black-and-white graphic
novel, go to www.
acredalemedia.com and
check out the prices. Acre-
dale won't give you many
options, and they accept
only all-ages material, but
the prices are better than
print-on-demand printing
for runs that seem too short
for traditional printing.

 Perfect Paper Picking

Did you see the graphic novel *HeliCatterpillar* and think "that looks just like what I want!"? Ask the publisher which printing company put it out. Tell that printing company you want your graphic novel on that same stock as *HeliCatterpillar.*

Look at this area under bright light to see bleed-through.

Steve Sez: Ask the Artmonkey

Artists who have been published before have seen how their work reproduces on different sorts of paper, and they've probably noticed the same when looking at other artists with similar styles. Get your artist's opinion.

question for the outside covers, the inside covers, and the interior pages. The printing folks need to know how many copies you'll want to print, although they don't need the exact number—ask for the minimum you're planning to print and for the *marginal copy cost*, which is how much it will cost to print each additional copy.

They also need to know what sort of stock (that's paper) you want your graphic novel printed on. Actually, you need to pick two types of stock, one for the interior and one for the cover. Paper varies in a lot of ways. There are gloss papers, which are shiny, and matte papers, which are not. Papers vary in thickness, in graininess, in color, and even in how they feel in your fingers. They also vary in the amount of bleed-through. That may sound like the horrific effect of a paper cut, but actually it is the ability to look at a page and see the print that's on the other side of the page, as you can see in the accompanying image. Bleed-through can be caused by two things: ink actually soaking deeply into the paper, and bright light shining through thin paper and reflecting off the next page.

Don't assume that the whitest paper is the best. Very white paper creates a stark, photocopied look, and many black-and-white graphic novels look better on a muted color such as beige or cream. Really bad graphic novels would look better printed on black paper, so you wouldn't have to see the art.

Pricing the Price

The price quote or price sheet will show a basic printing price. For a book, it might say that printing 1,000 copies costs $3,000, and then each additional copy will run you $1 to print. So if you want 2,000 copies, it will cost you $3,000 for the first thousand and $1,000 for the second thousand, so it will run you $4,000 total, right? No, because that's just the start of the costs.

Somewhere else, you'll probably see something that says "tolerance +/–5%." What that means is that they're really not going to try to print 2,000 copies, but rather 5 percent more, making 2,100 copies. That way, if something goes wrong with printing some of the copies, they can still promise to get you at least 1,900. This also means that you have to be prepared to pay for 2,100 copies, bringing your potential total to $4,100.

Now you've paid to get your books printed, which is all great and wonderful, except now you just have a pile of books at the printer. If you want copies of the book to get to you and to the distributors, you'll have to pay for shipping. The

printer will do an upfront shipping estimate by adding 10 percent to the total cost of printing. That $4,000 price has become $4,510.

And sadly, that may not be the end of the money you give the fine and gorgeous folks at the printer. If you're overprinting your book for long-term sales, you may want to keep the extras in the printer's warehouse, for an additional monthly fee. Otherwise, you end up with a living room full of boxes, which is no good even if you try to use them as furniture.

Prepress with Success

Printing isn't magic. You have to send your printer all the contents of your graphic novel to print. It used to be that you'd send your actual art to the printer and hope they would treat it nicely as they processed it. These days, no one wants to see your physical art. They want files. Specifically, they want two or three files. One file has all the interiors of your book or issue. If you're doing it as an individual issue, your second file will have the entire cover as a series of pages, with the front cover, inside front cover, inside back cover, and back cover in that order. If you're doing a book, one file has the entire outside cover including spine, and one has the entire inside cover—unless your inside covers are blank. They don't need a file for blank.

What kind of files do they want? They either want the file from your page layout software (most printers will take the files for InDesign, some will take files for QuarkXPress), or they want a PDF (Portable Document Format). The good news is that just about any piece of graphics software now available can create a PDF file. The bad news? They can't give you quite what you need—a precisely sized PDF file that doesn't degrade the art. Trying to make the PDF for your graphic novel using your word processor will be like trying to mash potatoes with your thumbs—it will take a lot of awkward effort to get it done, and nobody's going to want to eat the results.

What you really want: desktop publishing software. A program like InDesign or QuarkXpress is designed for serious book and magazine design. They'll give you all the features you need and plenty you don't. Few graphic novels need an index generated for them, for example ("Penguins, fighting—32. Penguins, smooching—16-17, 49, 102. POW—*see* Ka-POW.") And those features will cost you something in the general neighborhood of a thousand dollars.

What you can certainly make do with: PDF assembly software. These are programs meant to let you take pieces from various places and throw them into a PDF. The gold standard on this is Adobe Acrobat, which will run you $400 or so. However, there are cheaper programs in this realm, like NitroPDF ($50–$100).

What you may be able to make do with: PDF combiners. Since whatever program you're using to scan in your pages or to add lettering can probably save the result as PDF files, you can make a PDF for each page. As long as you have each page sized right from the very beginning, a program that just combines

How Big Is Your Spine?

You can calculate the width of your book's spine based on the number of pages, the thickness of the paper, and the thickness of the cover stock. But a better idea than calculating it is to ask your printer, because they're less likely to make a mistake. Printers love answering questions. It's so much easier to help you not to make mistakes than to fix mistakes later.

several PDFs into one multipage PDF, like the shareware PDFMerge for the Macintosh or PDF Merger for Windows, may get you by.

What you really want: a friend. If your pal Faruk already does layout, he's got the software and the know-how. All he needs is the bribe of a nice large pizza and he'll not only do the layout for you but also explain what he's doing, so you learn. That's how I got my first book laid out. Of course, your friends may be different. They may prefer cupcakes.

Each Page Is a Picture, Pretty or Not

Modern graphic programs can put out files in umpty-gazillion different file formats, give or take eleventen. Many of your favorite formats are useless here, however, because they degrade your image, and even if your art isn't very good, degrading it isn't an improvement. Save your pages as flattened TIFF files (that's Tagged Image File Format). If you're coloring your image or doing other, layer-based work in your graphics program, then you'll also want to save a copy in the program's native format so you can go back and make changes and corrections later, but the flattened (no layers) TIFF file is what you'll actually put into the PDF. That what will fit in the file, and TIFF is just "fit" spelled backward, badly.

If you're doing lettering in a vector program like Adobe Illustrator and are using a full desktop publishing program to put things together, you can save just the lettering layer in EPS (Encapsulated PostScript) format. In the desktop publishing program you can place the EPS file directly over the page's TIFF file to combine the lettering with the art. This will get you the sharpest lettering possible, although anytime you make your file more complex like that, the odds of something going wrong increase. Usually, I just use Illustrator to export a TIFF, and I've never heard a complaint that my lettering wasn't sharp enough. (My script, yes, but my lettering, no.)

Cutting and Bleeding

All of the pages you create are going to be a little larger than you expect. That's because the equipment that chops the paper for your book isn't as exact as you'd like it to be. Therefore, everything has to *bleed*, which means to continue beyond where you expect the edge to be. Your printer will give you the exact number, but usually you'll need about an extra eighth of an inch at the top, bottom, and outside edge (that's the right side of an odd-numbered page or front cover and the left side of an even-numbered page or back cover).

If you have art or color that continues to the edge of the page, make sure it goes off into the bleed. That way, if the page is cut a little off, you don't end up with dead white space. And if you have text or other things that absolutely must be on the page, make sure it's at least the width of the bleed away from the edge of the page. After all, it would be a shame to have the detective say,

"I've figured out that the killer is," and then have the rest of the sentence chopped off at the bottom of the page ("not a very nice person").

Avoid Gutter Talk

Beware of putting text or other important matter on the inside edge of the page. Open a book, and you'll see that there's about a half inch of page that slopes down into the binding and can't be easily read. You don't want readers to have to rip open the book to see things.

Even when you're preparing individual issues, avoid putting things close to the inner edge. That way, your files are ready for when you collect the issues into a book.

Please Your Printer Properly

Most printers will happily accept a PDF file, but many will also take (and some prefer) native InDesign or QuarkXPress files. If you decide to send that, make sure your DVD-ROM or ZIP file includes not only the main file, but all of the support files—all the images and fonts. Even then, you might find that the printer's systems will take Postscript fonts but not TrueType fonts, or some other messiness. Using a PDF file limits the problems you will face.

The printing company will probably give you a couple pages of suggestions to help you prepare the book for printing. Listen to those suggestions. Ask questions if you don't understand. It's better to *look* stupid than to *be* stupid.

Complete Idiot's Guide to Dummies

When you submit your digital files, you should send the printing company a *dummy*. No, they don't need a mannequin or a Guy Fawkes. What they're looking for is a handmade copy of your book. Print the pages off on your computer printer. If possible, print on both sides of the paper, or else you'll have to tape your pages together. Don't worry about using the same size paper as the final book or trimming off the excess edges. Staple the pages together. If the printing folk see something weird on their output, they can check your dummy and make sure that it's the weird thing you intended. Once you have a few books under your belt, you may choose to forgo the dummy, especially since you can send in your files via the Internet and skip physically shipping anything altogether.

In addition to the DVD-ROM and the dummy, the printing company wants you to send in a signed order sheet that includes the paper types and the print quantities. Often, you can just sign a copy of the quote and send or fax that in.

And that's not all you have to sign. You also have to sign a check, or at least a credit application. Most printers will give you 30 days to pay as long as you have some record of paying your debts. If you're going for credit, send in your

credit application a few weeks before you intend to send in the book, so that the printer has time to check and approve your credit.

The Proof Is in the Proof

You send in your dummy of the graphic novel and the printer usually sends back its dummy—but the printer calls it a *proof* or perhaps a *sherpa*. This is your last chance to catch mistakes. If the printer makes a mistake and you catch it now, then the printer has to fix them for free. If you catch mistakes that only you made, you can get them fixed, although in some cases your fixes will cost you money. But if you miss mistakes now, you've got a problem. Suddenly, you'll find yourself the proud owner of 4,000 copies of a book that has three copies of page 27 and no copies of pages 40 and 95.

Make sure your pages are all there and in the right order. Check to see that nothing is badly tilted. Make sure no text is placed too close to the edge of the page, otherwise a slight change in the cutting position will leave your characters cut off in midsentence.

If you're doing a color book, you might get a *color key* for the interior pages, which is a full-color proof you can check for color problems. Such color keys aren't cheap to make, and a printer may charge extra for them, so you may need to skip this unless you're rich or paranoid or both. If you are both, your money may be better spent on Gertler & Lieber Brand Space Alien Repellent.

You'll almost certainly get at least one proof for your color cover, possibly two. You'll at least get a color guide, a sharp-looking color reproduction of your cover that actually looks a little better than your finished cover will. Use this to check that your colors are reproducing as you intended.

The position guide is a trimmed and folded version of the cover, to show you exactly where the printer intends to cut and fold the cover. This may be produced on a very different printing system, so don't use it to judge the colors unless the printer gives you just one guide that is meant to be used as the color guide and position guide.

Proofs often come to you via overnight delivery service. When you get the proofs, look over everything carefully but quickly. Printing companies usually want you to respond the same day, so that they can make any necessary fixes and get on with the job. You may get the cover and interior proofs separately, because they'll be printed at different times and on different presses.

Your proofs will often come with a form that has to be signed and faxed back, on which you list any corrections that are needed. Remember, when you sign that approval, any blame for any mistakes you missed is now yours. Even though you must do it quickly to avoid your printing being delayed, you should still do it with care and fear. A trembling signature is a sign that you take this responsibility seriously.

Be FedExpecting It

If you're not constantly at home (or wherever your proofs are being delivered), ask your contact at the printer to call you when the proofs are being shipped. That way, you know to be home when the package arrives and can respond quickly to the proofs.

The Least You Need to Know

◆ Don't be too optimistic about your ability to publish your graphic novel both as a serial and as a book.

◆ Get price quotes from several experienced printing companies before picking one.

◆ Quality and convenience should be considered in picking a printer, not just price.

◆ The paper that best matches your book may not be the whitest or the most expensive.

◆ Send the printing company your files, a dummy, an order, and payment.

◆ Check your proofs carefully for page order, placement, and problems, then quickly return the approval to avoid delays.

Chapter

26

Put It Out Yourself: Print On Demand

In This Chapter

- ◆ Why would I use print on demand?
- ◆ How do I prepare my book for print on demand?
- ◆ Where do I demand my printing?

Print on demand is a technology that has swept the world. Wait, that's not right. The *broom*—that's the technology that has swept the world! Print on demand has merely made it quick and easy to produce books and comic books a single copy at a time, which means that it has cluttered the world with more books and comic books. Really, it's the exact opposite of sweeping … but a lot more fun.

When to Demand Print On Demand

As I said a couple chapters back, print on demand isn't really a way to make a lot of money. If you're printing thousands of copies, it's far cheaper to use traditional printing. The cost of printing on demand is generally about as much (or a bit more) than what your publication could wholesale for. And if you lose money on every sale, your only hope of making a profit is to sell negative copies. That's something I've never been able to achieve (although a few of my books have come tantalizingly close).

But that's not to say there aren't very logical reasons for taking the print-on-demand route. I've taken the print-on-demand route a number of times myself, and I'm perfectly logical. If you don't believe me, ask my invisible friend Dr. Hortense Donutface.

For Show Art, Not Show Business

The most obvious time to use print on demand is when you're not expecting or hoping to sell a lot. Maybe this is your first graphic novel, it's a learning experience, and you don't feel ready for the big time. Maybe what you want to do isn't something aimed at a big audience—your shocking behind-the-scenes look at your high school cafeteria ("the mystery meat is gerbils!") is just for a local audience, or your autobiographical adventure about life with a tiny ego and giant pinkies isn't meant to grab everyone. Photocopied comics are fine for projects like that, but print on demand gives you the slick, professional look and keeps it affordable to do color. Really, the mystery meat is not the same unless you can see its odd green tint.

A lot of this book is about business, because business can be important, but there is no shame in creating comics for love. Few people are in the field strictly for business reasons. I've been doing comics professionally for 20 years now, and I just created a print on demand edition of a 24-hour comic I drew. It could never sell a lot of copies, but I can sell a few at conventions and share it with the small audience that I think will enjoy it. Catch Steve at a convention and you'll see that, in addition to his big-time graphic novels, he's got some photocopied comics as well, stories he created with his talented novelist wife. The real mistake would be in assuming that you have to treat your object of art and love as an object of business. If it will sell 10,000, sure, print up 10,000. But if it will sell 25, print up 25. And if you sell those and want some more, it's easy to print up some more.

For Show Business, Not Comics Business

You've got a great idea for a movie. It's called *The Metal Pretzel*, and it has an ironic twist in the middle. And you've heard that Hollywood is really big on picking up movie rights based on graphic novels, sometimes even graphic novels that have not been released yet.

But the movie deal is your real goal. Publishing and promoting the book and trying to get distributors to carry it and comic book stores to order it so that you make back your printing costs? That seems like too much effort to you. So you skip all that. You print a few dozen via print on demand, and then let your agent get them into the right hands at the studio. You keep the option open to do full publication later, but for now, you're reaching your intended audience at the studios. People with considerable Hollywood experience are taking this very path. (Then again, people with considerable Hollywood experience are also joining cults, buying $2,000 sneakers, and smoking jelly beans. Truth to tell, "considerable Hollywood experience" is not always a mark of wisdom.)

For Show Then Business

Even if you're planning to do the full-on 10,000-copy publishing thing, print on demand can still be very useful. Sometimes, it's very handy to have a few

copies of the book months ahead of release. That way, you have copies to send out to reviewers without having to set your print run in advance or to have your entire print run in storage. Sure, reviewers can work from photocopies or printouts, but putting something that feels like a real book in their hands can change how they respond to it.

If you do go that route, make sure that it's clear to the reviewer that this is a preview copy. You can put on the cover "Preview copy. Publication schedule for July 2012. Actual publication to be printed on Grade A American cheese. Advertising scheduled for *Time* magazine, *Halftime* magazine, and *Women Swear Daily*."

You can even use print-on-demand copies when you're still at the pitch stage. If you have a completed graphic novel and are searching for a publisher, a print-on-demand copy is easy to send around. Just make sure that it is very, very, very clear (*very*) that this is just a mockup, and that you're not looking for someone to reprint an already-published work.

For Already-Shown Business

You went and you published your bicycle-cop graphic novel, *Two Tired*. You printed up a couple thousand copies, and over the years, sold them. You're still selling a few at each convention you go to—or at least you would be, if you had any. Sales aren't enough to really go back to press, but with print on demand, you don't have to retire it. You can print off a few copies every year forever, and also create an easy way to make it available for ordering online.

Dancing About Printing _____

Traditional comics collectors can get very interested in whether a book is "first printing," "second printing," or a "reprint." That terminology can still make a little sense if you're ordering all the printing done a batch at a time for copies you're selling yourself. However, if a book is available for ordering from a print-on-demand website, then an individual copy can be printed at any time, and the distinction between printings makes little sense.

Even if you serialized *Two Tired*, you may have plenty of issues 1, 2, 3, and 5, but have run out of number 4. It's hard selling sets with a hole in them, but a print-on-demand reprint can fill the hole nicely.

One of the neat things about print on demand is that it's easy to print off copies with a different cover. Create that special edition, available-at-this-con-or-this-signing-only Barack-Obama-eating-a-leprechaun cover, and what you have isn't a "reprint," it's a "rare exclusive variant edition"!

Setting You Up with Set-Up

If you came here looking for the right way to set your art files up for print-on-demand printing, I've got news for you: this section is a set-up. There's no answer here, because there is no right way.

This printer only prints from PDF files. *That* printer won't accept PDFs; they only want TIFF files. There's probably a printer out there that wants you to engrave everything backward on the bottom of a sneaker so that they can just stomp it into place.

Because of this, you'll have to pick out your POD company before you set up your files. Each of them has on their websites the details of what they need. Read those details, and make sure you deliver exactly what they want. Delivering something that's kind of like what you think they want can get your printing delayed, or worse yet, can have you paying for something kinda like what you wanted printed.

The paper-trimming systems for print-on-demand printers aren't as precise as big printers. As such, you'll have to leave a larger safe area without text and important details around the edges of the paper. You'll also have to have a larger bleed, extending your image and colors beyond where you want the paper to be trimmed. And for some POD printers, for certain sizes they aren't trimming at all, but printing on the correct-size paper to begin with. That may sound like a good thing, but since their printing method doesn't reach to the edges of the paper, you can't do a full bleed and will always have white at the edges.

Where to Demand Your Printing

There are plenty of print-on-demand publishing services. Some specialize solely in comics, and others are very inclusive of comics in their range.

 Scam-Per Away _____

> If you do a web search for print-on-demand companies, you're likely to run into companies that offer to be your print-on-demand publisher, paying you $1 plus royalties, or all sorts of other attractive enticements. What you're running into is a range of companies designed to make money off of would-be prose publishers, charging them for a pile of services and selling them their own books without a reasonable hope of generating sales elsewhere. They don't provide worthwhile service to prose publishers, and while they might gladly take your money, they don't know or care a darn about comics. Steer clear.

If you go to their websites, you'll find a lot of information about price, what formats they print, their sales sites (if they have them), and their turn-around time (how long after you send your files in do you put the product out). What they don't tell you is how good the results are. Well, they may tell you that they have the tip-toppest bestest printing in the whole widdly wide world, but there's

not much reason to believe them. The most obvious way to check their print quality is to buy something that they printed, perhaps from their online store.

The best way to check how well they're actually doing on turn-around time and on customer service in general is to do a web search for their website name. No matter what service you search for, there will be some complaints. That's human nature. There will always be someone who thinks that the printer should have made their crayon scratchings look like they were written by Shakespeare and drawn by da Vinci. Or that the mailman should've delivered their comic the same day they uploaded the files. But if a service gets more complaints than praise, take those complaints seriously.

Ka-Blam

The folks at Ka-Blam.com focus on comics and graphic novels, although they also print a few other items. Their prices are pretty good, especially if you let them place a Ka-Blam ad on the back or inside back cover of your publication. (Beware, however, that including such an ad technically prevents you from shipping those books using the U.S. Post Office's media mail rates.) I've printed a number of projects through these guys, and I've been pleased with the results.

One odd thing is that they strongly recommend sending them color files using RGB coloring rather than CMYK coloring, saying that for whatever reason, it comes off looking better from their presses. This is a real convenience if you are putting together a print edition of something you serialized on the web, since you can keep your RGB coloring.

Ka-Blam handles both color and black-and-white printing. They do *saddle-stitched* and square-bound materials. They offer a self-covered option, which means no separate cover paper—the cover is printed on the same paper as the inside, which is cheaper but also feels it. Ka-Blam doesn't charge a set-up fee, so you can print just a few copies to start with and have them be cheap. However, if you need to change some files after your first printing, there will be a fee.

Ka-Blam has one special advantage over less onomatopoeic services. Not only do they have a storefront you can sell your publication through (IndyPlanet. com), they've even set up their own distributorship, ComicsMonkey.com. If you let them, they'll sell your publication to dealers on a wholesale basis. As I write this, they're just getting the distributorship rolling, and it's clear that they don't expect to sell books in huge quantities. A book offered through here won't get anywhere near the sales that it would get through traditional distribution routes. On the other hand, as long as you're print-on-demand publishing, it's hard to see how offering the book through Comics Monkey would hurt. Unless the monkey rolled up the comic and stuck it in your eye.

ComiXpress

The folks at ComiXpress.com presumably want you to read their name as "Comics Press," and not "Commie Express," and I shall humor them in that.

 Saddle-Stitched

You know how comics are held together by two staples along the folded edge? That's called **saddle-stitching**. Sounds a lot fancier than "stapled together," doesn't it?

They specialize in comics and don't get into the whole printing-T-shirts-and-mousepads business. While their default is standard comics sizes, you can order custom sizes as well.

ComiXpress does charge a set-up fee the first time you print each publication, which is going to up your cost if you have a low print run. However, that generally allows them to charge a lower price per copy than some other printers for the actual publication, so depending on how many you order, your total bill may be cheaper with ComiXpress. Unlike Ka-Blam, they don't offer a discount for running a Ka-Blam ad in your publication. Instead, they offer a discount for running a ComiXpress ad. I guess that makes sense.

They do have a storefront at ComiXpress.com. As I'm writing this, they've announced that they will start a retail distribution service, but they've not announced the details. By the time you read this, that information should be on their website.

Lulu

Lulu is a big, big player in the print-on-demand self-publishing game, even though their name isn't worth much in the Scrabble game (a mere 4 points, far less than Ka-Blam or ComiXpress would be). As such, they don't specialize solely in comics, but they have clearly made comics part of their range.

Over at Lulu.com you'll see a slick, award-winning website. They don't let you set any custom dimensions you want, but they do have a wide range of standard dimensions, so you'll probably find something you'll be happy with.

Their pricing is odd. They are quoting higher prices for saddle-stitched books than for *perfect bound* ones. Not just a little more, either—several dollars more per copy. I heard on the news the other day that the price of staples was going up, but this is ridiculous.

They do offer a storefront and some distribution options targeted to the book trade rather than the comic book specialty stores. I've used their services for perfect-bound black-and-white books and have been satisfied with the results.

Café Press

The folks at Café Press (www.cafepress.com) do not specialize in comics. They do not specialize in books. They specialize mostly in T-shirts. And mugs … and mousepads, and bumper stickers, and coasters, and underwear, and buttons, and bibs, and an ever-growing array of tchochkes.

They do not print color interiors. They do not print cheaply. They don't do hardcovers. They don't offer comics distribution services.

Then why, oh, why am I bothering mentioning them? Because they do T-shirts. And mugs. And mousepads, and bumper stickers, and coasters, and underwear, and buttons, and bibs, and an ever-growing array of tchochkes. Café Press does some things well, but about the only reason I could see for using them to print

WHA…? **Perfect Bound**

Your basic modern paperback book is **perfect bound.** That means that both the open edge and the spine are nice and flat and straight, and the whole thing is held together by glue.

comics is if you're running an online comic. Café Press offers great ways to set up your own custom storefront with an array of print-on-demand merchandise. If you want to be able to offer a book of your comics through the same store-front as your merchandise, then Café Press can do it ... if you don't mind it being an expensive, black-and-white book.

CreateSpace

You don't actually get to create space at CreateSpace.com. Space is already infinite. What CreateSpace helps you create is books. They do only square-bound, paperback books, both black and white and color. They have an array of standard sizes, which does not include standard comic book size. They have a nice, slick website which has some nifty design features, but if you're doing comics, you probably want more control for yourself. They do allow you take that control if you want.

But what's their big feature, the thing that might make it worth using them? It's their storefront. You may have heard of it. It's called Amazon.com.

CreateSpace is Amazon's own self-publishing option. Given that Amazon has erected barriers (although not insurmountable ones) for folks publishing through other print-on-demand services to get listed on their ever-so-popular shopping site, there's much to be said for using CreateSpace. People searching Amazon might come across your book. If you're directing people from your website to a storefront, Amazon is one that they know and have used before and have an account with. It may not be optimized for graphic novels, but to say that Amazon sells a ton of graphic novels is leaving out the phrase "every couple days."

However, you don't have to push customers to Amazon. They also help you set up an "eStore" on your website. In fact, they encourage it and will give you a bigger chunk of the money for each sale you make through your eStore instead of through Amazon.

This is probably a good option to consider if you have a book that will show up well in Amazon searches. So consider it if your graphic novel is on a popular topic like "How to Make a Will," or if your name happens to be Stephen King.

Monogamy Is Overrated

If you're doing print on demand for the distribution possibilities, there's no law that says you can only use one. You could offer the same book through CreateSpace and Ka-Blam, using CreateSpace to reach the Amazon users and Ka-Blam for distribution to comic shops.

The Least You Need to Know

- Print on demand is an affordable option for low print runs.

- Some print-on-demand printers offer distribution options. Some offer online storefronts that you can sell your book through.

- Printers vary in reliability, in quality, and in services they offer.

- Ka-Blam.com and ComiXpress.com specialize in comics and have some expertise that comes with that.

- Lulu.com, CafePress.com, and CreateSpace.com don't specialize in comics, but each has special features that may serve you well.

Put It Out Yourself: Distribution

In This Chapter

- How do I get my graphic novel into comic shops?
- What do I tell the distributor about my graphic novel?
- Can I get it into bookstores?

You have thousands of copies of your graphic novel sitting in genuine cardboard boxes in your living room. And somewhere out there, you hope, are thousands of readers who want to have a single copy of your graphic novel in their living room, cardboard box not included. If you wanted to, you could hire Madam Louella, Comic Book Distribution Psychic, to divine the names of all of those thousands of people so you could mail copies right to them, but Louella isn't cheap and her accuracy is in doubt. Instead, you're better off dealing with distributors, companies that can offer your books to the stores.

Diamond: A Gem of an Operation

The main distributor you'll deal with is Diamond Comics Distributors. They are the heavy hitters in distributing to comic book stores. This is because they have the exclusive right to distribute the works of the four largest publishers to the *direct market*. You could theoretically run a comics shop without dealing with Diamond, but most of your day would be spent answering questions with "No, we ain't got that." So every single comics shop deals with Diamond, and a huge portion of the shops don't use any other source for graphic novels.

 Direct Market

> The **direct market** is the stores—primarily comic book shops—that buy comic books and graphic novels on a *nonreturnable* basis. That means that once the store gets the book, you get to keep the money, even if the store never sells it.

A company with a near-monopoly status could make the market sloppy and tough to deal with, but Diamond is at least a fairly well-run machine. They are conscientious, they know their field, and they can be very supportive of small publishers as long as the work is good enough and promoted well enough that it's likely to make them money. If you've got a product that's worth selling, Diamond will help you sell it, but realize that they can only do so much.

Pitching on the Diamond

The first step in getting Diamond to carry your book is to send in a copy. Don't worry, you don't have to have the book actually printed. In fact, you really shouldn't have the book printed yet. Send a photocopy or computer print-out of the completed work to Diamond's purchasing department. Go to http://vendor.diamondcomics.com for contact information and other information on dealing with Diamond.

In addition to the photocopy, Diamond wants to know the format of the book, so you'll explain how big the pages will be and whether it's hardcover or softcover. If you're serializing the work and Diamond sees the photocopy is 24 pages and is called *Thus-and-Such*, Issue 1, Diamond will assume your work's a pamphlet unless you say otherwise. Diamond will also want to know the cover price of the book, which is the price you'll print on the cover and that most stores will sell the book for.

Diamond needs to know your *terms of sale*. Basically, that means you're telling Diamond what portion of the cover price you expect to be paid for not only the work you just offered but also every future work you ask Diamond to carry. Diamond won't tell you the terms; it's your job to tell them. It's your choice to make.

The most common terms for a small publisher are *60 percent off.* That's right, that $20 graphic novel you're publishing? You get only $8 for it. And suddenly, you realize why it's not easy as pie to make a living in the graphic novel field. Why charge only 40 percent of the cover price? If you offer that as your terms, Diamond will charge the retailer about 55 percent of the cover price for the book, keeping 15 percent in return for distribution services. The retailer charges 100 percent, using the 45 percent profit to pay for rent, employees, all the books they bought that didn't sell, and cream-filled cupcakes.

If you charge more than 40 percent, Diamond's going to feel there isn't enough profit for the stores in carrying the book. You'll get a "thanks but no thanks."

Don't Dis Diamond

Some would-be publishers resent that Diamond refuses to carry some graphic novels, but Diamond is providing a needed service. The stores don't get to see your graphic novel before ordering it. Ordering a book that's too ugly for anyone to buy hurts the store, and things that hurt stores hurt the distributor and all the other publishers as well.

Charge less than 40 percent and Diamond may (or may not) pass the discount on to the retailers. Retailers that actually order from smaller publishers are used to paying that 55 percent. Oh, they'll tell you they'd rather pay less, but it's tough to be sure that having a lower base discount will generate enough additional orders.

In any case, Diamond wants to be convinced that your book is going to generate a $2,500 initial wholesale order (which, if you're offering Diamond the books at 40 percent of cover, is $6,250 in cover price). In Diamond's view, that's the size of an order that will make them enough to make the book worth carrying. If your book doesn't qualify, you can talk to your Diamond representative about promotional possibilities that might help your book reach that benchmark, or Diamond might offer you the chance to throw in some money to guarantee their profit. Or they might simply say "no."

Running Diamond's Bases

Once Diamond accepts your book, you'll have to properly *solicit* the book, which means giving Diamond all the information it needs to offer the book to stores. This begins a several-month process in bringing your book to the market. Let's say you want to release *The Deadly Art of Bonsai* in April. Here's the schedule:

- By mid-January, you have to e-mail Diamond a solicitation, which includes a scan of the cover; the title; the price; the format; the name of the printing company; the names of the writer, penciler, and inker; the ISBN or UPC code for the book (more on those later); and a 50-or-fewer-word description of the book, designed to sell the work: "*Bonsai is an ancient power that can reduce mighty trees to near nothing. Will young Bradley Goldfarb use his new power to avenge his family, or to win the heart of the girl he loves? Perfect for fans of* Sashimi Sword *and* Feng Shui Warrior."

- In February, Diamond sends all of the comic shops a copy of the monthly catalog *Previews*, including a listing and picture of your book.

- By the end of February, all of the comic shops have to send their orders to Diamond.

- In mid-March, Diamond adds up all the orders and sends you the total, including a list of how many copies you have to send to each of Diamond's warehouses. If the orders don't total enough, Diamond will send you a note telling you that they won't be ordering *The Deadly Art of Bonsai*.

- Sometime during the last week of March or hopefully at least a week before the last Wednesday of April, your books reach the Diamond warehouse. If they arrive more than about a month later, the books become *returnable*, which means that stores that have trouble selling them can send them back to Diamond, and you'll have to refund some money. That's bad. Keeping money is good.

◆ When your books reach Diamond, you send them an invoice, listing how many copies you sent them, the total cover price, the wholesale discount, and the total amount they owe you.

◆ A month after getting your book, Diamond ships you a check.

If you're serializing your graphic novel as pamphlets, you'll have several issues going through the process at the same time. As such, you have to be able to handle several issues in your mind at a time. If you have problems handling all the issues in your mind, consult a psychiatrist.

For the first three issues of your serialization, Diamond needs to see the full content of the issue as part of your solicitation. That way, Diamond knows the work is actually done, and stores won't be ordering something you won't bother to finish. Many folks get confused and scared by this, because Diamond tells them this in a confusing way. I've seen people spend a lot of money or give up altogether because of a misunderstanding. They think you have to have all three issues done before you solicit the first one, or even that you have to have the issues printed. Neither is true. Just send a photocopy of issue 1 when you solicit issue 1, a photocopy of issue 2 when you solicit issue 2, and a photocopy of issue 3 when you solicit issue 3. Once you've done that, you've conned Diamond into believing you can actually deliver on your promises.

After stores get their copies of your work, they may place reorders, asking Diamond for more copies. If enough requests are generated, Diamond will reorder the book from you. With books, they'll take reorders for as long as they come in, but with individual issues, stores have to reorder within 60 days.

Direct Distributors on Parade

While you absolutely need Diamond to carry your book for it to get into most comic shops, it's not a marriage. You don't have to be true to them. You can deal with other distributors on the side, and it's not cheating. Other distributors can reach other stores and generate more sales, more readers, and more money, three categories in which *more* is definitely better.

Solicit the other distributors at the same time that you solicit Diamond, and include a full copy of the graphic novel or issue you're soliciting.

Haven: A Bit of Heaven?

Haven Distribution is a comics specialty distributor that deals mainly with smaller publishers. They took over an older distributor called Cold Cut which specialized in back issues and reorders (orders placed after publication of the book), and quickly added to it advanced solicitation, like Diamond but much smaller. Their biggest strength is still those back issues and reorders. Haven keeps your back issues available for as long as you want to offer them, and they

will let you keep relisting your books in their catalog (Diamond will only let you relist a book if they think it will bring in another $2,500 order from them).

Because they're not so worried about hitting that high ordering minimum, Haven isn't concerned about seeing the finished product ahead of time. Basically, you e-mail the same information you send Diamond, including a digital copy of your cover. This is true whether you're listing an upcoming release or offering material published earlier. Haven is perfectly willing to carry print-on-demand books—which is good, because it gives you an option even if your sadly misnamed *World's Favoritest Comics* doesn't get enough orders to do a standard print run for Diamond. Head on over to www.HavenDistro.com to get the full skinny.

Last Gasp: A Breath of Fresh Air

Last Gasp isn't so much a comics distributor as a book distributor with a range that includes graphic novels. If you go to www.lastgasp.com and check out the catalog, you see a range that is very special. You may think the folks at Last Gasp carry all sorts of things, but they really don't carry *all* sorts of things.

Last Gasp sells mainly to alternative bookstores, so what it carries is alternative and underground books. Sex, drugs, and rock and roll all have a place in its catalog. *Underground comix*, tattoos, conspiracies, gay culture, geek chic, radical artists, and flying saucers are also there. Last Gasp is more likely to carry a graphic novel about a space alien who's mistaken for Santa Claus and becomes a rock-and-roll star than to carry some standard superhero tale.

Will Last Gasp be willing to carry your book? You can probably make a good guess, but don't. Instead, solicit your work, and let Last Gasp tell you whether it fits in—you may be surprised. The terms are 60 percent off, paid in three months. In at least some cases, Last Gasp carries books on consignment, which means you get paid only after the books are sold to a retailer. Send a copy of your printed book to Submissions Department, Last Gasp, 777 Florida Street, San Francisco, CA, 94110.

Underground Comix

Underground comix are black-and-white comics focusing on drugs, sex, and human concerns. Last Gasp got its start as a publisher of this kind of material, which thrived as counterculture items in the 1970s.

Slaves Laboring for the Big Kahuna

Slave Labor Graphics is a tenacious company. They've been putting out some very good and quirky comics (as well as some weak and quirky comics; not everything can be a gem, but there are plenty in their line-up) for about a quarter century now. And if you talk to their big man publisher Dan Vado or Editor-in-Chief Jennifer de Guzman, you're likely to get a bit of a "Yeah, maybe we should've quit a long time ago, but this is what we do" response. So when Diamond changed their rules to make it harder to reoffer already published comics, Slave Labor maybe should've just thrown in the towel.

But the folks there are not real good at quitting. Instead, they set up their own distribution business to distribute their own work—and as long as they were

doing all that packing and shipping, they might as well handle the work of others. So they set up Big Kahuna Comic Distribution. As I write this, the distribution effort is just getting rolling, but by the time you read this, it should be clear what they will and won't accept. Go to their website at www.bigkcomics. com to find out what's up.

Distribute On Demand

Both of the main comics-specific print-on-demand publishers have their own distribution system. The good news is that you can make *The Cheesy Adventures of Edam and Gorgonzola* available without any upfront printing cost and without any inventory. The store orders your comic, and the print-on-demand company prints it, ships it, and gives you some cut of the money.

The tough part will be getting stores to order it. Shops have to look at Diamond *Previews* every month, and will look at other distributors' catalogs when they have to order something from them. Since the print-on-demand distributors will inherently be focused on low-selling books, stores aren't likely to be already putting an order through them anyway. You have to hard-sell the store; make them want your cheesy goodness.

Dealing with Dealers

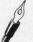

Some retailers are always going to be happy dealing with distributors. If your book sells well enough, however, you're apt to find a few dealers who will want to deal directly with you. By cutting out the middleman, you can charge more than you charged the distributor and still have the store paying less than the distributor's rates. This leaves the distributor having to eat the store-brand macaroni and cheese rather than the more expensive type shaped like Dora the Explorer.

The biggest downside to dealing directly with dealers is that the effort can be a real interruption. For a distributor, servicing the dealer is their constant job and they build their world around it. If you start selling directly to dealers, however, you'll probably have to deal with about one order every week or so, depending on how your book sells. You have to pack the books to make sure that everything is well protected, because receiving a bent book can make a usually happy-as-a-clam dealer turn as irritated as an oyster. You also have to get the package to the post office, which may be part of your normal routine, but for some people it's a big interruption. Generally, the dealer pays once the books arrive, which means that you're trusting the dealer for the money. Also, some of the books you sell direct to the dealer are ones which would have been ordered through Diamond anyway. The fewer you sell through Diamond, the less seriously Diamond will take you, and the more likely they'll choose not to carry your work.

Still, it can all be worth it. It's not just that you can reasonably charge dealers 50 percent of the cover price instead of the 40 percent you charge the distributor; it's also because you're building relationships with retailers, and those relationships can be very helpful for later projects. You really want retailers, especially the key independent-friendly retailers, to be on your side.

You'll also have to face the question of charging for shipping. The best bet is to make the shipping free if the dealer orders at least some amount, say $30 worth at wholesale. That encourages upping orders to reach the free shipping level, and it saves you from figuring out what to bill. Of course, you have to limit the area that you're willing to provide free shipping to, or you'll lose money sending copies to the four pointiest corners of the globe.

Be careful about making up your deal on the fly. If you offer a deal to one retailer that you don't offer to others, word will get around, and the other retailers will wonder why you're playing favorites. Of course, retailers don't mind you playing favorites, so long as they're the favorite.

Plus, it's very handy to get your local comic shop to be your buddy. The store can be a good resource in times of need, the folks there may even promote your work to their retailer friends, and some shops give sizable discounts to friendly creators.

Your Barcode: Always Tip the Bartender, Never Eat the Peanuts

If you want your book to be carried by Diamond or by most of the bookstores out there, it's going to need a barcode. Yes, that set of ugly stripes will make it look like somebody left an accordion print on your cover, but you can put it on the back cover and you do need it.

Even if you somehow didn't need it, you'd want it. Comic stores are switching over to computer-based inventory management at a swift rate. When they scan the bar code, it registers as a sale in their inventory, which can note if something is selling out quickly and should be reordered. You want them to reorder. Reorders are sales, sales are money, and money can be converted into McNuggets.

UPC: It's a Piece of Cupcake

If you're publishing a series of pamphlets, the bar code you need is a UPC (Universal Product Code). This is the same kind of code that you see on every can of frosting, every box of brownie mix, every carton of ice cream … and clearly I have to get a better diet. Really, just about any product that you buy that isn't a book has a UPC bar code.

The UPC is supposed to uniquely identify a product. It's a guideline the world conforms to—except in comics, we're nonconformists. Instead, each *series* gets its own UPC, and then we tack on an additional little set of zebra stripes (the five-digit supplement) that includes the issue number. That way, you don't have to pay for a new UPC number with each issue. Profit through nonconformity!

The Universal Product Code as it is used or abused on comic books.

The first three digits of the five-digit supplement are the issue number, starting with 001. The fourth digit is a volume number, starting (and almost always ending) at 1. The final digit shows whether this copy is first printing, second printing, or whatever. So the first publication in the series will have 00111 as the five-digit addendum. The more digits you get to change, the more successful your comic book is!

The absolutely proper way of getting your UPC is to go to http://barcodes. gs1us.org and apply for a manufacturer prefix, which will run you several hundred for the first year, but will let you create a bunch of UPCs. Some places will only carry your stuff if you have your own manufacturer prefix, but those places aren't comic shops and aren't places you're likely to sell individual issues. Odds are, you're just launching with one series and want to go cheaper than that. Type "UPC" into any online search engine. You'll find a ton of companies willing to sell you a single number. A place like SingleUPC.com sells them for under $30.

Now you have the number, but you don't have the zebra bars. You'll need the digital file to add to your cover. Some single-UPC sellers will offer you that file, but it won't have the five-digit supplement. You can buy software that will assemble the bar code for you, but at www.barcoding.com/upc/ they have a free basic program. For "Barcode data" type your UPC, followed by a comma, followed by the five digits to go in your extension. For "Barcode symbology," choose UPC-A. For "Output format," choose PNG. Click "Generate Barcode" and voilà, you'll have your own set of zebra stripes you can use for sending secret messages to other zebras.

Bypass BIPAD

Folks may tell you that periodicals need BIPAD bar codes, a special variant of the UPC. However, BIPADs don't work too well in cases where a retailer might have several issues of the same title available at once—in other words, it doesn't work well in comic book stores. Stick with UPC.

ISBN: It's Something Bookstores Need

If you're publishing a square-bound book instead of a series of pamphlets, get an ISBN (that's the International Standard Book Number) and an *ISBN-13* for your book. That's the number that you see on the back cover of many books, generally over a bar code that looks like a design for an electronic zebra.

ISBN zebra codes usually includes a five-digit supplement listing the price, so that cover price can change without changing the main ISBN.

How much will one run you? Well, if you're using some print-on-demand printers, they can include one pretty cheap. But if you're not, you U.S. folks can head over to www.myidentifiers.com, where they will sell you one for $125. Think that's steep? Then buy them by the 10-pack, only $40 per number. And goodness, the 1,000-pack is less than $2 per number. Really, at those prices, how can you afford *not* to publish a thousand graphic novels?

If you want to be a Canadian publisher, then www.collectionscanada.gc.ca/isn/ is where you want to go. If you want to be a publisher in the UK, then www.isbn.nielsenbook.co.uk is where you want to go. And if you want to be a publisher on Mars, then maybe you need a nice long trip to a very quiet place (which, admittedly, Mars is).

As for the zebra code to go with that number, your printing company may be able to generate the code for you and add it to your art, so long as you leave a nice white spot on the back cover for it. Otherwise, head over to www.cgpp.com/bookland/isbn.html for a site that generates the bars for free.

When you get your ISBN, you'll also get information about adding your book to the ISBN book listing. That will get your book listed in all sorts of online book guides, such as the listings at some online bookstores.

Code Diseases

Bar codes are delicate, and it's easy to make a mistake with them that leaves them looking fine to the naked eye but unscannable. A bar code that won't scan will cause you frustration and cost you money—your distributor will likely want to put a bar code sticker on every otherwise-minty copy of your book, and will

> WHA...? **ISBN-13**
>
> ISBN numbers used to be each 10 digits long, but they were running out of numbers. For a while now, they've been issuing each book both a 10-digit ISBN and the 13-digit **ISBN-13**. If you get both, you're supposed to put both on your books. Eventually, the ISBN-13 will be the only number they issue.

charge you a pretty penny (or, worse yet, an ugly beat-up quarter) for every copy they do. What follows are some tips for keeping your ugly beat-up quarters in your ugly, beat-up pockets.

- If you're using Adobe Illustrator to design your cover, *link* to the file with the bar code, but don't *embed* it.

- If you get a bar code as an EPS file, keep it as a vector format rather than converting it or flattening it onto the rest of the cover image.

- If you get a bar code as a GIF, PNG, or JPEG file, avoid resizing it.

- If you can get access to a bar code scanner, try scanning a printout of your cover before you send it to the printer. And whether you're putting the bar code on or the printer is, scan the printer's proof. If the proof won't scan, the book won't scan. (Cheap scanners can be had for about $10. Try searching eBay for "cue cat.")

- When laying out your second book and reusing the layout from your first book, remember to change the bar code. (Even the big publishers make that mistake sometimes.)

Get Yourshelf in Bookstores

These days, comics shops are only part of the equation for graphic novels. Bookstores are the other part, and for some graphic novels they are the biggest part, outselling the comic shops several times over. So bookstores are an attractive outlet, but they're tricky to deal with. They're used to dealing with humongous publishers. Remember, the Harry Potter books alone outsell, by a good margin, all graphic novels combined.

Bookstores are going to be interested in books. They won't be interested in serialization pamphlets. Don't even think about entering the mainstream magazine distribution market with your pamphlets. That is an expensive morass that has destroyed otherwise successful publishers.

Look, a Nook for Your Book

Once your book is in the ISBN directory, bookstores will have all the information they need to order your book. But that's just like saying that because you have the phone book, you have all the information you need to call the National Campaign for Calling Everyone "Myrtle." Stores can order from you, but the only time they will is if a customer comes in, requests the book, and expresses a willingness to wait for weeks to get it.

In order to get bookstores to seriously consider your graphic novel, you really want some middlemen in place. Distributors put out catalogs of upcoming releases that bookstores use to order from, just like in the comics fields. What's different from the comics field is that there's another middleman, the wholesaler, who buys from the distributor and sells to the bookstores. Big bookstore

chains like Borders have their own wholesalers. Smaller chains and independent bookstores rely on wholesalers with names like Ingram and Baker & Taylor and Fred the Amazing Cheez Doodle. Well, names like that.

A number of distributors handle some graphic novel publishers. That doesn't mean that they'll automatically take your book on, however. First of all, they don't want to deal with just a book; they want to deal with you as a publisher. And they generally want an exclusive deal, so you don't reach the bookstore through any other distributor.

Most graphic novels reach the bookstore market through one of the big book-market distributors, most of whom won't be interested in a company with one or two titles (although it never hurts to ask). But then there's Diamond. Yes, the same Diamond that serves the comic book stores has a separate division for reaching bookstores, Diamond Book Distributors, and they handle a lot of smaller publishers as well as some larger ones. You can learn more about this division at www.diamondbookdistributors.com.

Amazin' Amazon

Amazon.com will carry your graphic novel on consignment, no distributor needed. Go to www.amazon.com/advantage/ to learn about this system. It's really handy, because you can steer people looking to order individual copies to the Amazon site. Amazon takes credit cards and handles the shipping, so you have much less to worry about.

Hardcovers, Softcovers, and Hard Realities

The sad, sorry truth is that the bookstore market, with all its potential for great sales, is harder to deal with than the comic book shops. It's not just that you're dealing with stores that are less interested in what you're doing, although that's often true. It's that when a bookstore buys your graphic novel, you haven't really sold it yet.

Bookstores stock their stores with returnable books. This means if someone buys your book at a bookshop, it really is sold. But if the book sits on the shelf for a while and the store decides the space would be better used for something else, the book is sent back. You get a slightly battered book, and the bookstore gets a refund. Worse yet, you actually have to pay the distributor money for handling the return. You end up with less money than if the store had never wanted it in the first place.

Another hard part of the bookstore biz is that you have to plan further in advance. Distributors put out three or four seasonal catalogs each year, announcing a full season ahead of time what books will be coming out. Add in the distributor's lead time in making the catalog, and you'll find yourself needing to have the details of your book ready up to nine months ahead of time. Now, that's not all as dreadful as it seems, because you can miss being in the seasonal catalog and still be in the monthly catalog with just a few months notice. But you'll miss some promotional opportunities if you do so.

The Least You Need to Know

- Diamond Comic Distributors is the main supplier of comics to comic book stores.
- Solicit Diamond and Haven to find out how many copies they want to order.

- With complete graphic novels, you're likely to see ongoing reorders.

- Books need ISBNs while serial pamphlets need UPCs.

- A book distributor is key to getting stores to actually order your books.

Promoting and Publicizing

In This Chapter

◆ How do you get people to want your graphic novel?

◆ Where should you advertise?

◆ Which conventions are right for you?

Your graphic novel may be the wonderfullest, perfectest, most grammar-bendingest thing ever published. But people will know that only if they read it, and they'll read it only if they've heard of it. With dozens of new graphic novels hitting the shelves every week, few stores order everything, so readers won't even stumble across your book unless the stores have heard of it and expect people will want it.

Press. Release. Repeat.

The best and cheapest way to get the word out is to take advantage of the press. A handful of e-mails, faxes, and even a few pieces of old fashioned, put-it-in-the-mailbox mail can get information about your book before the eyes of tens of thousands of graphic novel readers.

A press release is your most basic way of informing media outlets about your book. Some places will cast your press release aside. Others may use your information as the basis of an article. But the comics press has a number of web outlets that will simply publish the press release you send them, letting you get exactly the message you want out to the public, unimpeded by the pickiness and demands for honesty that would come from more rigorous outlets.

What to Say

The point of a press release is to make your book sound interesting. That's very different from what makes your book interesting to read. It's not a matter of subtle concepts and nuance. It needs to be an idea that people can grasp quickly. It may not be enough to sell them on the book, but at least it will get their attention. This can come from a number of categories:

- **Content:** The series *Little Laps* is set in the exciting world of midget car racing.

- **Format:** The book *The Hole Truth* is the first graphic novel printed on real Swiss cheese.

- **Creative team:** Jane Superstar paints the cover of the first issue of *Sans Gorilla*.

- **Synergy:** The upcoming mystery *False Killer Whale* is written by a marine biologist.

A press release should read like an enthusiastic article. First, you start off with information for the reporter or editor who has to deal with this:

> For immediate release
>
> For further info, contact Iggy Ologist, (805) 555-0100, iggy@unfathomprod.com

This way, the editor knows the press release can be run immediately (as opposed to being embargoed until a certain date), and if it inspires a full article, Iggy's the guy to reach out to. Next up is a headline, in all capital letters.

THE FIRST FISH MYSTERY WITH ACCURACY

Follow that up with a subhead, a secondary headline that explains or adds to the first. This can be a bit longer.

> Real marine biologist writes graphic novel *False Killer Whale*

After that, it's time to get into the body of the article. The first paragraph should be short—three sentences at most. But that small amount of text should carry the heart of the information. A reader who reads just the first paragraph should take away what's memorable about the book, as well as the title.

> Unfathomable Productions announced today a new graphic novel, a mystery set below the waves. *False Killer Whale*, written by a marine biologist with more than 12 years experience studying undersea life, is a 96-page private-eye tale with deceit, danger, and a shamus named Shamu. This lushly colored tale hits store shelves in August.

That wasn't hard. Now they know who the publisher is, what the title of the book is, what's interesting about it, the format, and when it's coming out. After

that, it's time to flesh out not only detail about the hook of the story, but also other key details about the project. It's also time to make it seem more comfortable and chatty.

> "When I sat down to write a graphic novel, I remembered the old advice 'write what you know,' and what I know is marine creatures," explained Iggy Ologist, writer of *False Killer Whales.* "There are actually very complex societies and social interactions beneath the waves, with creatures speaking, vying for power, and yes, even killing one another. So a detective story seemed a natural in that setting."

Realize that no one was actually interviewing Iggy. In fact, Iggy wasn't speaking out loud. Iggy wrote the press release himself. You're allowed to invent quotes for yourself. And remember, it's supposed to read as if the magazine running the piece wrote it, not you, so don't use *I* or *we* except within a quote. Nat says that talking about yourself in the third person is not only okay, it's actually fun. And Nat is so wise, you should all listen to him.

> The book and movie world has had big success with fish-based mysteries, or "fishteries" as the fans call them. *Wat'ry Grave* spent three weeks on the *New York Times* best-seller list, and *Finding Nemo's Stolen Watch* was an all-ages box-office success. "Bringing the form over to comics was the logical next step, and I wanted to include a more realistic sense of sea life to make it even more interesting," explains Iggy.

> "Finding artist Winter McLeod was fate. Her years at the Sequential Art and Scuba Institute prepared her for telling stories with fish. And her second career as a police sketch artist has gotten her deeply familiar with the criminal physicality."

> The plot is a classic noir-style tale. When Danny the Dolphin is found dead, Willie the Killer Whale quickly confesses. But there's something fishy about the confession. Who is Willie covering for? Billy the Blowhard Blowfish? Or is Tina the Tuna not as dolphin-safe as she seems?

If you have someplace for readers to get more information (and you should), send them there.

> The Unfathomable Productions website has a several-page preview of the story, along with interviews with the creators and other vital information. The URL is www.unfathomprod.com.

Then you wrap it all up with the technical details.

> *False Killer Whale* (ISBN 0-9847-632) is a full-color 6"x8" graphic novel priced at $16.96. It ships in August from Unfathomable Productions, distributed by Diamond Comics Distributors, Haven Comics Distribution, and Rosemund Book Services.

Include some graphics from the story, both in black and white for print outlets and color for better print outlets and websites. Pretty pictures will sell your book at least as effectively as pretty words.

Don't feel you need to squeeze every bit of good news into a single press release. If you have enough good information for two press releases, you can follow up the first one with a second one a month later. That way, readers get more exposure.

Who to Tell

Send your press release out to the comics magazines and newspapers like the *Comics Buyer's Guide* and *Comic Shop News*. Realize that every magazine has its own tone and you may want to steer the press release toward it. The highbrows at the *Comics Journal* aren't apt to be interested in the fact that your graphic novel has a limited edition hologram cover, and the superhero-loving folks at *Wizard* aren't likely to care that your story is inspired by Molière and your art inspired by Moiré.

Some of the magazines will run your stuff, some won't. The easiest place for an unknown publisher of unknown creators to get a press release released is online. A number of websites specialize in comic book news, and most of them want to carry as much news as possible. They don't have the printing cost limitations of a magazine. Go around to sites like Newsarama.com, ComicBookResources.com, and Comicon.com. Check out the e-mail addresses of the folks who post press releases in their news or press release sections, then e-mail your press release to them.

Then there are comic book discussion sites that don't have news coverage. Go to these and post your press release as the first message of a new discussion. Make sure you post in the correct discussion section and put *[HYPE]* before the title of your press release in the discussion board's title field. Otherwise, you may tick off the board's regular users looking for a discussion and finding hype instead. The hype warning isn't needed at the *CBIA*, where the savvy retailers know that you're hyping anyway.

Once you get your press release posted on one of these sites, keep going back to that site for a while. People may end up responding to your press releases, talking it up, asking questions, and so on. Getting yourself involved in these threads is a good way to get people excited about the book and to feel like they know you personally. And you can always count on the occasional bozos who will talk down about your book simply for the joy of being nasty. Feel free to ignore them. The regulars who read the discussions generally know these folks for who they are.

But that's all just the comics scene. If your book has hooks beyond the comics field, spread the word other places as well. *False Killer Whale* might make only a ripple in the comics field, but there could be a tidal wave of interest if you send your press release to *Modern Aquarium*, *Fishery Mystery Magazine*, and *Water World Daily*.

Turnaround Time

Weeklies and monthlies don't get the press release in one day and have it in the issue that goes out the next. As a rule of thumb, a press release you send out today will appear three issues later.

The CBIA

The **CBIA** (Comic Book Industry Alliance) is a discussion board primarily for retailers, with publishers and creators encouraged to talk to them. Go to www.thecbia.com for more information.

When to Release

The most important time to spread the word to comic shop customers is shortly before the issue of Diamond's catalog *Previews* comes out with your graphic novel listed. A lot of comic book store orders these days are generated from readers *preordering*, seeing a book in *Previews* and telling their retailer to get it for them.

Comics retailers send in most of their orders during the last week of the month, so reminding them of your existence during the prior week is a good idea. Don't hit them afterward with a "you should have ordered this" message, or they'll just hit you with a "you should have told us sooner" response.

Outside of the comics field, you want the press information to hit when the book is actually available. You want people to see the coverage, go to their bookstore or comics shop, and actually be able to buy the book. The problem is that for a new publisher, most stores won't have ordered your book, so a lot of people may come back from their quest empty-handed. Don't let that stop you! People asking stores for a book they don't carry is a good way to help stores figure out "we should carry this book." They'll realize it's a good way to make money—at least the smarter ones will. There will always be a few retailers who will tell 75 people in a row, "We don't carry that book. No one wants it."

Use the Newspaper

Send press releases to your local paper, particularly if you're not in a big population center. Editors love the local-boy-(or girl or marmoset)-makes-comics angle.

Get Your Book Viewed and Re-Viewed

Comics are a visual medium. Telling people about your work is not as good as showing them your work. Anytime you can get a few pages of your book out in front of a reader, do. Put them up on your website, so anyone you can steer there can see them. Link to them when you're discussing the book. Tell the gang on the CBIA that the pages are there.

Better still is getting a whole copy into people's hands. If you're feeling aggressive, use the list of retailers at www.the-master-list.com as a mailing list, sending photocopies or print-on-demand copies around. Diamond also offer services where they can send your preview copies (or posters, postcards, bookmarks, or other promo goods) to their top 500 retailers, or their top 2000, or retailers who order heavily on a specific sort of book. The service costs, but it's a way of reaching targeted retailers. Send photocopies or PDF-file versions of your book to online reviewers.

If you can, go for reviews outside the comics market. *Library Journal, School Library Journal, Booklist, The New York Times Book Review,* and *The New York Review of Books* all have information on submitting your books for review. Alas, most of them are wary of reviewing self-published books, but look carefully to see if you meet their guidelines. They'll want to see the book months before release. A good review in any of these sources can influence bookstore orders and library orders, and their review will show up on your book listing at online bookstores.

And there are plenty of bloggers and podcasters who write and talk about the books they read. You may not want to mail physical copies to all of them, but e-mailing a link to a PDF file costs little. And a good review is much more persuasive than a good ad.

Adding Ads

Advertising is an expense. Expenses are bad. Advertising in the right way to the right audience can build sales. Sales are good.

The most popular place to advertise graphic novels is in *Previews*. Diamond will sell you ads there. The ads aren't cheap, but comic book stores and the preordering customers will see your ad at the time they're figuring out what to order. With an ad, you get a half page or a full page to show off your graphic novel to good effect, in addition to the small cover shot and blurb that *Previews* normally runs. *Previews* has some strong limitations on ads, not letting you list your website or do anything else that would encourage people to order directly from you rather than through a retailer and Diamond.

> **Drawing a Crowd of Readers**
>
> Anything you can do to get potential readers to associate themselves with the comic can help turn them into customers, and even encourage them to spread the word for you. In an extreme example, when Erika Moen needed to draw a crowd scene on the cover of the first volume of "DAR: A Super Girly Top Secret Comic Diary," she put out a call on Twitter for people to submit their photos. Folks who did were drawn into the crowd, and you can bet that every member of that crowd not only bought a copy, but showed their friends.

The same magazines and websites that you send your press releases to all sell ad space, and the advantage there is that they will generally let you push direct customer sales. If an ad can drive someone to mail-order your graphic novel from you, then you get all the money. If someone orders your book from a retailer, then you get 40 percent. After spending a few hours with the calculator, I find that "all" is better than "40 percent," but I also realize that steering sales to retailers can result in a friendly retailer. Besides, the overhead effort of handling individual orders should not be underestimated. Perhaps the best compromise is to steer them to a page where they can either mail-order a copy or find the name of a retailer who carries your book. Use the CBIA to find out who is stocking your book, or just direct them to the Comic Shop Locator Service (www.ComicShopLocator.com) or The Master List (www.the-master-list.com).

Don't just throw money into advertising without thinking about it carefully. If you have a $10 graphic novel and you spend $800 on a *Previews* ad, the ad will have to generate 200 additional retailer orders just to break even, and that's not counting the additional printing and shipping costs for those 200. On the other

hand, the difference between a store ordering zero copies and a store ordering one copy can be much more than one copy. The store that orders one copy and sells it quickly will reorder another copy, and keep reordering copies as long as they sell. A store that doesn't order in the first place will never reorder.

If you're serializing your *I Was a Vampire for the CIA* graphic novel, the most important issue to advertise is issue 1. Sell folks issue 1 and they're apt to order issues 2, 3, and so on, as long as they're enjoying the blood-sucking tale of political intrigue. If you skip advertising issue 1 and then try to advertise heavily on issue 3, you're asking people to come in during the middle of the story, when you've already revealed that the werewolf is a double agent. It's a much harder sell.

The Conventions of Conventions

Comic book conventions are good places to go to, be seen, and get the word out, as well as to sell a few copies. Conventions range from small local dealer-oriented shows that are only worthwhile if you happen to live in the area, all the way up to big national conventions that attract tens of thousands of people per day.

It is hard for the publisher whose book is not yet out to justify the expense of buying a table or booth space at a convention. Smaller publishers generally depend on actually selling their materials to make conventions worthwhile, and some publishers even find that such shows are their biggest profit center. They spend their summers bouncing from convention to convention, often to the disappointment of their spouses, who are sure that they're out there seeing the exciting sights and having wild times. In reality, they're seeing an endless string of convention centers, cheap hotel rooms, and airports.

If you want to promote your upcoming work at a convention, there are several options. One is to take advantage of artists' *alley*, an area at the convention set aside for comics creators where the tables are generally cheaper or even free. There your artist can display the pages from the upcoming work and hand out fliers for it while chatting with folks, and can often cover expenses simply by doing sketches for a fee. Comics fans aren't nearly so eager to see writers in artists' alley, and almost no one wants to buy an original paragraph.

If your book is out, you can still go the artists'-alley route if you want, but you should seriously consider buying an actual dealer's table or publisher's booth. At some conventions, artists are allowed to sell only art at their table, not published books. At other conventions, the artists'-alley space is less desirable space, reached only by people who want to buy original art. Paying for space will get you more in the flow of customers.

Steve Sez: Tales from the Art-Side

As an artist at a con, you have to be "on" nonstop—tracking time, money, and the availability of schmoozable editors; holding and prioritizing multiple simultaneous conversations; trying to remember names; being funny; hustling up the next gig; escaping friends for a couple hours of sleep; critiquing insightfully; and dodging crazed babbling fans, all while sketching decent drawings for your potential customers.

Put Info in Your Infomercial

Unknown creators talking about unknown projects won't draw much of a crowd. If you give a talk about creating graphic novels or another larger topic related to your work, the audience may become interested in you and your work. Would you have bought this book if it was entitled *Why You Should Buy* The Big Con?

Write Right

Get your hands on good *signing pens,* pens that write well on slick book covers, unlike most writing pens. Many signers use Sharpie-brand markers, while others use metallic ink pens.

See if you can give a talk at the convention. The smallest conventions don't have talks, and the largest ones usually have too many better-known people who want to give talks, but a medium-sized convention may be in need of anyone it can get to fill its small auditoriums.

Many of the talks at conventions are panel discussions, where a group of supposedly knowledgeable people discusses some topic in front of an audience. If you can get on one of these panels, do it, but only if you're actually knowledgeable about the topic and can present yourself well. I've seen too many folks embarrass themselves by getting on the panel and having nothing to say. That won't build your sales or your self-esteem.

Autographing Like a Superstar

When you publish your own graphic novel, you may do a lot of autographing. Unfortunately, at first you'll be autographing checks. The printing company, the shipping company, and the magazines that take your advertising will all want to see your pretty autograph.

Once the book is out, however, it's your chance to do signings in comic book stores and bookstores. You can autograph like a famous person. If enough people believe you're famous, that's how you become famous.

Contact bookstores and comic shops within driving range. You don't want to set up signings at two shops that are close enough to share customers, but at least that probably won't be a problem at first. If you know the shops in your area, you know which ones do signings and which do it well. You may find some stores that would do well with a signing but never even thought about it. Let the retailers know that you're available for signings, and that you're willing to have them carry your books on a consignment basis on the day of the signing. That means the retailer doesn't have to risk ordering a lot of your book, but there will be plenty of copies for anyone who shows up.

Arrange the signing at least a month in advance, to give the retailer time to publicize it. Then, don't count on the retailer doing the work to publicize your visit. Especially if you're local and covering all expenses, the store has no money at risk and sometimes will not do anything to promote the signing.

Send signs to the retailer weeks in advance, with a picture of the art from your book and saying, *"Iggy Ologist will be signing his new graphic novel* False Killer Whales *here September 31st."* Make up a master copy of a flier for them to put out, again announcing the signing but including the store name and location. The retailer may copy this to hand out or just ignore it, but you're far more likely to get a flier out there once you've shown the retailer it's something you expect.

A week before the signing, go to some of the online comics discussion sites and mention your upcoming signing. Mention it on your website. Get the word out any way you can, because the more people who show up at your signing, the

more you sell on that day, and the more the retailer will believe you're a big name whose work should be ordered heavily.

Otto Graph

A normal signature, a more efficient practiced signature, and a designed signature for Mr. Otto Graph.

Before the signing, practice your autograph. I know, you've been signing your name for years, but you rarely have to impress people with it. You may want to develop a special signature just for signings. As you can see in the signature picture, it doesn't have to be readable, as long as it has enough readable letters for people to tell which member of the creative team signed the book. It can even be something that looks more like a design than like handwriting, so long as you can reproduce it quickly. This won't matter to you early in your career, but if you ever get to where you're signing hundreds or even thousands of autographs, this will save your wrists.

At the signing, be gracious and charming, even if it is poorly attended. Sometimes that happens even to famous creators, even when the signing was properly promoted. Maybe the signing conflicts with another event, or the weather is too miserable to go out, or the big evil robot Dethpuppi is holding everyone at bay several blocks away. Whatever the reason, don't growl too loudly at the store manager. Remember, you want this retailer to order your next project as well. The good news is that very few people see you have a bad signing, while lots of people see you have a good one. That helps your reputation.

Before you collect the money for any copies that have sold, offer to sign some more for the retailer to sell to people who missed the signing. That's just that many more copies sold.

And do take a moment to look around the store. Look at all the fine comics and graphic novels on the rack, and enjoy the fact that you've added another piece of enjoyable graphic literature to the world.

Steve Sez: Give 'em a Taste

Produce a simple, cheap giveaway for your signings. A photocopied booklet or signing card with some teaser art or behind-the-scenes info is great. (Think "DVD extras.") Include your cover, your web address, and your ISBN. Add the store's logo and contact info on there, too, because a store that hosts your signing is a store you want to promote.

The Least You Need to Know

◆ Press releases are a cheap way to spread the word about your book.

◆ Your press release should have an interesting title and key information in the first paragraph.

◆ Advertising sells more books, but not always enough more to make it worthwhile.

◆ Conventions offer opportunities to create new readers and turn existing readers into real fans.

◆ Signing sessions at stores can win you a following with both readers and retailers.

Chapter **29**

And Then ...: The Graphic Novel Career Paths

In This Chapter

- ◆ Do you keep making graphic novels?
- ◆ Is there steady employment in the graphic novel field?
- ◆ Where else are your skills useful?

So you've come out with your graphic novel reinterpretation of Shakespeare's *Richard III* in a 1970s milieu. And while *The Winter of Our Disco Tent* made back its printing and advertising costs with some to spare, it hasn't exactly made you wealthy. So what do you do next?

Do More Graphic Novels

The obvious career path for someone who has completed one graphic novel is to do more. If the first one didn't pay you too much, that can be difficult. There is, however, reason to be hopeful that the next will do better for you. In fact, several reasons follow shortly after this colon:

- ◆ You have gotten better. In doing your first graphic novel, you have made mistakes, you've seen your mistakes, and you've learned from your mistakes. You may discover a brand-new, shiny set of mistakes to make on your next project, but you will not make those mistakes again.

- ◆ You have gotten a reputation. If the book didn't sell well, it might not be a very big reputation, but as someone out there like it, it's better than being an unknown. People who liked your adaptation of *Richard III* will want your adaptation of *Richard IV*, *Richard V*, and *Richard vs. Predator*. They'll even be interested in any Richard-less wonder you offer up.

WHA...? **Backlist**

Your **backlist** is all of your projects that aren't your current, latest thing.

◆ You've gotten a *backlist*. Just as your first graphic novel can create interest in your second, your second can (not *will*, necessarily, but can) create interest in your first. If you get a good reputation, your backlist can be an ongoing source of income.

◆ You've got a sample. A completed and published graphic novel shows that not only have you got the talent to create one, but that you're able to stick to getting it done. In the eyes of a potential publisher, that can put you far beyond the thousands of talented folks out there with three good pages in their portfolio. To some degree, once you've been published professionally, you're on the inside of the business. You may be scooched uncomfortably up against the screen door, but at least those grid patterns being embedded into your skin come from the right side of the screen door now.

... But Not Your Graphic Novels

Of course, having a sample is only of use if you're not publishing yourself, and thus need to impress somebody. The truth is that a lot of the work in this field, particularly the profitable work, isn't doing your graphic novels, it's doing someone else's graphic novels or whatever the publisher wants to put out. It's doing an adventure of Amazing Mammal-Man, it's doing the comic book adaptation of the latest Stallone film, or it's working on a how-to-repair-your-Jeep manual in comics format.

There is a lot to be said for this sort of work. For some people, doing Amazing Mammal-Man has always been their real goal anyway. For others, it's the day job, but it's a better day job than what they were doing before.

Ask yourself whether you're only into artistic expression, or if you like creative challenges in their own right. Because if you can just embrace a creative challenge, there's a lot of fun to be had working on someone else's graphic novels. One of the most fun times I've had in writing comics was when an editor asked me for a story where three famous stock car racers (Richard Petty, Bill Elliott, and Bobby Allison) help Santa Claus save Christmas. Once I was faced with that unusual request, it was a joy to try to make it good.

You may find that you'll be asked to do just part of the effort that you've done before. Folks who have broken into the field writing and drawing their own material may find themselves in demand just as a writer, or as an artist working from someone else's scripts. A few creators even work regularly as writers on projects they don't draw, as well as artists on projects they don't script.

The Dark Winter of the Graphic Novelist

Here are some tough truths about working in the graphic novel field:

◆ **It's freelance:** Very little comics creation is done as an employee. Creators are freelancers, which gives them the joyous ability to turn down work they don't want, but also means that they often don't know where

their next assignment is coming from. Freelancers have to pay for their own insurance and pay their own Social Security taxes. If you get in good with a larger company, they may offer you an exclusive contract with a guaranteed amount of work and some health insurance, but that's the exception rather than the rule.

- **It's inconsistent:** You will find yourself working hard on projects to get everything out of the way—and then once you get everything out of the way, working hard to line up some more projects. Sometimes the projects are far between. It took me a long time working as a freelancer to start trusting that the next project would come from somewhere before things got too bad, and even then I suspect that trick works until it suddenly, painfully doesn't. And even when the work is consistent, the royalties often are not.

- **It's subject to trends:** The size of the field fluctuates greatly. When times are good, there's work for almost everyone who wants it. That brings in a lot of new creators who are suddenly fighting over the scraps of work when the field shrinks a bit. And the style you're acclaimed for may be one that falls out of favor, which is not an insurmountable problem if you're willing and able to adapt.

- **It gets in your blood:** Working in the comics field can leave you feeling like this is where you're supposed to be. Now, that's a good feeling when things are going your way—but when the tide turns against you and the comics field doesn't want you, it can leave you feeling insufficiently competent for any other field.

Now, some of that may be overstating things a bit. There are folks who walk away from comics and are perfectly happy. There are more folks than you realize whose names don't show up much on the comics rack, but are still in some hidden corner of the field, doing educational comics, doing commissioned drawings for private collectors, polishing Uncle Scrooge's money vault, or doing some other comics-related work.

Learn to Say "No"

When you're first starting out in the field, you're likely to talk to publishers about a lot of projects that never quite happen. You learn to say "yes" to everything, knowing that only one thing in five will actually come through. Then the tipping point comes, and you're popular and they offer you the serious projects, and four out of five will come through. If you're not ready to say "no," you can find yourself overwhelmed, getting sloppy, and missing deadlines.

Moving Beyond Comics

But learning to create comics actually does give you a set of tools that will be useful even when you decide that creating comics can no longer be your primary gig. There are jobs to be had where the work is more steady and the hours

more normal, and that can be very handy when you're the main breadwinner for a spouse and two kids (or two spouses and five kids!).

And moving beyond comics does not mean abandoning comics. There are many folks who successfully keep their feet in multiple worlds. You can't really write and draw *The Monthly Adventures of Captain Monthly* while holding down another gig, but you can certainly write the occasional *Captain Irregular* graphic novel, or even post a weekly page of *The Serialized Adventures of Lieutenant Junior Grade Online McWeekly*.

Everyone Kneads a Gud Editter

Comic book companies have a range of editorial positions. The big publishers have people who edit the books, people who handle layout, people who do art corrections, and people who work on cover design and the general look of comics. Smaller companies often make do with people who have at least a little talent in all those regards.

There are, however, tough aspects to working on the editorial side, and not just that it's work, and hard work at that. Whereas freelance creative work lets you work from anywhere the Internet and FedEx reach, editorial work is largely office work, requiring you to move somewhere close to the company. And if what you really want to do is create your own comics, you may get some chances as an editor, but you'll also have to understand how to work as an editor. If you become the editor of *Janey Love's Lovelost Tales*, it can be very tempting to make Janey tell the tales as you would tell them, when really your job is to get Janey to be as good a Janey as she can. If you can't do that job, there will be no love lost between you and her.

Even Those Who Can Do, Teach

If you can draw comics, then there may be a role in the teaching field. And I'm not talking about some general high school art teacher, as noble a profession as that is. I mean teaching people how to make comics.

It's not just a matter of specialty schools like The Kubert School or The Center for Cartoon Studies. These days, many institutions of higher education are including some form of comics in their curricula. In some cases, it's more of a class in critical theory, best suited to someone who always aimed for a career in academia, but in other cases it's genuine how-to-draw-comics courses.

Now, the trick is that you need to know more than just how to draw comics. You need to know how to explain how to draw comics. If you're too instinctive—too much of a natural at it—that can actually be tricky. The best creators aren't always the best teachers, and vice versa.

The Screen Is One Big Panel

If you've learned to write graphic novels, it means you're writing scripts aimed at creating striking visual images along with interesting dialogue—which makes it much like writing a movie. If you're writing serial comics, you're learning to build new stories on what has gone before, yet have them approachable as self-contained units—which is exactly what a TV series needs.

This has always been true, and for a long time comics have insinuated themselves into Hollywood, although for a long time it was mainly into animation writing. However, as comics have gained respect, and as more studio executives have grown up with a love for comics, a respected comics writer is now seen more as a respected writer, period. Some get their first screenwriting break adapting their comics work; others use their reputation to get work on projects that match their style. Some have moved from writing comics, to writing movies, to directing movies. But this rise in respect for comics does come with a downside for the comics writer: ever more Hollywood screenwriters are leveraging the respect they've earned to compete for comics writing assignments.

Boarding Stories

Telling a story across a series of pictures is the heart of drawing comics. It's also the heart of storyboarding, a career in its own. The main difference is that the storyboard is not the final product, but merely a piece of the process of getting something on film. When you see James Bond on the wing of an airplane, punching the bad guy into the engine then leaping off and diving safely into the giant inflatable Santa in the used car dealer's parking lot, every single shot of that was planned in advance by a storyboard artist working with the director to plan the camera angles. That way, plans can be made and problems worked out when it's just a few guys in a room, rather than when you're on set with dozens of stunt fighters, stunt pilots, and stunt Santas.

The reality is that there's probably more work in drawing storyboards for bank commercials than there is in storyboarding James Bond. That may sound like bad news—rarely do bank commercials allow you to draw secret agents plummeting Santaward. But the good news is that there may be work on a freelance basis near where you are, rather than having to move to Hollywood and compete with the large number of talented storyboarders—although the option is there if you want it. You will have to learn some things about filmmaking before you can storyboard, but the comics skills give you a strong start.

Games Are Work

There's a large overlap between comics creators and folks who work on video games. They may seem like very different media, but video games need artists that can work out how the Alien Battle Pandas will look from a range of angles

and how they will work in motion. They need folks who can design an entire visually consistent battle panda world. Many of those same considerations of design that Steve told you about earlier are just as important in games.

And today's games aren't just moments of action. They have scenes with a plot and dialogue. With the many optional paths and choices which the player might make, many game stories have much more dialogue than the typical player will ever hear. All of this has to be written by someone, and comic book writers—particularly comic book writers used to writing characters created by others—are well-equipped for taking characters that they are given and crafting pithy and appropriate dialogue for getting them to the next scene.

> ### Steve Sez: Nat's Not Just Talking Talk
>
> Nat's written comics for more than a dozen publishers, and I've drawn comics for more publishers that he's written for. I've also drawn storyboards, advertising art, and design art. Nat's done editorial work, written video game dialogue, and has guest lectured on comics. And believe it or not, both of us have written a book on how to make comics and graphic novels. These things can be a natural part of a graphic novelist's career.

And Everything Else

Writing for television, designing cookie jars, drawing coloring books, crafting corporate logos, crafting Army guides on how to maintain tanks—you name it, working in comics has lead to it.

And if you do wander off to some other field, do come back to comics. Take what you were doing elsewhere and bring the texture of it into a new graphic novel. The world can always use more rich, well-informed graphic novels.

The Least You Need to Know

- Working in comics and graphic novels can be tough but emotionally rewarding.

- The creative tools you learn as a graphic novelist can serve you well in a range of other careers.

- You can stop reading now. The book is over. Except for the appendixes, of course.

Appendix

Graphic Novel Publishers

Many publishers put out graphic novels. The following are important North American ones in the English-language original graphic novel field at this point. However, new players emerge all the time, and the existing players often change direction. Don't assume that the publisher you're interested is open to submissions. Go to their website and check their submission guidelines before sending them anything.

AiT/PlanetLar: Cinematic original graphic novels.
2034 47th Avenue
San Francisco, CA 94116
www.ait-planetlar.com

Ape Entertainment: Original concepts, mostly serialized.
PO Box 7100
San Diego, CA 92167
www.ape-entertainment.com

Dark Horse Comics: An eclectic mix, heavy with licensed properties. Mostly serialized, some original graphic novels.
10956 SE Main Street
Milwaukie, OR 97222
www.darkhorse.com

DC Comics: DC is best known for superhero material (Superman, Batman, and so on), generally serialized and then collected. However, DC also does significant original graphic novels, including nonsuperhero material.
1700 Broadway
New York, NY 10019
www.dccomics.com

Drawn & Quarterly: Very artsy, mostly original graphic novels.
PO Box 48056
Montréal, Québec, Canada, H2V 4S8
www.drawnandquarterly.com

Dynamite Entertainment: Action-oriented, heavy with licensed properties, all serialized.
155 E 9th Avenue, Suite B
Runnemede, New Jersey 08078-1158
www.dynamiteentertainment.com

Fantagraphics Books: Eclectic, heavily artsy, some porn. Some serialized, some not.
7563 Lake City Way NE
Seattle, WA 98115 USA
www.fantagraphics.com

First Second (:01): All original graphic novels with a literary bent, including kids literature.
175 Fifth Avenue
New York, NY 10010
www.firstsecondbooks.com

IDW Publishing: Serialized-then-collected stories, primarily licensed material, some horror and others.
5080 Santa Fe
San Diego, CA 92109
www.idwpublishing.com

Image Comics: Heavy on superhero and action material, but interested in other things as well. Mostly serialized, some original graphic novels.
1071 N Batavia Street, Suite A
Orange, CA 92867
www.imagecomics.com

Marvel: Primarily superhero (Spider-Man, Hulk, and so on) and everything is serialized first. Marvel has done original graphic novels in the past, and that may happen again.
10 East 40th Street
New York, NY 10016
www.marvel.com

Oni: Hip alternative material, mostly original graphic novels.
6336 SE Milwaukie Avenue, PMB 30
Portland, OR 97202
www.onipress.com

Scholastic Books: This huge kids book publisher has a substantial graphic novel line, many (not all) derived from their prose publications.
557 Broadway
New York, NY 10012
www.scholastic.com

SLG Publishing: A mix of material leaning toward humor. Mostly serialized and then collected.
PO Box 26427
San Jose, CA 95159-6427
www.slgcomic.com

Toon Books: Graphic novels for kids.
c/o Raw Junior, LLC
27 Greene Street
New York, NY 10013
www.toon-books.com

Top Shelf Productions: Mainly original graphic novels in alternative styles.
PO Box 1282
Marietta, GA 30061-1282
www.topshelfcomix.com

Comic Book Conventions

Comic book conventions are great places to find collaborators, talk to editors, and sell your work. Many comics conventions are held each year in the United States and Canada, ranging from small shows with a handful of dealers in a church basement to shows that fill major convention centers with tens of thousands of creators, dealers, and fans. Larger science fiction or gaming conventions also often offer comics programming.

Listed here are some of the larger and more important annual conventions. For a fuller list of conventions and schedules for the current year, pull up www.comicbookconventions.com in your web browser.

Full-Range Conventions

These conventions cover a full range of the comics scene, from photocopied small press materials all the way up to the biggest mainstream superhero work:

◆ **Comic Con International: San Diego** (summer, San Diego, California). More commonly known simply as "The San Diego Comic Con," this is the huge granddaddy of the convention scene. This goes beyond comics to include a lot of film, TV, and animation material. Unspeakably huge. For more information: www.comic-con.org

◆ **New York Comic Con** (winter, New York, New York). This burst on the scene as a full-scale, well-rounded convention in the heart of publishing country. For more information: www.nycomiccon.com

◆ **Chicago Comic-Con** (summer, Rosemont, Illinois). After buying out the long-running Chicago Comicon, *Wizard* Magazine used this as a basis for running mainstream-oriented but still broad-ranged conventions around various major cities. For more information: www.wizardworld.com

◆ **MegaCon** (winter, Orlando, Florida). For more information: www.megaconvention.com

◆ **Mid-Ohio Con** (fall, Columbus, Ohio). For more information: www.midohiocon.com

- **Emerald City Comicon** (spring, Seattle, Washington). For more information: emeraldcitycomicon.com

- **Baltimore Comic-Con** (fall, Baltimore, Maryland). For more information: www.comicon.com/baltimore

- **WonderCon** (spring, San Francisco, California). For more information: www.comic-con.org

Alt/Indie Conventions

These conventions shy away from the big mainstream superhero material to focus on small press and alternative content. It's easier to avoid getting lost in the shuffle at these shows, all of which are better known by their acronyms than by their names:

- **SPX, the Small Press Expo** (fall, Bethesda, Maryland). For more information: www.spxpo.com

- **APE, the Alternative Press Expo** (fall, San Francisco, California). For more information: www.comic-con.org

- **MoCCA, the Museum of Comic and Cartoon Art Festival** (summer, New York City, New York). For more information: www.moccany.org

- **SPACE, the Small Press and Alternative Comics Expo** (spring, Columbus, Ohio). For more information: www.backporchcomics.com

- **Stumptown Comics Fest** (spring, Portland, OR). For more information: www.stumptowncomics.com

Appendix C

Other Resources for Graphic Novelists

Your reading doesn't end here. There are a number of other fine books, magazines, and web resources that will help you create your graphic novel. For books that may be out of print, try used book dealers or your local library.

Books

Comics and Sequential Art, by Will Eisner. Eisner didn't just produce one of the first graphic novels, he also wrote one of the first serious textbooks on their creation.

The DC Comics Guide to Pencilling Comics, by Klaus Janson. Janson's book reflects his years of experience as a teacher and adventure cartoonist.

Drawing the Head and Figure, by Jack Hamm. Hamm crams an enormous amount of useful information into his books. Get them all.

Figure Drawing for all it's Worth, by Andrew Loomis. Loomis's many books are the gold standard of how-to-draw books. Of course they're all out of print. Used copies will cost you hundreds of dollars, and library copies are frequently stolen. If it wasn't wrong to recommend violating the copyright, I'd suggest you borrow them by interlibrary loan and make cover-to-cover photocopy sets.

The New Comics: Interviews from the Pages of The Comics Journal, edited by Gary Groth and Robert Fiore. This book contains thoughtful interviews with some of the most important graphic novelists of the last 50 years.

On Directing Film, by David Mamet. This short book by the acclaimed playwright, screenwriter, and director is full of advice about visual storytelling that graphic novelists will find valuable.

Panel Discussions: Design in Sequential Art Storytelling, by Durwin Talon, et al. Interviews with comic book illustrators, with a strong emphasis on their artistic process.

Panel One: Comic Book Scripts, Top Writers, by Neil Gaiman, Kevin Smith, et al., and edited by Nat Gertler (yes, the cowriter of this book you hold in your hands). This book reproduces complete comic book scripts for published comics. A useful resource for artists who want to practice on a professional script and for writers who want to see how others do it.

Perspective! for Comic Book Artists, by David Chelsea. This is a textbook in comics form on the art and science of perspective. It's not easy to make perspective—with its complicated diagrams—fun to read about, but Chelsea succeeds.

Understanding Comics, by Scott McCloud. McCloud's thoughtful comic about how the comics medium works is considered a must-read by most cartoonists. His follow-up *Making Comics* is also worthwhile.

Websites

The World Wide Web is the greatest single informational and conversational resource ever. This proves as true for graphic novelists as for anything else.

comicbookresources.com, newsarama.com, comicon.com, sequentialart. com: Fan-oriented sites with news, reviews, and discussion, all of which can be handy when it comes time to promote your graphic novel.

panelandpixel.com, digitalwebbing.com: Discussion forums heavily populated by those on the way into the comic book scene. These are good places to compare notes and hunt for collaborators.

comicspace.com: A popular website for up-and-comers to show off their art, this is a good place to cruise for collaborators.

thecbia.com: The Comic Book Industry Alliance discussion board is primarily a hangout for graphic novel retailers. It comes in handy for self-publishers when promoting your works or seeking advice about what makes a book marketable. Simply lurking here will give you an education on the reality of the graphic novel business.

comicbookconventions.com: A list of almost all of the upcoming comic book conventions.

the-master-list.com: The Master List attempts to list every comic book store in the United States, which makes it handy if you're planning on sending out mailings or looking for stores in a given area where you can do signings.

balloontales.com: An online guide to digital comic book lettering, done by people who know what they're talking about.

kleinletters.com: More on lettering from a master letterer, including a useful view of comics logo design.

Index

Numbers/Symbols

2-ply Bristol board, 128
3-D models, 145-146
3-D tools, 63
24 hour comics, 10
180-degree rule, 120

… (ellipsis), 75
– (em dashes), 74
! (exclamation points), 68

A

Acredale Media Inc. website, 249
action themes, 35
action-line drawings, 154
advantages
 freedom, 6
 personal vision, 4
 speaking to everyone, 4
 speaking to individuals, 4
 unlimited lengths, 6
advertising
 books, 282-283
 websites, 241
aerial perspective, 152
agents, 231
Al Williamson Adventures, 180
All Nighter, 101
analyzing scripts, 107-108
antagonists, 41
art, 12
article body of press releases, 278
artistic goals, 12
artistic greatness, 10-11
Atlas of Human Anatomy for the Artist, 149
attitudes of characters, 40-41
audiences, 12
autobiographical genre, 30
autographing novels, 284-285
Awkward, 5

B

background, 64
balloons
 bursts, 74
 electric, 74
 elliptical, 197
 formatting, 74
 inflated ellipses, 197
 lettering, 197-198
 bursts, 199
 flattening, 199
 outlining, 199
 shapes, 196-198
 tails, 198-199
 thought, 71
 word, 69
barcodes, 271
 ISBNs, 273
 mistakes, 273-274
 UPCs, 271-272
The Big Con
 finished pages, 203
 pencils, 167
 script example, 77
 thumbnails, 125
bird's-eye view shots, 121
black-and-white reproductions, 188
bleeds, 136, 252
blocking out in coloring, 215
blowing up thumbnails
 copying and tracing, 135-136
 image manipulation programs, 134-135
Blue Pills, 41
bluelining art, 135
bodies of characters, 92-93
books
 drawing, 148
 format, 15
 inking, 189
bookstore distribution
 returns, 275
 wholesalers, 274
brands of ink, 184
breaking pages into panels, 58
 layout planning, 60
 rhythm method, 59

Brenner Printing, 249
brevity of dialogue, 68-69
brushes, 181-182
budget decisions, 111
building webcomic readership, 243-244
burst balloons, 74, 199
Busiek, Kurt, 11

C

Café Press publishing services, 262
camera angles, 63-64
 distance from subject, 64
 repetitive, 65
 scene height, 121
 zooming, 64
capitalization, 196
captions, 71-72
career paths, 288
 beyond comics, 289
 editorial positions with publishers, 290
 storyboarding, 291
 teaching, 290
 video game design, 291
 writing TV/movie scripts, 291
 emotional, 289
 freelance, 288
 inconsistency, 289
 subject to trends, 289
 working on someone else's novels, 288
 writing more novels, 287-288
caricatures, 110
cause and effect, 45
CBIA (Comic Book Industry Alliance), 280
changing
 characters, 44
 pencils, 185
characters, 39
 abilities, 40
 antagonists, 41
 attitudes, 40-41
 cause and effects, 45
 changes, 44

conflicts, 44
descriptions, 61
drawing
 bodies, 92-93
 clothes, 93-94
 heads, 90-92
 imaginary, 95
 model sheets, 96
 reading scripts, 89-90
examples, 45-46
gestures, 153-156
guides, 226
histories, 42
identification, 40
Japanese manga, 92
names, 42
protagonists, 41
products, 241
publisher-owned, 233
relationships, 53
revealing attributes, 42
 decision-making, 43
 physical appearances, 42
weaknesses, 41
cheap publishing
laser printers, 236
photocopiers, 236-237
print on demand, 237-238
webcomics, 238
 building readership, 243-244
 comics specialty websites, 240
 domain names, 239
 downloading to portable
 devices, 244
 making money, 240-243
 personal websites, 239
 spreading the word, 243
chins, 92
choosing
art supplies
 erasers, 129-130
 light boxes, 132
 paper, 128
 pencils, 128-129
 rulers, 130
 T-squares, 131
 tables, 131
collaborative or solo work, 13
 desires, 15
 personalities, 13
 time constraints, 14-15
 weaknesses, 14

colors, 217
drawing influences, 161-163
formats, 15-16
printers, 248-249
 main North American
 printers, 248
 overseas, 249
 price quotes, 249-250
 shipping costs, 250
 tolerance, 250
publishers, 228-229
themes, 109
Cintiq monitors, 143-144
circular panels, 121
clip files, 63
close shots, 64
close-up shots, 64
clothes, 93-94
CMYK (Cyan, Magenta, Yellow,
Black), 213
cold press papers, 128
collaborative work
choosing, 13
 desires, 15
 personalities, 13
 time constraints, 14-15
 weaknesses, 14
disagreements
 misunderstandings, 115
 subverting, 115
 withdrawing from projects,
 116
 working out, 115
collaborators
colorists, 19
cover artists, 20
designers, 20
editors, 20
evaluating
 coloring, 24
 cooperation, 24
 inking, 23-24
 lettering, 24
 penciling, 22-23
 writers, 21-22
finding, 25
inkers, 18-19, 178-179
intellectual property rights,
 26-27
letterers, 19
paying, 26-28
pencilers, 18, 179-180

proofreaders, 20
sounding boards, 20
unique combinations, 21
writers, 18
color keys, 254
coloring
blocking out, 215
CMYK, 213
computers, 217
contrast, 214-215
cuts, 220-221
flatting, 219-220
four-color printing, 213
gradients, 220
lens flares, 221
local colors, 215
textures, 221
colorists
color selection, 217
evaluating, 24
lighting/shading, 216
overview, 19
painting, 219
photos as surfaces, 221
placing pages, 218-219
combining genres, 33
comedy themes, 35
Comic Book Industry Alliance
 (CBIA), 280
Comic Shop Locator Service
 website, 7
comics specialty websites, 240
ComiXpress publishing services,
 261
communication, 4
complications, 36, 52-53
composition, 124
computers, 217
conflicts, 44
construction lines, 180
contrast, 214-215
conventions
 book promotions, 283-284
 publisher meetings, 230
conversation, 67
balloons
 bursts, 74, 199
 electric, 74
 elliptical, 197
 flattening, 199
 formatting, 74
 inflated ellipses, 197

lettering, 197-199
outlining, 199
shapes, 196-198
tails, 198-199
thought, 71
word, 69
brevity, 68-69
exclamation points (!), 68
interesting conversations, 69-70
realistic sounding, 68
cooperation, 24
correcting pencils, 185
cover artists, 20
covers of proposals, 226
CreateSpace publishing services, 263
creative momentum, 10
creative teams
colorists, 19
color selection, 217
evaluating, 24
lighting/shading, 216
overview, 19
painting, 219
photos as surfaces, 221
placing pages, 218-219
cover artists, 20
designers, 20
editors, 20
evaluating
coloring, 24
cooperation, 24
inking, 23-24
lettering, 24
penciling, 22-23
writers, 21-22
finding, 25
inkers, 18-19
evaluating, 23-24
overview, 18-19
splitting work with pencilers, 179-180
intellectual property rights, 26-27
letterers, 19
balloons, 74
breaking between word balloons, 74-75
emphasis, 73
evaluating, 24
formatting text, 73-75
overview, 19
special requests, 73

paying, 26-28
pencilers, 18
evaluating, 22-23
overview, 18
splitting work with inkers, 179-180
proofreaders, 20
sounding boards, 20
unique combinations, 21
writers, 18
evaluating, 21-22
overview, 18
plots, 51
crime genre, 31
cross-hatching, 19
current market, 7
curved balloon tails, 198
cuts, 220-221
cutting, 252
Cyan, Magenta, Yellow, Black (CMYK), 213

D

dealers, 270-271
decisions
characters, 43
themes, 109-111
artists' skills, 111
budgets, 111
print size, 111-112
resisting strengths, 112-113
Definition, 5
depicting time, 123
depth in drawing, 151-152
describing panels, 61
amount of detail, 65
characters, 61
emotional impact, 62
locations, 62
picture references, 63
designers, 20
desktop publishing software, 251
developing styles, 161-163
dialogue, 67
balloons
bursts, 74, 199
electric, 74
elliptical, 197
flattening, 199
formatting, 74
inflated ellipses, 197

lettering, 197-199
outlining, 199
shapes, 196-198
tails, 198-199
thought, 71
word, 69
brevity, 68-69
exclamation points (!), 68
interesting conversations, 69-70
realistic sounding, 68
Diamond Comics Distributors, 265-266
pitching, 266-267
soliciting books, 267-268
digital drawing tools
3-D models, 145
Formfonts's library, 145
Google 3-D warehouse, 145
poser figures, 145-146
Cintiq monitors, 143-144
graphic tablets, 142-143
image editors, 139
GIMP, 140
Manga Studio, 141
Photoshop, 140
tablet PCs, 145
digital lettering, 192
balloons, 197-198
bursts, 199
flattening, 199
outlining, 199
shapes, 196-198
tails, 198-199
capitalization, 196
fonts, 193-194
scanning line art, 194-195
size, 195-196
sound effects, 200
supplies, 193
text, 195
dip pens, 182-183
direct distributors
distribute on demand, 270
Haven Distribution, 268
Last Gasp, 269
Slave Labor Graphics, 269
direct market, 266
disagreements between writers/artists, 115
misunderstandings, 115
subverting, 115

withdrawing from projects, 116
working out, 115
distance from subject camera
 angles, 64
distribution
 barcodes, 271
 ISBNs, 273
 mistakes, 273-274
 UPCs, 271-272
 bookstores
 returns, 275
 wholesalers, 274
 dealers, 270-271
 Diamond Comics Distributors,
 265-266
 pitching, 266-267
 soliciting books, 267-268
 distribute on demand, 270
 Haven Distribution, 268
 Last Gasp, 269
 on demand publishers, 270
 Slave Labor Graphics, 269
domain names, 239
double dashes, 74-75
downloading, 244
drafting brushes, 130
drawing
 characters
 bodies, 92-93
 clothes, 93-94
 heads, 90-92
 imaginary, 95
 model sheets, 96
 reading scripts, 89-90
 collaborative disagreements, 115
 misunderstandings, 115
 subverting, 115
 withdrawing from projects,
 116
 working out, 115
 depth, 151-152
 digital tools, 139
 3-D models, 145-146
 Cintiq monitors, 143-144
 GIMP, 140
 graphic tablets, 142-143
 Manga Studio, 141
 Photoshop, 140
 tablet PCs, 145
 experiments, 163

gestures, 153-154
 action-lines, 154
 exaggerating, 154
 interactive, 156
 silhouettes, 155
 spiral body movements, 155
layouts
 The Big Con thumbnails, 125
 camera angles, 121
 composition, 124
 not fitting together, 124
 shapes, 121-122
 speaker order, 119-120
 thumbnails, 117-119
 time depiction, 123
learning, 148
 books, 148
 simple forms, 149-150
light, 156-157
live art areas, 136
motifs, 113-115
pencils, 157
plagiarism, 133
props, 104-105
references, 132-134
requirements, 147
script analysis, 107-108
settings
 accuracy, 101
 details, 100
 events, 101
 feeling, 101
 imaginary, 103
 importance, 100
 model sheets, 105
 realistic, 102
 size, 101
 time-consuming, 102
supplies, 127
 erasers, 129-130
 light boxes, 132
 paper, 128
 pencils, 128-129
 rulers, 130
 T-squares, 131
 tables, 131
theme decisions, 109-111
 artists' skills, 111
 budgets, 111
 print size, 111-112
 resisting strengths, 112-113

thumbnails, 134-136
 unifying theme, 109
*Drawing on the Right Side of the
 Brain*, 148
dummies, 253

E

editorial jobs, 290
editors, 20
Edwards, Dr. Betty, 148
electric balloons, 74
electric erasers, 130
ellipsis (...), 75
elliptical balloons, 197
em dashes (–), 74
emotions, 34, 289
emphasizing text, 73
erasers, 129-130
essay genre, 32
establishing shots, 64
evaluating
 colorists, 24
 cooperation, 24
 inkers, 23-24
 letterers, 24
 pencilers, 22-23
 writers, 21-22
exaggerating gestures, 154
examples
 The Big Con
 finished pages, 203
 pencils, 167
 script, 77
 thumbnails, 125
 characters, 45-46
 inking procedures, 186-187
exclamation points (!), 68
existential themes, 34
experiments
 drawing techniques, 163
 formal, 165
 subject matter, 164
extreme close-ups, 64
eyebrows, 92
eyes, 92

F

fantastic designs
 characters, 95
 settings, 103

A Fax from Sarajevo, 30
feathering, 19
fictional locations, 48
files, 251-252
financial success, 10
finding creative team members, 25
first-person narrations, 72
flattening balloons, 199
flatting, 219-220
fonts, 193-194
foreground, 64
formal experiments, 165
formatting, 8
 book, 15
 choosing, 15-16
 pamphlets, 15
 proposals, 226-227
 text for letterers, 73
 balloons, 74
 breaking between word
 balloons, 74-75
 emphasis, 73
 special requests, 73
Formfonts website, 145
fountain pens, 183
four-color printing, 213
freedom, 6
freelancing, 288
full scripts, 56
future market, 7

G

genres, 29
 autobiographical, 30
 combining, 33
 crime, 31
 essays, 32
 historical, 31
 horror, 32
 romance, 32
 science fiction, 31
 slice-of-life, 30
 superheroes, 29-30
gestures, 153-154
 action-lines, 154
 exaggeration, 154
 interactive, 156
 silhouettes, 155
 spiral body movements, 155

GIMP (GNU Image Manipulation
 Program), 140
goals, 9
 artistic, 10-12
 financial, 10
 guidelines, 16
Google
 3-D Warehouse, 63, 145
 AdWords, 241
 Image Search, 63
gradients, 220
graphic novels
 compared to novels, 8
 defined, 3
 formats, 8
graphic tablets, 142-143
gutters, 253

H

Hahn, David, 101
hair, 91
hand lettering, 191-192
Hard SF, 31
hatching, 19
Haven Distribution, 268
headlines of press releases, 278
heads, 90
 features, 91-92
 shapes, 90-91
Hendrix, Shepherd, 50
Hernandez, Gilbert, 91
high-angle shots, 121
histories, 31, 42
horror genre, 32
Hosler, Jay, 48
How to Draw the Human Figure, 149

I

identification, 40
illustrating
 characters
 bodies, 92-93
 clothes, 93-94
 heads, 90-92
 imaginary, 95
 model sheets, 96
 reading scripts, 89-90

collaborative disagreements, 115
 misunderstandings, 115
 subverting, 115
 withdrawing from projects,
 116
 working out, 115
depth, 151-152
digital tools, 139
 3-D models, 145-146
 Cintiq monitors, 143-144
 GIMP, 140
 graphic tablets, 142-143
 Manga Studio, 141
 Photoshop, 140
 tablet PCs, 145
experiments, 163
gestures, 153-154
 action-lines, 154
 exaggerating, 154
 interactive, 156
 silhouettes, 155
 spiral body movements, 155
layouts
 The Big Con thumbnails, 125
 camera angles, 121
 composition, 124
 not fitting together, 124
 shapes, 121-122
 speaker order, 119-120
 thumbnails, 117-119
 time depiction, 123
learning, 148
 books, 148
 simple forms, 149-150
light, 156-157
live art areas, 136
motifs, 113-115
pencils, 157
plagiarism, 133
props, 104-105
references, 132-134
requirements, 147
script analysis, 107-108
settings
 accuracy, 101
 details, 100
 events, 101
 feeling, 101
 imaginary, 103
 importance, 100
 model sheets, 105

realistic, 102
size, 101
time-consuming, 102
supplies, 127
 erasers, 129-130
 light boxes, 132
 paper, 128
 pencils, 128-129
 rulers, 130
 T-squares, 131
 tables, 131
theme decisions, 109-111
 artists' skills, 111
 budgets, 111
 print size, 111-112
 resisting strengths, 112-113
thumbnails, 134-136
unifying theme, 109
images
 3-D tools, 63
 drawing. *See* drawing
 editors, 139
 GIMP, 140
 Manga Studio, 141
 Photoshop, 140
 freedom, 6
 Google Image Search, 63
 press releases, 280
 references, 63, 133
 speaking to everyone/
 individuals, 4
 as surfaces, 221
imaginary designs
 characters, 95
 settings, 103
Imprimerie Lebonfon, 249
inconsistency, 289
inflated ellipses, 197
influences on styles, 159-160
inkers
 evaluating, 23-24
 overview, 18-19
 splitting work with pencilers,
 179-180
inking
 black-and-white reproductions,
 188
 books, 189
 changing pencils, 185
 construction lines, 180
 learning, 181
 object lines, 180

pencils, 157
procedures, 186-187
responsibilities, 180
tools
 brands of ink, 184
 brushes, 181-182
 dip pens, 182-183
 fountain pens, 183
 markers, 184
 technical pens, 184
transitions/textures, 188
intellectual property rights, 26-27
interactive gestures, 156
interesting conversations, 69-70
The Interman, 4
ISBNs (International Standard
 Book Numbers), 273
It's a Good Life If You Don't Weaken,
 30

J–K

Japanese manga characters, 92

Ka-Blam publishing services, 261
Kingdom Come, 219
Kirby, Jack, 13
kneaded erasers, 129
Kubert, Joe, 30

L

Last Gasp, 269
layouts
 The Big Con thumbnails, 125
 camera angles, 121
 composition, 124
 defined, 18
 not fitting together, 124
 panels, 60
 scripts, 57
 shapes, 121-122
 speaker order, 119-120
 thumbnails, 117-119
 time depiction, 123
lead holders, 128
learning
 drawing, 148
 books, 148
 simple forms, 149-150
 inking, 181

Lee, Stan, 13
lengths, 6
lens flares, 221
letterers
 evaluating, 24
 formatting text, 73
 balloons, 74
 breaking between word
 balloons, 74-75
 emphasis, 73
 special requests, 73
 overview, 19
lettering
 balloons, 197-198
 bursts, 199
 flattening, 199
 outlining, 199
 shapes, 196-198
 tails, 198-199
 capitalization, 196
 digital, 192
 fonts, 193-194
 hand, 191-192
 scanning line art, 194-195
 size, 195-196
 sound effects, 200
 supplies, 193
 text, 195
licensing, 12
light
 colorists, 216
 drawing, 156-157
light boxes, 132
Likewise, 5
line art scans, 194-195
linear perspective, 151
live art areas, 136
local colors, 215
locations, 47
 descriptions, 62
 fictional, 48
 real, 47-48
Loomis, Andrew, 149
low-angle shots, 121
Lulu publishing services, 262
Luth, Tom, 213

M

Manga Studio, 141
marginal copy costs, 250
markers, 184

marketing
 advertising, 282-283
 conventions, 283-284
 getting reviews, 281-282
 press releases, 277
 article body, 278
 available information
 identification, 279
 content, 278-280
 graphics, 280
 headlines, 278
 project details, 279
 sending out, 280
 subheads, 278
 technical details, 279
 when to release, 281
 signings, 284-285
Marvel style scripts, 58
Marvels, 11
master list of comic book and
 trading card stores website, 281
masters, 236
Maus, 8
McCay, Winsor, 14
McCulloch, Derek, 50
medium shots, 64
midground, 64
minor themes, 35
model references, 132-134
model sheets
 characters, 96
 props, 105
money
 financial success, 10
 paying collaborators, 26-28
 webcomics, 240-243
Morgan Printing, 249
motifs, 113-115
mouths, 92
movies
 licensing, 12
 rights, 233
 script writing, 291

N

names, 42
negative space, 155
noses, 92
novels, 8

O

object lines, 180
offers from publishers, 230
 page rates, 230-231
 profit deals, 232
 rights deals, 233-234
 royalties, 231-232
out of print, 234
outlining balloons, 199
overlapping, 152
overseas printers, 249

P

pacing pages, 55
pages
 breaking into panels, 58-59
 layout planning, 60
 rhythm method, 59
 pacing, 55
 placing, 218-219
 rates, 230-231
 splash, 122
painting, 219
Palomar, 91
pamphlets, 15
 publishing, 248
 UPCs, 271
panels
 The Big Con thumbnails, 125
 breaking pages, 58-59
 layout planning, 60
 rhythm method, 59
 camera angles, 63-64
 repetitive, 65
 scene height, 121
 types, 64
 zooming, 64
 composition, 124
 describing, 61
 amount of detail, 65
 characters, 61
 emotional impact, 62
 locations, 62
 picture references, 63
 layout, 60
 not fitting together, 124
 pacing pages, 55
 shapes, 121-122
 time depiction, 123

paper
 choosing, 128
 stock, 20
Parker, Jeff, 4
paying collaborators, 26-28
Peeters, Frederik, 41
pencilers
 evaluating, 22-23
 overview, 18
 splitting work with inkers,
 179-180
pencils
 The Big Con, 167
 changing, 185
 choosing, 128-129
 construction lines, 180
 defined, 157
 inking, 157
 object lines, 180
perfect bound, 262
personal vision, 4
perspective
 aerial, 152
 linear, 151
Photoshop, 140
physical appearances, 42
picture references, 133
pitching, 225
 conventions, 230
 Diamond Comics Distributors,
 266-267
 proposals, 226-227
 submissions, 227-228
placing pages, 218-219
plagiarism, 133
planning panel layouts, 60
plots
 breaking into pages, 55
 character relationships, 53
 checking, 52
 complications, 52-53
 editing, 54
 locations
 descriptions, 62
 fictional, 48
 real, 47-48
 proposals, 226
 time period, 49-50
 writing down, 51

POD (print on demand), 237-238,
257
 advantages, 258
 Hollywood movie goals, 258
 publishing services, 260-261
 Café Press, 262
 ComiXpress, 261
 CreateSpace, 263
 Ka-Blam, 261
 Lulu, 262
 reprints, 259
 reviewer copies, 259
 setting up, 260
portable device downloads, 244
poser figures, 145-146
Potential, 5
premium web content, 243
prepress
 cutting and bleeding, 252
 files, 251-252
 gutters, 253
 page formats, 252
 printer suggestions, 253
press releases, 277
 article body, 278
 available information
 identification, 279
 content, 278-280
 graphics, 280
 headlines, 278
 project details, 279
 sending out, 280
 subheads, 278
 technical details, 279
 when to release, 281
Previews, 282
print on demand (POD), 237-238,
257
 advantages, 258
 Hollywood movie goals, 258
 publishing services, 260-261
 Café Press, 262
 ComiXpress, 261
 CreateSpace, 263
 Ka-Blam, 261
 Lulu, 262
 reprints, 259
 reviewer copies, 259
 setting up, 260

printers
 choosing, 248-249
 main North American
 printers, 248
 overseas, 249
 price quotes, 249-250
 shipping costs, 250
 tolerance, 250
 on demand services
 Café Press, 262
 ComiXpress, 261
 CreateSpace, 263
 Ka-Blam, 261
 Lulu, 262
 prepress
 cutting and bleeding, 252
 dummies, 253
 files, 251-252
 gutters, 253
 page formats, 252
 printer suggestions, 253
 price quotes, 249-250
 proofs, 254
printing
 cheaply
 downloading to portable
 devices, 244
 laser printers, 236
 on demand, 237-238
 online. *See* webcomics
 photocopiers, 236-237
 on demand, 257
 advantages, 258
 Hollywood movie goals, 258
 publishing services, 260-263
 reprints, 259
 reviewer copies, 259
 setting up, 260
 self
 books versus pamphlets,
 247-248
 choosing a printer, 248-250
 cutting and bleeding, 252
 dummies, 253
 files, 251-252
 gutters, 253
 page formats, 252
 pamphlets, 248
 printer proofs, 254
 printer suggestions, 253
 size limits, 111-112

procedures for inking, 186-187
profit deals, 232
Project Wonderful, 241
promoting novels
 advertising, 282-283
 conventions, 283-284
 getting reviews, 281-282
 press releases, 277
 article body, 278
 available information
 identification, 279
 content, 278-280
 graphics, 280
 headlines, 278
 project details, 279
 sending out, 280
 subheads, 278
 technical details, 279
 when to release, 281
 signings, 284-285
proofreaders, 20
proofs, 254
proposals, 226-227
props, 104-105
protagonists, 41
publishers
 choosing, 228-229
 editorial positions, 290
 meeting at conventions, 230
 offers, 230
 page rates, 230-231
 profit deals, 232
 royalties, 231-232
 owned characters, 233
 pitching, 225
 proposals, 226-227
 query letters, 229
 rights deals, 233-234
 submissions, 227-228
publishing
 cheaply
 downloading to portable
 devices, 244
 laser printers, 236
 online. *See* webcomics
 photocopiers, 236-237
 printing on demand, 237-238
 distribution
 Diamond Comics
 Distributors, 265-268
 Haven Distribution, 268

Last Gasp, 269
Slave Labor Graphics, 269
printing on demand, 257
advantages, 258
Hollywood movie goals, 258
publishing services, 260-263
reprints, 259
reviewer copies, 259
setting up, 260
self
books versus pamphlets, 247-248
choosing a printer, 248-250
cutting and bleeding, 252
dummies, 253
files, 251-252
gutters, 253
page formats, 252
pamphlets, 248
printer proofs, 254
printer suggestions, 253
submissions, 227-228
Purvis, Leland, 165

Q-R

Quebecor World, 248
query letters, 229

radio balloons, 74
readership of webcomics, 243-244
real locations, 47-48
realistic dialogue, 68
realistic setting designs, 102
rectangle panels, 121
references, 132
3-D models, 145
Formfonts's library, 145
Google 3-D warehouse, 145
poser figures, 145-146
models, 132-134
web, 134
repetition, 114-115
requested submissions, 230
retractable erasers, 130
revealing character attributes
decision-making, 43
physical appearances, 42
reversion of rights, 234
reviews, 281-282
rhythm method of breaking pages
into panels, 59

rights
offering to publishers, 233-234
reversions, 234
TV/movie, 233
Rogers, Stephen, 149
romance fiction genre, 32
Ross, Alex, 11, 219
royalties, 231-232
rulers, 130

S

saddle-stitching, 261
samples for proposals, 226
The Sandwalk Adventures, 48
scanning line art, 194-195
scene height camera angles, 121
Schrag, Ariel, 5
science fiction genre, 31
scripts
amount of detail, 65
analyzing, 107-108
The Big Con example, 77
breaking pages, 58-59
layout planning, 60
rhythm method, 59
camera angles, 63-64
repetitive, 65
types, 64
zooming, 64
pacing pages, 55
panel descriptions, 61
characters, 61
emotional impact, 62
locations, 62
picture references, 63
styles, 56
full, 56
layout, 57
Marvel, 58
text
balloons, 74
breaking between word balloons, 74-75
brevity, 68-69
captions, 71-72
emphasis, 73
exclamation points (!), 68
formatting for letterers, 73
interesting conversations, 69-70
lettering, 195

realistic sounding, 68
sound effects, 72
special requests, 73
thought balloons, 71
word balloons, 69
unifying theme, 109
self-publishing
books versus pamphlets, 247-248
choosing a printer, 248-249
main North American printers, 248
overseas, 249
price quotes, 249-250
tolerance, 250
distribution
barcodes, 271-274
bookstores, 274-275
dealers, 270-271
Diamond Comics Distributors, 265-268
distribute on demand, 270
Haven Distribution, 268
Last Gasp, 269
Slave Labor Graphics, 269
pamphlets, 248
prepress
cutting and bleeding, 252
dummies, 253
files, 251-252
gutters, 253
page formats, 252
printer suggestions, 253
printer proofs, 254
printing on demand, 257
advantages, 258
Hollywood movie goals, 258
publishing services, 260-263
reprints, 259
reviewing copies, 259
setting up, 260
sending press releases, 280-281
serializing, 14
settings
captions, 72
drawing
accuracy, 101
details, 100
events, 101
feeling, 101
imaginary, 103
importance, 100
model sheets, 105

realistic, 102
size, 101
time-consuming, 102
print on demand, 260
shading, 216
shapes
balloons, 196-198
flatting, 219-220
heads, 90-91
panels, 121-122
Shenton, Tony, 237
signing pens, 284
signings, 284-285
silhouettes, 155
simple form drawing, 149-150
simultaneous submissions, 229
situations, 36
size
lettering, 195-196
printing limits, 111-112
settings, 101
Sketchup, 145
skin, 92
Slave Labor Graphics, 269
slice-of-life genre, 30
slush piles, 230
small press, 237
soliciting books, 267-268
solo work, 13
desires, 15
personalities, 13
time constraints, 14-15
weaknesses, 14
sound effects, 72, 200
sounding boards, 20
speaker order, 119-120
spiral body movements, 155
splash pages, 122
square panels, 121
Stagger Lee, 50
stories
characters, 39
abilities, 40
antagonists, 41
attitudes, 40-41
cause and effects, 45
changes, 44
conflicts, 44
examples, 45-46
histories, 42
identification, 40
names, 42

protagonists, 41
relationships, 53
revealing attributes, 42-43
weaknesses, 41
complications, 36, 52-53
editing, 54
plots
checking, 52
locations, 47-48
time period, 49-50
writing down, 51
scripts
amount of detail, 65
analyzing, 107-108
The Big Con example, 77
breaking pages, 58-60
camera angles, 63-65
pacing pages, 55
panel descriptions, 61-63
styles, 56-58
situations, 36
storyboarding careers, 291
straight balloon tails, 198
styles
defined, 160
developing, 161-163
experiments
drawing techniques, 163
formal, 165
subject matter, 164
influences, 159-160
scripts, 56
full, 56
layout, 57
Marvel, 58
subheads of press releases, 278
subject matter experiments, 164
subject to trends, 289
submissions for publishers, 227-228
Successful Drawing, 149
superhero genre, 12, 29-30
supplies, 127
digital tools, 139
3-D models, 145-146
Cintiq monitors, 143-144
GIMP, 140
graphic tablets, 142-143
lettering, 193
Manga Studio, 141
Photoshop, 140
tablet PCs, 145

erasers, 129-130
inking
brands of ink, 184
brushes, 181-182
dip pens, 182-183
fountain pens, 183
markers, 184
technical pens, 184
light boxes, 132
paper, 128
pencils, 128-129
references, 132-134
rulers, 130
T-squares, 131
tables, 131
surface photos, 221

T

T-squares, 131
tables, 131
tablet PCs, 145
tags, 100
tails of balloons, 198-199
tangencies, 185
teaching career, 290
technical pens, 184
text
captions, 71-72
dialogue, 67
brevity, 68-69
exclamation points (!), 68
interesting conversations, 69-70
realistic sounding, 68
thought balloons, 71
word balloons, 69
formatting for letterers, 73
balloons, 74
breaking between word balloons, 74-75
emphasis, 73
special requests, 73
lettering, 195
sound effects, 72
textures
coloring, 221
inking, 188
themes, 34
action, 35
choosing, 109

comedy, 35
decisions, 109-111
 artists' skills, 111
 budgets, 111
 print size, 111-112
 resisting strengths, 112-113
emotional, 34
existential, 34
minor, 35
third-person narration, 72
thought balloons, 71, 198
thumbnails, 117-119
 The Big Con, 125
 blowing up
 copying and tracing, 135-136
 image manipulation
 programs, 134-135
time
 constraints, 14-15
 consuming setting designs, 102
 depicting, 123
 period, 49-50
Transcontinental Printing, 249
transitions, 188
trapping, 24
TV
 rights, 233
 script writing, 291
types
 camera angles, 64
 graphic novels, 29
 autobiographical, 30
 combining, 33
 crime, 31
 essays, 32
 historical, 31
 horror, 32
 romance, 32
 science fiction, 31
 slice-of-life, 30
 superheroes, 29-30

U

underground comix, 269
unique collaborations, 21
unsolicited submissions, 229
UPCs (Universal Product Codes),
 271-272

V

vellum papers, 128
verisimilitude, 30
video game design careers, 291
vignettes, 122
Vox, 165

W-X-Y-Z

Wacom graphic tablets, 142
Waid, Mark, 219
weaknesses
 characters, 41
 personal, 14
web
 publishing premium content,
 243
 references, 134
webcomics, 238
 building readership, 243-244
 comics specialty websites, 240
 domain names, 239
 downloading to portable devices,
 244
 making money from, 240-243
 personal websites, 239
 spreading the word, 243
websites
 Acredale Media Inc., 249
 Brenner Printing, 249
 Café Press, 262
 CBIA, 280
 Comic Shop Locator, 7
 comics fonts, 194
 ComiXpress, 261
 CreateSpace, 263
 Diamond Comics Distributors,
 266
 domain name sources, 239
 Formfonts, 145
 GIMP, 140
 Google
 3-D Warehouse, 63
 AdWords, 241
 Image Search, 63
 Haven Distribution, 269
 Imprimerie Lebonfon, 249
 ISBNs, 273

Ka-Blam, 261
Last Gasp, 269
Lulu, 262
Manga Studio, 141
master list of comic book and
 trading card stores, 281
Morgan Printing, 249
Quebecor World, 248
Slave Labor Graphics, 270
Transcontinental Printing, 249
UPCs, 272
wholesalers, 274
wide shots, 64
Williamson, Al, 180
word balloons, 69
working collaboratively versus solo,
 13
 desires, 15
 personalities, 13
 time constraints, 14-15
 weaknesses, 14
worm's-eye view, 121
writers
 evaluating, 21-22
 overview, 18
 plots, 51

zooming camera angles, 64